The Art of the Migration Period

Gyula László

The Art of the Migration Period

University of Miami Press
Coral Gables, Florida

Original edition: *A népvándorláskor művészete Magyarországon*
Corvina Press, Budapest
© 1970 by Gyula László
Translation by Barna Balogh
Translation revised by Paul Aston
Illustrations: line drawings in text by Gyula László.
Black and white photographs Nos. 62 and 63 are by Joan Dezort, Prague;
black and white photographs Nos. 18–21, 31 and 145–162
are from the Archives of Kunsthistorisches Museum, Vienna;
all other black and white photographs by Kálmán Kónya.
Color plates II, X, XI, XV, and XVI are by Kálmán Kónya;
all others by Károly Szelényi.
Maps by Gyula Gáll.
Cover: Tamás Oly

English edition © 1974 by University of Miami Press,
Coral Gables, Florida
ISBN 0-87024-222-9
Library of Congress Catalog Card No. 70-171454
Printed in Hungary, 1974

CONTENTS

INTRODUCTION

This book was written in the course of thirty-five years of archaeological work, almost imperceptibly, amidst meditations, anxieties, and "eurekas." I lingered with awe among the great creations of art—and the word "art" here is used advisedly; it is not taken to include works which only the biased expert knowledge of the archaeologist would consider as art. It needs no stressing that we know little of the past, that many things have perished through the ravages of time; the remains that chance has preserved for posterity should not be underrated nor, indeed, over-estimated only because they are old. Probably we can feel, and come to like, the past for what it really was if we somehow succeed in seeing it in its entirety, surmising or adumbrating many a thing in it which has long perished. From the time of the Great Migrations, practically nothing but buckles, strap ends, belt mountings, earrings, stirrups, bridles, sabers, potsherds, bone work, and similar fittings—buried along with the dead—have come down to us. As for villages dating back to the Migration Period, we have uncovered only one—at least on Hungarian territory—or, rather, we have only just started excavation work on the site. It should be stressed that all items we know of from this period have come out of unearthed cemeteries. How would posterity judge our own age if it knew only our cemeteries and found in the graves only wedding rings, the rusty works of watches, metal teeth, perhaps a few necklaces, or the crosses and prayer books of those who were religious? What would posterity learn of the richness of our lives?

All analogies, including this one, are imperfect, yet it suggests a great deal of what I would like to say. Most likely, future archaeologists will find vestiges of our towns, villages, and factories, but they might never dare even to conjecture that the giant bridges, factories, buildings, and laboratories were built by the same men in whose graves lay only modest and paltry finds. Perhaps the tombstones in the cemeteries, providing they are left in place undisturbed, might betray that these men of the past were creative artists as well.

But let us not pursue this discouraging train of thought and say only that it is the prime duty of an archaeologist to make inferences from the "finds" as to the way of life of a long perished people, insofar as it is at all possible. He must realize and put up with the idea that his work will remain incomplete forever, for it is ultimately impossible to conjure up the past in its entirety. The other danger is that because his knowledge of the past will be uneven in the various fields, he will know more of one and less or next to nothing of the other. Indeed, the synthesis of his erudition

will also differ from the one-time reality, so that he may contradict himself without being able to resolve the contradictions. These contradictions he has to put up with, but his work will be a hundred times more sincere and true than if he tried to bridge the gaps with his reasoning, his mind, or than if he regarded the archaeological lacunae in his work as nonexistent.

The reader should be acquainted with all these considerations before he plunges into the discussion of the Migration Period in this book. Inasmuch as the Carpathian Basin is our special area of reference, the archaeological specimens we have chosen as examples are preserved in Hungarian museums or were uncovered long ago and have thus been amply discussed in Hungarian archaeological literature, even though today the sites themselves are in other countries. Since the readjustment of the national frontiers, we are no longer in a position to deal with the whole Carpathian Basin, so the omissions will have to be left to the archaeologists in the other countries concerned.

Despite the inevitable shortcomings of this book, it was written because my lifetime of observations will, it is hoped, lend the Migration Period—over and above a strict description of historical events—a human nearness. The present population of Central Europe, and indeed more distant territories, may thus become acquainted with their ancestors through the works of art shown here. Far from drawing unequivocal conclusions from the material presented, we have only made inferences to the extent the material and our own abilities have allowed us to do so. As a matter of course, the artistic material chosen is primarily of a kind that serves to underline the general, eternal human element.

The Carpathian Basin has for several millennia been one of the most important focal points for contact and synthesis between the races and cultures of Eurasia. The area is the last island of the scrub-covered steppe stretching from the Far East to the West, the last station of the peoples of the steppe, and it was crossed by the trading routes. From the south the roads leading north from the Balkans run along the Danube, and along the same trading routes men and goods streamed southward. From the north the ancient Amber Road led to Italy. Thus, on Hungarian territory the east-west and north-south routes intersected, and along these roads the drama of the Great Migrations which shaped Europe was enacted. For these reasons, the present photographs of Hungarian finds from the Migration Period must inevitably be treated through Eurasian perspectives as well. This survey begins therefore with Germanic-Hunnish times and concludes with the foundation of the Hungarian State, thus encompassing both the Migration Period proper and the Early Middle Ages.

Although the illustrations and examples compiled in this volume derive mainly from the area of the Carpathian Basin, the book as a whole cannot be regarded as a monograph merely of a small island, as it were, in Eurasia. Perhaps the simplest way to describe the contents of the book would be to say that although the examples listed hail from the Carpathian Basin, the problems dealt with, the method of elucidation, and the validity of the results arrived at are Eurasian! As we have said before, the Carpathian Basin served as a junction in Eurasia of trading routes and roads traveled by the peoples of the Great Migrations and as such is eminently suited for the purpose of raising the problems of the art of the Migration Period and of making a bid at solution with the help of the finds unearthed here. The false analogy of the

saying "the ocean is represented in a single drop" here gains a real value, inasmuch as all the questions of any importance of the Migration Period can be raised in connection with the finds found in this area. Consequently, the results will also bear upon that enormous quantity of finds that could not be included either in photographs or drawings.

How exactly should we treat the term "Great Migrations"? Men have at all times disliked moving away from the immediate surroundings of their childhood where not only every nook and corner but also life and nature are so familiar. It seems evident therefore that the Great Migrations did not represent a law of history but a departure from the ordinary course of things. Attachment to a locality and lack of mobility are laws even if they were never absolutes. Hunters and fishermen moved with their prey, farmers moved on when the soil was exhausted, and those with livestock sought better-sheltered winter quarters. But all this movement, within a generation and often involving only a few days' journey, was merely a slow swell on the tide of history, scarcely perceptible on the map, and cannot be called migration in the historic sense of the word.

The Great Migrations, however, involved displacements over thousands of kilometers across the map, as entire peoples, tribes, and confederacies of tribes swept like a flood toward their distant goals or fled in terror from invasion or deadly droughts. Such historical "dam-busting" presumes particular historical circumstances, one of which was the use of the horse for riding. Another circumstance was the development of navigation along the network of rivers, which made control of the riparian lands possible. The closing period of the migrations came when the land was densely inhabited by peasants and interspersed with towns, which with properly constructed defenses and high walls—*limes*—dammed the tide. Within these time limits, the great arena in which the migrations took place can be marked off even territorially—the grassy steppes with their boundless horizon, the riverbanks followed by the farming peoples, and the seacoast. In confined, forest-clad, and mountainous regions the human ebb and flow is more restricted.

The Great Migrations began to get under way in the early part of the first millennium B.C. with the appearance of the Cimmerian, Scythian, and Sarmatian nomadic peoples. Then, while the incursion from the east was still in full flood, the Celts from the west and the Teutons from the north invaded Eastern Europe. The creation of the Hungarian State in the tenth century ended this turmoil of tribes in present-day Hungarian territory, and although subsequently Petcheneg and Cumanian tribes from the east also settled down here, the Golden Horde avoided the Carpathian Basin as a place of settlement.

It has long been known that the ancient races who in the Early Stone Age occupied the vast areas of Eurasia were strongly mixed as a result of slow but steady migrations over hundreds of thousands of years. With the Great Migrations this process of intermingling speeded up. However, it is often forgotten that the synthesis of culture is rooted in and synchronous with this blending of peoples. Indeed, one of the aims of this book is to show the reader that what we consider in Eurasia to be independent cultures are only the specific varieties of a whole genus, incomprehensible if taken independently, yet enhanced if considered in their major interrelations. We would be on the wrong track if in the art of the steppes and the vast forest regions we saw only a sort of "degraded culture," a primitive imitation of the great "southern" arts—the Greco-Roman, Byzantine, Iranian, Indian, and

Chinese. In this book I shall attempt to analyze this intermingling process, the common basis of all Eurasian cultures, by way of emphasizing that all peoples in all ages had an art to express themselves fully, an art which might appear "primitive" to us only because of an artistic approach and value judgment derived from a one-sided educational system.

But is this in fact true? Sometimes the epithet "primitive" might be considered appropriate. For what could we answer if someone asked us whether the Germanic and Slavic races or the peoples of the steppe of the Migration Period ever built monuments such as the Pantheon, Hagia Sophia, or anything comparable to the mosaics of Justinian or Theodora? Did they ever carve wonderful rock reliefs and temples such as were made by the Chinese artists of the Han and Tang periods? To these questions the answer has been up until now a decisive "no." And behind this negative reply, according to Wilhelm Worringer's research, lies the fact that in the art of these peoples abstract, transcendental forces manifested themselves which, far from demanding lifelikeness and naturalism in their works, discarded even the natural images of memory. Indeed, it may appear that, when faced with such questions, we are bound to accept the epithet "primitive," which in the present case can be construed as applying equally to the ability and intention of representation, so that we feel that the "abstract-transcendental" explanation is a disguised excuse.

Yet we should beware of a historical fallacy which has fooled many scholars. When approaching the art of the Migration Period, we should not equate costume ornaments, clan signs, and trappings with the objects made of stone, marble, and bronze that have survived elsewhere. Rather, we should compare the large scale with the large scale, even if we have only a written allusion to them. For did not the highly erudite Priscus Rhetor, who set out from Byzantium, marvel at the pomp of Attila's wooden palace and Queen Reka's home, so richly ornamented with rugs? And even the much traveled Byzantine ambassadors spoke enthusiastically in their reports of their visits to Turkish *khagans* or other princes of the steppes, and their civilized eyes were never scandalized by any primitiveness. Excavations in the Altaic region—mainly at Noin-Ula and Pazyryk—have revealed to us the wooden burial chambers, the "micro-palaces" of dead chieftains. Despite later plundering, they betray how splendid they must have been once. Walls and floors covered with rugs, lacquer paint, splendidly carved pieces of furniture, figurative designs with zoomorphic and anthropomorphic motifs, and a range of hues containing all the colors of the rainbow are what we find in the tomb vaults, which imitated the palaces of the living. Their timber structures still strike us with wonder. We know of dazzling "table sets" of gold from the somewhat later Turkic times, an example of which was found in Hungary, too, at Nagyszentmiklós. Having examined the meaning of the word "primitive," let us now take a look at the Germanic peoples.

Had the Oseberg ship and other similar vessels not been discovered, we would still be judging the Germans of the north by the "micro-art" of inlaid saber hilts, fibulae, and trappings. But the superb wood carvings of the Oseberg ship can justly be compared with the art of antiquity although stylistically the Oseberg find opens up a new world to us. The question then arises: If we were acquainted only with the buckles and trappings found in Byzantine cemeteries between the fifth and ninth centuries, would anybody be so foolhardy as to infer Hagia Sophia from them? And who would dare to think of the wonders of Rheims or Rouen on seeing a Gothic belt with leafwork ornament?

The reader will have an opportunity—which will presently become apparent—to become acquainted with a good many works of art from the heritage left by the Germanic tribes and the peoples of the steppe. These works demonstrate that it would be a premature and sweeping conclusion to speak of the abstract way of thinking of these peoples, or of their art unfolding itself only in the field of ornamentation, merely because of the metal mountings and other finds found in the graves.

It is true, however, that our conclusions are largely guesswork rather than positive knowledge, inasmuch as next to nothing has survived of the perishable materials (wood, textiles, and so forth), and we can thus make only cautious, though inescapable, inferences.

Of course, we should not forget that the Rome or Byzantium of the Migration Period for a classically erudite observer was just as "barbaric" when compared with the same cities in classical times as the arts of steppe and forest-clad areas stretching in another layer above them. When speaking of the Lombards and the Avars, we should not compare them to Phidias or Praxiteles but to the works of the contemporary Mediterranean masters; we can then judge with more success, particularly if we compare the belt mountings and jewels found in those graves with similar mountings, metal fittings, and jewels found in Mediterranean tombs rather than with buildings. In this case the goldsmiths and other masters of the peoples of the Migration Period would, far from being eclipsed, outstrip with their independent style their southern fellow artists, who subsisted on the morsels of antiquity. We would come to the same conclusion if we compared a pre-Romanesque temple with the Oseberg ship: it would not be the Norman who came off the loser; or, if we compare the figurative expression of the cosmic duel at the end of this book with early Romanesque painting: the first is full of liveliness, the latter is repetitive and stiff.

So the situation is not that the civilized peoples were grouped around the Mediterranean and surrounded by barbarians who partook of civilization only to the extent they could learn the lessons given them from the south. Even the Greeks did not think like that. Contemporary descriptions in Greek literary, historiographical, and philosophical writings, as well as belles-lettres, describe the barbarians of the north as ideal members of an ideal society. Several of their deities, including Apollo, the Shedder of Light, derived from the far north, and indeed there were Hyperboreans even among his priests. Dionysus also derived from the north, that is, from among the "barbarians."

It would be helpful to revive this ancient Greek approach to the problem in order to take a dispassionate look at the one-time peoples of Eurasia on a basis of equality. Indeed, we have every reason to do so, although we sometimes forget to. If the map of Eurasia were peopled not according to languages but, say, according to the spread of elements and types of folktales, we would have a thoroughly different map from that of modern Eurasia, which is divided into so many nations and has so many intersecting frontiers. In the same way, if we were to chart the popular beliefs or the general knowledge used in everyday life, we would see large units merging into one another. We could go on with these map tests indefinitely, and the more time and care we devoted to them, the sooner we would realize how close—and often identical—is the knowledge of peoples totally ignorant of one another's languages. This book will show that the same phenomenon applied in the Migration Period.

Let us examine a few convincing proofs from those ancient times. Let us quote

first as an example the great feasts, specifically the celebrations arranged on the occasion of the winter solstice. This feast was a most important focal point of sacral time and place. It was held in the sign of Sol Invictus and Vita Invicta, with the content being more or less standard throughout Eurasia. These great sacral feasts are as significant in the Old Testament and the Gospels as they are among the Hindus, in the Mithras cult or the Osiris cult, and we find them equally in the cult of Freya, in the Roman Saturnalias, and in the folklore of the Hungarian and kindred peoples, and in the ancient European tribes. Their tremendous historicity, bridging tremendous distances in space and time, seems to derive from prehistoric times. A scholar of comparative ethnography would simply laugh at the idea that these are the independent creations of the individual peoples. It is not our task to take sides in the debate as to whether this great unity was brought about independently, by identical approaches, or was provoked by the migrations. For the present it will be sufficient to observe that the time and content of the constantly recurring feasts which divide man's life into periods can be regarded as uniform among all the peoples of Eurasia.

The same uniformity can be observed in the magic rites which were so helpful in the difficult moments of life—for they, too, are independent of language barriers. Let us take as an example the role played by sharp, cutting or thrusting tools in warding off the influence of the evil eye or other spells. We find ample archaeological traces of their use. For example, the four or five-year-old daughter of an Avar chieftain was buried in a dress of a wonderful gold material, with a rich necklace of almandine jewels, earrings, and rings, but beside her head an unwieldy axe was placed with its edge turned skyward. In other graves sickles were buried for the same reasons, and arrowheads were placed in women's graves. It would be well in this context to consider some of the superstitions of the world. It was a custom among the Hungarians of the Carpathian Basin to throw an axe with its edge upward, into the courtyard during a hail storm, so that the witch hiding in the hail cloud might cut her foot on the axe and flee. In the same manner axes are struck into doorjambs in Norway against evil spirits, and in Scotland fishermen "touch iron" at sea when they utter God's name in vain. The Germans throw a knife into the whirlwinds caused by witches, as do the Finns. Instead of heaping up ethnographical examples, let us quote a few from antiquity: Palladius records that the ancient Greeks shook blood-stained axes toward the sky when a storm was about to break loose, and Herodotus writes about the Thracians shooting arrows into the sky when a storm was drawing near. Professor Sándor Solymossy collected a mass of material on parallel uses of thrusting and cutting tools, and it turned out that they had been used for the same purpose outside Europe as well as all over Europe. In fact, whatever field of popular belief we start in, we come to the same conclusion: the basic knowledge of the peoples of Eurasia on man, spirits, demons, and sicknesses and their cures was on the whole the same. Their ideas about beings never seen by man—gryphons, dragons, and water sprites—were as identical as the signs and constellations of the zodiac.

The common content of the ancient culture of Eurasia unfolds with strange and fascinating beauty in the analysis of the folktales. Thanks to the active collecting of Antii Aarne, Thompson, Bolte, Poliffka, Berze Nagy, and others, an immense amount of material is available to the scholar. Let us quote as a first example the tale so familiar in its ancient versions—Bellerophon and the Chimera, Perseus and Andromeda, and the story of St. George. This tale was told all over Eurasia, and it has many

Hungarian versions too. It is about a strong lad who arrives, accompanied by the animals he has befriended, at a place where a dragon is killing young girls. With the aid of his animals he kills the dragon and saves a princess. However, his treacherous rival kills the dragon-killer and poses to the princess as her savior. The animals then raise their dragon-slaying master from the dead, and he unmasks his rival and marries the princess. I do not think that any reader of this book, whatever his mother tongue, will fail to recall his childhood on reading this tale.

The number of such widespread tales is enormous, and so are the parallels that can be found in them; the adventures of the hero born of an animal mother with the dragons of the Castles of Copper, Silver, and Gold, or the lively stories of heroes and heroines changed into animals can be found everywhere. The planetary genii who defeat the dragons devouring the stars lead us among cosmic forces, so that it is almost a relief to turn to the stories of the young prince longing for immortality, the Swan Woman, Helen the Fairy, or the maiden who wept tears of pearl. But even such specifically Oriental Hungarian folktales as The Tree That Reaches to the Sky (see Chapter III) were known among the Western peoples, and, conversely, the children in the Mongolian yurts heard tales that resembled the ancient Celtic tales. The tale of the Maiden with the Golden Hair is as well known all over the Continent as that of Snow White or the "animal cousins."

We shall not take up here the question as to the reason for this unity, a much discussed theme in folktale research; no doubt the collections of tales reaching the west by way of the medieval crusades and the trade routes had a part in this unity, although the majority of the tales have their roots in the age of the planetary gods and the Great Goddess, in prehistoric Eurasia. The main point at present is that the range of knowledge of the peoples of the Migration Period and their mythological conceptions of the forces surrounding them stood on the same level, and in fact were handed down in the same form. We can approach their true essence only if we look at them comprehensively; when viewed individually, they are more or less incomprehensible.

All this is important because we have now reached the basic layer of art, the starting point of this book. So far the antecedents of the art of the steppe and the Germanic peoples and how they differed from each other have been the main subjects of research; now our new objective will be to keep an eye on the differences and at the same time look for the aspects that are as common in the art of the Huns, Germans, Avars, Hungarians, and Slavs as are the underlying popular beliefs, creeds, and knowledge. Indeed, anthropology has also demonstrated the intermingling of these peoples.

What exactly we aim to arrive at can be best expressed with a quotation from László Németh, the great Hungarian writer and thinker, concerning the anthropological composition of the Hungarians: "This blend of races colored its elements, under the influence of Hungarian history and Hungarian soil, in such a way that it finally showed Magyar characteristics. The social scientist should never select one particular Hungarian type because one type does not exist. I am reminded of spectral analysis: just as the character of chemical substances is determined by the position and width of its spectral bands, so the character and individuality of a people are determined by the spectral band of its groups and its great intellects. A true ethnic analysis should begin with the determination of the large or small number of bands of a people's spectrum."

The truth does indeed lie somewhere here. No matter which people of Eurasia we examine, the whole human spectrum is present, and only fine differences of tone signal that we are approaching this or that area of historical tradition or, if we prefer the term, this or that people.

The book opens with a survey of the heritages of the individual peoples of the Migration Period and the particular scholarly questions involved. Neither in this first chapter nor in the subsequent chapters do we claim to give a full description; rather we wish to enrich the reader's knowledge. Chapter II deals with the work of the master craftsmen of the period. Without a knowledge of their trade, any statement about their art would be incomplete. This chapter aims to show how fully and richly the Migration Period preserved and developed the knowledge handed down from antiquity. Chapter III provides a picture of the mythology, which proves better than anything that the human content of this mythology is fundamentally the same, regardless of whether the people in question evolved on the steppes or in the Black Forest. If we view this art only from outside, no connections seem to exist between its individual manifestations, such evidence as there is appearing distant and insignificant, the styles being so different. However, if we succeed in approaching it from inside—and that is our purpose—we will find that these manifestations of the art of the period are so uniform and identical that we can at best find differences of shade. The style separates, but the content connects.

Hungarian versions too. It is about a strong lad who arrives, accompanied by the animals he has befriended, at a place where a dragon is killing young girls. With the aid of his animals he kills the dragon and saves a princess. However, his treacherous rival kills the dragon-killer and poses to the princess as her savior. The animals then raise their dragon-slaying master from the dead, and he unmasks his rival and marries the princess. I do not think that any reader of this book, whatever his mother tongue, will fail to recall his childhood on reading this tale.

The number of such widespread tales is enormous, and so are the parallels that can be found in them; the adventures of the hero born of an animal mother with the dragons of the Castles of Copper, Silver, and Gold, or the lively stories of heroes and heroines changed into animals can be found everywhere. The planetary genii who defeat the dragons devouring the stars lead us among cosmic forces, so that it is almost a relief to turn to the stories of the young prince longing for immortality, the Swan Woman, Helen the Fairy, or the maiden who wept tears of pearl. But even such specifically Oriental Hungarian folktales as The Tree That Reaches to the Sky (see Chapter III) were known among the Western peoples, and, conversely, the children in the Mongolian yurts heard tales that resembled the ancient Celtic tales. The tale of the Maiden with the Golden Hair is as well known all over the Continent as that of Snow White or the "animal cousins."

We shall not take up here the question as to the reason for this unity, a much discussed theme in folktale research; no doubt the collections of tales reaching the west by way of the medieval crusades and the trade routes had a part in this unity, although the majority of the tales have their roots in the age of the planetary gods and the Great Goddess, in prehistoric Eurasia. The main point at present is that the range of knowledge of the peoples of the Migration Period and their mythological conceptions of the forces surrounding them stood on the same level, and in fact were handed down in the same form. We can approach their true essence only if we look at them comprehensively; when viewed individually, they are more or less incomprehensible.

All this is important because we have now reached the basic layer of art, the starting point of this book. So far the antecedents of the art of the steppe and the Germanic peoples and how they differed from each other have been the main subjects of research; now our new objective will be to keep an eye on the differences and at the same time look for the aspects that are as common in the art of the Huns, Germans, Avars, Hungarians, and Slavs as are the underlying popular beliefs, creeds, and knowledge. Indeed, anthropology has also demonstrated the intermingling of these peoples.

What exactly we aim to arrive at can be best expressed with a quotation from László Németh, the great Hungarian writer and thinker, concerning the anthropological composition of the Hungarians: "This blend of races colored its elements, under the influence of Hungarian history and Hungarian soil, in such a way that it finally showed Magyar characteristics. The social scientist should never select one particular Hungarian type because one type does not exist. I am reminded of spectral analysis: just as the character of chemical substances is determined by the position and width of its spectral bands, so the character and individuality of a people are determined by the spectral band of its groups and its great intellects. A true ethnic analysis should begin with the determination of the large or small number of bands of a people's spectrum."

The truth does indeed lie somewhere here. No matter which people of Eurasia we examine, the whole human spectrum is present, and only fine differences of tone signal that we are approaching this or that area of historical tradition or, if we prefer the term, this or that people.

The book opens with a survey of the heritages of the individual peoples of the Migration Period and the particular scholarly questions involved. Neither in this first chapter nor in the subsequent chapters do we claim to give a full description; rather we wish to enrich the reader's knowledge. Chapter II deals with the work of the master craftsmen of the period. Without a knowledge of their trade, any statement about their art would be incomplete. This chapter aims to show how fully and richly the Migration Period preserved and developed the knowledge handed down from antiquity. Chapter III provides a picture of the mythology, which proves better than anything that the human content of this mythology is fundamentally the same, regardless of whether the people in question evolved on the steppes or in the Black Forest. If we view this art only from outside, no connections seem to exist between its individual manifestations, such evidence as there is appearing distant and insignificant, the styles being so different. However, if we succeed in approaching it from inside—and that is our purpose—we will find that these manifestations of the art of the period are so uniform and identical that we can at best find differences of shade. The style separates, but the content connects.

I. FARMING AND LIVESTOCK BREEDING

Antecedents

Ways of Life and Theories

The peoples who lived in Hungary in the Migration Period were farmers or stock-breeders. As a matter of fact, neither of these two modes of life existed separately because, in addition to their plow lands, the farmers kept not only pigs and poultry but also sheep, cattle, and horses. Likewise, the stockbreeders were not mere nomads, for in the vicinity of their dwellings they cultivated land, maintained gardens, raised poultry, and kept other stock besides beasts of burden. Both the Germans, who were generally husbandmen, and the Eastern equestrian peoples living on the border of the great stock-raising areas were imbued with the traditions of their one-time hunting life. Thus the situation is far from being that the Germanic tribes were farmers and the Huns, the Avars, and the Magyars great stockbreeders. If we look at the agreement that the *khagan* Bayan reached with the Lombards, it is evident that the latter must have had large studs and herds, for, the agreement reads, Bayan "shall receive, without delay, one-tenth of all quadrupeds owned by the Lombards, and in the event of a victory half the booty and the whole country of the Gepids." Imagine the tremendous number of livestock the Lombards must have owned if Bayan was satisfied with one-tenth!

It may be presumed that some of these peoples, particularly the nomads, changed their way of life just at the time of the Great Migrations because of the cramped nature of the Carpathian Basin. This may have involved as much upset and hardship as leaving the ancient dwellings and seeking a new country. Let us examine this supposition in the light of a few later data.

This is how Tacitus in his *Germania* writes of the savage Finns (presumably he means the Lapps): "They trust only in their arrows which, for lack of iron, are pointed with bone... They live on hunting, men and women alike... but they prefer this to toiling and moling on the fields, working within the walls of houses, or, amid hope and despair, working at their own or other people's property." Hunting peoples are indeed reluctant to abandon their accustomed way of life. The above-mentioned quotation from Tacitus is substantiated by another quotation, and although it comes from a totally different context, it deserves quoting here. According to Crèvecœur, a North American Indian chief recommended farming to his people in these words: "Don't you see that the white man lives on grain and we on meat? Meat takes more than thirty days to grow and still we have little of it, while the miraculous seed which the Whites sow into the soil repays them a hundredfold. The meat we live on has four legs to run away with and we only two to overtake it.

Meanwhile the grain of the Whites lies still in the soil and grows. Winter is our most difficult hunting season—for them it is the season of rest. That is why they have so many children and live longer than we. I therefore say to all of you who have ears to hear me that before the cedar trees of our villages die of old age and the maples of our valleys cease to yield sweet syrup the other seed-sowing race will have exterminated the race of the meat eaters if our hunters do not make up their minds to sow too."

These are great and mature thoughts, and true; we could not possibly give a more exact sociological analysis of the situation. Quite naturally, we should not neglect factors of popular mood or pride either. Here we should note what Tacitus writes in Chapter 14 of his *Germania* about the Germanic tribes: "Their liberality can be ascribed to their wars and looting. It would be difficult to induce them to till the soil, sow, and wait for the crops instead of challenging the enemy and receiving wounds. Indeed, they regard it as cowardice and sluggishness to acquire things with the sweat of their brow when they can get them by shedding blood." At the same time we know that the Germanic tribes settled on their lands according to clans and kinsfolk and cultivated their lands as common clan property.

A similar community constituted also the smallest unit of the so-called nomadic societies. In the last century, Radloff gave a very vivid description of this after observing the life of the Kirghizes. We know from him that the natural unit of nomadic social formations is the "large family," the kindred groups which form the clans. However, the clan is not a constant unit, inasmuch as clans and the other major tribal units changed incessantly and their lives were full of clashes and friction. "However," Radloff writes, "this does not affect the welfare of the entire people because when a tribe disintegrates, its parts join the increasingly powerful neighboring tribes and are given protection. Nomads can thus sustain wars for centuries without prejudicing their prosperity and in fact it sometimes happens that they gain in number and prosper even in the most turbulent times. Like the spread of wildfire we see the appearance of some great nomadic state, but it disintegrates as quickly as it materialized."

As we have mentioned, "purely" nomadic peoples did not live in the Carpathian Basin—for that type of living the area would have been small—but the invaders and settlers here were farmers as much as stockbreeders. This is clearly shown by cemetery excavations in the course of which, in "nomads' cemeteries," we found bones of pigs and poultry, eggs—sometimes painted—and sickles.

A Hungarian scholar recently dealt at length with the question of the development of feudalism in Eastern Europe and Central Asia and described several "semi-nomadic" societies. The following extract deals with the Uigurs: "Plow lands marked off from lands set aside for winter quarters were fenced in, as were the hayfields. Cattle and horses were allowed to graze in this enclosed area only after the harvest, at the end of the summer 'nomadizing' season. Thus the winter quarters of the clan consisted of a system of fences several kilometers long. One of the visible reasons for the consolidation of farming was that it was mainly the richer strata of the tribes who took up farming, since they were the ones who had enough draught animals. It should be mentioned at this juncture that they never used the horse for plowing."

In Hungary, as a result of the Turkish occupation in the fifteenth to seventeenth centuries, vast areas became depopulated and nomadic stock raising—which resembled the nomadic shepherd's life—was revived. Water conservancy operations

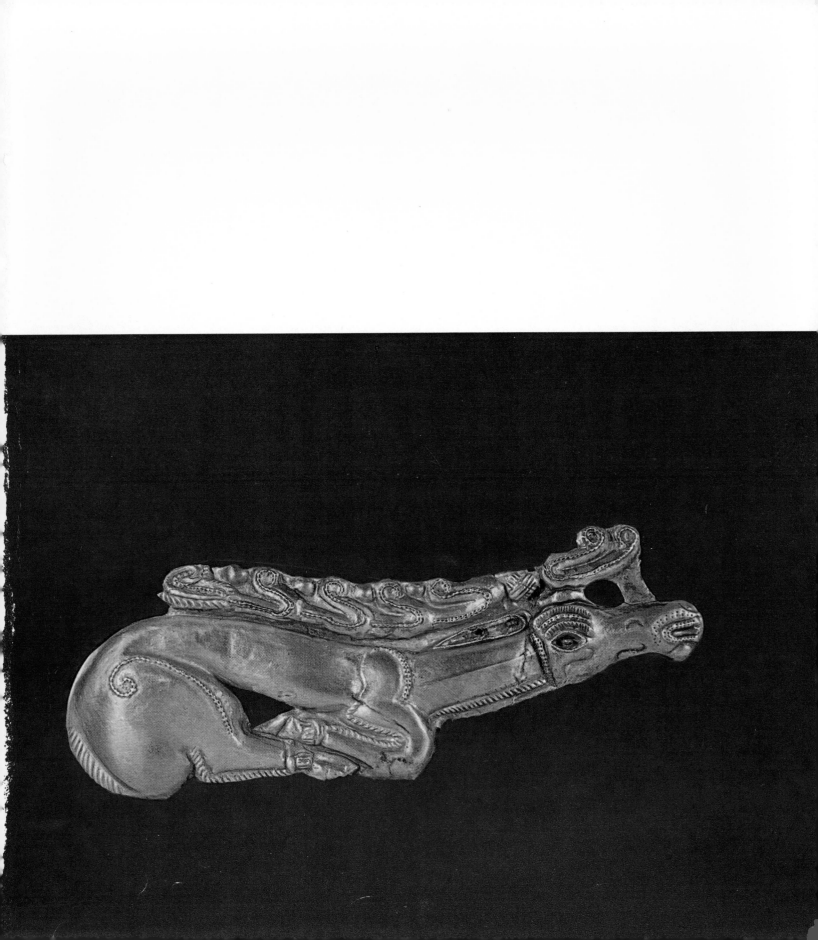

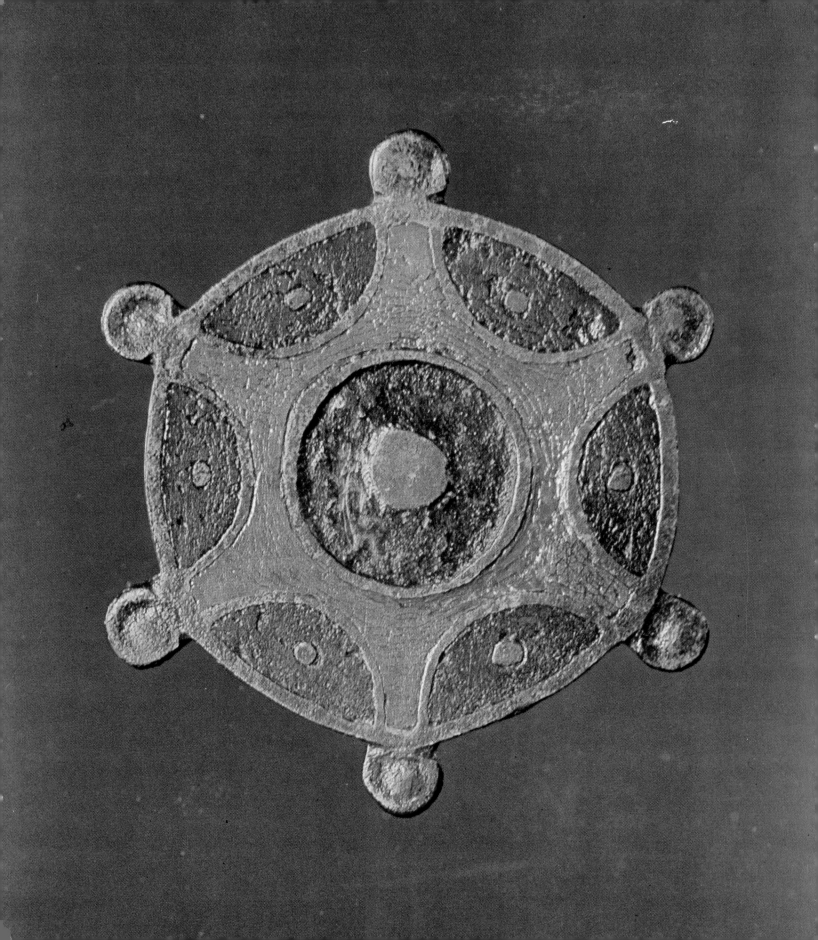

put an end to this pastoral life, and pastures were turned over to the plow. In the 1930s I was able to talk to old shepherds who had lived through those times. They deeply despised the "mole work" of the peasant and would not touch a hoe or spade for anything in the world. Such psychological factors should be remembered when we talk about the farmers and stockbreeders of the past.

Interesting theories explain the gulf between the two ways of life, and also these theories throw light on the differences in their art. From these theories much can be gleaned to help us better orientate ourselves.

We may begin with the hypothesis—now scarcely accepted by anybody, if at all—that the art of the stockbreeders and farmers is no more than a mindless imitation of classical art, and in more recent times, an imitation of the art of the upper ruling classes. This theory was formulated at one time by Adolf Furtwängler on the basis of his Scythian finds at Vettersfelde. He claimed that the lower classes have no need of more sophisticated art.

One of the theories accepted today, initiated by Herbert Kühn and expanded by myself, links the content and style of art with everyday experience. The art of the hunting peoples is always realistic, agitated, just as a close attention to reality helps them in their everyday life, and they are always on the move after game. In this art, therefore—which irrespective of time is the reflection of a way of life because it is found among the hunters of the Paleolithic Age, the Bushmen, and the Eskimos—nothing is transcendental, for life and death depend on the outcome of the struggle between man and beast.

This realistic and powerful art of the hunting tribes was replaced by the rhythmic and abstract art of the farming peoples. This rhythmic abstract character is explained by the life of the farmer, which is dominated by the rhythm of sowing and reaping, of the sprouting and ripening of the seed, and which is influenced by the unexplainable and unpredictable natural forces of wind, rain, drought, and hail storms. These forces are not visible in the sense that hunted game is visible and therefore cannot be depicted in a concrete manner, only in an abstract one. Moreover, a specific rhythm—imparted upon the soil-bound life of the farmer by the annual return of the seasons and the constant repetition of feast days—is mirrored in the rhythm of his static and ornamental, abstract art.

The movements of societies making a fresh start—particularly the Great Migrations as well as trade and military movements—give rise to an art full of a renewed momentum and animation, this time not between man and animal but between man and man. The subject of this art is no longer the animal, for the art finds its ideal in the human body. Thus in this theory sharp differences exist between the farmers' and stockbreeders' ways of life. However, this ingenious theory is not borne out by the art of the Migration Period distinctly enough. Let us have a look at another theory.

Books on modern art often start by giving us basic tenets derived from Wilhelm Worringer's theoretical statements of sixty years ago. His theory of art is eminently suitable to characterize the art of the Migration Period. Worringer's three archetypes are well known: the precognitive man of impulse, or "primitive man," who lives in chaos and whose means of artistic expression is therefore transcendentalizing abstraction; then "classic man" living in an absolutely ordered cosmos, who with his insight into the world creates harmony and beauty in a human form identical with ourselves; and finally "Eastern man," who, having gained and transcended

II. Disk-shaped fibula from the Sarmatian Period, third century. MNM

the knowledge of life, is led to express his view of the world in abstract imagery. These three types, according to Worringer, are inspired by the fact that abstraction is always transcendent, originating from the belief in a God outside this world, whereas suggestive art, which creates from the visible world, celebrates nature. It is an immanent art in which duality ceases and finally ends in realism and materialism. These three types, again according to Worringer, did not develop from one another but are supposed to be timeless and to a certain extent predetermined. He thinks that the latent, then emerging Gothic art, which in the Renaissance was again driven underground, may be the means of expression of the people of the north. Worringer's theory is reminiscent of H. Taine's doctrine of the mysticism of the rigorous north and the harmony of the serene and fertile south.

The art of the Migration Period would splendidly fit into Worringer's theory: its Germanic part would correspond to the abstract, its Avar Period to the classical, and its Hungarian ornamentation to the Eastern outlook. As we shall see later, however, this classification is rather forced, inasmuch as it adapts facts to theory; so, we shall have to look elsewhere.

Another theory deserves mention in this context, a more exact historical approach which attempts to explain animal or zoomorphic styles. In this theory the Eurasian animal style is the linear descendant of the cave art. The cave hunters followed the animals migrating north with the retreat of the ice, and their art, together with their way of life, was left stranded in the north. Hence the style was handed down much later to the Scythian-Sarmatian stockbreeding tribes of the steppe. Gregor Boroffka was the first to elaborate this theory. András Alföldi made a much more penetrating study of the animal style in which he posited the zoomorphic concept in the theriomorphic view of the world and art, in contrast to the anthropomorphic, where art and the artistic outlook were formed after man's image of himself.

The attentive reader may have noticed that all these theories are based on the same observations and facts, and try to explain them with simple reasons. There is not the space here to discuss any of these theories, but occasionally we shall need to remember them when we look at examples of the art of the Migration Period. The reader's attention is only called to the fact that in taking note of the divergencies our primary aim is to establish, over and above the various styles, the consistency of the human spectrum in the art of the period.

The Antecedents of the Animal Style in the Carpathian Basin

"Eurasian animal style," "Scythian animal style," and "Germanic animal ornament" 1–17 are no chance appellations. The styles developed in the steppes and forests north of what was in art the anthropomorphic zone. Here, right from prehistoric times, the everyday life of man was inseparably bound up with animals, both for hunters and for stockbreeders or farmers who also kept livestock. Farming is largely dependent on the weather, which is obviously why farmers, observing the movement of the heavenly bodies and their influence on the weather, projected the animal worship inherited from their hunting days onto the sky at a relatively early date. Their animals were no longer earthly game but part of the population of the starry sky. On the steppes, however, a mutation of this kind was out of the question because life depended on animals. On the steppes the prehistoric hunting tradition, instead of being projected

onto the sky, was imbued with ancestor worship. That is why the animal mummeries of the ancient European farmers are grouped around the solstices, whereas on the steppes the sagas telling of the origins of the clans preserve the traditions of the past. All this is of course only approximately true, since in the forested regions of the west we find, for example, the animal image linked with ancestor worship among the Celtic and Germanic peoples, just as the people of the steppes personified the heavenly bodies in an animal form. Under favorable circumstances these myths may be shaped into pictures or reliefs. This is in fact the process we shall be following throughout this book.

Zoomorphic and anthropomorphic motifs used in the personification of myths have been found in Hungary, as elsewhere, dating back to long before the Migration Period. From the Neolithic Age on, zoomorphic idols increase in number, until in the Late Bronze Age and the Early Iron Age the animal style of the steppes first appears in this region, imported presumably by Mongoloid elements and later the Cimmerians (?). The traditions of the steppe and the art of Luristan south of the Caucasus Mountains are reflected in the exquisite bronze casts. In their mythological background stands the Great Goddess (see Chapter III). From the sixth century B.C., the Carpathian Basin was practically flooded with the creations of Scythian art, but whether or not their appearance in the Basin meant also the incursion of the Scythian peoples does not concern us at the moment. The main point is that it was in this art that the stock of motifs that were faithfully preserved for the next thousand years first developed and came fully to fruition again during the Migration Period. This conservatism derived not from incompetence, a sort of "Asiatic retardation," but from the fact that the view of the world the motifs expressed remained alive. The most characteristic Scythian finds in Hungary therefore are presented here by way of an overture to what came after them and without which later finds cannot be understood. The art of the Migration Period drew mostly on Scythian, Celtic, and Mediterranean traditions. Of course, over such a long period, these traditions survived in a considerably changed form in the styles of the various peoples.

Instead of touching on the usual problems arising from these late prehistoric arts, let us rather examine other questions which have not yet figured in scholarly debate. These exquisite animal ornaments must have been finds to which few had access, just as they were later, in the Migration Period, because they are not found in every grave. Indeed, very few people in the past were entitled to wear on their shields, clothes, weapons, and trappings the images of animals representing their ancestors.

We find these images in some cemeteries only in the graves of those who held high rank, or of those who detached themselves from the common people even while still alive and were buried apart in some hidden place. It may safely be said that among the men it was an art that belonged wholly to the tribal chieftains, or to persons of equal or higher rank. In the tribal society such men not only wielded actual power but represented the weal of the entire clan, as well as its fertility and increase in its possessions. Thus they were to some extent the tribal priestly order. The fact that we find objects in the animal style only in their graves suggests that this form of representation is closely connected with the ancient creeds and rites of ancestor worship: its use was limited to those who mediated between the living and their ancestors.

Thus the art we are concerned with in this discussion, far from being popular,

restricted itself to the ruling strata of the ancient societies (among the common folk, membership in the tribe must have been indicated by the use of *tamgas* or other tattooed or embroidered motifs). However, we should remember that with both the Germanic and the steppe peoples the culture of the ruling strata was on an "international" level, that is, they lived everywhere on a higher level than the common folk, which is why a single find suffices to analyze Germanic, Scythian, Iranian, or even Central Asian features. This presupposes not merely the tradition of the goldsmiths and silversmiths working for the chieftains but also a diversified and refined taste which expected the "content" to be clothed in an artistic form, and, moreover, to be on an "international level."

With the antecedents of the animal style in the Carpathian Basin in mind, we pass over to the art of the peoples of the Migration Period, and here again we must employ the same approach. To sum up: the intellectual legacy of the ruling strata is embodied in the artistic remains of the Migration Period, and Eurasian artistic traditions show through the "national" styles as much as do the underlying creeds, sagas, and legends which all are part of the same common heritage. The folk art of the peoples of the Migration Period is as yet an unresolved problem. The more impermanent material failed to withstand the ravages of time, so that our knowledge of its characteristic features is limited to a few fortunate survivals (such as the *tamga* clan signs).

Before presenting the finds, we should say a few words about procedure. Instead of proceeding from site to site, from description to description, we have left it to the reader to interpret the photographs with the help of the relevant data given in the Appendixes. What we are aiming at is the human element, the essentials, so when treating the individual peoples and groups of finds we shall expand on the importance of only some of the more outstanding pieces. By throwing light on the basic questions, we believe that the other finds should also become more comprehensible, inasmuch as they are nothing but variations on the basic theme, and it would be superfluous to examine each in detail.

The Germanic Peoples

During the Migration Period, many Germanic tribes settled in the Carpathian Basin 18–64 for a longer or shorter time. Some among them (for example, the Gepids) settled here for good. Avar rule ended the movement of the Germanic peoples. After the political fall of the Avars, Carolingian troops and settlers invaded Pannonia. With the arrival of the Hungarians, Norse wares also reached the Carpathian Basin, perhaps accompanied by a number of mercenary troops who settled there.

Hungarian archaeologists have subjected the Germanic tribes living in Pannonia to profound study, and the following brief historical sketch of the period is taken largely from the work of one of them, István Bóna.

The first tribe to appear—at about the beginning of our era—was the Quadi, who came from the regions of the Elbe to the areas north of the Danube (now belonging to Slovakia) and the contiguous north Hungarian border zone. For four centuries this tribe pressured the Roman *limes* across the Danube. This period lies outside the scope of this book. With the collapse of the *limes* in the fifth century the Quadi occupied the northern Transdanubian part of Pannonia, calling themselves Suevians, their original name. Here they came under Lombard rule in the sixth century, and part of the tribe left Pannonia in 568 for Italy, together with the Lombards. Other groups of Suevians settled in Spain and Portugal.

The Vandals also came from the north, from Jutland in the first century B.C., and settled along the Oder. We find their tribes by the end of the second century already in the northeastern part of the Carpathian Basin. From here—presumably to escape the Huns—they moved toward the Rhine along the Danube and out of the history of Hungary. Their later movements led them right down to Africa.

The Goths were of major importance in the Carpathian Basin during the Migration Period. They set out from southern Scandinavia for Eastern Europe and separated into two branches. In 271 the Visigoths occupied Dacia (Transylvania), which had been evacuated by the Romans, and the Lower Danube Plain. Crossing the Maros River, they attacked the Sarmatians living on the Great Hungarian Plain several times but never settled on the plain. Having been defeated in 376 by the Huns, they sought refuge in the Balkan provinces of the Roman Empire. From here they moved to Italy in the early fifth century, touching Pannonian territory en route, but they did not settle here either. Suffice it to say about their further travels that, after Italy, southern France and Spain gave them a final home, until the Arab conquest put an end to their kingdom there in 711.

The Ostrogoths lived on the steppes of the Ukraine from the third century and adopted the customs and clothing of the Sarmatians living there. Their first bands, fleeing the Huns, reached Pannonia in the 380s. The bulk of the tribe, however, came under Hunnish rule in southern Russia and at the time of the conquest of the Carpathian Basin formed the vanguard army of the Huns. It was they who defeated the Suevians and the Gepids, but the tribe did not settle on the Hungarian Plain until after Attila's death in 456. Here they were given territory as the *foederati* of the Romans, but fifteen years later, led by Theodoric, they set out again and founded an Ostrogothic kingdom in Italy. An army of theirs returned later to conquer southern Pannonia. According to legendary accounts, Theodoric is said to have been born on his father's estate near Lake Balaton, perhaps at Keszthely-Fenékpuszta.

One of the strongest Germanic tribes living at the time in southern Russia was the Sciri, or Scyri, who had reached the shores of the Black Sea back in the second century B.C. There their culture was transformed by Scythian-Sarmatian traditions even more powerful than those of the Ostrogoths. As the Huns' auxiliary troops, they moved to the region between the Danube and Tisza rivers in the 430s and here they were still mentioned in 469. Their great king Edika was once Attila's trusted confidant. The Hungarian National Museum now houses the splendid finds taken from the grave of a Scirian princess. Being a people small in number, the Sciri slowly fragmented in the course of their wars with the Ostrogoths.

The other people which became absorbed in Hungary's future population were the Gepids. They came from Scandinavia or from the areas along the Vistula toward the south, as close relatives of the Goths. During the accentuated migrations set off

by the abandonment of Dacia, they settled down on the northern periphery of the former Roman province, on the northeastern fringe of the Carpathians. From here they descended slowly to the south and in the fourth century were already approaching the Maros River in Hungary. Here they came under Hunnish rule and became one of the spearheads of the Hunnish army. Their part in destroying the Huns' rule was decisive (battle of Nedao in 454), and after their victory the entire eastern part of the Carpathian Basin came under their rule. It was the Lombard-Avar alliance that put an end to their state in 567, but the Gepids as a people were never destroyed, and even in the middle of the tenth century Constantine Porphyrogenitus mentioned the survivors.

The Lombards, the Germanic allies of the Avars against the Gepids, proved equally restless. Their original home had been around the mouth of the Elbe, from where they had attacked the northern Pannonian Roman *limes* back in the second century, but the mass of the tribe moved to the northern bank of the Danube only at the end of the fifth century. Here, in the early decades of the sixth century, they subjugated the East Germanic tribes of the Heruls, whose survivors found refuge with the Gepids along the Tisza River, and about 526 they occupied Pannonia. From here, having defeated the Gepids of Syrmium, they moved to Italy in 568.

For the next 250 years, the Avars ruled the Carpathian Basin. Of course, the surviving Germanic tribes should not be overlooked, a proof of whose vitality is the flourishing of the Germanic Animal Style II in the Avar Period, amply represented in Hungarian finds. There are also instances of Germanic tribes fleeing from Italy to the Avars. The Germanic peoples in the region were only slowly assimilated by the conquering Avars and the Slavs who appeared later in the borderlands.

The campaigns of Charlemagne, resulting in the overthrow of the Avar *khagans* at the turn of the ninth century, set off the Carolingian colonization of the country (mostly Bavarians, who lived side by side with the Avar population), but a Slav immigration also started from the borderlands. A symbolic relic of this period is the Cundpald chalice in the Sopron Museum and the Blatnica find, which must have belonged to a Slav chieftain. However, the Bavarian settlements cannot have been dense, inasmuch as only sporadic weapon finds testify to their presence. Moreover, weapons do not always identify a people.

It is certain that only very small settlements existed in the Carpathian Basin as a result of the trading contacts between the warlike Norsemen and the Hungarians arriving at the end of the ninth century. Nevertheless, most Nordic finds in Hungary are not indicative of settlements but rather are evidence of trade contacts stretching as far north as Scandinavia. We shall deal with them briefly, as well as with the trade products of other ages.

The Germanic finds may be divided into three parts: (1) the Early Germanic Period or Style I; (2) Style II; and (3) the Late Germanic Period or Style III, that is, the Carolingian and Norse relics.

Some of the Relics of the Early Germanic Period

A few preliminary words should be said about the places of the royal finds. What we discover is that in the close vicinity of Germanic royal finds graves of Hunnish princes were unearthed (for example, Petrossa-Concesti, Szilágysomlyó-Moigrad, and so on). This implies that German princes or tribal aristocrats on the fringe of Hun influence, refusing to be cowed, buried their treasures (the Huns maintained the nucleus of the established Germanic administration but placed their own men in power). It has been noticed that while the Huns were in southern Russia the treasures and the grave finds surrounded the area in a huge crescent, but when Hungary became the center of the Hunnish armies, the treasure finds were abundant along the Hungarian border

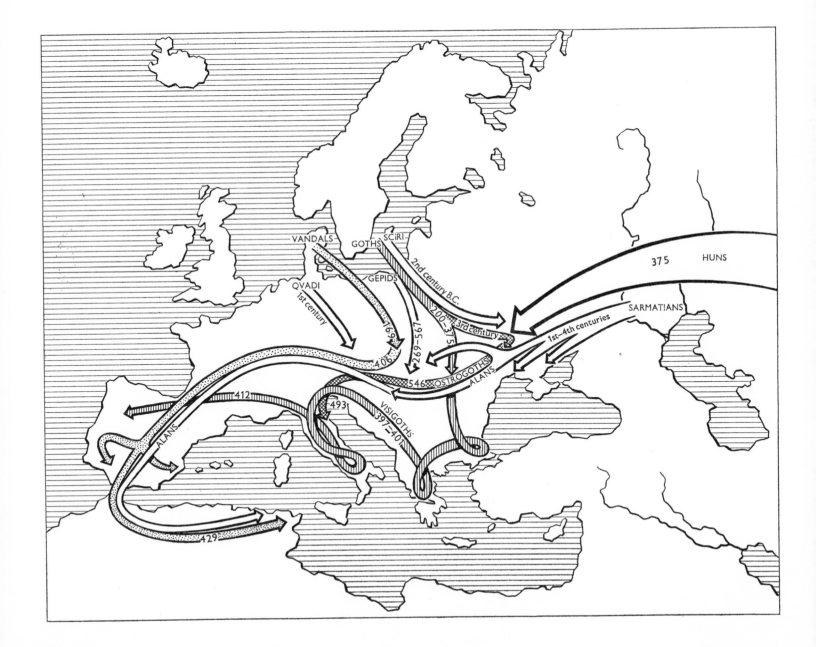

area too. The importance of this fact stylistically is that while the treasures hidden from the Huns were still mostly untouched by the influence of Hunnish art, the style of the Germanic peoples living under Hunnish rule mingled with that of the Huns.

The Two Finds of Szilágysomlyó

The first find is preserved in the Kunsthistorisches Museum in Vienna, the second in the National Museum in Budapest. The finding place was beside the Gate of Meszes, one of the gates to the former Dacian *limes*. The finds were discovered in 1797 and 1889, but it may be presumed that they belonged together. Archaeologists have attempted again and again to explain the finds. We will examine them now from our own point of view. 18–30

The first find consists of fourteen large Roman breast disks embossed with the emperor's head (three more were lost, one of them, a Valens' coin, perhaps being in Berlin), a bull, a few accompanying finds, and a gold chain. The find can be dated on the basis of the imperial effigies. They date from Maximianus (286–305) to Gratianus' medallion made after the death of Valentinianus I (375–383), so that they span about a hundred years.

Apart from the original Roman coins, two Germanic imitations are also in the series. It was from these imitations that the gold *bracteatae* used in the north beyond the *limes* were copied. They are interesting because on them it can be clearly traced how the Roman pattern became a Germanic one. The Roman was shaped according to the rules of the classical relief, with a neutral background, whereas on the Germanic copy the relief becomes a drawing and its natural proportions change (for example, a huge head with a tiny horse beside it, and so forth). The rhythm is wholly linear, the lines continually interlacing, so that the picture assumes an ornamental character. 18

An examination of the way the large disks are framed is also interesting. These are the works of Germanic goldsmiths, and in their ornamentation we find the clear-cut rhythm of Late Roman carved buckles, wreaths on masks decorated with filigree in a way reminiscent of Celtic tradition, and cloisonné stone inlay in many colors, which can be traced through southern Russia back to Iran. This kind of frame is an example of what we have said earlier about the international education and cosmopolitan style of the ruling strata. It was an age when the Roman imperial court was pervaded with Persian ceremony, for the East influenced not only the Germans but also the Roman and the Byzantine courts.

The rock crystal ball hanging from the middle of the large necklace protected its owner from the spells of evil spirits; the tiny gold tools hanging from the chain illustrate all the agricultural and other implements of the Gepids. The find was presumably hidden by a Gepid prince when the Huns were invading. It can only be supposed that these tiny images on the princely necklace symbolized his power over all the handicrafts, trades, and soldiers. 19–21

In the first find nothing suggests that any of its pieces were owned by women, whereas the bulk of the finds of the second treasure (such as the pairs of fibulae) were worn by women. Only the onyx fibula, the gold ring, and the omphalic cups may have been the insignia of the prince. Roughly speaking, it can be justly presumed that the two finds were from the treasury of the prince and his consort. Nándor

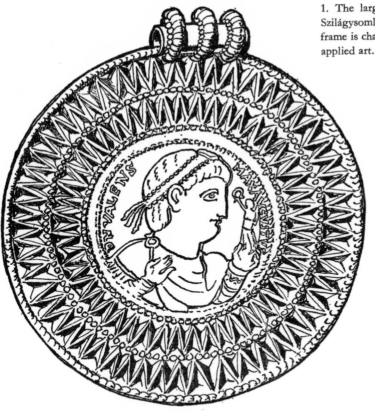

1. The large gold coin of Emperor Valens from the first Szilágysomlyó find. The chip-carved decoration of the coin's frame is characteristic of the Late Roman and Early Germanic applied art.

IV Fettich tried to establish the chronology of the fibulae in the second find by arranging the pairs according to their degree of wear, inasmuch as it seemed clear that the most worn pair had been worn longest and must therefore be the oldest. To confirm his hypothesis, in the first treasure the most worn coin is the oldest one. If we compare the pieces of the two finds thus arranged chronologically, we find differences which indicate that find 2 is much more recent than find 1. The Late Roman chip carving is missing from the first treasure, as is the expert goldsmith's trick of placing smooth-milled gold plates under the tiny stone slabs. Forms corresponding to the fibulae of find 2 were still in use at the beginning of the fifth century. It appears therefore that find 2 is twenty to thirty years younger than find 1. The evidence seems to show, however, that the two treasures were hidden at the same time and for the same reason. It is possible that the Gepid princes, from the end of the fourth century onward for some reason or other (perhaps an alliance with the Huns?) stopped getting large medallions from the emperor in recognition of their rank (the two imitations may have been made at that time), and this fact may have caused the apparent difference in time between the two finds. However, we are interested not in questions of chronology but in problems of art.

22–27, 30 Three of the ten pairs of fibulae in the second find are of pure gold (the two pairs with the lion motif and the pair with an animal head). The large, solitary onyx fibula is also of pure gold. These are among the most worn pieces in the second find. However, I do not think this means that they are the oldest but only that they were worn most, the onyx fibula by the prince and the others by his consort. It may

25

be that these jewels belonged to their ceremonial dress. The other fibulae are in fact *opus barbaricum*, that is, silver casts covered with a thin golden plate. These must have been the ornaments for everyday wear. The onyx, as a precious stone, may have had some magical importance—just as the rock crystal ball played an anticharm role—and the animal figures on the women's fibulae may have played a similar role. It cannot be mere chance that we see animals only on the three worn fibulae of pure gold. The dignity of one prince's consort was denoted by zoomorphic representations. If we take a close look, we will see that the beasts on the pair of fibulae are, as it were, surrounding the princess's head, and in fact the lions are looking directly at her. These lions have no hindquarters; they look like "sea lions," or rather the hippocamps 22–23 of old. Before them a small, winged animal with a beak can be seen cowering. On the disk-shaped fibula there are five lions springing, and dogs (?) on the rim, whereas on the round fibula there is the embossed figure of a pair of fantastic animals, and on the three buttons boar and eagle heads can be seen. To these four fibulae of pure gold belong four more pure gold objects, all princely insignia: the gold ring (it was used for a long time and one of its segments had to be replaced), the small omphalic cup, and two large omphalic cups.

Let us look closely at the lion figures. We see at first sight that they are wearing dog collars. On the large fibula with the lion this collar is the most pronounced part of the beast because red stone marquetry highlights the collar. Beasts with ribbons around their necks are—like winged creatures—"not of this world." The same ceremonial atmosphere is conjured up by the gold ring used at the inauguration of kings. Most convincing evidence of the fact that cups had some ritual meaning are the pair of omphalic cups of the Nagyszentmiklós treasure, for inside their rim there is either a cross or fighting beasts.

The Princess's Grave at Bakodpuszta

The animals on the exquisite pair of pure gold bracelets from the Bakodpuszta finds 37–38 also have collars. These two bracelets are masterpieces of the goldsmith's craft of the Migration Period. A few words should be said about the grave itself, inasmuch as it is of vital importance. In one of his recent studies, István Bóna writes at length about it, and we will draw on his findings.

The grave was unearthed in a Scirian territory at Dunapataj in 1859. It should be remembered that the Sciri, before they came to this country, had lived in a late Scythian-Sarmatian environment along the Black Sea for five hundred years as the most loyal allies of the Huns. Every object of the Bakodpuszta grave was of pure gold, conclusive evidence that the grave of the princess must have been found here during the last century when the foundations of the village school were excavated. Two more graves with gold furniture and another closer to the surface with silver objects in it were also found. The Archbishop of Kalocsa had the finds identified by Joseph Arneth in Vienna and then donated them to the Hungarian National Museum. In female Grave 1, in addition to the pair of bracelets, an exquisitely worked necklace set with garnet was also found. All the jewelry uncovered in this grave is ornamented with garnet, including the inlaid work on the golden buckle, earrings, and rings. The head of the dead person was ornamented with a gold-plated headdress, and her libation was laid in the grave in a Roman-style barbarian vessel. The nearest parallels we know

to the princess's bracelets derive from a royal grave in the vicinity of Kiev, which can be dated to before the second half of the fifth century. The necklace in Grave 2 is paralleled by a find in a princess's grave discovered near Vienna. On this basis we can date the Hungarian grave, which led Bóna to think that the dead princess may have been the mother of Odoacer and Hunvulf, King Edika's wife, and powerful queen of the Sciri. Her sons buried their mother in the Aryan way with her face turned toward the east.

We have found with the two Germanic peoples who lived along the border of the Byzantine Empire, the Gepids (the Szilágysomlyó finds) and the Sciri (the Bakodpuszta find), that royalty is expressed by pure gold and red-stone inlay; however, on the queen's jewels, animals derived from the world of antiquity appear. We can directly infer from all these observations that these Germanic peoples clothed the royal office in the Byzantine fashion: gold is the symbol of divine light, and red or purple in Byzantium was the prerogative of the royal family. The appearance of animals on the queen's jewels and insignia is a different question; this was not a Byzantine but a Scythian-Sarmatian tradition.

It would appear from the preceding examples that zoomorphic representations were reserved for the female members of Germanic royal families, but this was not so. The gilt boss on the shield found in the Herpály grave (Gepid? Vandal? Roxolan?) with its fighting beasts and its repoussé-work "barbaric" sequence of patterns, and the fighting beasts on the silver vessel of the Osztropataka find and the fantastic creatures pressed in its decorated plates testify that the representation of animals, alien to the ancient Germanic world, was accepted in the international range of symbols of the royal courts at a very early date. Stylistic considerations refer us to the Mediterranean, as do the facts that in historic times lions were for a long time unknown on the steppes and in the forests of the north, and north of Iran they were no longer hunted. Other signs show, however, that the Celtic assimilation also left its imprint on the dress, art, and creed of the aristocratic class (see the Celtic-type fighting beasts on the shield boss in the Herpály find).

Although the princely and royal families used zoomorphic symbols, the belts of the free Germanic tribesmen and the jewels of their women were ornamented with rich abstract patterns. We have no idea from where they borrowed the Late Roman chip carving, inasmuch as they had an opportunity to do so all along the Germanic *limes*, and in fact the Roman legionnaires stationed in southern Russia wore belts with similar ornaments. It may be presumed from the Szilágysomlyó find that this finely cut ornamentation appeared among the Germanic peoples before the middle of the fourth century. The other "abstract" pattern was a network of meandering rinceaux, the antecedents of which go back into Germanic prehistory. Károly Kerényi has produced a wealth of comparative material to show that these meandering patterns expressed the primitive European ideas of labyrinths. Thus Roman, Byzantine, Pontic, Primitive Germanic, Celtic, and Primitive European elements contributed to forming the culture of the fourth and fifth-century Germanic royal courts, and the fondness for colored stone inlay must have spread from Iran to the West, where it was combined with the exquisite goldsmith and silversmith techniques of antiquity, particularly granulation, filigree, wire plaiting, beaded wire, and grooved-spaced plates. These examples show that we can understand the phenomena of the Migration Period only from a Eurasian perspective.

The Heyday of the Germanic Animal Style II

Whereas in Early Germanic art animal figures appeared only in exceptional cases accompanying only exceptional persons, from the sixth century on a profusion of combined zoomorphic motifs appears on jewels, belt fittings, and everyday objects. This ornamentation rapidly replaced surfaces inscribed with chip carving and the labyrinthine rinceau patterns. The word "replaced" is used advisedly because it might be supposed that only the form changed leaving the content intact, or that the older "abstract" patterns also had a meaning and were not merely surface ornamentation.

An enormous number of studies have appeared on the Style II, and on the Germanic Animal Style in general, but its origin and meaning have to this day remained unsolved, although we know a great deal about its chronology, its geographical spread, and its relation to the individual peoples.

The first great comprehensive work was written early this century by B. Salin, and we still use his classification of the Style I, Style II, Style III. Salin thought that the styles developed from one another in sequence. Today it seems clear that the Styles I and II developed independently of each other. There was a long debate over what forces could have created a descriptive art hitherto alien to the north. Initially archaeologists supposed that the impetus was provided by the spread of the buckles and mountings of applied Roman art. Later they noticed that Scythian antecedents were also traceable in the Germanic Animal Style. Salin still believed that the organic understanding of animal anatomy had disintegrated into ornamentation, and that the separate motifs had been constantly reassembled in new compositions. Worringer subjected the pathetic linear force of Germanic art to a profound analysis, tracing its linear magic from prehistoric times to the Gothic and subsequent styles. Worringer's analysis is of interest here only because the Style II was predominant in the Carpathian Basin at the time. There is indeed a local variety which is found only sporadically beyond the Carpathians, as Nándor Fettich has established. Its distinguishing mark—indentation, that is, a tiny comblike group of notches on the ribbon-shaped body of the beasts—is an apparently insignificant auxiliary element. Fettich found antecedents for it in Late Scythian art. The question arises as to what the meaning of this sign may be. It was first thought that the notches denoted the animal's ribs, but the fact that the notches were found not only where the ribs should be contradicts this theory. It was also suggested that these tiny signs marked the traces left by the claws of the fighting beasts on each other's bodies. However, there is nothing to prove this. Fettich's theory was that the indentations survived merely as an element of style without content, but this theory cannot be proved either. The idea was also raised that the Gepids were a people with a special liking for combs, inasmuch as the most characteristic objects found in their graves were combs. But this hypothesis also has its weak spots, because if indentation was a clan sign (a *tamga*), then we would expect it to be used in ornamenting vessels as well or to be applied independently as ornamentation on trappings, mountings, and so on. This not being the case, it is hardly likely that indentation was a clan sign.

The other question that constantly arises in connection with the problems of the Style II is ribbon ornamentation. Fettich was inclined to derive this motif from the ribbonlike lengthening of the animal body, which sometimes became so divorced from zoological reality that the odd animal leg was all that was left. Where

this ingenious theory falls down is that there is no chronological difference between the ribbon-bodied animals and the wholly ribbon motif. There was not even enough time for the style to pass through this process. The style lasted 100 to 150 years, which is too short a time for such a thoroughgoing transformation. Nor can it be proved, for that matter, that the ribbon-bodied animal motif appeared later than its presumed antecedents. Undoubtedly such contradictions induced Nils Aberg and Joachim Werner to seek the solution elsewhere. They believed that the Style II originated among the Lombards in northern Italy, the animal representations of the First Style blending with the Byzantine-Mediterranean ribbon style. From here the style then

45–46 migrated between 568 and 600 toward Central Europe, England, and Scandinavia. After the recent excavations of Lombard cemeteries in Hungary, however, Werner abandoned his theory. And at this point we must stop for a moment before going any further. In Hungary, in the same critical period, two highly developed varieties of the interlacing ornament existed. One of them is known from the bracelets found in cemeteries near Keszthely and is associated with early Christian round brooches from the south, some of which were probably made on the territory of present-day Hungary, inasmuch as indentations can be seen on them. The other variety is the interlace found in Avar cemeteries, which still survives in the work of Siberian and Mongolian handicraftsmen. Herewith new vistas open up before us concerning the question of the origin of the Style II, which we have only touched upon. Furthermore, the Italian origin of the Lombard interlace cannot be rejected either. The question seems to have a bearing also on the age-old magic interlace ornament known as "Hercules' Knot" and "Solomon's Knot." This can be traced back, through medieval Christian carvings, to Mesopotamian times, Lombard interlace being only one of its forms. These questions were elaborated by the late scholar József Csemegi, who ascertained that interlace is not just a motif but has a magical meaning in various ages and societies. With this thought we reach one of the most important questions of Germanic animal ornament: the content of the representations. I shall expand on the subject in my discussion of the Great Goddess (see Chapter III). At this juncture, I shall only say a few preliminary words about the finds.

47 One of the most typical features of the Style II is that the animals are represented in antithetical composition back to back, or face to face, in which case

IV–VI they claw each other with their paws. This placement lends them a sort of heraldic character and points far back to the confronting animal pairs represented in prehistory. However, this comparison is misleading, for here the pair of beasts stands back to back. Fettich seems to have said the decisive word in this question. It is particularly appropriate to cite his findings inasmuch as a considerable number of scholars have totally ignored them. Fettich proves convincingly that these pairs of animals do not represent two animals but represent the two sides of the same animal. Thus this representation has a certain "barbarian perspective," which we find in the art of the steppes in the centuries before Christ, as, for example, in the wonderful headless double stag figures on the horse trappings found at Pazyryk (in the Altai region) and elsewhere too. It is the same kind of outlook that we find in the Mediterranean and Mesopotamia in the animals with a double perspective, that is, animals having two bodies which meet in one head. The same motif is frequently used on capitals of medieval columns. The concept must have been transmitted to the Middle Ages from antiquity through the Germanic masters of the Migration Period. The Germanic goldsmiths and silversmiths must have been conscious that they were representing

2. Projection of Avar bracelets from the vicinity of Keszthely.

3. Appliqué work from the bag of a Mongolian saddle (folk art). Interlace is one of the most ancient ornamental motifs, and mat, strap, horsehair, or felt bands could be used for forming the pattern. It has always been thought that the interlace ornament of the Migration Period derived from the Germanic peoples. This specimen shows clearly that the Avars may have brought it with them from the East. The stitches were imitated by the goldsmiths and silversmiths by rows of dots.

4. Interlace ornament from the Lower Amur region (folk art). The different formation of the plaits and cuttings gave the craftsmen countless opportunity for variety. As is shown here, in the far distant Amur country the same motifs were used as in the Migration Period and the Early Middle Ages in general.

5. Picture of a boar and sow from one of the "Siberian gold plates" from the finds in the Scythian kurgan at Kelermes. In this heraldic composition the two bodies form an ornamental unity. This "pair of animals" was the forerunner of the "pairs of animals" which were later so important in the Germanic Animal Style II. Here there can be no doubt that two animals are involved, but in later periods, the craftsman suggests two projections of the same animal.

6. A "pair of animals" from one of the bridles of the kurgan at Pazyryk. Compared with the previous illustration, the change here is considerable: the two animals are represented back to back and have no head. The latter phenomenon is frequent enough in Germanic animal representations of later periods, but there the head of the two animals forms the molded animal mask on the fibula. Here the head may have been omitted because such bridle mounts were put on a live horse's head.

not two, but only one animal from two sides. Indeed, it often happened that on the trunk of the fibula (for a long time erroneously called the "foot of the fibula," although its wearer wore it the other way up, since the animal or human head was also there) two headless animals are shown, with a common head at the head of the fibula itself. So the fibulae, in my opinion, show the head from above, plastically molded, and the body in perspective spread out on both sides. In the light of this it is not immaterial that the foot—erroneously called the head—of the fibula is ornamented with animal legs.

If my hypothesis, which I have developed from one of Fettich's observations, is correct, then we have hit upon quite a novel explanation for the Germanic fibulae of the Style II, an explanation which seems to be the most plausible one. The fibulae would thus be of the same type as the lion-ornamented fibulae we found in find 2 at Szilágysomlyó. But, whereas on the Szilágysomlyó fibulae the figure of the beast is plastic and lifelike, here the figure, transformed in the spirit of Germanic "abstract" art, preserves a plastic head, while the trunk is projected onto a plane. Fibulae with the head of a man or woman deserve special consideration. The trunk ornamentation of the fibula (erroneously called "foot") consisted mostly of labyrinthine motifs, interlace, indecipherable and patterned wedge runes, and entwined ornamental foliage. These are found also on the fibulae with animal heads of a period earlier than the Style II. Because these were later replaced by an animal trunk, it seems plausible that the earlier "abstract" pattern must also have had some similar meaning. Here we are helped by Kerényi, who demonstrated that the entrails of the animals were used in oracles and that the representation of the bowels is identical with the labyrinth pictures. Kerényi demonstrated clearly—without broaching the question of Germanic animal ornaments—the labyrinthine character of the spirals,

31

meanders, and other similar patterns. His theory is that even older representations prior to the development of the animal style showed the entire animal on the fibulae, whereas the trunk of the animal, or rather the place where it should have been, was filled with twisting entrails running in a maze of zigzags. The animal style then merely presented this idea more concretely.

We could sum up what we have said of the animal style by again mentioning that the myth underlying it had existed before the spread of the style and that the influence of Rome or the steppes stimulated the Germanic handicraftsmen to embody it. The desire to represent concretely thus arose in a society that had previously used only abstract symbols. The influence was there, but an influence can assert itself only where the necessary preconditions exist. All this happened in the sixth and seventh centuries in the Carpathian Basin, and inasmuch as the Gepids remained in this country until the tenth century, research into the further fate of the animal style will be needed from Hungarian scholars.

48–58

7. The ornament on the Cundpald chalice. A variant of Carolingian interlace, ingenious even in its plainness. It is not known whether the ornamentation had some significance or merely replaced the older garland.

III. Details of finds in a Hunnish prince's cremation grave at Szeged-Nagyszéksós. Szeged, Móra Ferenc Museum

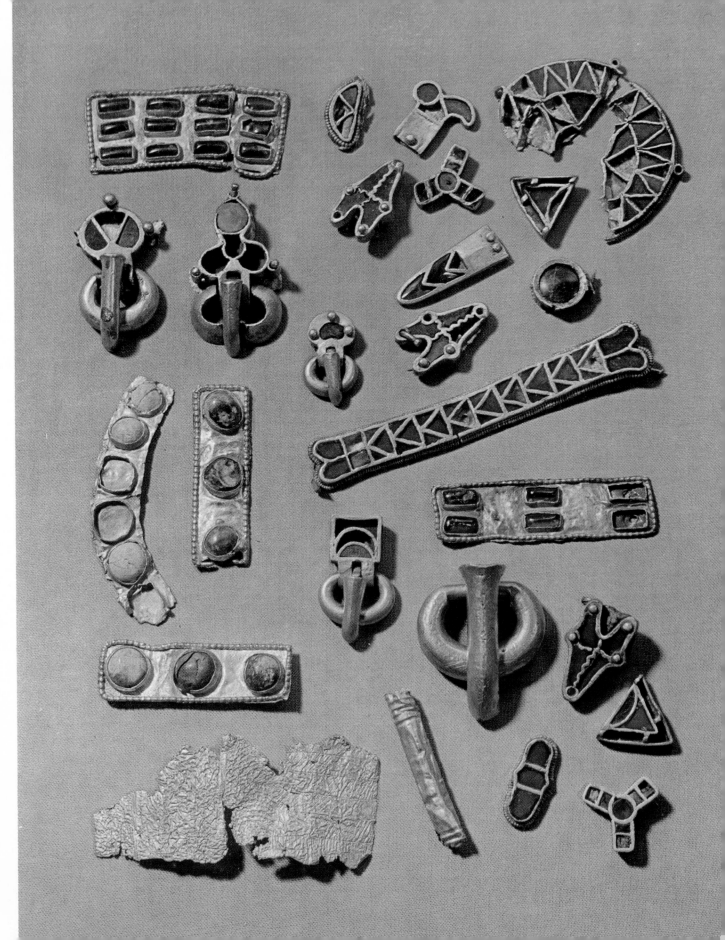

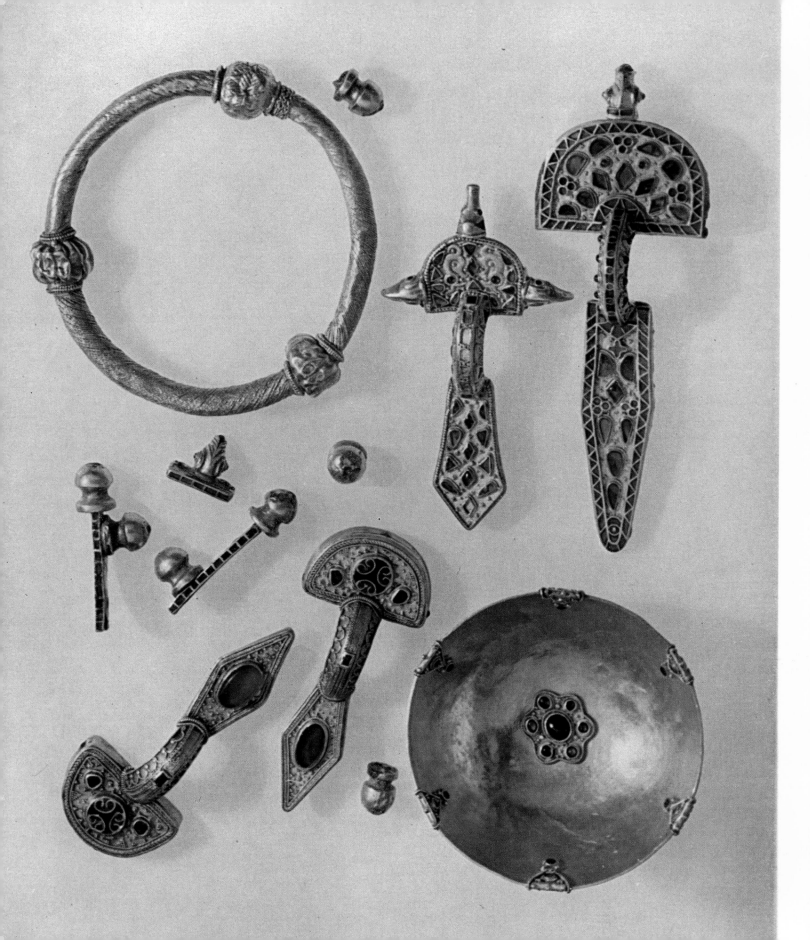

The Relics of Carolingian and Norse Art

We shall give two examples of the appearance of Late Germanic art in Hungary: the first is the Cundpald chalice in the Sopron Museum, the second a sword kept in the St. Vitus Cathedral of Prague. Tradition has it that this sword belonged to St. Stephen, King of Hungary. The first example takes us to the world of Carolingian art, the second to that of the Norsemen.

The photograph and accompanying data of the Cundpald chalice make any kind of description superfluous, so only a consideration of its historical and artistic importance need detain us. (See István Bóna.) The shape of the chalice puts it among a series whose most exquisite piece is the Tassilo chalice. The present chalice dates from the eighth century; made of gilt copper, it was once studded with precious stones under the brim. A peculiarly individual interlace composition was engraved on its brim and foot by the Bavarian master who made it. The chalice must have been made in exactly the same way as was described a century later by Presbyter Theophylus when he wrote of the contemporary goldsmith's art of making small chalices. A collation of the historical sources with the place in which the chalice was found indicates that it must have belonged to a bishop, and, as such, it marks the beginning of the Avars' conversion to Christianity. There is no doubt that it came from the grave of a bishop, most probably from that of Bishop Theodoricus, who must have been active in the *khagan*'s residence in western Transdanubia, where he was also buried about 820.

Evidence of the Carolingian Period in Hungary consists of several weapon finds and a few cemeteries (Fenékpuszta, Kőhida), but the only artistic relic that approaches the value or importance of the Cundpald chalice is a carved set of antlers, which is discussed in the section dealing with the Tree of Life.

And now we turn to an example from the Hungarian times following the Carolingian Period, that is, from the remains of Norse trade. In fact, many Norse finds have been unearthed in Hungary. They were collected at the end of the 1930s by Peter Paulsen, and sometime later Fettich wrote a monograph on one of the most beautiful Norse finds, the sword of St. Stephen, now preserved in Prague. We shall follow his train of thought on the whole, adding our own comments only in matters of date.

There is the following entry in the 1368 inventory of the St. Vitus Cathedral of Prague: "Gladius S. Stephani Regis Ungariae, cum manubrio eburneo" (The ivory-hilted sword of St. Stephen, King of Hungary). According to some hypotheses, the sword may have reached Prague from the family treasury of the Árpáds, under the reign of Béla IV or Louis the Great. On the blade of the sword is inscribed the name of Ulfberth, who was a prominent armorer working along the Rhine between 900 and 950. It is possible that the blade is not his work but only an imitation signed with his name, although this assumption is by no means inevitable. It cannot be inferred that the hilt is from the tenth century because the blade may be an imitation, inasmuch as we know that Norse arms traders bought their blades from the Carolingian Empire, as they might have done in the case of Ulfberth's highly prized blades. The costliness of the ivory mounting also shows how highly this blade was prized. Paulsen thought that this was a dress sword used on solemn occasions and held with its point upward as an insignia. However, the worn parts on the hilt show that its owner regularly used the weapon. Unfortunately, the carvings are badly worn, although they are what interests us, particularly because, as Fettich has stated, there is much more at

59–61

62–63

33

IV. Detail of a fibula from the second Szilágysomlyó find. MNM

8. Drawing of the ivory carvings on St. Stephen's sword in Prague; the interlace and animal motifs are blended with consummate artistry, a characteristic feature of the Scandinavian Animal Style of the time as well. For further details see text.

9. Projection of a gilded Norse spearhead socket found in the Danube at Budapest. The interlace design is woven into a new composition incorporating the acanthus patterns of antiquity.

stake here than the Árpáds merely having bought a fine Norse sword. For, in connection with the styles of Norse art, he raises the question of the art of the steppes, particularly the art of the invading Magyars. Once again we are reminded of the constantly recurring fact that not a single area of Eurasia can be examined in exclusion since the roots of its culture spread all over the continent. In Fettich's words: "As I see it, the art of the Viking Period was influenced by two main currents coming from eastern Europe; the first began at the time of the Norse raids, around 800, and its most striking result was the new-style carvings of the Oseberg find. This trend was stimulated primarily by the flourishing art of the Avar Empire in Hungary. The second current, which started in the second half of the ninth century, exerted an intensive influence on the art of the whole of Scandinavia. Behind this influx stands first and foremost the art of the first Magyar settlers in Hungary... The art of the Scandinavian world had had its contacts with the art of the steppe peoples even in earlier centuries. At the same time the art of the northern provinces of the Roman Empire also had an impact on it. These ancient elements mingled with new impulses and the various trends lived on, transformed, in the specific style of Northern art.

The composition of the guard on St. Stephen's sword is a transition from the Jellinge style to the Ringerike style. The basic motif is a four-legged beast of prey represented in profile, which from time immemorial had been the principal motif of the east European steppe. It is generally referred to as the cowering panther gryphon, and not a 'lion gryphon,' as it is often termed. Its accessory elements spring from the Jellinge style predominant throughout the entire tenth century. The palmettelike structure rising from the knot is the mark of the Ringerike style. No doubt this structure developed under the influence of the Persian palmette which predominated in the art of the first Magyar settlers of Hungary... All data tend to show that the ivory mounting of St. Stephen's sword was made in the last decades of the tenth century."

Now that we have introduced this splendid Norse masterpiece, let us dwell awhile on Fettich's last sentence, inasmuch as other Norse objects found in Hungary can be dated in the same way. This fact will be very important when we come to the chef-d'œuvre of the entire European Migration Period—the Nagyszentmiklós treasure. Thus, although this book is primarily about art and not archaeology, we should dwell for a few moments on the question of dating. What did the Hungarians give the Norse traders in return for their arms? The answer to this question is the flood northward of Hungarian Stephanus Rex silver coins. The route of these coins can be traced as far north as Scandinavia. The Norse traders must therefore have sold their goods for solid silver. But since St. Stephen ascended to the throne only in 997, that is, in the last years of the century, his coins could not possibly have been bartered for swords and arms, as they had not even been minted. Bearing this contradiction in mind, and taking many other factors into consideration, I think there is a likelihood that the Stephanus Rex coins were minted by St. Stephen's

10. Enlarged drawing of the first Hungarian coins. Hungarian engravers made these silver obuli after the model of Prince Henry II of Bavaria's coins minted in Regensburg. The exact counterpart of the P in the inscription Stephanus Rex is found in the runic inscriptions on the Nagyszentmiklós treasure.

father, Prince Géza, because on his conversion he had also been baptized István (Stephen). This hypothesis would explain the apparent time discrepancy between the production of the imported Norse weapons and the first export of Hungarian silver coins.

It is worth dwelling on the point because a few pieces of the Nagyszentmiklós treasure were made by the same goldsmiths and silversmiths who punched and chiseled the minting dies of the Stephanus Rex coins. Just as the formation of the Hungarian State meant the end of the Migration Period in Hungary, so the discussion of the Nagyszentmiklós treasure will make a fitting conclusion to this book.

11. In the last chapter of this book the Nagyszentmiklós treasure is discussed at length. This runic inscription from Bowl No. 8 is included here partly because it includes the *P* of the Stephanus Rex coins, partly because on the evidence of the word-dividing crosses it too must have been made in Christian times. The inscriptions have not yet been deciphered satisfactorily.

The Huns

Of all the peoples of the Migration Period, the Huns and the Vandals are those the peoples of Europe least like to remember. Their memory is associated with destruction and terror. Countless legends speak of them; the establishment of a large number of towns is linked with Attila's campaigns, including the foundation of Venice. The Nibelungenlied and the Edda erected an epic monument to the Huns and Attila. Raphael painted Attila turning his troops back from Rome after seeing a vision, although it is a historical fact that he never crossed the line of the Po. (The sagas confuse him with the Ostrogoth Totila.) The historical sources on the European history of the Huns are exact and detailed, yet in answer to the question as to who Attila's Huns were, we are faced with a number of question marks.

The Chinese chronicles of the Han Period and the period prior to it often speak of a formidable nomadic people whom they call Hiung-nu or Hun-nu. The Great Chinese Wall was built as a line of defense against them. Yet the best defense of the Chinese was to take over the Huns' tactics of horsemanship, arms, battle array, and battle wear. From then on, the struggle of the Chinese Empire against the Huns went on with varying success, in the course of which Chinese historians, reporting on ambassadorial missions, the allies of the Chinese, and the peoples living along their frontier gave us a wonderfully rich source of material for the history of Central Asia and the Far East. In the first decades of the first century B.C., the Hiung-nus sustained a crushing defeat at the hands of the Chinese armies and from that time on less and less was heard of the Huns. Some of them fled toward the west. These most important Chinese historical sources became known to European historiography

65–74

only in the middle of the eighteenth century, when the transmitter of these sources, the eminent sinologist Desguines, established a connection between the Huns who appeared at the Volga in 375 and the progeny of the Hiung-nus who had fled to the west. The topic has been a subject for research ever since, but it seems to be difficult to bridge a gap of 400 years and a distance of several thousand kilometers relying on sporadic historical data.

Recently archaeologists have found certain vestiges in Europe indicating a connection with Central Asia. The most important of these are the cicada fibulae denoting rank. Even the Chinese army adopted them from the Hiung-nus, so that their occurrence spans the distance between Europe and China. The second relic bridging the vast distances involved is the series of round bronze mirrors, and the third a series of large bronze cauldron finds. As further links, the gold bow, as a royal insignia, and the bone-plated "reflex" bow also come into consideration. The latter was found in the areas along the Volga and appeared in Hungary together with the Huns, who must have brought it with them. Another characteristic feature of Hunnish metallurgists was the scale pattern, which is known from the Rhine to Korea. The Huns who appeared at the Volga incinerated their dead, and we find the same ceremony in Central Asia at about the beginning of our era, and in the Carpathian Basin during the Hunnish Period too. There is a field of Eurasian archaeology that is specially concerned with a whole series of exquisite objects known as "Siberian goldwork." These were spread over an area from the great bend of the Hwang Ho (Ordos region) to the territory between the Volga and the Don, around the beginning of our era. Thus their geographical spread coincides with the assumed terrain of Hiung-nu history.

It would appear therefore as though the archaeological finds were decisive proof of the origin of the Huns. Yet there is another side to the question which gives much food for thought, above all in the field of art. The Asiatic Hiung-nu territory was the classical home of the animal style. Suffice it to point to the rugs of Noin Ula, the appliqué ornaments, wood carvings, or the Pazyryk finds dating back to much

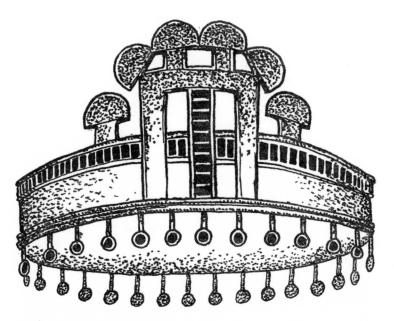

12. Reconstruction of a crown after a Hunnish cauldron from Törtel. The row of cells inlaid with stone and pendants are characteristic of Hunnish crowns.

earlier times. Among the archaeological material presumed to be Hunnish, eagle's heads or cicadas can be made out only with the greatest difficulty, and we find no 69–70 trace of the crowded animal-figure art so characteristic of the eastern territories of the Huns. András Alföldi, who has been preeminent in defining Hunnish finds, thinks that during their migrations the Huns "lost" the animal style, or replaced it with the Sarmatians' polychrome stone-inlay style. However, in view of the conservatism 71 of tribal societies in regard to their *tamgas*, it is difficult to agree with Alföldi on this 72 point, as this "exchange of styles" would imply that the Huns broke with their past, animal ancestors, sagas, and clan traditions. This departure would have been tantamount to moral death, inasmuch as not so long ago a man of the steppes was still not held to be a man if he could not enumerate at least seven of his ancestors in a convincing way. And, since art likewise played a part in conjuring up the spirits of ancestors, breaking away from this art would have meant breaking away from one's ancestors—which was unthinkable for any self-respecting people, let alone the Huns, who aspired to world domination.

All these contradictions mean that we are not yet properly acquainted with the Hunnish archaeological material; we can only surmise where to look for it. We shall now try to present the art of the Huns with the aid of the scanty finds at our disposal, including the bronze cauldrons, particularly since we can see from them how Hunnish tradition was enriched with European ceremonies as well.

These huge bronze cauldrons are exactly the same shape as those found in Central Asia, but on some of them, including those found in Hungary, we find an ornament

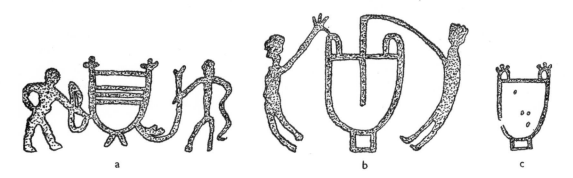

13a–c. Altaian rock drawings. These drawings use exactly the same forms as the Hunnish cauldrons, but the scenes represented on the drawings are incomprehensible. In view of the traces of fire on the cauldrons, and the ethnographical parallels, we may presume that cauldrons were used in burial rites.

that is alien to the Far East. A look at the photographs will show on the handle of 65 the cauldron the same row of semicircular ornaments we find on the foot of the Szilágysomlyó fibulae and kindred Germanic fibulae of the fourth and fifth centuries. Hungarian scholars demonstrated long ago that the handles of the cauldrons are wreathed with pseudofibulae, that is, the form was taken over but not the function. It was also observed that the rim ornament on the cauldrons is actually an imitation of Hunnish cloisonné diadems. These two phenomena are undoubtedly interdependent. The fibula heads, cloisons, and row of imitation pendants did not reach the rim of the cauldrons as a manifestation of stylistic trends or the imaginative use of ornament; I think in fact the artist wanted to represent a "crowned" cauldron. If we

mentally remove the "crown" from the cauldrons, the idea seems plausible enough. Nevertheless, before trusting our own judgment, we must clarify two things: Did pseudofibulae ever serve the purpose of headdresses, and can we find examples for the "coronation" of cauldrons?

The first question can be answered in the affirmative. In the Migration Period cemeteries of the Soviet Union we find examples of headdresses consisting of eight pseudofibulae. The pseudo-objects always materialized where the structure was functionally useless. Stockbreeding peoples did not need fibulae for their closely fitting dresses, so that in taking over the fibula they were borrowing only the form, not its function. The difficulty that then arises is to explain why the fibulae that the Germans wore on their shoulders were here a head ornament? We have seen when dealing with the Germanic fibulae that they are no mere ornamental pins but have a very deep spiritual significance. We shall examine the latter in more detail in the section on the Great Goddess, sufficiently, we hope, to explain convincingly how the pseudo-fibula became a headdress or crown.

The other question is whether or not there was any evidence of the cauldrons ever having been crowned. In the Altaian rock carvings the cauldrons are represented with a man stirring something in them. Quite close to this scene we see a sleigh, animals, and horsemen. Although it is not clear what these pictures mean, I would like to call attention to the fact that sleigh burials as a tribal memory of colder forested regions survived in many places even when the peoples in question were living under quite different circumstances. Thus the rock carvings do not contradict the idea that the Hunnish cauldrons were in some way used at burial rites. Indeed, traces of burning can also be observed, because the legs, cast in special molds, mostly melted off the bottom of the cauldrons. And yet the cremation of the dead is characteristic of the archaeological legacy of the Huns. Metal urns often play a role in the cremation rites of the peoples of Central Asia. For example, we read that the Torguts cremated the bodies of their outstanding members, whose ashes were then collected by the lama in a copper urn. Then mixing the ashes with clay, he molded a human figure out of the whole mixture and set up the image on the cremation spot.

In the ample written sources of antiquity we often come across passages about the custom of enwreathing, that is, crowning, of cinerary urns. Thus everything was crowned that had to do with celestial beings. Plutarch twice mentions the custom of crowning the cinerary urn. At the burial of Demetrius, his son Antigonus, learning the sad tidings of his father's death, put out to sea with all his ships and sailed up to the Islands to meet the boat that was bringing in his father's body. There he transferred the pure gold urn to his own commanding galleon. At every port where they called wreaths were brought aboard for the urn by emissaries in mourning garb. When the fleet called at Corinth, the urn, adorned with purple and diadems and guarded by armed youths, could be seen from afar.

A similar case was that of Hannibal, who contemplated Marcellus' body for a long time, then adorned him and had him cremated. Then, having placed the ashes in a silver urn, he laid a gold wreath on it and sent the body down to Marcellus' son.

There are many instances of funerary urns covered with gold wreaths or helmets in the Mediterranean area. The Museo Archeologico in Florence, the Villa Giulia in Rome, and many other Italian collections preserve a whole series of crematory urns surmounted by bronze helmets, and Montelius quotes many other examples from Italy's Bronze Age. In the Museum at Chiusi a funerary urn is placed on a throne. 39

In this context let me quote a sentence from Inostrantsev: "We read in the historical annals of the North Chinese Empire and the Sui Dynasty that in the neighborhood of Tashkent, during the period between the fourth and seventh centuries, the funerary urns of the deceased parents of the King were placed on a throne on a certain day of the year."

These data go too far back to justify a theory of borrowing, and I am inclined to think that these customs are rooted in prehistoric anthropomorphic urns. Indeed, several bronze cauldrons with a human head on the side were found at Minusinsk.

We have dwelt upon the subject of the Huns' bronze cauldrons rather a long time, but a summary retrospective glance will reveal the use of this discussion. To begin with, the bronze founders of Central Asia in the Hunnish Period cast the funerary urn, or the vessel used for funeral rites, in bronze, as their Scythian ancestors had done. The belief that the urn had something to do with man (anthropomorphous urns, human faces molded on prehistoric urns) remained undimmed. In Mediterranean areas the custom of crowning or garlanding the funeral urn had existed since time immemorial. It seems that the custom was taken over by the Huns, who for their part introduced the crown of pseudofibulae, which represents the Germanic compository element. Thus, to find the origin of the garland motif on cauldrons, we ranged 66 from Central Asia to Germanic and Greek territories, and from the goldsmith's art of the Black Sea peoples to the Iranian use of stone inlays.

We find a similar mixture of motifs with the cicadas, where the Eastern form is III overlaid with Iranian-Sarmatian-Germanic stone inlays. But other remains from the 73–74 Hunnish Period also involve similar perspectives, for example, the gold vessel from Szeged-Nagyszéksós, whose stone and glass inlay melted on the funeral pyre. A similar vessel, Chosroe's cup, is preserved in the Bibliothèque Nationale in Paris. Several bird of prey heads are reminiscent of the ancient animal style. A Christian bronze lamp relates to fifth-century Byzanto-Coptic traditions. From this period we also have rich finds of gold solidi, which must once have been paid as tax. It seems that 67–68 the Hun invasion, instead of crippling the large trade network, nourished and stimulated it, which was one of the aims of Hunnish power politics. At any rate, it can be ascertained that in the Hunnish Period the exchange of cultural goods extended from the Far East to the Rhine (see the Wolfsheim find).

The Avar Period

In 568 the Avars and their Lombard allies occupied the territory of the Gepids and 75–139 subjugated the entire Carpathian Basin. The Avars found in the Carpathian Basin remnants of Germanic tribes other than the Gepids, and on the Hungarian Plain Sarmatian groups as well. Bulgarian tribes may have dwelt in some places suitable for grazing, while in the vicinity of Keszthely and Pécs, population groups of the Roman period remained and were joined by new settlers from the south.

Who were the Avars? All the sources give different answers to this question. The most widespread theory is that their ancestors may have been identical with the survivors of the Jwen-Jwen people living on the northern frontier of China who were expelled by Turkic tribes. The Turkic-Jwen-Jwen wars took place in the 550s, but Priscus Rhetor mentions the Avars as early as 463 as being a people whom the tribes living beside the sea had ousted. The Avars then pushed the Sabiri westward, who in their turn attacked the Ugors and Onogurs. Thus, about the time of Attila's death, a new migration started from the East involving the peoples of the steppes almost in a chain reaction. Prior to this, not much is heard of the Avars, although it is highly probable that a Hyperborean priest called Abaris, who we find in the service of Apollo in the seventh century B.C. and who could turn into an arrow and fly away, was an Avar. He came from a country where gryphons watched over the gold. There are two points of note in this prehistoric saga: Apollo's priest may have been a shaman too (in the old shamanistic rites not the drum but the bow and the arrow were the ceremonial instruments), and the priest came from the land of the gryphons. The gryphon is the bird of the Sun and as such belongs to Apollo. Thus it is not mere chance that the gryphon was once the symbol of an Avar tribe.

So far then it is clear that in the Prehistoric Age the Avars must have lived in the vicinity of the gold-bearing Altai Mountains and that about the middle of the fifth century they set the peoples of the steppe in motion. We shall see later that part of the early Avar relics do in fact refer us to Central Asia, but at the same time the majority of the finds cannot be traced back so far, since we find similar examples in northern Iran, the Caucasus Mountains, the south Russian steppes, and Byzantium. Written Byzantine sources indicate that the Avars who occupied Pannonia came indeed from these regions. Theophylactus Symocatta writes that they were not true Avars but Varkhonites, that is, the peoples of the allied Uar and Xyon tribes. Károly Czeglédy found evidence of the latter two peoples in the steppes of northern Iran, and we also know that one of the two tribes was Heftalite, that is, descended from the Hiung-nus. The two tribes carried with them part of the south Russian Bulgarians, and they were later joined by eastern tribes. The internal strifes of the huge Avar Empire, which in the beginning stretched as far as the Don, are only of secondary importance at this juncture. These internal struggles shook the very foundations of the Avar Empire about 630, when the Bulgarian uprising was crushed and the Frankish trader Samo organized a mixture of rebellious Slavs and Avars into a state that survived for a few decades in what is today Austrian and southern Czechoslovak territory. The early Avar Empire set up a large diplomatic and military network extending right out to Persia.

Byzantium bought peace from it by paying astronomical sums which at times amounted to 120,000 gold solidi. The *khagan*, Baian, was a great ruler and military commander, comparable only to Attila. In the seventh century, as a result of the crisis mentioned previously, the Avar Empire was reduced to the Carpathian Basin and became more and more an agricultural country. In the middle of the century a royal family of pure Mongolian descent still headed the allied tribes, but their rule was already on the decline. In the 670s a new people with a peculiar Late Hellenistic art appeared in the Carpathian Basin, densely populating it. Hungarian scholars used to call this people the "people of the Keszthely Culture," then the "rinceau-gryphon" people. (Their culture is characterized by belt mountings adorned with rinceau and gryphon motifs.) József Hampel was the first to claim that the tribe was a mixture

of Sarmatians and Huns which had survived into the Avar period. Alföldi established that their bronze-work culture is indeed of the Avar Period; he felt that this bronze work was the art of an Asiatic stratum of the Avars, whereas the Bulgarian stratum is represented by finds of a Byzantine character. It turned out that when a more exact archaeological chronology was worked out the two strata are not of the same period but that the early Byzantine-style Avar culture was replaced by bronze work. Hungarian scholars thought that this difference was merely a change in fashion; but, quite recently a Slovak colleague conjectured that perhaps Coptic and Byzantine bronze founders had immigrated into Avar territory, and they made these bronze casts. However, all these theories ignore the fact that not only the belt ornamentation changed from Byzantine foliage into the rinceau-gryphon ornament, that is, art

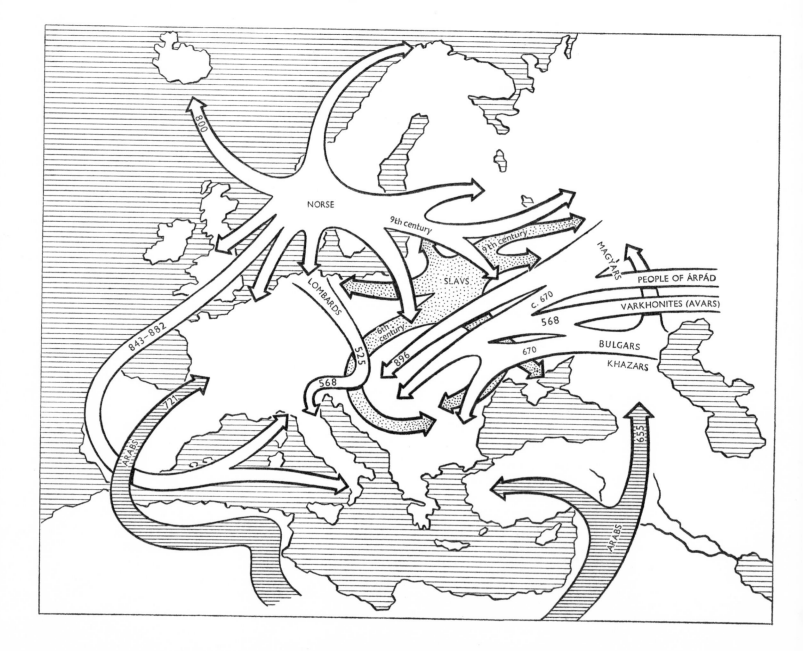

changed, but completely new forms appeared in all fields of life—male and female dress, horse trappings, weapons, ceramics, spinning and weaving methods, and so forth. None of these changes have any antecedents in the Carpathian Basin, only in the East. Consequently, we must assume that around 670 a new people appeared in the Carpathian Basin, with links with the left bank of the Volga, the distant steppe region, and the Caucasus. This new immigration may have happened simultaneously with the original settlement of the Danube Bulgars. One historical source says that one of the five sons of the Bulgar *khagan* left southern Russia and moved to Pannonia, while another went to the banks of the lower Danube. A similar migration of the Black Ugors is recorded in ancient Russian chronicles, and Hungarian chronicles also speak of a double conquest of the land. We shall see in the section on "The Two Hunting Brothers" that the name Magyar was a variety of the word Onogur as used by the neighboring peoples (*ungar, ungur, hungarus, venger*, etc.). This is important because we know that Bulgarian Onogurs moved to the Danube, and presumably other Onogurs under Kovrat's son occupied Pannonia. To determine archaeologically who the newcomers were, the following facts have to be considered: much is known of the place names in Hungary from the eleventh century, and the cemeteries of the rinceau-gryphon people are equally known. If we project these two phenomena upon the map, they give the surprising result that the rinceau and gryphon finds extend to the boundary line of the Hungarian language and occur in abundance even in places that were not occupied by Árpád's Magyars. It follows that the influx of peoples around the 670s brought a fair number of Hungarians into the Carpathian Basin. This supposition is borne out anthropologically too, since the finds of eleventh-century Hungarian cemeteries indicate that the population of the time was a continuation of the people who made the late Avar cemeteries. We may therefore justly call the rinceau-gryphon archaeological style the legacy of the early Hungarians. Hereafter the rinceau-gryphon people will also be referred to as Late Avars/Early Hungarians.

This historical detour proves how wrong it was to mark off the end of the Avar cemeteries and Avar culture with Charlemagne's campaigns at the turn of the ninth century. The Magyar population of the Late Avar Period has survived to this day, having merged with Árpád's Hungarians who arrived in 896. On the peripheral regions of the Carpathian Basin the Slavs also appeared in Late Avar/Hungarian times. Recently, attempts have been made to ascribe the cemeteries found on the periphery, for example, the splendid Avar finds found north of the present frontier of Hungary, to the Slavs. However, such attempts have absolutely no foundation whatsoever, since everything about these cemeteries is unmistakably Avar and the finds have nothing in common with distinctly Slavic finds. Nor can pottery be adduced as proof of a link, because pottery ornamented with undulating lines was the mark not of an ethnic nature but of the period and can be found everywhere between the Carpathian Basin and eastern Turkestan. At the same time, it seems that the Slav ruling classes ruled in an Avar fashion. I shall go into this concept in more detail in the section on the Slavs. In short, the preceding paragraphs show that the ethnical and cultural pictures of the Avar Period were very diversified; naturally this diversification was reflected in the archaeological finds and art as well.

The Artistic Legacy of the Early Avar Period

The diversified phenomena discussed in the introduction can be followed in the archaeological finds as well; in this section we will trace the thread of their complexity. 75–95

The Central Asian Stratum

The bone engravings showing the Tree of Life, the struggle of the Two Heroes, or a hunt and beasts indicate links with Central Asia. These subjects will be treated in the chapter on mythology, in the sections on "The Tree That Reaches to the Sky," "The Two Hunting Brothers," and the "Cosmic Duel." The exquisite, long stirrups,

14. Avar bone carving with a semipalmette ornament from the cemetery at Bágyog-Gyürhegy. The Avar carvers used great ingenuity in applying their stock of motifs to the surfaces to be ornamented, weaving an independent composition from motifs taken from the infinite reticular pattern. Here a first glance suggests a leaf rinceau, but, if the pattern is completed, the result is a reticular design extending over a large surface.

the exact counterparts of which can be found in the T'ai T'song monument or in the Turkic cemeteries of Central Asia, are the work of the goldsmiths and silversmiths of the period. Also, among the Central Asiatic strata may be ranked the bone plates ornamented with half palmettes which were worked into saddles and quivers, since their exact counterparts have been found in the Turkic cemeteries. It is therefore evident that the bone "drawings" in this country do not reflect an "artistic" influence but a Central Asian people who among other things brought their art with them. We should mention at this juncture that in the cemetery of Avar princely families where Iranian goldsmith's work was found the anthropological material is wholly Tungid. Our thoughts instinctively turn to the Xyon tribe of Hiung-nu origin mentioned previously as the bearer of this art. Thus it cannot be mere chance that until now we know of two *khagan* graves and that the names of both finding places (Tépe and Bócsa) are Turkish, or perhaps Pecheneg.

The Iranian Stratum

We have just mentioned that the archaeological remains, that is, clothing, weapons, of the Tungid princely family have an Iranian character. In Iranian silver work, and particularly in woven textures, the use of pearl-ornamented borders was very common. The bordering disks or ribbons look like a string of real pearls, and they can be compared with the pseudobuckles found in Avar princely graves. (How one particular example, the specimen found at Tépe, was made will be analyzed in detail in the chapter on handicrafts.) Such pseudobuckles have been unearthed in closed finds

15. The egg is a very ancient symbol and as such has survived to this day in the Eastern custom of exchanging painted eggs. The egg is generally regarded as a symbol of fertility or of resurrection. This painted egg, found in an Avar grave near Szeged, was probably dipped into the paint and later incised with a pattern.

86–87 too. In the royal grave at Bócsa a princely belt was ornamented with six pseudo-buckles, and from it hung a gold quiver and gold drinking horn. On the prince's clan belt a row of electrum mountings carried his gold-mounted sword. The gold cup in the find is also Iranian in character. However, we must dwell on the question of the pseudobuckles. Pseudoforms have already been mentioned in connection with crowned Hunnish cauldrons: the fibulae used by the Germanic tribes became the ornament of the crown. With pseudobuckles the process was slightly different. The mounted herdsmen carried enough "kit" for days or weeks tied to their saddles or their belts. The more things they had, the more buckles or rings they needed. We know of such herdsmen's belts from the ethnography of the steppe peoples. The number of buckles or rings gradually became the insignia of rank. We can see this development best in the ancient Chinese army. In the system of organization adopted from the Hiung-nus, rank was designated by either the number of cicadas or the number of rings dangling from the belt. The pseudobuckle was already wholly symbolic, as nothing could be hung from it. On Late Avar belts, as the cemetery finds bear out, the number and material of the belt mountings were also indicative, denoting both social and military rank.

Returning to the question of the pseudobuckles bordered with beads, we should mention that this fine form of framing spread under Iranian influence among Byzantine goldsmiths and silversmiths too. It is therefore very difficult to decide whether, on Hungarian territory, this framing style was an Iranian or Byzantine legacy. Never-theless, we must opt for the first because this pearl-studded ornamentation appeared once again in the Late Avar Period in the painting on pottery of forms of a definitely Iranian character. The large pyramid-shaped earrings of the Early Avar Period were likewise covered with a wreath of globules, the like of which is found also in the Byzantine area. Because of the pseudobuckles of these finds we may assume that these

VII, IX–X exquisite earrings were made on Hungarian territory as well.

The Byzantine Stratum

It is very difficult to separate this stratum from the Iranian, since Byzantine fashion and dress were strongly influenced by Iran. In the art of the Early Avar Period in Hungary we can distinguish two strata of Byzantine influence: Byzantine goods, and things made in Hungary in the Byzantine fashion.

45

16. Reconstruction of the Dionysian gold plates cut up for the funeral sword from an Avar prince's grave found at Kunágota. This design, which was stamped out in several copies, must have been made in Antioch in the middle of the sixth century; it is a valuable "classical Byzantine" piece. Originally, the plates may have been intended as chest mountings. Despite the use of perspective, the design is unmistakably from the age of Justinian.

Original Byzantine objects were imported by the Avars through trade links, as booty or as taxes. To this group belong the gold solidi and the weights of the goldsmith's scales, the *exagia*. The best example of Byzantine work is the "classical" Byzantine chest mounting used to make the funeral sword found at Kunágota and ornamented with reliefs of Dionysus and Thyrsos. The silversmith preparing the sword did not take the picture into consideration but cut out the plates according to his needs. Similarly, the stone inlays were worked into the loops irrespective of the outlines of the figures, as was the custom with the goldsmiths and silversmiths of the steppe peoples, as the bowl of Bishop Paternus and the Poltava find bear out. Since many uniform chest mountings were found in the same place, we must assume that they fell into Avar hands as booty and came into the possession of the prince buried at Kunágota at the sharing of the spoils. The vestiges of a similar spoil-sharing are borne by the dolphin-ornamented silver bowl found at Tépe. Only one-third of the bowl is extant, but as luck would have it, this remaining part bears the authenticating Byzantine stamps on the base. There are five of them. Both the Kunágota and the Tépe pieces are from the Early Avar Period, that is, from the time of the Avar-Byzantine wars and Byzantine tribute. It is possible that the other part of the Dionysus plates found at Kunágota reached the Tépe prince himself, inasmuch as the plate of its gold-hilted dagger was hammered from chest mountings very similar to the Kunágota find.

Thus we have seen a few pieces of decorative art that were made in Byzantium, but much more important and more characteristic of the Avars is the influence of Byzantium on the mountings of the Avar belts. The Avar belt was the symbol of the free man, so what he ornamented it with was not immaterial. When Christian

17. The cemetery at Kiskőrös-Vágóhíd parish belonged to an Avar princely family (Hring). The newcomers who destroyed the power of this princely family—the gryphon and rinceau people—despoiled all the graves, leaving only the grave of a girl intact. She wore the sort of necklace Byzantine court etiquette prescribed, with tiny socketed, almandine stones hanging from the gold collar.

emblems were on its mountings, we can assume that its owner was a Christian. (In early times quite a number of Christian Byzantine goods—crosses, earrings ornamented with peacocks, and others—reached the Avars.)

Avar belts in the early times were adorned with chased bronze, silver, or gold designs. How they were made and who the goldsmiths and silversmiths were who made them will be described in the chapter on handicrafts. The subject we will

a b

18a–b. This sheet-gold headdress was found in an isolated grave at Cibakháza; it probably belonged to a princess. We should note that although no animal representations are found in the graves of Avar princes they do occur in the graves of the princes' consorts.

discuss now is how ornaments of a Byzantine character came to be found on Avar clan belts. What must have happened was that when the Avars arrogated the south Russian goldsmiths' and silversmiths' workshops for their own purposes, they and the Caucasian peoples wearing similar belts became the buyers. Apparently, their only stipulation was that belts should be ornamented with plant and not figurative motifs. As far as the goldsmiths and silversmiths and their customers were concerned, the leather kilt of Late Roman armor—whose rows of jointed mountings were ornamented with metal plates in the form of double shields with acanthus and palmette patterns— was for them an old and well-liked pattern that they willingly imitated. The mountings on the long bands of leather had to be jointed, otherwise they prevented the legs from moving. However, with Avar belts this consideration did not apply, so the double-shield mountings were molded without joints but with the accustomed ornamentation on them. It was in this changed form that the plant-ornamented mountings of Late Roman armor survived on Avar belts. Elsewhere it survived in the Christianized pair of doves on double mountings or in the bearded Dionysus masks found here and there. Initially, we began with the apparently unjustified assumption that the Avars ordered plant ornamentation. Indeed, this must have been the case because the reliefs on Late Roman armor had to a large extent not plant but animal ornamentation. Had it been up to the goldsmiths and silversmiths to ornament the belts, the Pantheon of Roman mythology would surely have figured on them, but what

48

V. Golden buckle from the former Jankovich collection. Germanic Animal Style II, indentation style, seventh century. MNM

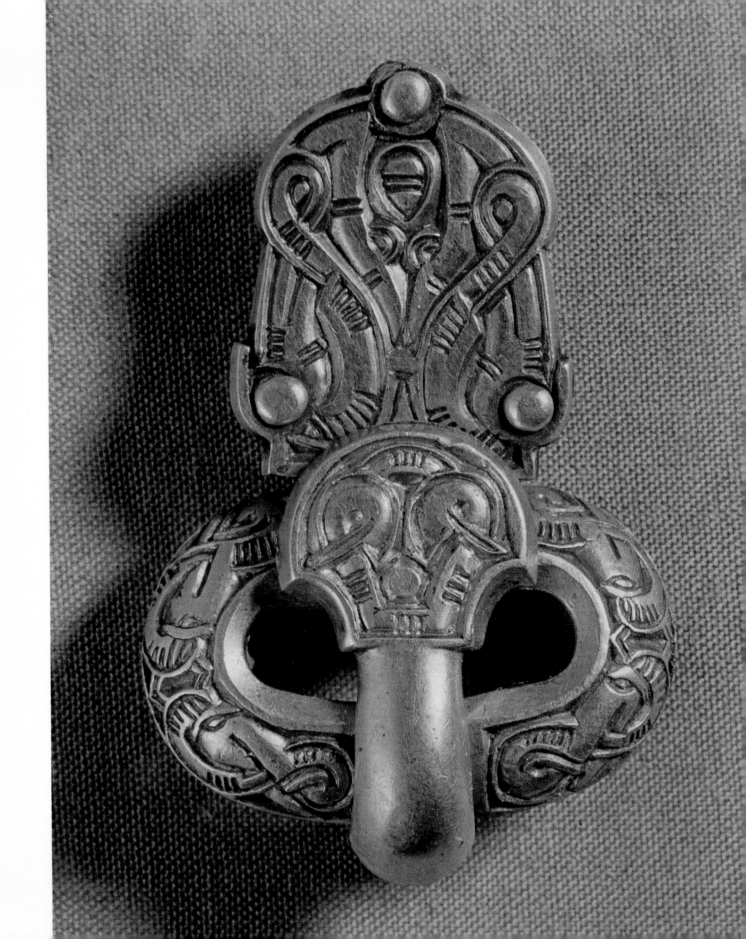

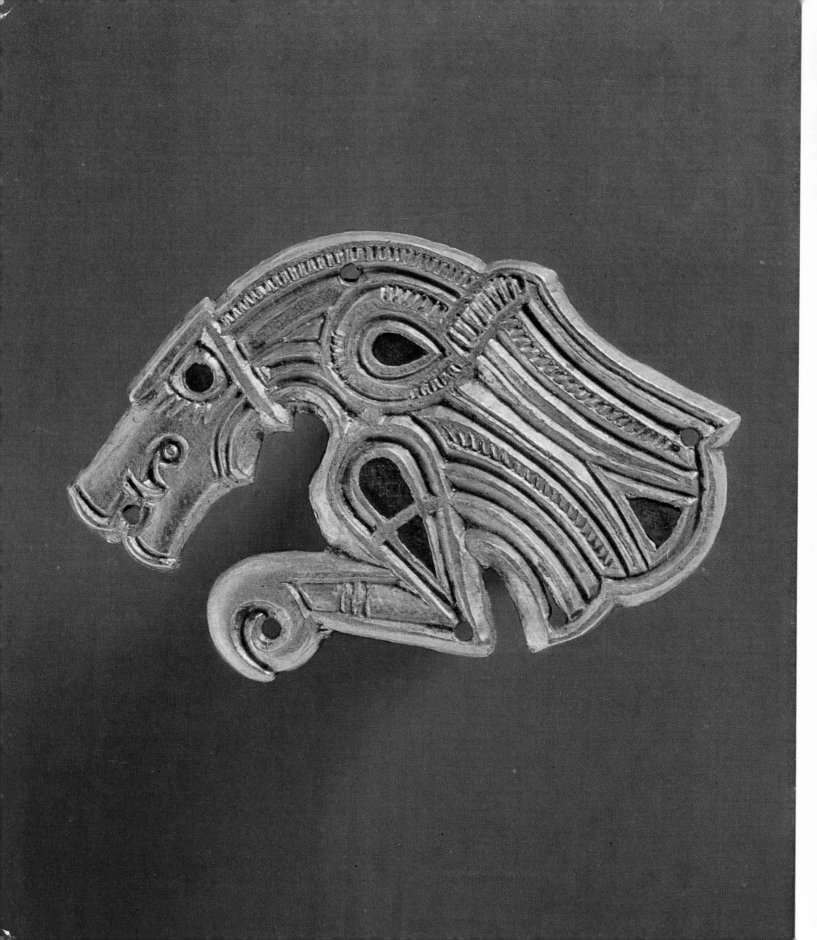

19. Strap kilt on a Late Roman statue in parade armor in the Athens National Museum. I earlier established that the palmette mountings and strap-end garlands on Early Avar belts derived their forms from the Byzantine goldsmiths' and silversmiths' workshops on the northern coastal region of the Black Sea; therefore, their stock of motifs can be traced back to the strap kilt of Late Roman-Byzantine armor.

we see is that ninety-nine percent of these mountings were plant ornaments. The only explanation for this is that it was the Avars who ordered their belts like that. All this is very important inasmuch as there were three peoples in Hungary during the Migration Period using the plant style—the Early Avars, the later rinceau people, and the invading Hungarians with their Persian Islamic art.

Among the relics of the Late Roman-Byzantine stratum, mention should be made of the round brooches found mostly in the vicinity of Keszthely and Pécs. As fibulae, 78–81 they cannot belong to the Avar style, but rather they are the legacy of the indigenous population mixed with Germanic elements. Early Christian iconography is amply evident on these round brooches fibulae. They must have been made between the middle of the sixth century and the last quarter of the seventh century, and some of them must have been produced locally and not in the Balkans, since the local hallmark of the Germanic Animal Style II—indentation—is easily recognizable on them.

In connection with the Byzantine stratum we must mention the plate found at 95 Szeged-Öthalom showing an eagle clawing at a fish. (It must have been the plate of a pendant and not the earpiece of a helmet, since in this case the scene on the plate would have appeared upside down.) The motif of an eagle clawing a fish was handed down from steppe tribe to steppe tribe right from the time of the Scythians. Originally, it may have been the emblem of Olbia, and perhaps it was derived from there.

Germanic Traits in Early Avar Art

It was mentioned previously that the round brooches, which are characteristic of Late Roman-Byzantine ornamentation, bear the imprint of Germanic craftsmen, as their indentation shows. We have also discussed the greater part of the Germanic finds from the Avar Period. In Hungary, among the best specimens of the Style II V–VI are the exquisite Jankovich gold pieces. (Jankovich was a famous art collector in the first half of the last century who presented the National Museum with these three gold pieces.) The pieces, which must have come from the grave of an important

49

VI. Pommel mounting from the former Jankovich collection. Germanic Animal Style II, indentation style, seventh century. MNM

military commander, are a very good example of how content changed form depending on whether it was made to Germanic or Avar order. In the illustration in color plate VI the motif is the emblem of a winged boar. If we looked at it merely as a "motif," we might think of Celtic "influence," but there seems to be a much more obvious solution. Gustav Kossina published his find of the grave of a Burgundian chieftain or commander. The runic inscription says that his name was Ranja, which means "boar's snout." We know too that the old wedge-shaped Germanic battle array was named after the boar's head and the wild boar rune spear of the Burgundian grave marked the grave of the leader of such a "wedge." Thus the wild boar gold piece of Jankovich's collection must also have been owned by a military leader (and it must surely have been one of a pair). Whether or not the Avar leather strap ends with their boar-head ornament also had this meaning we do not know. There are two possible solutions: either they were worn by Avarized Germans who kept to their clan traditions, or the boar was the symbol of an Avar clan with its own traditions. Indeed, the word "boar" occurs in Magyar nomenclature as a personal name, and the bulk of the Late Avar population was named "Magyar." It was, moreover, the name of a mighty Pecheneg tribal chief, Thonuzaba (The Boar-Father). Such totemistic relics can be found among the names of Turkish leaders, too. Likewise, the name of Árpád's son, Üllő, meant in the Hungarian Székely dialect "hawk," which fits in with the Turul saga, the family saga of the Árpáds (see the section on "The Son of the Sun").

The owners of a few belts with silver inlay found in Transdanubia must be regarded as Germanic, and the belts must be of immigrant Bavarians. The belts have human heads depicted on them. Avar belts with similar motifs also exist; whether or not the symbolic content of the Avar and Germanic belts is identical, we cannot tell. It is certainly worth noting that the Avar belts and funeral rites of mounted warriors were echoed in the West, but, of course, the ornament of the belts tended gradually toward the Germanic style. Just as the fibula was not worn by horsemen, so the belt of the nomads was not an accoutrement of infantrymen. The livestock-breeding peoples took over the fibula in the form of a pseudofibula, whereas the Germanic peoples adopted the belt from them. It should be mentioned that Germanic goldsmiths and silversmiths also worked in the workshops of the Avar *khagan*, since indented Germanic animal motifs are found on the belt clips of the Avar prince's sword at Bócsa. 51–52

The clan signs and their development into pure ornamental motifs are a special field of research. A few of them will be discussed here. Fettich recognized that the starting point of these patterns was an animal figure. On Avar territory few *tamgas* have been found, and even these presumably date back to Sarmatian times, although their close "relatives" are found on Germanic territory.

Thus Eurasian "oecumenicity" is demonstrably reflected in Early Avar art, illustrating the hypothesis we posited at the beginning.

Late Avar (Hungarian?) Art

In the preceding sections we have already broached the subject of Late Avar art. For the present the specific archaeological chronology and stratification of the Avar Period will be passed over, as the emphasis in this book is mainly on works of art. Nevertheless, a few words must be said about why—unlike Alföldi—most Hungarian 96–139

scholars consider the rinceau-gryphon group to belong to this period. In the first place, in the finds of the style, dated Byzantine coins and representations, so characteristic of the Early Avar Period, are missing after about 670, so that the rinceau-gryphon group may be dated from this time. The Carolingian swords among the Late Avar finds unearthed at Hohenberg in Austria and Blatnica in northern Slovakia date back to the turn of the ninth century, so that the rinceau-gryphon group may have lasted at least until then. However, the technique and design of the ornamented studs in Moravia resemble Late Avar ornamental art so much that Béla Szőke was justified in thinking that refugee Avar masters also worked in the Moravian goldsmiths' workshops. This theory is relevant merely because of the chronological sequence since we can thereby date the Late Avar incised and punched ornamentation

20. Belt mountings from a grave in the Kiskőrös-Városalatti Avar cemetery, with clan signs *(tamgas)*. The *tamga* is one of the essential sources of the art of clan societies. It was tattooed on the body, embroidered on textiles, worn on belts, and so forth. The patterns may originally have represented animals.

21. Clan signs on a belt from Martinovka. In some of these Fettich recognized stylized animal forms.

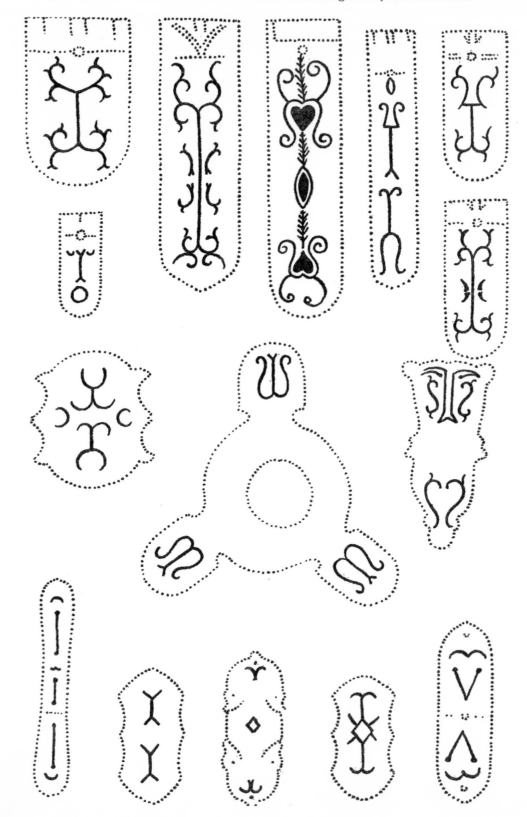

to the ninth century. The campaigns of Charlemagne therefore did not end the independent existence of the rinceau-gryphon people, although the large-scale settlements of the empire changed the ethnic picture considerably. The casts of the Hohenberg type, produced by complicated silversmith techniques, show that the workshops of the princes' goldsmiths and others of the Early Avar Period in which the pseudo-buckles and globule-studded earrings were made continued to work for buyers of a later period. The methods of work from phase to phase are identical in each period.

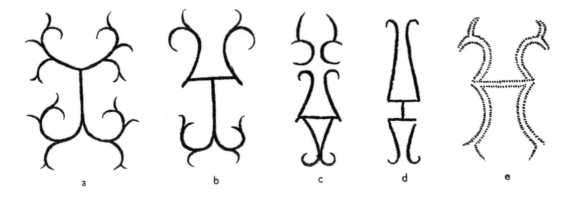

22. Of course, not only the Avars had clan signs (belt mountings included), but the Germanic peoples also had them. Sometimes these *tamgas* are so closely related to one another that we must postulate that Germanic tribes resettled Avar territory, the records indicating that Teutons settled on Avar territory and vice versa. (a–b) Martinovka; (c) Kiskőrös-Városalatti cemetery; (d) Müncheberg; (e) Čadjavica.

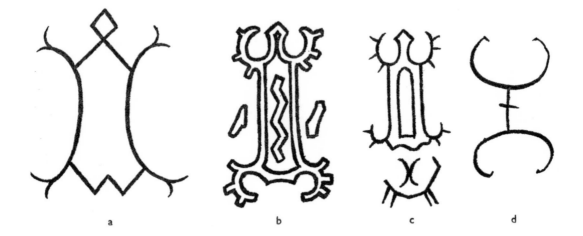

23. Sometimes by observing the geographical spread of the clan signs we can follow the various nationalities as they disperse to distant parts. (a) Ob-Ugrian, (b) Manshi-Vogul, (c) Manshi-Vogul, (d) Ob-Ugrian.

Having largely clarified the question of chronology, let us consider more closely the art of the Late Avar Period. Because of the noble proportions and the stylized reshaping of nature in their sculpture, these works can claim to be called art, especially when we consider that the bronze belt buckles are only tiny variants and copies of large-scale works of art. This book is not the place to catalog these immensely rich finds (the number of the graves discovered until now is 35,000 to 40,000); instead, a few general statements may help to give a better idea of the style. Far from dying out, the style survived and flourished again in the Romanesque Period in the art of the Magyars and the peoples of the Carpathian Basin. In Austria its influence was likewise considerable.

We begin with rinceau ornamentation. Even to the unpractised eye the rinceau ornament falls into two main substyles, and these substyles can be further subdivided. We shall content ourselves with presenting the two main substyles, the variety of which can be seen in the illustrations in this book. In the first substyle the undulating line of the stalk and the flat, disk-shaped leaves growing from it remind us of a plant and nothing else. In the second group, although the central stalk remains, the surrounding plants are distinctly recognizable, notably grapes. These mountings, scarcely a few centimeters in size, echo lost large-size monuments or carvings; they must have originally ornamented beams, gate columns, and ceilings, and these were probably painted too.

XI

96–103

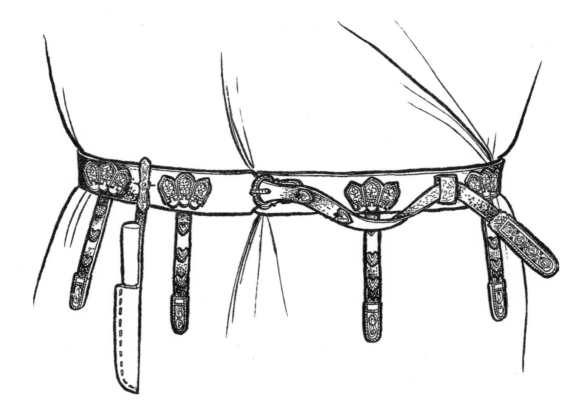

24. Reconstruction of an Avar belt. The belt denoted the clan and the rank of the free Avar man. The number and design of the mountings exactly define the place of the wearer in Avar society. The artistic and technical skill of Avar craftsmen can be gauged from these belts.

25. This typological series of bronze finds from the Karasuk and Tagar Periods of the Minusinsk Basin was compiled by Appelgren-Kivalo and Alföldi.

a b c d e f

It is of course striking that two diametrically opposed principles of art should have flourished in the same period. The hypothesis that the rinceau motif with the disk-shaped leaves may not derive from a plant motif deserves serious consideration. The idea was first entertained by Appelgren-Kivalo and developed by Strzygowski and Alföldi. According to them, this kind of rinceau is practically a series of heads of birds of prey, and the round holes at the base of the round leaves are eyes. This "rinceau" may have originally taken shape in the Late Bronze Age in Minusinsk and developed in a way comparable to the Germanic round brooches, on which arcades grew from the same series of bird's heads; here, too, only the small stone inlays where the eyes should be are reminiscent of an animal origin. However, there is something that makes this ingenious hypothesis dubious. Very often on the socket of strap ends with flat leaves and rinceaux we find two fighting beasts with open mouths, or we find the fighting beasts on the other side of the strap end. The question then arises as to why the two animal heads or the scene of the fighting beasts did not become a sign or a symbol when the bird's heads, through endless repetition, gradually changed into rinceaux. A possible answer and a likely solution is that the two were the meeting of two separate worlds and that a sort of blending of plant and animal ornament came about in these tiny works of art. In brief, the gryphon people and the rinceau people amalgamated like kindred tribes, and this joining is reflected in the mountings. During the Avar Period, the gryphon people would have been relegated into the background by the rinceau people of the Volga, so the gryphon people slowly vanished by the end of the Avar Period. If we accept this explanation, we have the answer as to why the art of one of these peoples gradually changed animal orna-ment into rinceaux whereas the other did not. This theory would take us back into the long past of the Ananjino Period, when the process of "rinceauization" is supposed to have ended among the peoples who streamed in from the Minusinsk Basin to the region along the banks of the Kama in the fifth to third centuries B.C. In the new environment the ornament may have survived wholly as a rinceau until the time of the Nevolino Culture in the first millennium A.D. The end of this period curiously

55

26. Parallels and antecedents to the bronze casts of the rinceau-gryphon style: (a–c) from Japan and Korea; (d–f) from the Amur region.

enough coincides with the beginning of the rinceau-gryphon style in Hungary, that is, with the incursion of the new people. These people, before leaving their ancestral home on the Volga, merged with a new ethnic group from Central Asia whose symbol was the gryphon. About this time the use of the gryphon as a symbol among the Turkic peoples of Central Asia ceased. Another point about the rinceau and gryphon people is that the right bank of the Volga where they set out from toward Hungary was presumably also the home of the Magyars; on this bank the thirteenth-century monk Julianus must have found the remainder of the Magyars who stayed behind

108–110

in their country of origin. The region lay for a thousand years on the fringe of a Hellenistic culture, so it is not unusual that in bronze casting—the very techniques of which confirm the fact—the legacy of Late Hellenistic art, naturalistic scroll design, proved all pervasive. That the naturalistic scroll design is Hellenistic in origin is shown by the whole series of anthropomorphic representations, not just the plant ornaments, that derive from the same source. These representations were collected by Fettich and recently commented on by Jan Dekan. I will follow their conclusions with my own remarks where necessary.

First, Fettich. He compared the anthropomorphic reliefs of the cast bronze strap ends with the mythological figures of late antiquity and found a great number of coincidences, including the Triumph of Dionysus, Fighting Dionysus, the Nereid Riding a Sea Monster, Nike and Heracles. The figures underwent a "transposition" into Avar terms, inasmuch as instead of soft, patterned surfaces they are set in clear-cut planes of carving. Instead of suggesting perspective, this style of drawing—very much like Persian and Byzantine art—projected persons and objects onto a single plane above or beside each other. Fettich suggests that the transformation is primarily due to Persian mediation, seeing the immediate predecessor of many representations 104–107 (for example, Mártély, Klárafalva) in the Persian rock reliefs. Since then, many such 125–127 representations have been found (for example, Bánhalma) which seem to be closely related to the Persian sphere. At the same time, as we shall see later, there are Christian

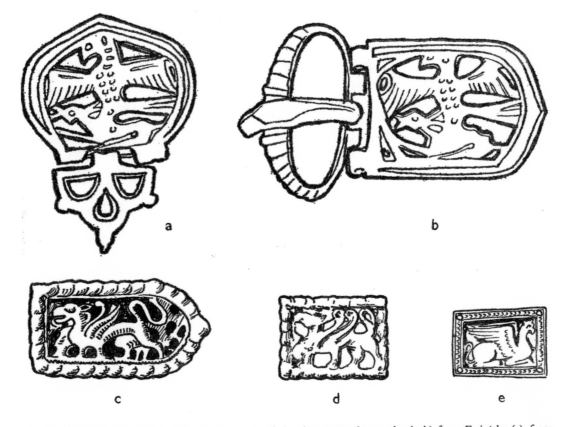

27. Parallels and antecedents to the bronze casts of the rinceau-gryphon style; (a–b) from Fativízh; (c) from Kudirge; (d) from Samarkand; (e) from Nizhny Georgon.

57

28. Parallels to the "rodlike" rinceaux in the Nagyszentmiklós treasure: (a) rug pattern from eastern Turkestan (Bäzäklik); (b) rinceaux on a strap end found at Keszthely; (c) the last detail is from the drawing of a detail of the Nagyszentmiklós treasure.

representations that can have been borrowed only from Byzantium. This aspect of Fettich's findings is expanded by Dekan. His parallels, however, are not always as ideal as possible as, for example, when he considers the Persian figures with *bashliks* on their heads and holding flowers or perhaps branches in their hands to be priestesses shaking the sistrum. Or again, he sees the representations on the strap ends from Mártély as scenes of Jonas, when the scenes on the strap ends have nothing in common 104–107 with the Jonas relief presented. Unfortunately, because of such analogies and comparisons his conclusions are rather shaky. His view is that the style and its rich supply of Hellenistic motifs were brought into the Carpathian Basin partly by Late Egyptian, Coptic craftsmen, partly by Byzantine masters, so that it is not characteristic of the Avars but of the Slavs as well. Yet in seeking the origin of the style, it will be more appropriate to begin not with a haphazard comparison of motifs but with the techniques and tricks of bronze founding handed down from craftsman to craftsman (see the chapter on handicrafts). There is convincing evidence that these techniques are the direct continuation of the founding processes used in the workshops where the "Siberian gold plates" were made, which has nothing to do with the techniques of either the Byzantine or the Coptic masters.

A single but very instructive example will show how dangerous it is to judge by isolated motifs.

Dekan analyzed one of the strap ends of the former Fleissig collection. The openwork strap end shows a man in the posture of prayer with an open-mouthed beast underneath him. The empty space on each side of the man is filled in with two *S*-shaped motifs. Dekan thinks that this strap end was a type of prehistoric representation that can be traced to the Achaimenide period; then, like Fettich, he says that the two *S*-like figures are nothing but stylized lions, whereby this scene would represent Daniel and the lions. He considers the stylization of the lions into an *S* to be a mark of Coptic art, which leads him to the conclusion that Coptic bronze casters came to live among the Avars. The Coptic texture quoted as an example does indeed resemble the strap ends. But on the strap ends the lion is fully shown "licking the sole of Daniel's foot," just as on western buckles. Although nothing is said about 104–107 this in the Old Testament texts, popular belief seems to have imagined tamed lions 125–126 like that. But then, if the lion was fully represented on the present strap end, what 127

29. Parallels to the palmette motifs and compositions of the Nagyszentmiklós treasure: (a) from Grave 141 in the Avar cemetery at Gátér; (b) from Grave 285 in the cemetery at Szeged-Kundomb; (c–d) Nagyszentmiklós: pattern on the handle of patens Nos. 15 and 16, and ornament on Jar No. 2.

are the two *S*-forms doing there? I do not know, but they must have some meaning because the *S*-motif can be seen also on older Swiss buckles that likewise show the lions licking the prophet's foot. The Avars could easily have borrowed the motif from the Swiss too. However, even more interesting things appear just by glancing through art books. For example, the praying figure and two *S*-shaped spirals appear in an archaic Greek vase painting in the same way as they do on the strap end or on the Daniel buckles. Was this form a mere space-filling element, or did it become an

104–107 independent element that took shape from the two wings of the fluttering veil? We cannot tell, but one cannot draw artistic or ethnic conclusions by considering the migration of isolated motifs when a whole series of facts and observations contradict the inferences made from the connections between the motifs.

But apart from that, no one denies that Avar bronze casting was pervaded by the Hellenistic legacy, the proof of which is the mythological iconography we have outlined. One thing is certain: this Late Avar art cannot have developed from Early Avar art; all the evidence contradicts this supposition. Indeed, not even motifs bridge the gap between the two periods. The antecedents of the gryphons can definitely be traced from the Far East to Hungary. At the same time, a style related to the rinceau style will be found in the Lomovativ culture, which ceased to exist in the Volga region just about the time that the rinceau-gryphon people appeared in Hungary. The Perm region and areas of the Far East are full of Hellenistic remains. Somewhere in this area we should look for the place where the rinceau and gryphon clans merged.

30. Drawing of a strap end from the former Fleissig collection and parallels: (a–b) drawing and detail of the strap end; (c) detail of an archaic Greek vase; (d) detail of a Coptic rug; (e) head of a Lombard fibula from Várpalota; (f–g) detail of two Daniel buckles.

The whole question becomes clearer if we remember my observations while I was analyzing the maps of Avar cemeteries: the patterns on the strap ends or belt mountings are not questions of fashion or taste but rather denote the rank or origin of their wearer. Thus social consciousness and clan traditions defined what could be represented on the belt. We are faced with the problem of how the Avars interpreted the types of patterns of antiquity. (From now on, the terms Avar and Early Hungarian will be considered interchangeable.) Who can tell now what arbitrary interpretation brought the Great Hero (Heracles), the divine origin (Dionysus), and the mermaid (Nereid) among the patterns of Avar bronze casting?

60 If we switch from historical to artistic questions and imagine a gryphon or a man

fighting a beast in lifelike or even larger proportions, the mature likeness of the lifelike proportions and the exquisite blend of bronze casting and wood carving is surprising. The bronze casts must have been made by men of a very high culture. There can be no question here of migrating nomads, and, in fact, the Mongolian element derived from the nomads of Asia represents only an infinitesimal stratum even among the ordinary population. The rinceau-gryphon style shows the mingling of the great Eurasian cultures, whose roots go back to Korea, Iran, Byzantium, and the West; in itself, however, the style represents an original departure on the part of the Late Avars/Hungarians. One of the most beautiful pieces of Late Avar small sculpture, an intertwining composition of fighting beasts, is discussed in the section on "The Two Hunting Brothers."

119–131

Of course, a style so rich in all these aspects influenced the neighboring peoples, just as its later developments pervaded Early Romanesque art too. In the south the "Albanian find" marks the border, in the north Finland. Yet despite the sheer north-south extent of it, there is no evidence of trade with Byzantium, which makes the pair of clasps used on female clothing found at Dunapataj all the more remarkable. The row of human heads on the clasps and the pearl setting are suggestive of goldsmiths trained at Byzantium. They must have been made for a princess of the Late Avar Period, since similar brooches are characteristic of the Late Avar Period.

134–135

The incredible wealth of gold and splendor that marked the Avar *khagans'* courts is evident not only from the pure gold casts of the "Albanian find" but also from an outstanding piece of enamelwork, a vessel preserved at St. Maurice d'Agaune in Switzerland. Alföldi suggests that the enamel pieces on it were transferred from a scepter and that this *chef-d'œuvre* of early enamel art belonged to the Avar booty of Charlemagne. Monastery tradition considers it to be a gift from Harun al-Rashid, but Alföldi dates it to the Avar Period. To give an idea of the wealth that reached the West after the looting of the *khagans'* treasury, I quote here Alföldi's words in connection with the enamel vessel: "The huge gold hoard of the Avar *khagan* was plundered by Charlemagne, who made gifts of it to his courtiers, military leaders and also the more important churches and monasteries of his empire, so that, as J. Deér will explain in detail, the Frankish Empire was suddenly showered with unheard-of quantities of gold." Byzantine ambassadors described the pageantry and pomp of the Turkic *khagans'* palaces. Indeed, their enthusiasm surpassed even that of Priscus Rhetor.

Thus, with the Avars and later with the second incursion of tribes in the seventh century, not "barbaric hordes from Asia" but peoples organized in military formations came to the Carpathian Basin whose culture was in no way inferior to that of the other peoples living among the ruins of the Roman Empire; in some senses it was a more far-flung culture, stretching across the vast steppes of Asia to the Far East.

XII

Strzygowski, Fettich, several Scandinavian scholars, and I have already pointed out that certain features of the symbolic language of Christian art in the Romanesque period, particularly the long tradition of fighting beast representations, are inconceivable without the Late Avar-Hungarian art which long flourished in Central Europe. We are also beginning to suspect that the inspiration behind Romanesque carving in Hungary lies chiefly in the same style. Thus, after the close of the Migration Period, the art of the Migration Period lived on in early German ecclesiastical art and the rinceau-gryphon style spread toward the west and blended with the classicizing ecclesiastical art of the Romanesque period.

The Art of the Slavs

Within the present frontiers of Hungary very few Slavic relics have appeared which 140–144 merit treatment in a book on art. The finds include a number of artistically valueless vessels used at cremation burials, that is all. There are, however, two relics of outstanding value and exquisite beauty which do belong in this book: the Blatnica find and the wooden church of Zalavár. The first undoubtedly came from a Slavic environment (the northern part of modern Slovakia), and the whole assemblage shows its Slavic origin beyond question. We have already mentioned the suggestion that the Avar rinceau-gryphon style was partly Slavic. Since there is no objective archaeological or historical basis for this assumption, the suggestion will not be further discussed.

The Blatnica find, however, is of extraordinary interest and beauty, despite its 141–144 incompleteness. Unearthed at the end of the last century, it consists of two parts: the prince's sword and the trappings of his horse, and the belt that supported his weapons. We know from the four-branched mountings, which cannot be imagined on anything but a horse's trappings, that he was buried with his horse. He was thus buried in Avar fashion. We may appropriately quote from a passage by the Arab writer Ibn Rusta. Writing in 920, he speaks of a Slav prince called Swetmalik, who can presumably be identified with Prince Svatopluk. Ibn Rusta says of this prince that he was titled the "Prince of Princes," that is, a *khagan*, that he had mares whose milk was this king's only food, and that among the Slavs only the chieftains have horses. These data speak of princes living in the Avar fashion; drinking the milk of mares was particularly a custom among the steppe peoples. Several Hungarian scholars have pointed out that the neighboring Avar *khaganate* strongly influenced the life and culture of the Moravian state, as was only natural.

Reverting to the Blatnica find, it cannot be mere chance that in the Avarized atmosphere of the princely court the prince was buried with his horse. (It should be noted at this juncture that the Blatnica prince rode without stirrups like the Moravian and Slovene princes.) The ornaments on the sword and the trappings are not of Avar character but rather indicate Carolingian influence, what we might anachronistically call the "national" form of an already assimilated and transformed art. The antecedents of this form of trappings are familiar from the Veszkény find, which contained the four-branched bridle mounts of the Lombard period. (Earlier they were assumed to be Carolingian.) On the Blatnica finds Fettich recognized the triumphant Dionysus, and the peak-headed masks belong to the same mythological range. The Carolingian form and ornament of the sword (gilt bronze plates with silver inlay) derive from the same sphere. The belt is a different case. It seems to be the direct descendant of Avar belts with cast mountings and later incised ornamentation. Indeed, the pattern on the strap end is so reminiscent of the Nagyszentmiklós treasure that it is likely that in the immediate neighborhood there was a *khaganic* goldsmith's workshop. On the other hand, a striking difference is that the pendants of the Blatnica belt are cast together with the upper part of the mounting. This development must be similar to that of the Huns' pseudofibulae or the Avars' pseudobuckles. Here, too, the pendants were no longer needed, but the customary form was

31. The Second Church at Zalavár, as reconstructed by Ágnes Cs. Sós and Antal Thomas.

nonetheless included in the casting mold of the mounting. This belt was not made for an Avar prince, only in the Avar fashion, and the customer's needs were different. It is not gold, only gilded. We now know that the belt symbolized freedom for the Avar men, and tearing off the belt was a rite for depriving a man of his freedom and making him a thrall. In the case of the Blatnica belt, therefore, more than Avar stylistic influence was involved, inasmuch as the wearing of this belt meant freedom and dignity to the Blatnica prince too. Such rulers must have imitated the Avars in keeping mares and drinking their milk and in performing the ceremonies of the Avars. This is all characteristic of freshly liberated peoples: in the beginning they adopt the forms and symbols of the former power, since in their eyes these mean power, freedom, and the existence of their country as a state. Just as the Avar *khagans* kept one eye on Byzantium and the Hungarian princes on the Khazar court, so the Slavic princes, during the process of independence, looked at the gold-hoarding Avar *khagans*. Thus the duality of the Blatnica find is not due to chance but shows the natural orientation of the Slavic principalities that sprang to life between the Carolingian and Avar powers.

Although Hungarian excavations cannot even approach the scale and effectiveness of those carried out by Czechoslovakian archaeologists, Ágnes Cs. Sós still succeeded in finding the remains of a ninth-century church at Zalavár and drew a recon-

32. Ornamental button from a Conquest Period find at Gyöngyös. Similar buttons occur in Moravian cemeteries from an earlier date than the Hungarian Conquest (896), but this find shows that they were used until the tenth century. The punched background links this button stylistically with Oriental art, including Late Avar art, the Nagyszentmiklós treasure, and the purse plates.

63

struction of it with the assistance of Antal Thomas. Their reconstruction shows a stone and timber church with nave and aisles and a slightly curved chancel. The building dates from the time of Pribina. The width of the aisles was 4 meters, the width of the nave was 8 meters, and the length of the church was 30 meters. We find similar churches mainly in the valleys of the upper Rhine. On the site of the church at Zalavár a wooden church must have stood earlier, probably erected by missionaries to the Avars.

In connection with the reconstruction of the Zalavár church mention should be made of the likelihood that the Slavs in Transdanubia (Pannonia) had several similar churches. These created no sensation of novelty among the monumental timber buildings which became known by the name of the "Avar ring." Unfortunately, we have not yet found any archaeological evidence of them, and the ex-soldier of Charlemagne's campaigns may have been exaggerating when he talked about the Avar ring. Nevertheless, it is certain that the Avars had large-scale timber structures. Very able master craftsmen and artisans may have immigrated with the ninth-century Bavarian settlers, who were capable of building large churches and village buildings. The wooden church of Zalavár must have fitted in harmoniously with the other contemporary timber structures in the tradition of the Rhine country, and its *fachwerk* walls must have been particularly imposing. Thus, in ninth-century Transdanubia, the works of Frankish, Slavic, and Avar masters were to be seen all over Pannonia.

In passing, we should briefly touch upon a theory first put forward by J. Hampel, as a result of which hair-ring burials of the Bielo-Brdo culture were attributed to the Slavs, and the hair ring was considered to be a Slavic jewel. Later it was established that the jewel was a mark of the period and not of the people. Of course, hair-ring burials were found in both Slavic and Hungarian cemeteries as well. Ultimately, the question can be solved by anthropologists and place-name experts. What is certain is that the exquisitely fashioned necklaces and snake-headed bracelets date mostly from the eleventh century; they are thus not the concern of this book. There are, however, two major silver finds from this period: the Darufalva find and the Tokaj find. The Darufalva find is of a Russian character, and, judging by the place names, was brought by immigrants; the Tokaj find was presumably imported from Byzantium, and although it is exceptionally beautiful, it does not belong to the artistic development of the Carpathian Basin, nor the art of the Slavic peoples.

The Art of Árpád's Magyars

It is difficult to draw a picture of the prehistory and culture of the Magyars and 145–193 Árpád's conquest of the country because of the contradictory nature of the sources. The basic structure of the language indicates that Hungarians are Finno-Ugrians, whereas the archaeological legacy of Árpád's Magyars makes Hungarians Turks of the steppes. Constantine Porphyrogenitus wrote that the Hungarians were once

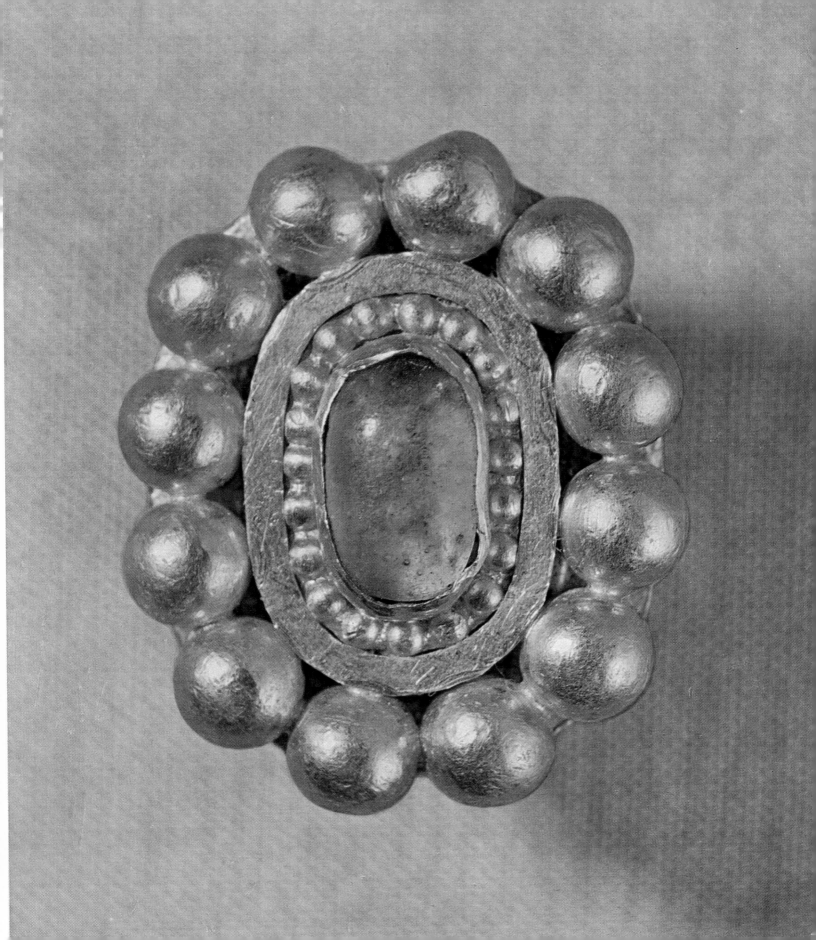

part of a tribal alliance—of which the chronicles know only indirectly. The chronicles place Hungarian ancestors either in the Volga region or on the shores of the Meotis. The migration of the Hungarians to their new land, according to the Emperor of Byzantium, was set off by a defeat at the hands of the Pechenegs. Hungarian chronicles know nothing of this: according to them they set out from the old country because of overpopulation.

In the face of so many contradictions, scholars consequently hold diametrically opposing views even on basic questions. My view is that if the authentic sources describe Hungarian prehistory in two ways we should not attempt to make two peoples into one, but must accept as a fact that the Hungarians sprang from two branches, and that is the reason the sources do not agree.

Thus Hungarian is ranked among the Finno-Ugrian family of languages, and we may justly infer that the bulk of the population was of Finno-Ugrian descent. The region where the ancient Ural-Finno-Ugrian people lived was Europe, presumably somewhere between Central Poland and the Urals. In this area, right from the end of the Ice Age, we can follow the separation of the ancient peoples into many tribes and their slow migration northward and westward. Even today the chain of the Finno-Ugrian languages stretches from the Baltic Sea to the Ob River in various degrees of affinity. The location of the Hungarian language is between the Ob-Ugrians and the Permians. And, since the settlements of the former stretched as far as the Kama region, this disposition of the chain of language affinity means geographically that the Finno-Ugrian branch of the Hungarian people may have emerged somewhere in the heart of the Volga country, more exactly on its right bank. This area has been since time immemorial the northern borderland of the scrub steppe, where the people lived by farming and livestock breeding even in the second millennium B.C. It was from here that the Hungarians of the Avar Period broke away, and here, in the thirteenth century, the monk Julianus may have found part of the Hungarians who had stayed behind when the majority rode west. In this area the majority of place names are derived from the word Magyar. The place names formed from the Hungarian tribal names as recorded by Constantine can be found on Bashkir territory, on the left bank of the Volga. And, since Mohammedan writers speak of Hungarian Bashkirs even in the centuries after the Magyar conquest of Hungary, we may presume that a Turkish stratum joined the Finno-Ugrian stratum of the Hungarian people. More than 300 words in the Hungarian language are a relic of this fact. The question is where did the amalgamation take place. According to the classical view, this Turkish stratum had already become Magyarized in the East, but I have concluded that there were two conquests of Hungary (around 670 and 896), so that the full Magyarization of Árpád's Bashkir-Magyars took place in the Carpathian Basin. One thing is certain, namely, that the Árpáds established a strong state in the Carpathian Basin which from the tenth century through the Middle Ages played a European role in power, authority, and culture.

The invaders of 896 brought with them a quite different culture from the Mediterranean and Germanic culture of the West; this culture was, in fact, a peculiar variety of Persian Islamic culture. Islam encircled Europe in the shape of a crescent, from Central Asia to Spain. Over this vast area the peoples of Islam created a culture of unparalleled richness, which at the time was equal to that of Byzantium, not to speak of the West, and which in many respects was richer, more differentiated, and more "modern." Developed from ancient traditions, their medicine, astronomy,

VIII. Inlaid, bossed beads from the Early Avar Period, seventh century. MNM

natural science, and mathematics, and no less their poetry, intellectual life, universities, and academies meant civilization in the eyes of the western regions of Eurasia at the time, a civilization that has become one of the components of modern European culture.

A lasting link between the European traditions and the Arab-Persian world was established by the conquest of Hungary by Árpád's Hungarians. This link is evident not only in the Persian Islamic character of Hungarian art, as can be seen in the illustrations to this book, but also in what we know of the state of medicine. At that time few surgeons in the West dared to undertake brain operations or cranial surgery; on the other hand, we know from finds in Árpád-period graves of trepanations of the cranium carried out by the ancient Hungarians. Sometimes the resulting holes were covered with a silver plate half the size of a man's palm. The edges of the hole in the skull knitted together beautifully, which means that the patient must have survived the operation by at least ten years.

Naturally this kind of culture did not pervade the entire people (not everybody can carry out operations even now); the operation was restricted to the ruling classes, whose culture was more international. The higher a man's social position, the more likely he was to know of contemporary Eastern culture. In view of this fact, it is no mere chance that on the coronation scepter of the Hungarian kings was a rock crystal ball carved in one of the centers of Arab culture, the Egypt of the Fatimids, which may have reached the Árpáds as the gift of an ambassador. At the same time the emblem of one of the Magyar chieftains was the horn, and again, it can hardly be an accident that one of the Hungarian museums preserves an exquisitely carved Byzantine horn found in Hungary. To turn to the royal insignia: the sword of St. Stephen is Norse work, whereas in the golden embroidery of the coronation robe the iconographies of the West and Byzantium meet. These few examples may convince those who doubted that the best elements of Magyar society lived on an international level, and yet it was a culture that kept its original character, the Nagyszentmiklós treasure being a good example of how influences from widely diverging sources synthesized (see the section on "The Son of the Sun"). Other examples are the Sword of Attila and the saber preserved in Vienna made by the court armorers 145
and goldsmiths of the Árpáds. There may be similar examples, but as a whole this work is an individualized example of the Oriental influences in the art of that time.

Whereas the art and taste of the Magyar royal court can be considered international, the fondness of the ruling classes for pomp and display established itself primarily under the spell of Persian Islamic art. Let us look at a few examples of this development.

The finds include a series of purse plates, mostly made of thin sheets of silver, with 165–172
chased patterns and a punched, or gilded, background. Ninety-nine percent of these purse plates were found in Hungary, so probably they were mostly made in Hungary. It is just possible that the first such purse plates were brought to Hungary by the invading Hungarians from southern Russia, where they may have been made by the goldsmiths and silversmiths of the tribe at Khorezm—the Kabars. These craftsmen apparently came to settle in Hungary with the Hungarians. Another view is that the purse plates and all the silver objects with chased palmette patterns are characteristic of the Kabar tribe. This idea seems unlikely, inasmuch as we have seen that previously—in the Early Avar Period and among the rinceau people—two peoples had settled in Hungary whose art was based on plant motifs. The style is not impor-

33. Syrian Koranic ornament from about 900. Its importance here is that the palmettes on it are woven into infinite patterns, just as on our purse plates or the Kiev sword, which was also made by a Hungarian craftsman. Mohammedans are known to have lived in Hungary in the tenth century, so the historical circumstances give us every reason to suppose an affinity with the Arab miniatures.

tant, but the fact that they used plant ornament is. Therefore, even if we accepted that the majority of Magyar goldsmiths and silversmiths were Kabars, the people who demanded the plant motifs from them lived on a far more extended territory than the Kabar tribe.

The ornamental element of the purse plates is very plain: a palm flower with dense leaves, or perhaps a fresh palm sprout. However, this simple pattern was elaborated in innumerable varieties. The very variety, the eternal freshness, and the splendid inventiveness show that it was a freshly thriving art that had not yet degenerated into the use of standard patterns. The motifs derive from the Persian Sassanid period, although the inspirations of pattern weaving are suggestive of an Iranian origin.

Before examining in detail a few varieties of these purse plates, we should note that even these palm-sized silver plates are reminiscent of large-scale and nonmetal surroundings, primarily textures, such as woven patterns and appliqué work. The reason for this similar appearance is a narrow hatched band running along the edge of most of the palmettes. This band is an unequivocal survival of the metal thread pattern with which the felt applications were fastened. What was necessary in the case of the applications became a mere ornamental element in the metal work. From this imitation, another technique evolved in Hungary in the late Middle Ages. Twists of cloisonné enamel also developed from the recollection of appliqué work and hemming. (Recently, István Dienes traced the antecedents of the plate ornaments to the accumulation of mountings on the leather cover.)

The simplest arrangement of the surface-filling structure of the purse plates is when the palmettes join each other, like a grill pattern, in such a way that two leaves touch and the palmettes of the next "tier" grow out of the stock thus formed. These XIII–XIV palmettes touch again, thus serving as a basis for the next rows to be woven, and so on. This clear, logical patterning suggests the harmony of waves gently forming. The gentle waving movements rise not only along the lines that fade into each other diagonally but also in a horizontal and perpendicular direction. This technique

67

34. Hungarian (?) mounted falconer on a silver bowl from the Urals. The patterning of the horseman's trappings and quiver coincide exactly with the ornamental art of the Hungarian Conquest Period—hence our assumption that it must have been made by a Hungarian silversmith. It has long been established that the Hungarians living along the Volga split into three parts, the first remaining there, the second migrating to present-day Hungary, and the third part settling on the southern slope of the Caucasus.

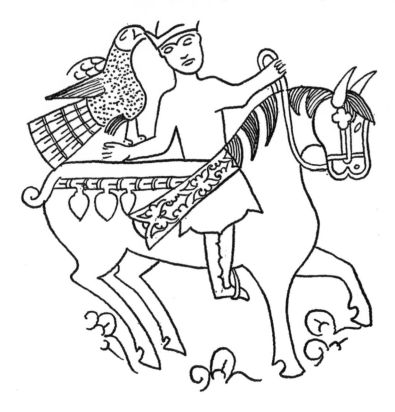

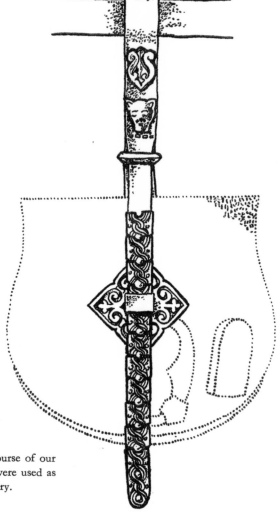

35. The purpose of these square mountings was long a mystery. In the course of our excavations at Bodrogszerdahely, however (1942), we observed that they were used as decoration on the clasp of leather purse plates, thus clearing up the mystery.

derives from the inventiveness of Islamic craftsmen who used it for filling in the rigid, ruled line grid; but it reached perfect harmony at the hands of the Hungarian craftsmen. The most beautiful example is the Kiev sword.

The perpendicular wavy lines may become a band, from which arises a surface ornament more inorganic than the above: the palmettes seem no longer interwoven but lead a separate life, detached from each other, in the compartments formed by the bands. We have an example of this, and also of the further loosening up of this interplay of bands when the bands do not undulate at a tangent but frame the ornamentation by interlooping. Some historians see a symbol of the boundless thirst of the steppe people for freedom in the infinite extension of the patterns. However, this fine poetic simile is rather a play with words, since the same network of patterns

can be seen also on the orientalizing Italian brocades of a later period, although the Italian town dwellers were mostly seamen and merchants. István Kovács, the brilliant archaeologist from Transylvania, approached the problem of the palmettes from another angle, and, I think, more realistically. He realized that this vegetation of succulent water-storing leaves is characteristic of the perimeter of the sandy steppes. This observation is true, since we have seen that some of the patterns of the purse plates derive from the Sassanid Persian world, and only their reticular construction is an Islamic invention.

It is worth dwelling a moment on these Sassanid Persian antecedents. We are well acquainted with the superb silver pieces in which these palmettes also appear. However, the palmettes and other plant ornaments are scarcely perceptible, being hidden in the smaller ornamental surfaces, whereas the larger surfaces are filled in with splendid scenes of a royal hunt. Why did not Hungarian silversmiths take over this form? Why were they not inspired by the captivating beauty of the hunting scenes? We know of a silver bowl on which the Hungarian silversmith chased and punched a falconer with mature skill. Yet this example seems to be an exception, whereas in Hungarian finds the plant ornament, of secondary importance to the Sassanids, was profusely used. Was some inhibiting factor involved? We might be tempted to think of Islam if we did not know that the exquisitely done portraits of the first caliphs are displayed on their coins, for nowhere does the Koran prohibit the representation of the human form. In fact the Koran does not forbid it but the popular tradition based on the Koran. This tradition drove the representation of living beings from the art of Islam. This reason may be why instead of the pageantry of hunting scenes a more modest type of ornament gained ground in Hungarian art. The natural overture to this phenomenon may have been that the Hungarians themselves used plant ornament, that is, their creed centered not so much on the animal ancestors as on the Tree of Life. (In our folktales we have even today numerous varieties of The Tree That Reaches to the Sky, as we shall see later.)

Let us now observe what became, at the hands of the Hungarian master craftsmen, of the simple, reticulated palmette composition. One type is a symmetrical pattern in which a leafy band runs along the axis and on both sides undulating palmettes grow out of one another and spread everywhere. We should mention that the structural ancestor of the central axis is the closing strap, which, as a continuation of the suspension strap, ran through the middle of the purse, and closed it underneath. Purse plates exist of which only the middle part—the closing mechanism—was made of metal; through this part the strap was reeved. This design inspired Hungarian master craftsmen to draw a central pattern structure. They could bring out other surface effects by leaving the punched design in the plane and making the drawing clear by gilding the background, and many other effects could be made by concentrating on a light-and-shade effect so that the drawing on the plate could be seen from afar. Another scholar suggested that Hungarian craftsmen gradually tended to move away from smooth surfacing toward the use of more pronounced relief work. It is just possible that there was such a tendency, too, but I think that the underlying reason for the various techniques used by the goldsmiths and silversmiths may rather have been the imitation of effects seen in other materials, for example, a texture with its single plane, or a strongly protruding carving, or again pressed leather. Each master's method was different. If one of them had to repair a piece broken off an object made by another master, he involuntarily worked in

his own style. For example, when the broken flat loop of a saber was replaced, a new, more embossed pattern replaced the older, smoother decoration; for this reason many persons have thought that the moving away from flat surfaces to more embossed ones was a general tendency.

The examples I have quoted show how freely and with what inventiveness Hungarian goldsmiths and silversmiths handled the Persian palmette. It is particularly instructive to study, from this point of view, the bordering of the purse plates. Their curving lines would not have cut the infinite pattern organically, so a transition had to be created, with a conjuror's skill and inventiveness, to make the filling in of the surface seem organic.

XIII–XIV

Did this Persian Islamic plant arabesque art become a folk art? There can be no absolute "no" to this question. It is true that purse plates were found only in the graves of clan chiefs or richer joint family chiefs so that their value as symbols of rank is beyond the shadow of a doubt, but palmette-ornamented trappings, and disk-shaped or oval mountings occur more widely. The range can be extended still further if bone carvings are included as well. However, if the palmette-ornament finds, or the graves where they occurred, are compared with the graves in which no such ornaments were found, on the whole the same proportions will be established, as in the case of the rinceau-gryphon mountings of the Avars: not everyone had a right to them. Thus, to the question of whether or not Persian Islamic plant ornament was folk art, the answer must be that, although it was the distinguishing mark of free men, it was not representative of the entire Hungarian people—in modern terms, it was an art denoting class. (It might be objected that the art denoted not a class but a tribe. As yet, it is difficult to say which is right.)

One thing can be justly assumed, namely, that in the mythological concepts of the peoples using the palmette ornament, the Tree of Life reigned supreme, in contrast to the art using animal figures which preserved the memory of totemistic ancestors. The choice of symbols was not dictated by stylistic factors or taste.

The legacy of the first Magyar settlers of Hungary can be looked at from the same angle. Here animal ornament finds in the men's graves are few and far between. On the Bezdéd purse plate, on either side of a Tree of Life crowned with a cross, we find the gryphon and Iranian "dog-bird," the *senmurv*. On the splendid Vienna saber an intertwined pair of beasts is pushed aside into a hidden corner of the brass plate of the fuller. On the Benepuszta find is an animal that looks partly like a gryphon, partly like a plant. In the chieftain's grave at Zemplén five disks were ornamented with mythical Turul eagles or with beasts woven into plant forms. At Karos two small mountings ornamented with Turul eagles were found. These are all the animal representations that have been found in men's graves. On the ornamental and open-work temple disks and bracelets found in women's graves in Hungary, however, numerous examples of animal figures bear a strong resemblance to those of Late Avar/Hungarian art. It is true that these disks and pendants were made by the same silversmiths who made the purse plates, and many of the disks and pendants have palmette ornaments on them, which is precisely why it is so striking that the ornamental mountings made for men were not adorned with animal figures. The buyer's stipulations must have been involved, or, in historical terms, animal pictures—mostly gryphons or four-legged beasts of prey—were the emblems of the female clan and the plant ornaments were assigned to men. Scholars have traced the family tree of the House of Árpád, and we know that its young men married foreigners. This

166–168

163–164

36. Conquest Period Hungarian belt found at Bocsárlapujtő, as reconstructed by István Dienes, who found a complete leather belt with a row of closely packed mountings in the course of his excavations and used it as a model to reconstruct belts found elsewhere.

arrangement may have had far-seeing diplomatic reasons, but it cannot be doubted that exogamy existed as a law in the House of Árpád and the ruling class. With this information in mind, the fact that animal ornamentation—or as István Dienes assumes, the animal figure art originating in Saltovo—occurs primarily in the graves of rich women will appear quite differently. It should be stressed again that in this case not artistic style but content is decisive. Two examples will prove this: the first is a bridle ornamented with animal heads and found in an isolated female grave. It is the work of a Norse master craftsman, made in the Norse style. The other example is a bridle ornamented with eagle heads and found in another isolated female grave; this bridle preserves Scythian traditions. The style thus was not important. A test of this hypothesis might be that in the only grave known of a Hungarian prince, the Geszteréd grave, there is no trace of animal representation.

Stylized plant motifs appear again in the patterns of the ornamental disks found in female graves, and in one group the Tree of Life looms behind the beast's figure. These occurrences may be ascribed to the fact that orders were placed only with silversmiths who were thoroughly accustomed to the palmette method of ornamenting. The question has another side, too, which was hinted at when the anti-representational tradition of Islamic art was mentioned. For the last two or three thousand years, the art of the steppes has had several periods when the decoration of animal bodies, for example, feathers, took on a decidedly plant character. We also surmised,

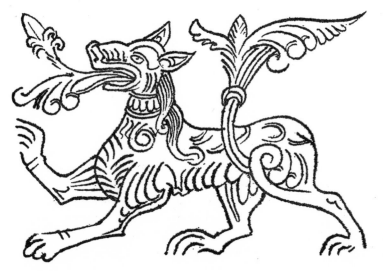

37. Palmette-ornamented animal figure from among the reliefs in the cathedral at Yuryev-Polsky. Mention is often made in the text of the "vegetization" of animal figures in art, and perhaps the finest, monumental examples of the process can be seen in this Russian cathedral. The same occurs, in diminutive form, on the strap end from Benepuszta.

38. Punched ornament of semipalmettes on a Conquest Period bracelet. Illustration 14 shows a similar kind of surface ornamentation with a ribbon from an infinite pattern imitating the meandering of the rinceau as it winds its way across the thin plate bracelet.

in connection with the flat-leaved rinceaux, that the rhythmic sequence of animal heads may turn into ornament of a plant character through constant repetition. Nevertheless, the dominance of the palmette in the eighth to tenth centuries in the area north of the Arab world may have had other reasons than mere repetition or a mere simplification or "rinceauization" of patterns. In view of the vast extension of the Islam world at the time and the strong Mohammedan stratum living in Hungary (for Turks, Moslims, and Jews went to the Prague Fair from Hungary in the middle of the tenth century), we may recall a Mohammedan legend: "It is said that one of the animal-painters complained that he could not continue his art if he were allowed to paint nothing but plant patterns. Ibn Abbas answered him thus: 'Cut off the head of the animals to damp the light in their eyes and make the many heads resemble flowers.'" It is as if the Mohammedan sage were speaking about the strap end of Benepuszta or the openwork temporal disks of the women. It might be as appropriate to mention here the observations made by Fettich too, who, in connection with St. Stephen's sword, wrote of the vegetation motifs of northern ornament.

We have already mentioned that the finest piece of goldsmith and silversmith work of the Conquest Period is the saber kept in Vienna among the insignia of the Holy Roman Empire. On its mountings—the division of which is reminiscent of Caucasian parallels—we find an inventive maze of ribbon ornament and palmettes, and the copper inlay on the blade, as we have mentioned, shows fighting animals changed into palmettes. The gold mountings of the saber were made in the same workshop as the purse plates, leaving no room for doubt that it was originally a Hungarian prince's sword. According to German tradition, Charlemagne is supposed to have received it from Harun al-Rashid. The saber, however, is of a later date. This fact refutes the other assumption that states it came into Charlemagne's possession from the Avar loot.

Just as the saber is preserved today among the coronation insignia of the emperors of the Holy Roman Empire, so it was once a much valued part of the treasury of the House of Árpád. It was thought at the time that it had been Attila's sword, as we know from the chronicle of the monk Lambertus of Herzfeld, which, in the year 1071, records: "Luitpold of Merseburg fell from his horse so awkwardly that he died on the spot, for he fell upon his sword." The chronicler says that this fatal sword was once possessed by King Attila, and that the Queen of the Hungarians, Salomon's mother, gave it later to the Bavarian Prince Otto as a token of gratitude for having helped her son in his struggle for the throne. Lambertus then repeats Jordanes' story, according to which the sword, sticking out of the ground, wounded the leg of a cow. The cowherd who found it took it to Attila, who considered the

145

sword to be a symbol of his dominion of the world. The historical accuracy of this belief is not relevant in our discussion. The point is that the House of Árpád traditionally considered itself descended from Attila. If anywhere, we might expect that the representation of the Turul saga or some totemistic legend would occur on this particular sword, but all we find on it are two beasts changed into palmettes in a hidden corner of the copper inlay of the fuller. Otherwise, a masterly composition of palmettes and ribbon interlace ornament covers the curved surfaces of the hilt, crosspiece, and scabbard mounting. This design can be no more coincidental than the palmette-ornamented mountings found by the hundred in the graves of the first Hungarian invaders. It is beyond question therefore that Árpád's Hungarians, especially the Árpád family itself, no longer believed in the sagas of the animal ancestors and avoided the representation of animals for some religious reason.

There are other indications that the culture of Árpád's Hungarians had long transcended close clannish and tribal ties. Whereas with the rinceau-gryphon group the number of belt mountings and pendants denoted the wearer's rank and clan, Árpád's Hungarians could buy their belts at markets—leather belts on which the numerous mountings, melting into bunches of palmettes, practically covered the entire belt. These mountings can be found east of Hungary, in the territories of other peoples as well, which means the Bulgarian and Hungarian goldsmiths and silversmiths worked for the market and also visited foreign fairs.

There is an apparent contradiction between our previous remark about the loosening of tribal ties and the fact that the members of the leading joint families of the Árpáds buried their dead according to strict tribal customs. There is no contradiction, however, inasmuch as the joint family, bound by blood ties and economic concerns, still existed until a few decades ago in more remote villages. The many changes that occurred in society over a thousand years could not affect the resilience of its structure. Moreover, we must also remember that funeral customs are very durable and persist through many generations despite social changes.

178 To revert just briefly to the art of Árpád's Hungarians, it is generally true to say that the women's graves are far richer in horse trappings than the men's graves. The explanation for this lies in the ethnography of the related Turkish peoples; with them the most valuable item of a bride's dowry was her horse trappings. It was also a custom among these peoples to bury with the woman, regardless of how old she was, her one-time dowry, including the horse trappings. In view of this custom, it is striking how different the customs of the ruling classes were from those of the
179 common people, who left neither horses nor dowries in their graves. This is one more proof of the aristocratic nature versus the folk art character of Hungarian palmette art.

The final problem is what became of the Persian Islamic inspired, yet independently developed, art of the conquering Hungarians? For some time it was thought that this art lived on in the carved palmette ornaments of the churches of the first Romanesque Period. Today, although this supposition is open to doubt, it is at least likely that the plant ornament on the stone carvings of these churches must have derived from the obviously palmette-ornamented woven or appliqué rugs which adorned the walls of the churches. The stylistic language was enriched with motifs drawn from foreign sources.

II. IN PRAISE OF CRAFTS

We often make the mistake of forgetting the process by which a work of art comes into being—the material used, the tools used, the method of work followed, and so forth—which all seem secondary to the artist's will, although the finest masterpieces are always an alloy of matter and spirit. The photographs in this book show the diminutive replicas of large-scale works of art made in other materials; and size always leaves its imprint on the form and style.

However, these considerations are only one of the reasons why we shall deal in this chapter with the crafts; the other is that the development of the crafts is parallel to the general development of society and other aspects of a culture. Thus, even if we cannot make inferences from individual archaeological finds as to the society which gave them birth, we may nonetheless surmise whether they reflect a rich intellectual, spiritual atmosphere or a poor and backward ambience. This emotional value of the finds should never be forgotten; otherwise, we would tend to see a past society through the projection of buckles, strap ends, and fibulae.

The Goldsmith's Craft

In the Carpathian Basin, as well as in present-day Hungary, graves of many goldsmiths and silversmiths have been found mostly along the rivers and Roman roads. From these locations we can infer that the craftsmen had their workshops along the network of roads or at road crossings.

For the most part, cast bronze dies for impressing patterns, Byzantine weights, scales, punches, and other tools were found in the goldsmiths' and silversmiths' graves. This means that neither the Germanic tribes nor the Avars believed any longer in the "heavenly art" of the smiths and their forges, a craft which once assured privileged position for the *tarkhans*, the "smith kings." The tribes had outgrown the world of magic.

74

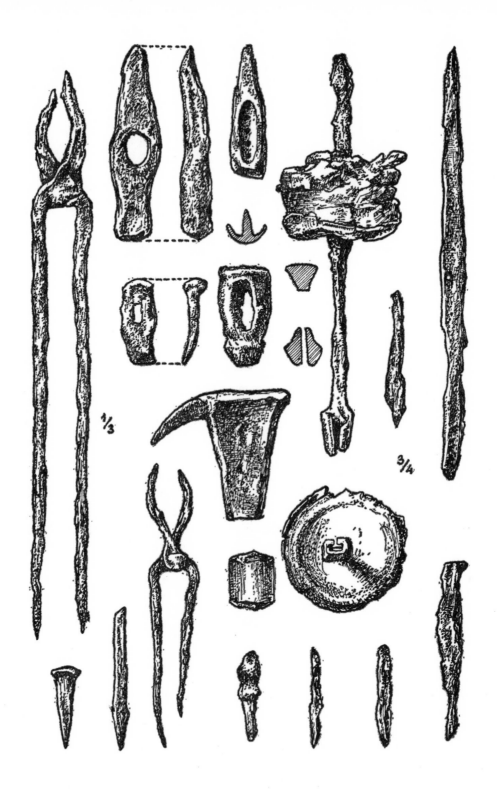

39. Details of a goldsmith's grave in the Gepid Avar cemetery at Mezőbánd. The goldsmith took his whole work-shop equipment and part of his goods with him into the grave, obviously with a view of continuing his trade in the other world.

75

We will look first at the grave of an Avar craftsman whose stock of tools was richer than that of his Germanic colleague. The grave was found at Kunszentmárton, along the Tisza River, but unfortunately it was not excavated by an archaeologist. Many things in it must have been lost, mainly iron objects. More than forty dies 83–84 were found in the grave, but obviously many others were missing. Among the finds were dies for belt mountings for eight kinds of belts and for large and small strap ends. In the patterns of these belts and strap ends is an intermingling of Byzantine and Avar styles and the Germanic Animal Style II. In addition to the stamp dies of the belt mounting, the dies of at least three sorts of trappings and a pyramid-shaped earring were found. Precision scales with two arms and nine Byzantine weights of glass and metal also belong to the finds. The existence of the scales proves that these craftsmen worked with precious metals, too, since the bronze obviously did not have to be weighed. The following tools of this particular goldsmith and silversmith have survived: punches, hammers, pliers, blowpipes for soldering, and fine and coarse grinding stones. To all intents and purposes the whole workshop equipment and accompanying wares were buried with the dead. It seems that the goldsmith was also an armorer, since 220 forged armor plates, sewn onto a coarse linen shirt; a sword; and a spearhead were found in his grave. Clearly, they were not part of his own accoutrement but belonged to his stock, his "shop." That is to say, the goldsmith took with him his entire stock of samples, in fact, the equipment of his workshop into his grave. Why then should survivors have buried all this valuable equipment with him? He was buried in the cemetery of the community in which he had worked. The members of the community were apparently following an unwritten custom when they made sure that they and those coming to the market would reap the benefit of the work of this prominent goldsmith in the other world.

The next grave we shall discuss is that of the Gepid goldsmith and silversmith found in the cemetery of Mezőbánd. The cemetery already existed in Early Avar times, so it may be dated to the end of the sixth century. The cemetery was excavated in an exemplary way in the 1910s by István Kovács, one of the greatest Hungarian archaeologists. The community goldsmith rested in Grave 10 of a cemetery consisting of 187 graves. The grave was the richest in the whole cemetery, although sexton beetles and thieves had disturbed the body. Illustration 39 gives us a better idea of the variety and details of the finds; other items in the grave will only be mentioned briefly. The illustrations will be instructive because the tools found in the grave of the Germanic goldsmith, as it were, supplement those of the Avar craftsman. In the illustration, among the tools placed at the feet of the body are the tongs, 45 cm long, which lifted the red-hot iron out of the fire and held it in place on the anvil under the hammer. There was a pair of smaller tongs, too, used for forging arrowheads and other instruments. A pinking iron, a sturdy cold-chisel, and a riveter with five holes are also shown. The latter may have served also for wire drawing. Our attention is drawn by two hammers, an iron anvil, and a boring mechanism with a balance wheel. With this mechanism the concentric rings on bone and bronze objects were made; used transversally, the mechanism could be turned into a lathe.

Among the wares of the various smiths are a banded iron helmet, strap ends, buckles, and spearheads. Waste and filings, which the smith was supposed to take with him for melting in his heavenly workshop, were also thrown in. With meticulous care, pitch was also added to the set of instruments, so that the dead man would 82
have the material with which to carry out his work.

40. How the pseudobuckles of Tépe were made. The work process is interesting because the same techniques were used to turn out cheaper pieces as were used for the more expensive pieces except that the last phases were left out. Thus, although the same work process was evidently followed, there is a world of difference between the two sorts of finished products.

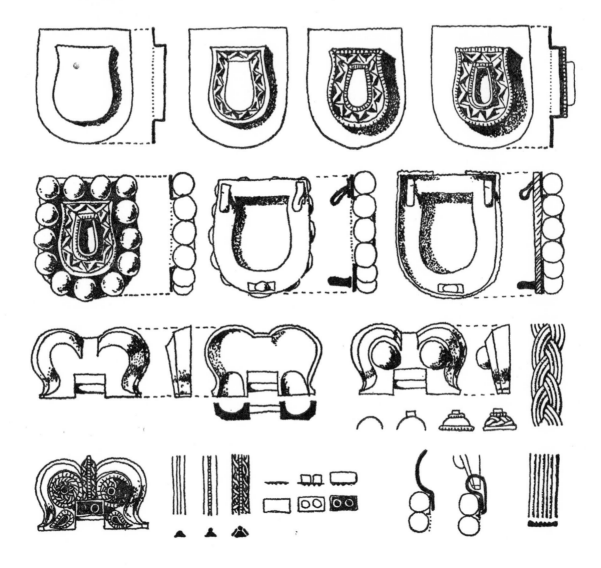

If we could divide the number of the cemeteries excavated from that period by the number of the goldsmiths' and silversmiths' graves, we would have some kind of statistical data to show us how great an area the workshops supplied. We know for certain that there was not a blacksmith or goldsmith in every village.

The tools in the goldsmiths' and silversmiths' graves betray much about their methods of work, but analyzing a single product may be even more informative. In the following we shall dissect a princely piece from a princely workshop, the pseudobuckle of Tépe, to find out how and with what tools it was made. By looking at the design, anyone can read from it the work process used, and I will only summarize the final result: the craftsman had at least three dies of different kinds

86

(for the buckle plate, the semispherical patterns, and the grooved patterns) and at least ten dies (two for the repoussé bands, four *organaria* for the engrailed wires, two for the obliquely hatched band, two for the buckle loop, and one for the broad, fluted band). He must also have had a complete set of forge equipment with anvils, hammers, tongs, melting furnace, wire drawer, and other tools. With all this equipment, the making of a pseudobuckle involved twenty-seven to thirty phases of work.

If we compare the complicated process used by the goldsmith with the few minutes it took to make a pressed belt mounting, the difference between the work of a goldsmith and silversmith and reproduction is evident. Of course, this difference does not mean that the two kinds of work were done by two different men, because a goldsmith worked both for the "market" and for individuals. We must suppose that the *khagan's* court and the courts of the chieftains had special goldsmiths and silversmiths. The pseudobuckle of Tépe must have been made in the *khagan's* workshop.

A goldsmith's technique has no "national peculiarities," inasmuch as gold melts at the same temperature everywhere and the punching iron can conceivably be used only in one way. The various procedures are defined by the material, the experience, and the finished product to be attained, and the techniques were the same in the Crimea as in Spain. For this reason this chapter on crafts is not divided into peoples but is an overall summary of the development of the crafts that survived from antiquity.

There were workshops in which craftsmen worked for Germans, Huns, Bulgarians, and Avars alike; in fact, their descendants worked for the conquering Hungarians too. Although work was performed in these workshops in the same way as in the western workshops, the difference was that the goldsmiths and silversmiths of the Migration Period were not monks, as were their fellow craftsmen working in the Western monasteries. The Presbyter Theophylus, who at the end of the tenth century collected and summarized the knowledge he could learn from the goldsmiths and silversmiths of the Mediterranean area, was likewise a monk. The majority of the goldsmiths of the Migration Period must have learned the traditions of antiquity in the Byzantine workshops of the northern shores of the Black Sea. And yet it seems there were no itinerant Byzantine goldsmiths, for they would have been buried in the Christian way. There are many graves indicating Christian customs, but not a single one of these is of a goldsmith.

For the time being we cannot answer the question of whether Hungarian goldsmiths and silversmiths worked alone or whether there was a kind of division of labor among them of the kind Pliny described when he wrote about the Roman workshops where casting, incising, and other work processes had special masters. In the goldsmiths' and silversmiths' graves no casting pot has been found, which suggests that casting was a special job. It will be appropriate therefore to have a quick look at the methods of work handed down by the goldsmiths of antiquity.

Punching

Punching was used in antiquity partly for filling in the background with patterned punches, and partly for stamps *(opus punctile* and *opus ductile)*. We find the punched background among all the peoples of the Migration Period, but stamped patterns found in Hungary are mostly characteristic of Germanic goldsmith work.

166

78

Chasing and Pressblech

169
82–84 If an individual piece is worked, on which chasing is done with punches and hammers, it is called chasing, whereas, if the same work is done in a series, hammered out in a pattern, it is called pressblech or repoussé work. Chasing itself has two varieties: either the plate is worked from behind and in front only the drawing is given a finish (as on the Hungarian purse plates), or the base is hammered from the front backward to create the relief (as in the Nagyszentmiklós treasure). Pressblech also has two varieties: either the thin metal sheet is hammered onto the negative through lead—in which case the design of all sheets directly touching the pattern will be sharp—or the sheets are hammered onto a positive pattern, whereby the design on the outside of the plate will be rather vague. All the matrices of the Avar Period are positive patterns, as they were everywhere on the steppe from the Scythian Period on. Late Roman-Byzantine dies, however, are negative, giving a sharper design.

A stiffening material called *tenax*, made of a mixture of wax and powdered tile or plaster, was also used in classical times for strengthening the thin, pressed plates. The procedure was used in the Carpathian Basin, particularly in the Avar Period, but the thin plate was often strengthened by another lamella of cheap material pressed under it.

Soldering

66 Although perfectly soldered pieces have been found from the Migration Period, we have never found any trace of soldering material. It seems they used a soldering process without solder of the kind experimentally worked out by F. Stanger after he had analyzed goldsmith products of classical times during his granulation tests. The procedure is briefly this: metal globules heated for a while under melting-point temperatures can be soldered without any binding agent. Certainly the goldsmiths and silversmiths of the Migration Period (except the Late Avars and Hungarians) were fully acquainted with the techniques of granulation.

Granulation

28–29

The German and Avar goldsmiths, in the antique fashion, heated pieces of wire cut into tiny particles in a nest of charcoal or ashes until they were red hot, when, shrinking to the smallest surface, they turned into tiny, perfectly shaped spheres. The soldering process has already been described.

75 Filigree

This noble technique flourished in the Early Migration Period. The pierced filigree (*à jour*) technique was also known, with which the large basket-shaped earrings found in the vicinity of Keszthely were made.

Niello

Niello work occurred in the Veszkény and Benepuszta finds. This technique is a
Mediterranean inheritance sometimes incorrectly called "black enamel" because with
its polished surface it is indeed related to enamel but the material is different. There
is scarcely any difference between the recipes given by Pliny and Theophilus. The
former prescribed three parts of sulphur and two parts of copper to three parts of
silver; the latter used sulphur at discretion, two parts of copper, and one part of
lead to four parts of silver. The molten niello, subsequently crushed to powder, was
melted into the engraved design or forged as a thread into the thin linear design and
polished. Because of its linear clarity, niello was popular during the Middle Ages.
In the Migration Period it was used all over Europe. The finest niellos were made
in Byzantium.

53
180–181

Silver Inlay

Niello gives a dark design against a light background; silver incrustation conversely
gives clear lines on a dark base. The design was undercut in the metal in silver inlay
work, too, then a heated filament of silver was hammered into the grooves and
polished. In the Avar Period mainly the Bavarians who settled in Hungary used silver
incrustation, but later the goldsmiths and silversmiths of the Magyar Conquest
Period used it.

178

51–52

Stone and Glass Inlay

The skill and refined taste of the goldsmiths and silversmiths of the Early Migration
Period are best seen in this kind of inlay work. From the Late Avar Period on, the
technique was rarely used. The cells were built high so that the surface was clearly
divided into light and shade, and the bases of the cells were filled with *tenax* to
prevent the tiny, thin, garnet slabs from sinking into it. To keep the color of the
tenax from blurring the brilliance of the garnet, a gold lamella was placed under the
garnet; to make the lamella reflect diffused light, its surface was hatched and slit, or
disintegrated, into tiny "crystals" with texture stamps, and thus an increased play of
light was achieved. The Germanic goldsmiths divided the gold surface with a series
of closely placed cells, whereas the Hun goldsmiths seem to have scattered the cells
on the surface at random. This practice is often simply called "polychrome," as though
the colors were the most important requirement, which apparently they were not.
The belief in the protective, salubrious, antitoxic effect of precious stones still persisted
from antiquity to the Middle Ages, which means that it must have affected the
peoples of the Migration Period as well. The polished glitter enhanced the spiritual
value of precious stones. We know the medieval *artifex* practically "dished up" the
beauty of the material, trying to match his presentation of the material with the beauty
of the stone. A Basilian monk of Calabria wrote of the Cappella Palatina of Palermo:
"The marble mosaic of the floor looks like a flowery meadow, but while the flowers
fade, this floor will last for ever." The polishing of stones in the Middle Ages created
flawless brilliance, directly invoking the neoplatonic mysticism of light. In what form

22

27

this practice existed in the Migration Period we have no way of knowing, but that the people did not value rock crystal, onyx, almandine, garnet, amber, and other stones merely for their color is obvious. Of the colors, only red had any particular significance; this color was the color of the Byzantine emperors and rulers of the Migration Period. In the cemeteries of the Avar common people red beads or red earrings are never found.

Enamel

27 The goldsmiths of the Migration Period were hardly acquainted with enamel, but we find it in the second Szilágysomlyó find and on the vessel at St. Maurice d'Agaune, presumably as part of the loot taken from the Avars. In the first example the influence is distinctly Romano-Celtic, in the second, Persian-Sassanid.

Considering only the techniques used in goldwork and silverwork, it is apparent that the arrival of Árpád's Hungarians brought a fresh wind into this world permeated with the traditions of antiquity, the freshness of the western offshoot of Persian Islamic art. The same spirit appeared with Moorish art, and a little later in Sicily.

In the final analysis, the work of the goldsmiths and silversmiths of the Hungarian invaders differed little from that of present-day goldsmiths: they chased the plate from behind on a pitch foundation, then made the design clearer with a punch from the front. Emil Szegedy's clear, enlarged photographs show this technique better than any description. A fine variety of products made in this manner can be seen in the Nagyszentmiklós treasure: there the nape of the body of the jars was hammered back in such a way that the design was left in its original plane. The sharp edges were rounded off, and thus reliefs "projected into plane" were achieved, which are practically nothing but embossed designs.

Before finishing this description of the art of the goldsmiths and silversmiths, a few words should be said about the "hierarchy" of metals. Like precious stones, metals also had a symbolical strength in the following order from most to least: gold, silver, copper, iron. From a modern viewpoint, this is a hierarchy of value, or price. Those versed in the history of philosophy will recognize in it the planet symbols of the Pythagoreans. Another connotation is that gold in early Christian times was the light of heavenly Jerusalem, the immaculate heavenly light. In folktales, the dragon of the Silver Castle is stronger than the dragon of the Copper Castle, but the dragon of the Gold Castle is strongest. The hierarchy in Hungarian folktales is the same as in the Avar cemeteries: the clan is divided into three groups; the belt ornament of the chieftain of the middle group is gilded, that of the right group is plated with silver, that of the left group is bronzed. This hierarchy of rank likewise existed in the Germanic world in the golden fibulae of the princes, the silver fibulae of the nobles, and the bronze fibulae of the common people. What mythical explanation lies behind this hierarchy of metals is not clear, but it was certainly not a mere
65 question of expense.

Bronze Casting

We do not know whether the great bronze casting centers of the Migration Period were controlled by the goldsmiths and silversmiths or whether bronze casting became a separate craft. The bronze casters of this period made some highly complicated products which, from the point of view of the techniques involved, are comparable with the pseudobuckle of Tépe, for example, the Hohenberg find. This fact seems to indicate that bronze casting and the goldsmith's art were in one hand. We cannot draw comprehensive conclusions, however, since the fact that casting pots are missing from the goldsmiths' and silversmiths' graves implies that these craftsmen were not—or at least not in every case—versed in bronze casting as well. However, Benvenuto Cellini, the famous goldsmith and silversmith of the Renaissance, molded and cast in bronze his Perseus himself, and Theophilus makes no distinction in his manual between the art of the goldsmiths and the work of the bronze casters.

The only large-size bronze casts that have been found are from the Hunnish Period, and these are the large crowned cauldrons we have already discussed. They were cast with the aid of piece molds, and their fitting together was not always successful; at times displacements were of more than one centimeter. The fibula heads and panel or pendant patterns were chiseled into the negative of casts consisting of four separate molds. The piece molds could not be removed from the cast, which meant that only one casting was possible. It is clear, particularly from the panel patterns, that the piece molds had to be chiseled or broken off after casting, inasmuch as it was impossible to lift them out of the panels.

These large bronze casts are few and far between among the relics of the Migration Period, and the majority of finds are only a few centimeters in size. Nevertheless, the examination of these small objects produced some interesting data which show that the goldsmiths and silversmiths of the Migration Period not only preserved the skills of antiquity but developed them as well. As this involves an investigation of quite a different order, we must dwell on it at some length.

Mass-production techniques can be used in bronze casting, just as in stamping. Molds carved out of hard materials, or fired, will stand many castings. Such casting molds were used in making the earrings or necklace pendants of the Late Migration Period. These are (without exception) imitations of fine originals made by granulation, filigree, and so forth. Although the making of the originals may have taken days, the process of casting needed only a few minutes. The casts were made with two part molds, and the casting seams were chiseled off. A prerequisite of casts of this kind is that there should be no undercutting on the object, the negative of which is formed on the piece mold, since if there was undercutting the hardened bronze could not be removed from the mold. The mold must be knocked or chiseled off, as was the case with the large bronze cauldrons. Naturally, casts deriving from a single casting mold were all exactly alike, and this is where some interesting details came to light. When most of the mass-produced mountings that seemed exactly identical at first sight (for example, the gryphon or rinceau-ornamented mountings of a belt, pairs of fibulae, or trappings) were examined, it turned out that they did not quite agree with each other, and that the marked divergencies could not be explained away by the bronze

41. Analytical drawing of the Veszkény trappings. The tricks of this trade used at the time can be discerned by examining apparently unimportant details. The "tufts of hair" (upper numbers) and the differing number of folds in the "skirt" (lower numbers) helped us to discover a hitherto unknown casting procedure.

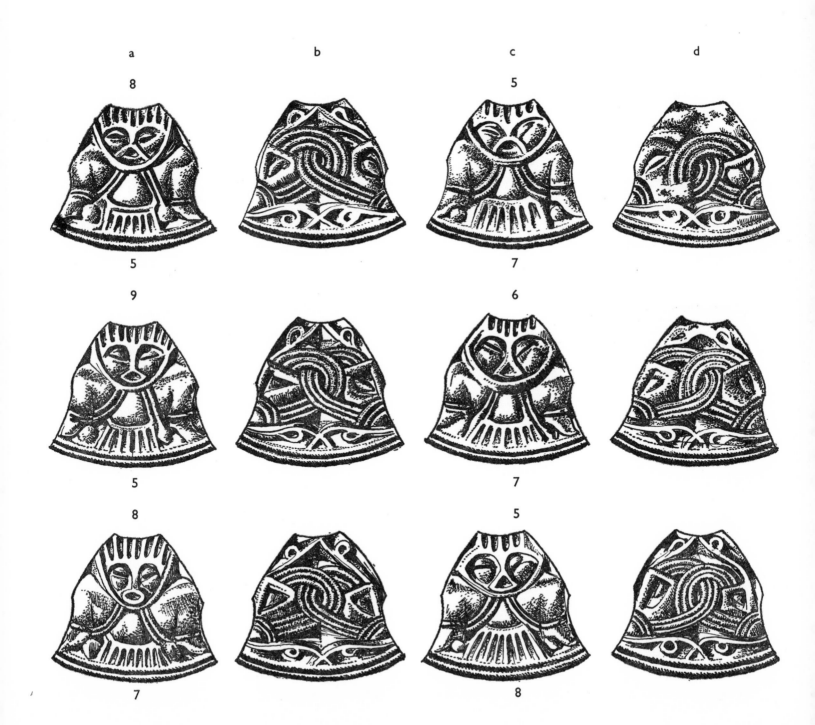

42. Enlarged drawing of a "pair of animals" from Veszkény (two projections of the same animal) and a branding iron.

having filled out one side better than the other. The examination of these seemingly "insignificant" details showed that the Germanic-Avar-Hungarian bronze casters made an important innovation by adopting the *cire perdue* process for the mass production of casts. The *cire perdue* process, the great invention of antiquity, was good only for casting individual copies because the negative had to be knocked off the casts. In order to understand the importance of the innovation, we must briefly recall what we know of the *cire perdue* process.

The large bronze statues of antiquity were first roughly molded from fireproof material, and the dimensions of the model were somewhat smaller than those of the object to be made. The difference depended on the thickness of the cast to be made. Upon this rough mold a layer of wax was applied and finely molded, thus giving the statue its final form. This thin layer of wax was covered by another layer of fireproof material (mostly fire clay or plain clay), and then the outer shell was nailed to the inner body through the layer of wax. The whole mold, having been provided with the necessary casting, airing, and drain channels, was then fired. The heat made the wax melt from between the two fireproof layers, and the bronze was poured into the space left by the wax. When the bronze cooled down, the outer shell was knocked off and the inner layer scraped out, the nails were filed off, and the surface marks polished.

The thickness of the wax, or that of the bronze taking its place, needed much forethought, because fired material shrinks when cooling, and the process of cooling naturally spreads from the surface inward. Thus the outer layer of the cooling mass of bronze shrinks when the inside is still liquid, and consequently, if the cast is too thick, the surface becomes crusty and cracked. The goldsmiths of the Migration Period were well aware of this shrinkage, and they made thin casts; in fact, Hungarian goldsmiths and silversmiths made chill-casts as thin as paper in large numbers.

Three examples will illustrate the knowledge, skill, traditions, and procedures of the goldsmiths of the Migration Period. The first is the Veszkény find, once considered to be Carolingian but now thought to be Lombard; the second is the casting technique of the rinceau-gryphon group; the third is the chill-cast used by the goldsmiths at the time of the Hungarian Conquest.

If we look closely at the drawing of the three four-branched and hemispherical mountings of the Veszkény find and the numbers written above and underneath them marking the number of tufts of hair and folds, we can conclude the following. The mountings on the whole are so similar in pattern, size, and character that there

84

53–55 can be no question of each mounting having been separately molded. Yet each and individual piece shows minor differences when compared with the others. These differences would be impossible if they had come from the same casting mold. The puzzle is enhanced by our finding not even the slightest trace of the master craftsmen ever having used piece molds, although the filed-off traces of the four casting channels can be distinctly seen on the back plate. There are undercuts on the molds of the mountings, so there can be no question of those masters simply having removed the casting mold. The cast holds the mold fast and cannot be detached. These contradictions can be resolved in only one way: the goldsmiths and silversmiths of the Migration Period must have used a process as yet unknown. The gist of the process is the following: The cast pattern was molded in such a way that about one millimeter of wax covered the clay hemisphere. This molded wax mounting was then covered with clay so that the edge of the upper clay layer joined the lower edge, thereby eliminating the necessity of nailing on the mold. Subsequently the clay mold was fired, and the wax melted out of it. These two molds were kept as "matrices." The negative was filled with hot wax, and the back plate was pressed upon it. When the wax grew cold, or was still in a soft state, the wax mold was removed from the negative. During this removal, the wax was always damaged in some way or other, and the damaged pattern had to be corrected. At this phase previously mentioned "insignificant" divergencies came about. After this, the casting proper took place in the way described in the *cire perdue* process. The thin wax sculpture received a new outside shell, then the core was removed and replaced by fresh clay. After drying, the mold and the clay were fired, bronze was poured in the place of the wax, and the covering layer was knocked off the cooled bronze. This process was repeated on every occasion. A great advantage of this procedure is that the complicated pattern of the mountings did not have to be remolded, only repaired, which could be done only on the visible positive. Of course, while repairing the minor damages, nobody cared if there were one more or one less fold or tuft drawn in with the modeling tool.

47 After the experiences gained at the Veszkény find, a comparison with the mountings of the pairs of fibulae showed that in each case similar "insignificant" divergencies existed. They were cast in the same way as the Veszkény find.

We come to the same conclusion after examining the cast rinceau-gryphon mountings. Among the half a dozen mountings of a given belt, no two are exactly alike, although it is an unquestionable fact that a single casting pattern served as
110 a mold for all of them. Again the evidence is that the bronze casters achieved mass casting with an improved variety of the *cire perdue* process.

József Huszka, followed by Fettich and Erdélyi, analyzed the bronze-casting art of the Avars. Despite the many valuable conclusions of these men, they could not solve one of the most difficult questions, that is, the purpose or meaning behind the imprints of fabric quite often found in the bronze of the hollow back plate of Avar castings. These are not pieces of fabric rusted onto the bronze but were pieces of fabric in the casting mold. I will pass over the various hypotheses concerning this phenomenon, as none of them provides a satisfactory solution. Certainly, we do not find the like of this casting technique among the Germanic tribes or in territories connected with Avar bronze casting, for example, in the Scythian-Sarmatian bronzes, or in Byzantium, let alone Coptic art, as a new theory suggests. There seems to be only one parallel to the technique: the gold objects of the "Siberian gold plates" were on the whole cast in the same manner. This similarity is an artistic and

historical indicator of vast importance, especially as regards where to expect rinceau-gryphon and Hellenistic motifs to be preserved. Recently, Erdélyi suggested that the fabric patterns were affixed to the back of the mold to strengthen the thin wooden model. But, if this were so, why did the pattern have to be whittled down to such thinness if subsequently it was strengthened with a piece of fabric? The statement that all mountings of the belt were cast from one wooden model is equally open to criticism, since the few millimeters of divergency between the individual mountings still have to be explained. This theory that the fabric patterns strengthened the mold is mentioned only because it contributed a valuable observation toward an acceptable theory: Erdélyi observed that in a whole series of mountings the pattern of the fabric on the reverse side remained unchanged, that is, the front side changed, but the back side did not. In view of the foregoing cases, it seems that the continually re-molded wax pattern of the front side was always molded on the same fired back plate.

With this technique we come to the "Siberian gold plates," whose numerous mythological and iconographic links with ancient Hungarian sagas of St. Ladislas are discussed in the section on "The Cosmic Duel."

In the recent critical edition about the "Siberian gold finds," S. I. Rudenko, the Nestor of Soviet archaeology, describes in detail the vestiges of fabric found on the reverse of the gold casts and the method of casting used. Rudenko's conclusions, freely interpreted, are that the original models of the gold plates were chiseled 117–118 out of wood or metal. When the model was ready, it was pressed into clay, thereby producing a negative, which was fired. This fired negative was then filled with wax. In this way, however, the wax would have filled the mold to the level of the back plate, and the gold cast would have been solid and heavy. To save precious material and diminish the weight, when the hot wax was poured into the negative, the thickness was reduced in such a way that the superfluous wax was squeezed out of the mold with fabric or a piece of leather spread over it. Thus the imprint of the fabric remained in the thin, cooling layer of wax, and when the back plate was filled with clay, the fabric was copied on this, too. The casting molds of the front and back plates were fired simultaneously, and the wax then melted out of them. While drying, the clay of the back plate shrank more intensively, and along the contours of the gold casts that thus materialized between the two, a fine, inward-turning edge was formed.

a

b

43a–b. *Bracteates* are an important part of Germanic archaeological material, inasmuch as they show how classical motifs changed into Germanic ornament. Detail of the *bracteate* from Várpalota.

Rudenko observed in many cases that the casts were also chased. All this evidence more than solves the question of the fabric imprints in Late Avar-Hungarian bronze casts, refuting at the same time the romantic theories that trace the fabric imprints back to various hypothetical sources, including the Gepids living in Hungary.

It is true that the techniques of goldwork and silverwork know no ethnic boundaries, but a characteristic workshop trick such as the back plate with the fabric pattern is very rare and is all the more convincing as a historic or art-historic factor.

We turn next to the techniques of the Hungarian goldsmiths and silversmiths of the Conquest Period. They were past masters at chill-casting. In this context the results of Emil Szegedy's research, which he was good enough to place at my disposal, may appropriately be quoted.

Judging from a few lucky cases, we can say that the small ornamental disks were not cast individually but were mass produced with the aid of connected casting funnels or pipes. Later the mountings were cut off and the traces of the running pipes were polished away. Under a magnifying glass the molding material can be seen to be of a loose consistency; when poured into the mold, the molten metal tore chunks out of it. Such casting flaws can be discovered elsewhere. The cast surfaces were left rough only very rarely. The surfaces were polished no matter whether they were left ungilded or were covered with gold; obviously, in the latter case a clean surface was indispensable. It was also frequently found that the design of the thin casts was given a finish with punches. There often was a striking resemblance between these bronze casts and pressed products, only the flaws and bulges at the edges showed that their makers were artists in chill-casting. So much for Szegedy's observations. For my part, I would like to add that among the techniques of the Conquest Period, in addition to chill-casting, the *cire perdue* technique, which was discussed in connection with the art of the Avar master craftsmen, is also found. It is strange—and more than mere chance—that the same fine discrepancies should be noticeable, proving that they used the *cire perdue* procedure on animal-ornamented cast disks. It is salutary to remember at this point that animal representation is frequent in Hungarian women's graves, and it may therefore be surmised that the *cire perdue* technique is an Avar-Hungarian survival. This supposition seems to be substantiated by the technical continuity, although technology is not an ethnical factor.

178

The Smiths

The work of the smiths is discussed only insofar as it affects the arts. There are many iron tools in Hungarian graves from the Migration Period, which means that the craft must have been widely practiced. We know of entire villages of smiths from the tenth and eleventh centuries, and we must suppose that prior to this the smithies were not scattered around but operated centrally. With this method of operation, the procurement of raw material became much easier. Eleventh-century iron foundries

136
173

have also been discovered; these could produce only comparatively small iron blocks that were sent to the smithies for processing. Possibly work was divided even within the smithy. The complicated techniques involved in making swords and sabers demanded quite different skills, abilities, and traditions than the forging of stirrups, bridles, and arrowheads. Szegedy, to whom I am indebted for showing me his work

44. Carved saddle ornament on a Hungarian female saddle of the Conquest Period from Soltszentimre. Illustration 38 showed the inventiveness of Hungarian craftsmen in using the palmette motif. Here the form of the saddle gave the craftsman a hard task. The drawing stood out on the white bone only if the background was painted.

on metallography, thinks that the forging of blades and the mounting of swords and sabers took place in a special smithy, inasmuch as the blade could be made more resilient by forging or soldering together several fine layers of steel. Another procedure was to solder a layer of copper between two iron layers.

All this would have little to do with art if it were not for something in the shaping of the sabers that points to the plate tracery and compass masters of the Middle Ages. Béla Pósta made tests with a twelfth-century saber and discovered that the sabersmiths, when planning their saber blades, handled their compasses with a virtuosity that puts Gothic rib profiles and plate tracery to shame. Forging even a plain arrowhead demanded much manual skill because, apart from a perfect symmetry of the form, the weight, too, had to be accurately divided between the two wings of the arrowhead or it could not have been aimed. Splendid ornamental arrows, with an almost Baroque contour, survive from the Avar Period. They must have denoted rank, as they did later in the Middle Ages.

The skills employed by the smiths approached those of the goldsmiths and silversmiths when the latter undertook silver inlay. Although the Bavarian belts with their iron mountings and silver inlay are the work of silversmiths, cutting the outlines of a human or animal body would have caused no difficulties to a master smith either.

Bone Carving

Antlers, shoulder blades, and long bones were used in all kinds of ornamentation. Making belt mountings, staff ends, quiver mountings, pommel ornaments, salt and ointment holders, needle holders, combs, and psalia were welcome tasks for the bone carver, and a number of such bone products and carvings are shown in the pictures of this book. Ethnographical parallels and common sense suggest that the bone

45. Partly on the basis of grave finds, partly by a close examination of the various forms of saddles, particularly the saddles still in use in the East, it has been possible to fully reconstruct the bone-plated saddles of the Conquest Period. The use of bone survives in modern shepherd and ornamental saddles in Hungary.

carvings were painted; either the background was painted to set off the pattern, or the paint was rubbed into the cuts to prevent the lines from melting into the background.

The graves of Avar girls and women often contain finely carved or turned bone tubes, used as needle holders. The needle was pinned into a ribbon dangling from the belt, then the bone cylinder was drawn over it. The bone got stuck on the knot at the end of the ribbon and thus covered the valuable needle. If the owner wanted to use the needle, all she had to do was to draw up the bone cylinder, then let it slide down again by its own weight. We know of two kinds of needle holders: one was carved, the other turned. Among the carved ones, no two are alike, whereas the turned needle holders imitated the *astragalos* row. Just as village lads presented their sweethearts with a distaff or a mallet, so it was the custom in the Avar Period to give the girls carved needle holders. The turned ones were made in the workshop with the aid of a bow-spindled turning lathe. Bone saddle inlays were also made by these craftsmen: on Hungarian shepherd's saddles bone plates carved of shoulder bones and ribs were used until the nineteenth century. A saddle ornamented with bone carvings was found in a grave of the Conquest Period at Soltszentimre. In one variety, the Avar and Hungarian antler-bone bridles were so alike that it almost seems they were the work of the same workshop.

The combs and the bow stays were also carved from polished bone. Although they have no special artistic value, their dainty form betrays the taste of the community that made them. All these objects for everyday use show harmony in their proportions and clear-cut lines.

Pottery

Technically, three processes can be distinguished in the pottery of the Migration Period; the pots handmade from clay "sausages," the vessels made with the aid of the slowly revolving throwing wheel, and the vessels made with heavy, quick-turning wheels. Scholars have rather neglected the pottery of the Migration Period in Hungary, and the attempts made to categorize it abroad (for example, "nomadic pottery," "Danubian type," and so forth) are premature.

So far we know of pottery that came from graves and excavated settlements containing only a few fragments. Mostly drinking vessels were put in the graves, which is why we are not yet acquainted with any cooking pots. Distinctions can be made between funerary vessels fired in improvised, primitive kilns and those fired in fine, large potter's kilns. As regards color, we find among the vessels all colors, ranging from black to light and dark grey, brick red, yellow, down to the patchy surfaces of badly fired pots. The thinness or coarseness of their walls and the sluiced or coarse clay they were made of might be the basis for further classification.

A preliminary measurement of the capacity of the vessels established that they were made to a definite capacity. This classification may be the first step toward

17, 48, 139

46. Stamped patterns on Gepid pottery found in Hungary. The die, like the goldsmith's punch, was the potter's main ornamenting tool. A comparison of all the known motifs used would serve not only to establish the clientele of a given pottery but might also help to clarify the meaning of the various motifs.

establishing their use. Form was not influenced by aesthetic considerations or taste but depended on the mode of use. It is characteristic of the forms used that without exception they were functionally sound: when used for drinking or pouring, the liquid they contained flowed out easily and smoothly.

Several methods of ornamentation were used. In the Germanic Period the surface, especially the shoulder, of the pots was articulated with the geometric play of stamped ornament. A few stamp patterns from the collection of my pupil, Margit Nagy, are given here. I do not think that this variety of stamps derives merely from the inventiveness of the stamp carvers. A comparison with the art of the North African (see Jean Gabus) and Australian hunters and other similar arts shows that the ornaments originate from the tracks of the animals or birds hunted and as such have a definite significance. The Germanic tribes stamped not only the body of the vessels; other similar stamped ornaments are found on metal objects, for example, in the

47. Presumed pattern on a jug found in Grave 130 in the Avar cemetery at Szeged-Kundomb. Unfortunately, the black and white painting was done after firing, and, by the time the jug reached the museum, the paint was peeling off. In the mid-1930s Fettich and I had made drawings of the design, and the paint was then still visible. We noticed that a row of white circles on the rows of disks resembled a string of beads. This design is suggestive of the Persian applied art. Several similarly painted vessels have been found among the tribes of the southern Avar territory.

Veszkény find. Research is needed to discover whether or not these samples of stamps handed down through the centuries by earlier cultures were signs of clans or were shaped after animal tracks. It is generally known that some Soviet archaeologists (Foss, Briusov, Chernetsov) consider neolithic vessel ornaments as signs of clans. These questions—which we will not even attempt to solve now—bring us to the problem of base stamps (found in Hungary from the Avar Period) which are the late imitations of similar marks used in late classical times.

Another popular ceramic ornament of the Avar Period is burnished ornament, which occurs on black and grey vessels alike: the wavy, zigzagging, and undulating bundles of lines seem to glitter on the porous body of the pots. It was thought once that the undulating lines indicated the existence of Slavic tribes in the region; today it seems certain that the undulating lines primarily denote the contents (liquid) of the vessel and that vessels of this type occur everywhere from Sicily to eastern Turkestan, so their use cannot be restricted to one people alone.

This series of vessels—denoting the period and not the people—includes the brick red and pink vessels, which were made on a fast potter's wheel and represent an Eastern tradition in the Carpathian Basin. They were sometimes painted. It is very difficult to explain what the paint meant, because the ravages of time have dimmed or washed the ornament off. Nevertheless, vague as it is, the decoration is full of echoes of Persian textile art. One of the pictures presented here was discovered during excavations made by Katalin Nagy, a former pupil of mine.

These were, of course, ornamental vessels, and even the flasks were not for everyday use. I cannot accept the explanation that the poor could not afford to buy the expensive metal vessel, and therefore, the imitations in clay were made for them. Indeed, it came to this only rarely; the explanation for the resemblance in form is that both the metal and clay vessels served the same purpose.

On Glass

In this connection two things should be mentioned briefly. First, a few good drinking glasses and similar cups were brought to Hungary from the Rhine and from Byzantium. Recently, a Byzantine gold cup from the fifth century was found in the vicinity of Kecskemét. These do not have much to do with local craft and art, rather, they flatter the taste and fastidiousness of the buyers as well as the resilience of trade.

The second point is more interesting. Sometimes we found pieces of colored Roman glass in purses deriving from Avar graves, including in one case mosaic squares of colored glass. Until now, not much attention has been devoted to these "trinkets," in fact, we looked down upon the "barbarians" who seem to have been glad to find and collect colored pieces of glass. However, several considerations give these pieces of glass a greater importance than was previously thought. I had an opportunity to inspect in the Ethnographical Museum of Neuchâtel Professor Jean Gabus's North African collection, the explanatory drawings of Hans Erni, and 76–77 accompanying scholarly literature. The North African beads are almost exact replicas of the bossed beads, made of glass paste, of the Early Avar and previous

periods. The makers of these beads were simple, uneducated North African women, and their "workshop" was astoundingly primitive—a sardine box and a metal needle the size of a knitting needle. After buying the powdered glass in the shop, they shape, roll, and pierce it with surprising skill, trickling and pouring paste of a different color upon the mass. Dry manure is used for fuel to raise the glass paste to a white heat. All this is done by one person without any help. Since the North African women made beads, it is quite plausible that the women of the Migration Period also would have made such beads, and that the pieces of glass and tesserae were raw material used for pounding. The fragments of glass occasionally found in the graves of men must have been used, as the wear and tear shows, for polishing or scraping.

The question of the flat, droplike, so called "melon-seed-shaped beads" (from the Late Avar or Hungarian Period?) still awaits a solution. These beads must have been heated to incandescence because the surface is shiny. In the middle of most of them there was a tiny tube, rolled from cigarette-paper-thin bronze, for the thread. They were made, I think, in the following way: the copper sheet, hammered thin, was twisted upon the wire, after which liquid drops of hot glass were poured on it at equal distances. On the wire, placed in a vertical position, the glass mass, not yet cooled down, began to lengthen and take the shape of an oblong drop. The drops were then pressed together a little and left to cool. The beads were then cut into individual pieces. This process, involving the bronze tube, the high temperature, and so forth, certainly required a workshop and a master craftsman.

So much for the Migration Period glass industry. It is a subject which needs a special monograph devoted to it.

We have surveyed all too briefly a few crafts that might be called artistic, and we have passed over crafts in which the ornamenting was done by other artists (for example, the saddler's trade). We have seen that our master craftsmen worked on the level of the period and even developed the *cire perdue* process. It needs no emphasizing that the knowledge of a trade or craft knows no frontiers or ethnic or linguistic barriers but spans vast distances in time and space. Hence the homogeneity of such crafts even when a thousand kilometers separate them.

III. MYTHOLOGY

The title may suggest more than we wish to convey, since it implies that the peoples of the Migration Period had a developed cosmology which, like the fixed creeds and organized religions or the earlier Greek mythology, classified the phenomena of existence and the world and pervaded everything from the greatest to the smallest. But that is exactly of what we are not so sure. We do not know whether such a cosmology obtained among certain peoples of the Migration Period, and whether they lived in a cosmos or only answered certain questions which arose in their lives as best they could, ignoring the rest, and not even observing that there might be other things besides those which affected their everyday lives. The reader should not expect therefore a comprehensive mythology in this chapter but only details, which despite their fragmentary nature, will illustrate the ancient Eurasian culture from which they sprang. We shall present five topics in this context, and although we shall seek any possible points of contact between them, we shall not attempt to equate them or place them in a common system.

The Two Hunting Brothers

Since Alföldi's study of the subject appeared nearly forty years ago, the animal fights of the Scythian and Migration Period styles are usually explained as the fight of totemistic ancestors. Alföldi's findings were expanded by the interpretations of later excavations and are now generally accepted, although two very essential objections can be made. The first is that the rug of Noin-Ula, upon which Alföldi founded his arguments, does not represent what he thought it did. It is not a wolverine, that is, the ancestor of the Huns, attacking a fleeing stag; rather, it is an eagle. For my part, I think this scene represents not fighting animals but the mating of a stag and an eagle, or more precisely, of the Hungarian mythical stag and Turul eagle of the saga. However, that discrepancy does not affect the essence of Alföldi's conclusions. The

other objection, however, is more serious. The peoples of Siberia have many beautiful sagas about the fights of their animal ancestors, but they never depict or represent these in any way. Thanks to S. V. Ivanov's monumental work of classification, we are well acquainted with the folk art of the peoples of Siberia, but in the several hundred pictures there is not a single trace of ancestors appearing in a fight as animals. It would appear that the picture of the two beasts of prey attacking an ungulate came

119–131 into the Scythian art from Greece or Mesopotamia. However, its presence is a fact, and the animal fight motif lived on tenaciously for over a thousand years on the steppe in the region of Perm, in Siberia, and in Avar art. From those sources it passed into the symbolic language of Christian art. Just to quote an example of the latter: on one of the Venetian mosaics of the Romanesque period a leopard and a lion (the Sins) are attacking from both sides the soul thirsting for Christianity (the Stag). This interpretation suggests right from the start that not only the picture or scene was taken over but its symbolism as well—not the scene as a whole was Christianized, but its unique symbolism.

It is, in fact, not motifs that "wander" but the unrepresented content behind the motif. This underlying meaning and not some "effect" that we might imagine explains and keeps alive the "image types" borrowed from alien peoples. The truth of the matter therefore must be the following: although the sagas of zoomorphic heroes and ancestors are now no longer represented in pictures, a "golden age" did exist in the life of the peoples of the steppe, when, for over a thousand years, zoomorphic representation gained ground. Why this tradition was so and what may have been the reason for it call for a special study.

After these preliminary remarks we may turn to the animal fights represented on the strap ends found in the graves of Late Avar/Early Hungarian chieftains. This scene is the direct descendant of the Greek-Scythian motif, and it turns up in several varieties—a fleeing stag, deer, or steer collapsing under the claws of the gryphons attacking it from behind. Alföldi interpreted this representation, too, as a saga of the tribal ancestry, and it probably represents the origin saga of the Hungarian people.

Simon Kézai, the cleric and chronicler of Ladislas IV (the Cuman), King of Hungary from 1272 to 1290, writing about the beginnings of Hungarian history, goes as far back as the Bible and makes Menroth the Giant, Japheth's progeny, the forefather of the Hungarians. Then, turning to the question of origin, he writes: "Hunor and Magyar were the first-born of Menroth by Eneth. They lived their nomadic life in tents separated from that of their father. It happened that one day they had gone out hunting, and in a deserted place there appeared before them a stag, which they followed into the Maeotic marshes as it fled before them. It disappeared again, and though they sought it for a long time, they could find it nowhere. Having at last searched the marshes thoroughly, they found that the place was suited for breeding herds. Therefore they returned to their father and having been granted his permission they went with all their goods and chattels to the Maeotic marshes, there to dwell and raise their herds... Issuing forth in the sixth year (of their stay in the Maeotis), they happened in a deserted place to come upon the wives and sons of the sons of Belar, without any of their menfolk... Quickly they fell upon them and carried them off with all their belongings to the Maeotic marshes... It happened also in that skirmish that besides the boys there were seized two daughters of Dula, ruler of the Alans, of whom one was taken to wife by Hunor and the other by Magyar; and from these women have sprung all the Huns."

48. Fighting beasts on a Kul-Oba vase made by Greek craftsmen for the Scythians. This kind of fighting beast scene undoubtedly came to the Scythians from the south, and there can be no doubt that it was linked to some tribal saga of the Hunor and Magyar type and survived on the steppe for a thousand years.

49. Fighting beasts from an Avar strap end. The hoofed animal between the fighting beasts of prey has been outlined in dots to mark him off from the rest of the composition: the gryphon (?) on the left is mauling the belly of the roe, while that on the right is thrusting its beak into the roe's withers.

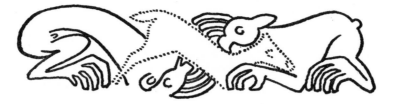

The writer of the *Illuminated Chronicle*, during the reign of Louis the Great (1342 to 1382), added to the saga that the women were just celebrating the Feast of the Tuba when the two brothers abducted them.

The primitive myths, sagas, legends, and tales speak of the adventures of the Two Brothers all over the world, from Cain and Abel, or Romulus and Remus, to the two sons of the King of the Uigurs, Tartar and Mogol, the ancestors of the Tartars and Mongolians. The sagas of the Two Brothers are intertwined with the sagas of the tribal origin, the Scythians, Huns, Bulgarians, Avars, and Khazars all having similar sagas about their prehistory. Even the people living along the Ob River, who are linguistically related to the Hungarians, have similar sagas relating to their origin. In Oriental sagas the Two Brothers are always the ancestors of two peoples springing from one stock, or else the two heroes are given the two names of one people. The Hungarians likewise have two names, "Magyar," as they call themselves, and "Hungarian" (*Ungar, Hungarus, Ongarese, Ungur, Venger,* etc.), as their neighbors called them, the term being nothing but a distorted form of the word Ugor. The name Hunor also comes from this word and does not mean Hun. Thus the saga of the origin of the Hungarians speaks of two ancestors, and here I must refer again to my theory that the Hungarian Conquest took place in two waves. Even ancient Russian chronicles mention both White Ugors (of the Avar Period) and Black Ugors (Árpád's Magyars).

IX. Pseudobuckle from a prince's grave at Bócsa. MNM

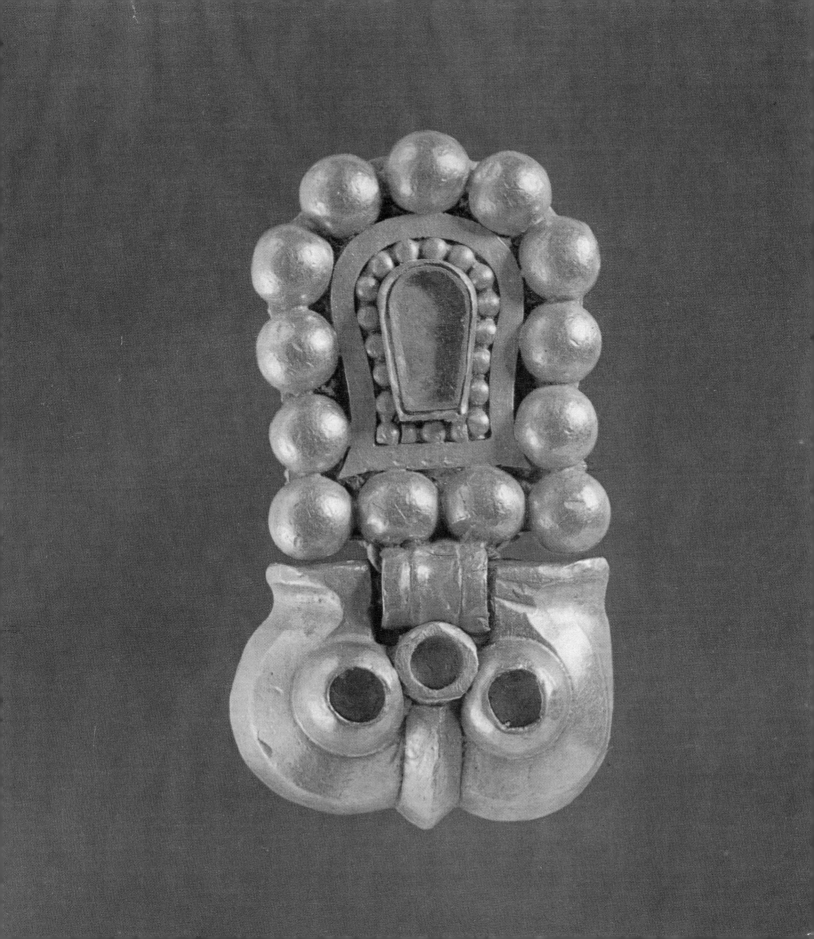

Before continuing with the theme of the two brothers and the stag, mention must be made of a Persian tale in which the primitive form of the Hungarian saga can be detected: "Prince Rusvanshad, son of the Chinese Emperor, while hunting in the forest, espied a wondrous stag whose hair was blue, whose eyes were like ruby, and whose hoofs shone like pure gold. This stag sped on before him and chase as he would, he could never bring it down. At last the stag jumped into a small lake and vanished. Rusvanshad, who fell asleep, was awakened later by gay music and rippling laughter. Following the voices, he soon found himself in a gorgeous marble palace where, surrounded by a dozen maidens, he caught sight of a maid of wondrous beauty seated upon a throne. To his question who she was she answered, 'I am only a gentle doe, my name is Shehristani. I am the Queen of Fairyland.' After several trials they got married, and went through many other adventures..." The further course of their life does not interest us now.

Not only this tale but a whole series of such tales proves that the stag or doe in the saga of the mythical stag was a girl who later became the ancestress of her people. Originally only one hunter (ancestor) chased her and married her. The Two Brothers do not seem to fit into this tale. The story became dual when it was woven into the many varieties of the saga of the two brothers, when two branches or two tribes of a people united, or when the institution of a dual kingdom was consolidated. We cannot tell which process led to the intermingling of the sagas of the two brothers and the mythical stag. One thing is certain, namely, it must have been much later when the chronicler described the story, inasmuch as he no longer understood what it was really about: for him, the "maid transformed into a doe" was no longer a primeval mother, only a hunter's decoy.

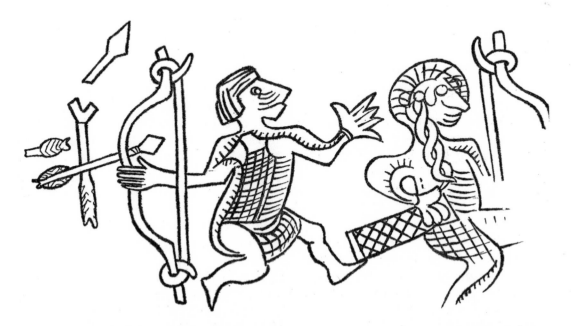

50. Detail of the Chernigov drinking horn. The reflex bow and form of the arrows so characteristic of Árpád's Hungarians is clearly visible in this drawing made from the original. The two distinct hair styles, that is, loose and plaited, are also unmistakable.

X. Late Avar painted pottery from the cemetery at Székkutas. Hódmezővásárhely, Tornyai János Museum

Among archaeological finds the two brothers are represented in both human and animal forms; there is also the stag (an ancient European tradition which later, in the Christian Hubertus Saga, became the symbol of Christ), and the picture of the doe representing the primeval mother. Two examples will be discussed here; the first is about one of the adventures the two hunting brothers undergo (depicted in Hungarian Romanesque art), the other is a representation of the origin saga on the belt strap ends of Late Avar-Early Hungarian chieftains.

The first then is the miraculous hunt, as it survives on the drinking horn of Chernigov. Before analyzing it, let me mention that according to a recent interpretation, one of the hunters is a girl because her hair is plaited. But then this particular hunter has a shaven head, leaving only his pigtail dangling, and in his hand he holds a Hungarian bow and a Hungarian quiver hangs from his waist. It is moreover definitely known that the noblemen of the Hungarian Conquest Period, and indeed some of the common people, shaved their heads and plaited their long hair into a pigtail. There can thus be no question here of a girl; it is a man, a hunter, which excludes the possibility of the scene being related to old Slavic tales. All the details are in accord with the graves of the Magyar invaders. In addition to the bow and the quiver, the shape of the arrowheads—the characteristic swallow-tailed arrows—relate to the two hunting brothers. This hunt was not a common, everyday hunt. The arrows of the hunters failed to hit the magic animals and turned instead crosswise in midair and broke. The animals were thus invulnerable, as was the mythical stag or St. Ladislas in his combat with the Cuman (see the section on "The Cosmic Duel").

The miraculous hunting scene repeats itself, apparently already in a Christian guise, on the find at Kisbény on the Garam River: here the hunter holds a bow in his hand and a saber in the other, which suggests that he had to fight an unusual beast because a hunter with a bow does not carry a saber. There is a small detail in these two wholly separate representations which proves the identity of the two: in the first the way the two hunters arrange their hair is different, in the second, their dress. The difference in the hair, like the difference in clothing, always meant a difference in descent, rank, and tribe.

And now a few words about the master craftsman who made the drinking horn of Chernigov. The drinking horn, together with its palmette-ornamented pair, was found in the grave of a Ruthenian chieftain. Fettich observed that despite the fact that the two representations were created in the borderland of Hungary, they both have a feature reminiscent of Norse art. The pairs of animals also indicate Norse influence, as on St. Stephen's saber. The two drinking horns of Chernigov were either made by a Hungarian-trained Norse master or by a Hungarian master working for Norsemen. The saga of the miraculous hunt existed also in the North, and it is represented on one of the Oseberg carvings. A comparison with the Oseberg carving tips the scales in favor of a Hungarian origin, especially as the Kiev saber was also made by a Hungarian master.

To return to the zoomorphic representation of the two brothers on the Avar-Hungarian strap ends: on the strap ends two gryphons are shown mauling a stag or doe or some other hoofed animal. The alternative definitions of the animal are quite immaterial from a stylistic point of view, but in tribal societies the difference was one of basic importance. In the eyes of the tribesmen it was essential to know whether their ancestors were stags, steers, or other beasts. It may seem surprising

to talk of a stag with antlers and not of a doe. The problem is rather complicated. We succeeded in demonstrating, partly by expanding on Alföldi's theories, that on sacral representations even the antlered stag is in fact a cow wearing an antlered mask, inasmuch as archaeological finds from the fourth millennium B.C. show an antlered stag suckling his—or her—fawn. The same scene occurs in earlier Luristan art. No further and more unequivocal proof is required. Possibly ethnic interrelations may have played a role here, because the doe of a reindeer does have antlers. If the Stag Creed, if it existed, really originated from the creed of the ancient hunters who migrated north, then it was quite possible that, moving beyond the habitat of the reindeer, they made up for the antlered doe by putting an antlered mask on the representation of hinds. The age-old tradition survived in Hungarian popular belief as evidenced by the ancient Hungarians' belief that witches—females without exception—wear such large antlers that they can pass through the gate of a church only by turning sideways. When one ethnologist objected that maybe the narrator was mistaken, he replied that witches at Midnight Mass have antlers as big as the stags

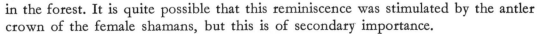

51. Detail of "Lehel's horn." The stag hunt is different from other pictures because there is a collar on the stag's neck and a garland (?) on its antlers.

in the forest. It is quite possible that this reminiscence was stimulated by the antler crown of the female shamans, but this is of secondary importance.

We have already mentioned how general were the zoomorphic ancestral figures in Siberian ancestral sagas. The one discussed here is particularly interesting as it tells of the ancestry of Genghis Khan, the "lord of the world." The Secret History of the Mongols begins thus: "The descent of Genghis Khan: There was once a bluish grey wolf born by the dispensation of Providence. His wife was a hind of reddish color. They crossed the Tengghis Lake and found a lair at the source of the Onon river, by the hill of Burkan-Kaldun. There their son Batachikan was born." Later, in the description of the Cosmic Duel, we shall see that good and evil shamans also fight each other in animal masks. For the present, if the doe or stag is taken to represent the primeval mother, then the two gryphons (which by the very fact of being gryphons refer to the ancestral country) may logically be supposed to represent the two hunting brothers, the ancestors of the two kindred peoples.

A few words remain to be said about the artistic composition of the ancestral sagas. During Scythian times, it was enough for the artist to represent the three fighting animals standing side by side in a row (the animal in the middle falling between the erect figures of its two enemies), since at that time the meaning of the scene was

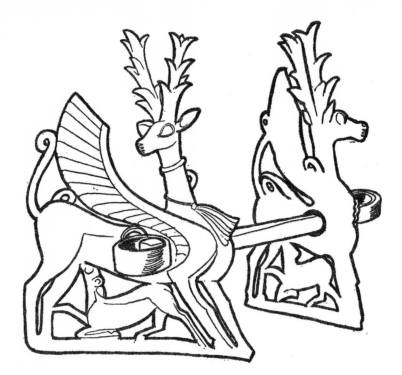

52. Bronze bridle from Luristan showing fawns sucking antlered hinds. We have tried to show how Luristan culture in the foothills of the southern Caucasus pervaded the imagination of the steppe peoples and how many common traits appeared in their creed. Apparently this mythological scene also took shape artistically in the Luristan culture. The scarf on the neck of the antlered hind and her wings indicate that the scene relates to myth and not to everyday life.

53. Gilded silver breastplate ornament from the Seven Brothers kurgan. Conceptually, a part of the same world as the previous picture (Illustration 52), the piece dates from the turn of the fourth century B.C. The figure of the eagle in the scene is not an expression of the artist's fantasy but again relates to myth, as the text explains.

clear to all and needed no further explanation. Later, the symbol became more graphic, no doubt under the influence of the optically more exacting style of the south. But why should it have been taken over? There is a much wider difference between symbol and representation than we would think. In the case of symbolism, the work just embodies the principal characters of the sagas, but ignores their actions, which were generally known. In the second case, the representation of the act is the aim; the oral tradition here is projected into pictures by every possible means. With the symbolic and the graphic representations we have arrived at the boundary line of two worlds; on one side communal awareness, which can be conjured up by a symbolical presentation of the scene, and, on the other, the awareness having dimmed, the graphic representation of the scene is essential. The problem can be worded to illustrate a more general law: in the first case, religion, creed, and folk memory are paramount, for which a surviving symbol, otherwise empty, is enough to evoke the mythological knowledge; in the second case, the content no longer lives in the mind but in the picture presenting the bloody fight. Without a doubt, the latter approach represents realism, but at the same time it indicates an increasing solitude of the individual. There are, of course, transitory phases between the two extremes. The representation of the Avar-Magyar saga about their origin is partly such a transition. Its content must have been widely known, even though only the heads of the clans and heads of the joint families were allowed to wear objects with such pictures on them. Yet, at the same time, these representations are "demonstrative" as well.

This "demonstration" happens in a composition of intertwining and undulating lines. The body of the fleeing stag or doe is transversally wedged between its two attackers. The gryphon attacking from behind claws at its belly, and the one attacking from the front tears with its claws and uses its beak to break the backbone of the collapsing animal. The intertwining of the repeatedly looping bodies is reminiscent of interlace ornament and is a unique composition of its kind. The scene occurs frequently, indicating that it was not invented in Hungary but had a long past. Nor was it the invention of the master craftsmen who made it; rather, the continuous repetition of content had become a symbol in itself.

The relief nature of the composition demanded that every essential part of the body should fold back into the plane of the picture to give a clear, well-readable design. Although this procedure is opposed to the proportionately decreasing depths of the classical relief style, the opposition is not conscious and did not first take place on the strap ends. We must imagine how these designs on large-scale beam carvings were finished with a chisel if we are to grasp the monumental background of the diminutive pattern before us.

The myths of the two hunting brothers may be linked with a few bone engravings of the Avar Period directly connected with Central Asia. Again, hunting scenes are represented in these bone engravings, and some of these, too, must be small-size imitations of monumental patterns. These incised engravings are found mostly on the instruments constantly used by shepherds and hunters to undo entangled straps.

The first of these is the presumably Avar knife-sheath ornament once in the Museum of Kecskemét, which unfortunately perished during the Second World War. The design shows a running stag being pursued by two dogs attacking it from both sides. Behind them three different horned animals can be seen. The drawing is clumsy,

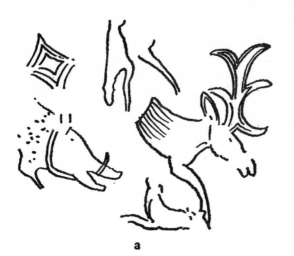

a

b

c

d

54. Avar bone engravings: (a) Jutas. Grave 125; (b) drawing of an untying implement from Alpár; (c) drawing of an untying implement from the Janus Pannonius Museum of Pécs; (d) drawing of a greatly enlarged bone plate from Tiszaújfalu. The exact meaning of these drawings, mostly of untying implements, which were used to loosen straps, is unknown, but the manner of drawings shows that they are closely related to the rock drawings of the Altai region.

but its composition is mature. It was evidently the imitation of some large-scale, precisely designed work. The momentum and vigor of the picture are reminiscent of Persian reliefs and Altaian rock drawings, particularly as the style of drawing is analogous to the latter. On another, also destroyed, untying instrument once in the Kecskemét Museum was a running panther and a dog chasing it. Not a trace of the surroundings remained on either of the two drawings. In the next two drawings discussed, however, the beginnings of a designation of the surroundings are present, or rather an attempt at a fuller representation.

In the design of the untying tool in the Pécs Museum the animal is shown fleeing at a gallop, perhaps between spread nets similar to the trap or hunting net on the disentangler fragment found at Jutas. The latter is very valuable because there the craftsman represented the animals only from the trunk upward, just like ancient Greek coin makers. What the meaning may have been, can only be guessed.

No matter how we look at them, the drawings are not symbolic or heraldic representations but small, free compositions that in every case cry out for large-scale realization. Even if we knew nothing of Avar art except these small-scale copies, it would be impossible to assert that the Avars—because of some strange "abstract" attitude—restricted their artistic efforts only to ornamenting clothes and trappings.

125–126 Another fine representation of a hunting scene, although in a different spirit, from the Late Avar Period is the strap end from Klárafalva. On it a galloping horseman shoots two swallow-tailed arrows, as his bow rebounds, at two hares tumbling over and pictured symmetrically as in heraldry. Behind the hunter his dog is seen, and on the base of the strap end is another hare. If anywhere this drawing certainly seems the work of a master schooled in the Persian rock drawings, even though the small relief was made in Hungary. The hare, represented as an image in a mirror, realized in its "abstract" symmetry the same principle as the pairs of animals in Germanic ornamental art. The two hares are the two projections of the same animal. It was a form of representation generally unknown in Persia but widespread in the Carpathian Basin from Scythian times on.

The Tree That Reaches to the Sky
(The Tree of Life)

In the discussion of the two hunting brothers we mentioned the Avar bone engravings with parallels in Central Asia. One of these engravings is a valuable relic of Avar mythology because it shows the Tree of Life, The Tree That Reaches to the Sky. The incised drawing can be found on a bone jar once used for storing ointments. The manner of representation precludes the possibility, suggested by one archaeologist, that the design is "like those in a modern book of outline drawings of animals and geometrical surface patterns for children to fill in."

The axis of the pattern is a structure that rises the whole length of the central axis of the jar. Below, a hill is roughly divided by seven vertical lines into as many parts, and between the lines are small dots and lines. The hill is spirally encircled by a band denoted by three lines. The scaffoldinglike column rising above the hill is topped by another hill (?), or what seems to be one, and from this rises the nine-branched tree. A ladder with nine rungs leads to the lower branches of the tree. The curved line right of the ladder may denote the moon and the circle on the left the sun. Parallel to the axis of the tree, and to the ground, the drawings of eleven animals are seen. (There may have been two or three more in the parts now worn off.) Of these animals, as zoologists have verified, the wild goat is easily recognizable (beside the sun and on the right), and so are four catlike or pantherlike animals. The biggest of them is parallel to the tree on the right, and the small animal in front of the wild goat on the right can be identified as a steppe fox. This zoological definition is very important because it defines the territory on which this kind of representation was born. In Eurasia there are only three regions—the Urals, the Caucasus, and the Altai—where all these animals are found. As we have seen, the style of drawing is directly related to the Altaian rock drawings, but other grave finds, for example, the bony belt, point toward the Altai, too. When analyzing the Altaian rock drawings, Tallgren convincingly demonstrated that the art and range of themes of the rock drawings has not died out, and, in fact, has survived to this day in the drawings on shamans' drums. It is true indeed that there are many drawings on the shamans' drums that are closely related to the Avar World Tree. Let us examine one of these: the drum is intersected by a horizontal band, roughly one-third of the way up. In the lower part a kind of wild goat is capering about. Above it, on an angular plinth, stands the Tree of Life, with the sun on its right and the moon on its left, and a man standing beside the Tree. Or in the middle of another example from the rich ethnographical parallels of the Siberian peoples stands the Tree of Life on a plinth. Over it the sun and the moon are seen, with birds at the end of their rays; stags, fish, and

55. Decoration on a bone jar from the Avar cemetery at Mokrin. This exquisite drawing, which is an almost classical representation of the World Tree, has been frequently discussed in the literature. Each part of it is an intelligent and precise representation of the World Tree myth and not a picture from a children's book, as one Hungarian archaeologist supposed. It was in fact found in an adult's grave.

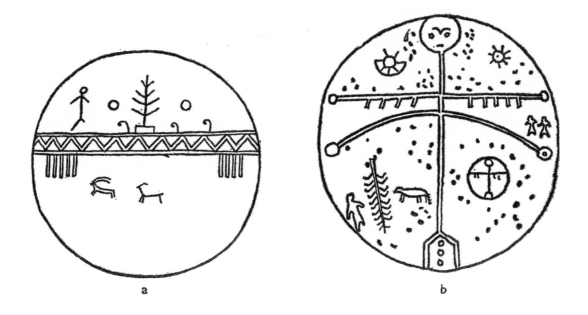

a b

snakes beneath; and beasts of prey at the bottom. The "tree of life," the "shaman tree," the "tree of the ancestors" can be cited by the hundred from the legacy of the peoples of Siberia. The variety of names given shows that diversified creeds sprang up around the symbol of the Tree. Reference has been made to the rich variety of adaptions as the Sacred Tree, the Tree of Paradisical Knowledge, was taken over by the traditions of the various peoples. It is obvious that the idea of the life-giving Tree came to Siberia from the south, and there it was transformed by local tradition. In many places the idea was that the Tree of Life gave birth to and sustained all life. According to a Siberian prayer: "Thou hast raised my white cattle, hast tended to my black cattle, hast taken care of my birds and crows and hast kept together the fishes of my dark waters." The idea of the World Tree often unites among the Altaian peoples with the idea of the World Navel *(omphalos)*, or with the World Mountain. We also come across the *ouroboros*, the *omphalos* encircled by the world serpent, in a word, with everything that occurs on Avar bone engravings. The World Mountain has many layers—according to Uno Harva's rich collection—and as a rule seven (or nine) floors can be distinguished in it, and its square summit reaches to the sky. In another place the concept of the World Tree mingles with that of the World Pole. It is characteristic of the imagination of the equestrian peoples that the World Column is practically a tether pole to which the heavenly stud and other animals of the constellations are tied by invisible tethers. The Buryats see in the starry sky a stud tended by the mounted Solbon (Venus) and his herdsmen. The custom of erecting a World Pole was still extant not so long ago in their villages. Apparently, such world poles or columns made of stone are also those which Appelgren-Kivalo presents to us in a whole series. Among other peoples, the belief survived that the Water of Life springs from beneath the Tree of Life, and herewith we reach the domain of the

105

57. The World Tree according to Siberian Ket folk art. S. V. Ivanov has compiled a priceless collection from the folk art of the Siberian peoples. Pictures of the World Tree flood the pages of his book, including ample evidence that these beliefs have survived right to the present among the peoples of Siberia.

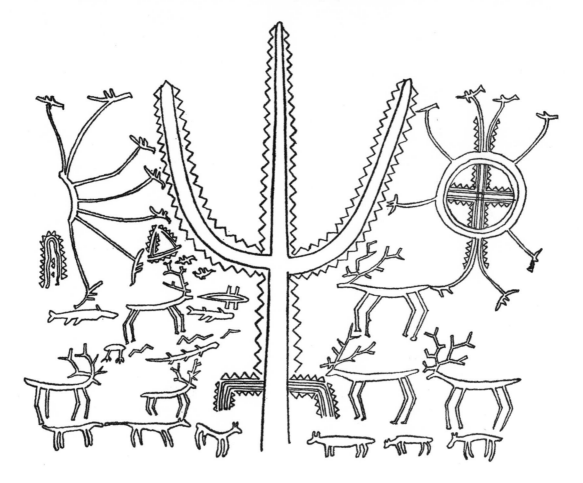

Old Testament and Christianity, that is, the four springs in Paradise and the tuberose bush of Islam.

All this background detail will help to make the Avar representation clear. The hill divided by seven lines means the seven layers of the World Mountain, which is encircled by the World Serpent. The column rising from the hill must be the World Axis, and from it grows the nine-branched World Tree. The replica of this tree was still being erected not so long ago by the peoples of Central Asia at shamanistic rites, when the shaman would enter and would mount nine rungs of the ladder and those who were attending the rites heard him stammer out the description of the nine regions of heaven. These nine regions comprise the universe, so it is quite natural that the sun and the moon accompany them. On the Avar engraving the animals and birds capering or flying about the Tree of Life show that it was believed (or only a legend?) in several Avar clans or tribes that the Tree of Life was the mother and nourisher of all life.

The test of this theory will be whether or not we can find this form of the Tree of Life in the legends of the Hungarians who merged with the Avars, and if so, where

106

the story leads us. In fact, not only does the story exist, but it exists in many varieties, proving beyond the shadow of a doubt that we have been discussing the very early heritage of the Hungarians.

Let us begin with the narration of an old shepherd whose words were taken down in the early 1940s by Sándor Szűcs, who was noted for his research into Hungary's old pastoral life: "There is a great miraculous tree in the world, with nine branches as dense as nine forests. When the foliage begins to stir, the wind begins to blow. It is such a wondrous great tree that not only the moon but also the sun passes through its branches. But only he who was born with teeth can find this tree..."

Thus this is a nine-branched tree with branches as dense as forests, and the moon and the sun pass between its branches, but only the *táltos* (shaman)—who is usually born with teeth—can find it. This brings us to the Hungarian *táltos* sagas, whose links with shamanism have long been established by Hungarian ethnographists. So, let us search among Hungarian stories of the World Tree to try to find parallels among the peoples of the steppes and the fishermen and hunters of the period.

The story of The Tree That Reaches to the Sky, according to Volume IV of *Ethnography of Hungary,* may be summarized as follows: "All these stories begin with the description of a sky-high tree, the fruits of which are unknown (according to another variation, it yields rejuvenating fruits), or a Tree into whose foliage the Dragon has abducted the King's daughter. The varieties agree on one thing: someone must climb up the Tree and if he finds the Princess, he may marry her as a reward. The trunk of the Tree is immeasurably high; according to some narrators it branches off only in the sky. The candidates who attempt to carry out the feat—princes and dukes—are forced to abandon the undertaking one by one. The last competitor is the King's young swineherd, who, taking his small hatchet, sets out on the great journey. He cuts notches into the Tree and starts to climb. At the sound of the hatchet blows a little trapdoor opens on the trunk and a little old woman thrusts out her head... (in the variations—the Mother of the Wind) who, well knowing what has brought the lad here, guides him higher to the granny living one story higher (the Mother of the Moon), who again guides him to the third (in the variations—the Mother of the Sun), but they know nothing of the top of the Tree. At last the lad reaches the first branches of the Tree." The story tells us about the sights at each level—an undulating meadow at the first branch, a castle at the second, three grazing horses at the third, until at last he reaches the top of the Tree. What subsequently happens in the variants is irrelevant here.

Ethnographers think that this tale is a relic of the shamanistic rite, where in the same way the shaman climbs higher and higher up the rungs cut into the World Tree. The Hungarian story "agrees phase by phase with the Asiatic texts, in which the old grannies likewise guide the lad, and the Sun and the Moon live at the top of the sky-scraping birch-tree." Particularly instructive in this respect are Eastern heroic poems, according to which (here again we quote from the *Ethnography of Hungary*: "Once the sky was as flat as the earth, only the branches of the growing trees pushed the sky higher and higher ... The stories speak especially of a giant tree which passes through the middle of the sky to reach up to heaven ... this is the World Tree..." In the shamanistic rites, this concept of a World Tree is symbolized by a freshly felled tree in which notches are cut for the shaman to mount to the strata of the sky, then through the flue of the yurt (the tree stands in the middle of the yurt) into the world of sunshine.

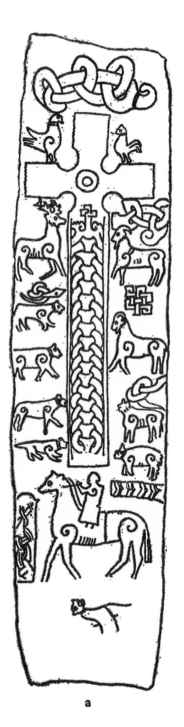

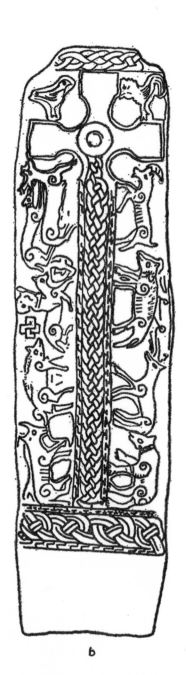

a

b

It is apparent that the World Tree handed down to us on Avar bone engravings was represented in the same way in textile, wood, and leather, just as in the art of the Siberian peoples. Although it is an individual piece of Avar art, its composition is so mature and accurate that it must have been widely spread and have had long traditions.

The tale of The Tree That Reaches to the Sky and the shamanistic rites are apparently not identical with ancient European traditions, rather, they are Oriental in origin. Nonetheless, the tree aspect of the myth, even if not the shamanistic rites, occurs in Germanic mythology as Yggdrasil, the giant ash tree. In a spacious hall beneath its trunk live the three Fates, in its crown sits an eagle, and between the eyes of the eagle is a hawk. A squirrel is seen running up the tree, among the branches of which are wonderful stags, and among the roots, serpents. (All this reminds one of the animals hiding in medieval foliage ornaments.) It seems clear that the World Tree has many echoes in Germanic antiquity. As will be discussed at length in the section on the Great Goddess, the Tree of Life and the figure of the Great Goddess

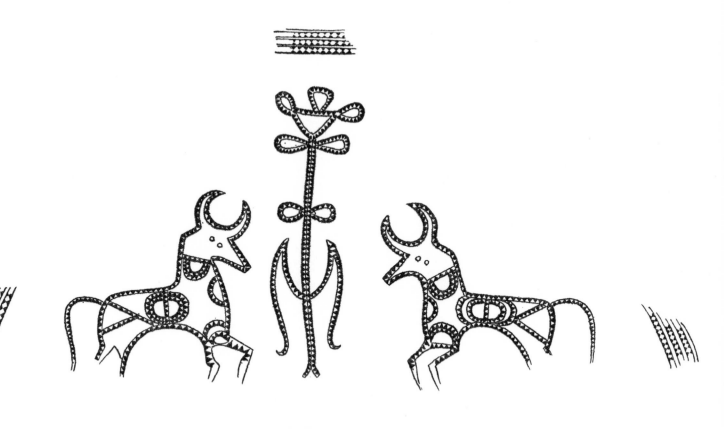

59. Salt (?) holder from Sopronkőhida. The bull-headed horses take a primitive form of *perspective tordue*, the antlers being shown from the front and the head from the side to emphasize the important features of each.

109

60a–c. Bull-headed horses of north Germanic origin.

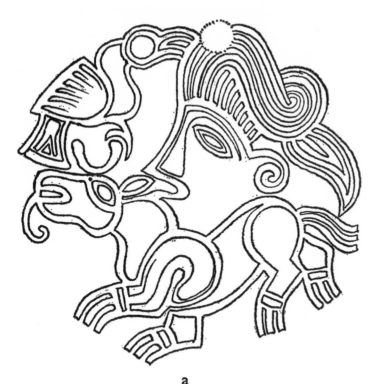

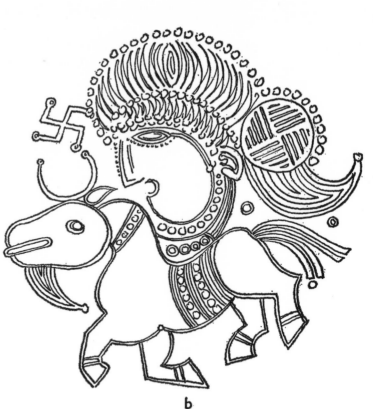

a

b

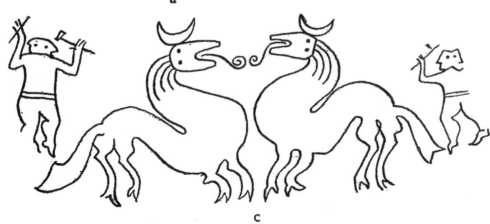

c

61. Salt (?) holder from the Tata Museum. The meaning of these fighting animals and their representation on a salt (?) holder are not clear. The holder may have contained not salt but something to do with animals or the Tree of Life. We may presume that the Mokrin jar contained ointment, but it cannot possibly be a bell box, as one Hungarian archaeologist supposed; there was no bell in the grave at all.

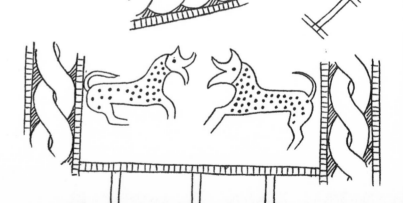

overlap considerably, as they do later in the Christian Middle Ages, when the Tree of Life lived on as the Cross. This tale is the source of the legend that Christ's cross was carved of the Tree of Knowledge in the Garden of Eden. It is consequently no surprise to find the Tree of Life represented as a cross on the stone crosses on the Isle of Man (compare the representation of the Bezeréd purse plate). It is also quite natural that there should be so many mythical animals around the Tree of Life. As an example of the latter, we will examine a Hungarian find and mention some of its parallels.

The find is the drawing on a salt (?)-holder antler from a ninth-century cemetery in western Hungary. In the middle is the Tree of Life and on the right and left are two miraculous horses wearing a bull's mask. Similar bull-masked horses were ridden by Scandinavian heroes in the *bracteates*, the horses at times doing the fighting in their masters' stead, if we may believe the evidence of the representations. The bull-masked horses of Sopronkőhida have a long story, beginning perhaps with the "horned" horses of Les Combarelles Cave from the Late Paleolithic Age. Later they occur in the Far East, the Near East, and among the Germanic finds. In the Far East they crop up on terra-cotta reliefs from the Han Period. The burial in the Pazyryk kurgan, with its bull-masked horses, is a more famous example of the type. On the coins minted during the Seleucid rule in Bactria a number of horses are adorned with horns. It will be recalled that the horse of Alexander the Great was called Bucephalus, meaning "bull-headed." The legend of this horse still survived in the time of Marco Polo. The horse with a bull's head occurs again in Buddhist pictures and early Caucasian bronze casts. In Europe horse representations of this kind are found from the La Tène Period on. Childeric is known to have worn a bull-headed plate, and on the *bracteates* the heroes ride bull-headed horses. On the antler drawing found at Sopronkőhida these magic animals are shown rearing on both sides of the Tree of Life, facing each other. It is impossible to tell whether this Tree of Life is the same as that of Yggdrasil. On another Transdanubian antler, beasts of prey, this time minus the Tree of Life but apparently wearing some sort of mask, are shown rampant.

Thus the steppe and Germanic variations of the World Tree both occur in the imperfect finds of the art of the Migration Period. Parallels may be found all over Eurasia. An expert ethnologist could obviously follow up the correlations between the Tree of Life and Yggdrasil with even more success.

The Cosmic Duel

An attempt will now be made to reconstruct something that certainly existed in the Migration Period, since it occurs both earlier and later than this time; during the Migration Period itself, however, the evidence is ambiguous. The kind of archaeological work we will be doing is similar to reconstructing a lost text from a chronicle on the basis of the corresponding passages in later chronicles.

In a previous work, I showed that the thirteenth and fourteenth-century frescoes of the Hungarian St. Ladislas legend preserved, with great accuracy, artistic traditions that went back to the Avar Period; some of the scenes, in fact, dated back to Scythian and earlier times. This first decoding of the legend and of a series of Ordosian, Scythian, and Sassanid relics was published in 1943; it was expanded, with texts from Central Asia, by Lajos Vargyas in 1960. In 1961, M. P. Griaznov, obviously unaware of the earlier publications, rediscovered the correspondences.

I was able to distill the pagan myth out of the St. Ladislas legend. The scenes of the pagan myth revived the struggle between Light and Darkness. Of course, the pagan myth was long before the tale of the pious king who lived at the end of the eleventh century. The frescoes depicting the legend survived in the peripheral areas of historical Hungary, that is, in the eastern marches, in the land of the Székelys (Transylvania), to the north in the country of the Szepes lancers, and in the west in the Őrség region, along the Mura River. The legends sang of the pious king who defended "the marches," that is, the borders of the country; the legends are less well known in the interior of the country.

Hungarian art historians, in the belief that Hungarian ancestors were nomads riding on horseback who possessed no graphic art, attributed the composition of the legends to some Italian master who supposedly painted the series of frescoes in the Cathedral of St. Ladislas in Nagyvárad, which village painters later imitated. Of course, there was no proof whatever for this theory. We can prove, however, that the paintings of the legend follow at least three constantly recurring variants that existed a long time before the conquest of Hungary, which excludes the possibility of a common source. If the frescoes in Nagyvárad were really painted by an Italian maestro, he would have adopted the best known version of the legend rather than invent one himself. We should remember that wherever permanent settlements of the steppe peoples have been found frescoes of high value also occur, for example, in eastern Turkestan, Penjikent, and partly in Tun Huang. I do not mean that the ninth-century Magyars had fresco painters, although the possibility cannot be ruled out, but that the depictions of the St. Ladislas legend survived on rugs or appliqué work as a sort of Oriental Bayeux tapestry.

Let us then look at the series of medieval frescoes that have survived but whose antecedents go back much farther. The first is a legend preserved in the text of the *Illuminated Chronicle*: "After this, the pagan Cumans broke into the border lands of Hungary... and cruelly devastated the whole province...; taking with them a

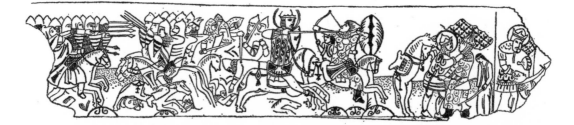

62. The St. Ladislas legend in the Unitarian Church of Sepsikilyén. (The final pictures are missing.) These frescoes were always painted on the north wall of the church, so there is little doubt that the series of pictures took the form of a tapestry.

XI. Avar openwork strap end; finding place unknown. MNM

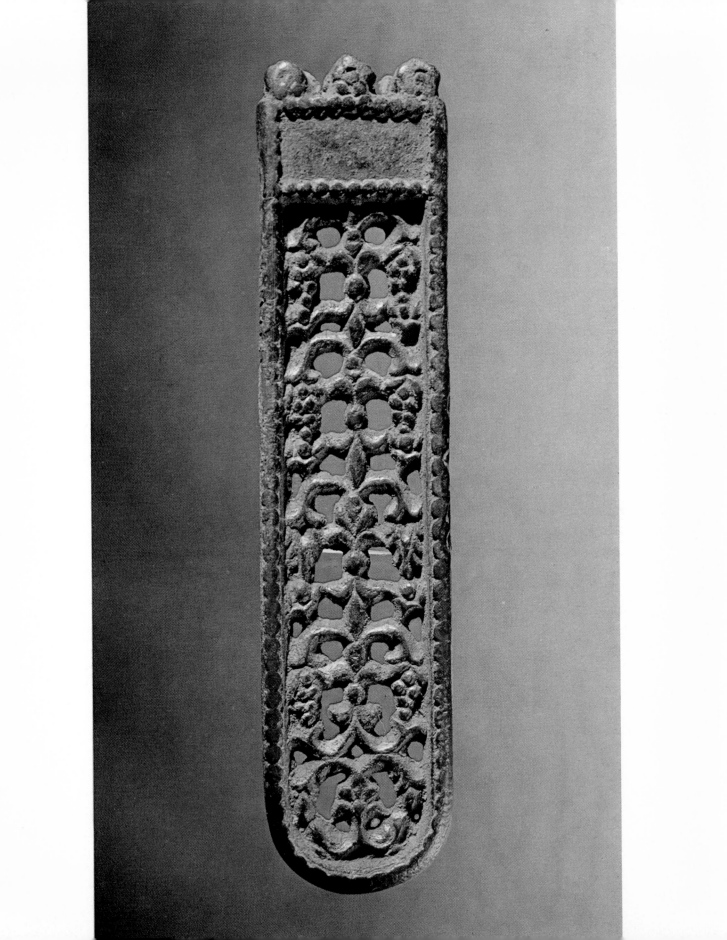

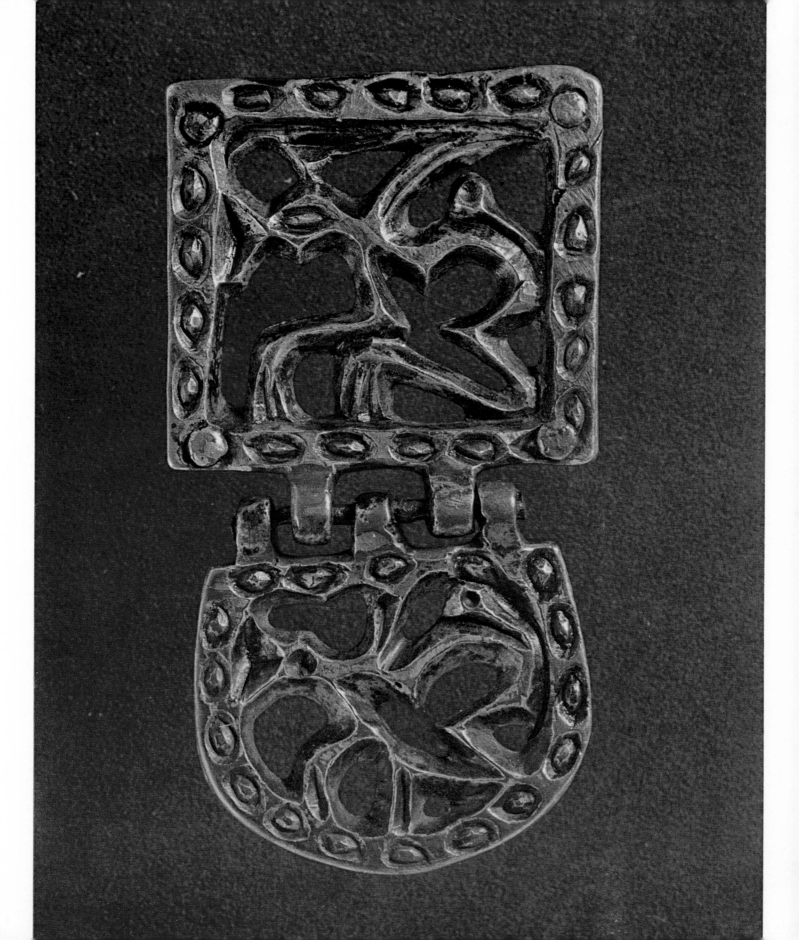

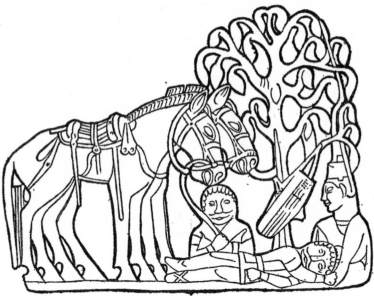

countless multitude of men and women and animals, before retreating. King Salomon, therefore, and Duke Géza with his brother Ladislas collected an army, and were hot on their heels in no time... The wretched pagans fled under the terrible blows of death dealt them by the Hungarians... With the strokes of their swords they severed the newly shaven heads of the Cumans as if they were unripe marrows.

"Then the most blessed Duke Ladislas saw one of the pagans who was carrying off on his horse a beautiful Hungarian girl. The saintly Duke Ladislas... swiftly pursued him on his horse, which he called by the name of Szög. When he caught up with him and wished to spear him, he could not do so, for... there remained the distance of a man's arm between his spear and the Cuman's back. So the saintly Duke Ladislas shouted to the girl and said: 'Fair child, take hold of the Cuman by his belt and throw yourself to the ground.' Which she did. The saintly Duke Ladislas was about to spear him as he lay upon the ground when the girl strongly pleaded with him not to kill him, but to let him go... The saintly Prince fought with him for a long time until he cut his throat and killed him."

The painters who painted Hungarian village churches or produced the wonderful miniatures of the lives of the Hungarian saints in the Vatican Codices had a different version of the saga from the chronicler. In their version St. Ladislas always rode a white horse and the Cuman rode a black one. The spear of the king could not reach the Cuman while they were galloping, nor did the latter's arrow hit the king, although the Cuman shot his arrow backward from his steed in the manner of the steppe peoples of the period. They were both invulnerable, according to the painters. The Cuman, thrown to the ground by the girl, and the king did not fight each other with weapons but laid down their arms and took hold of each other's belts or grabbed each other's throats. In some frescoes a tongue of flame shoots from the Cuman's throat toward the king. The combat is settled by the girl who cuts the Cuman's Achilles tendon with an axe. (Obviously, the Cuman could be wounded only on this spot.) Then the holy king severs the head of the Cuman, and, hanging his sword from a tree, lays his head on the girl's lap and rests.

113

XII. Gilded bronze mounting with pendant, from Keszthely. MNM

Thus the painters' version was better and more meaningful than the chronicler's. Now let us try to find the sources of this more richly described legend.

The identity of the last picture in the legend, the scene of rest, with one of the "Siberian gold plates" in the Hermitage, was first observed by Géza Nagy, the outstanding Hungarian archaeologist who lived at the beginning of this century. Fettich added that on both the pair of gold plates and the Hungarian frescoes the girl "cleans the man's hair with Oriental tenderness."

A few words must be said about the spread and the age of the "Siberian gold plates." The Siberian gold plates arrived at the Hermitage during the reign of Peter the Great. There are no contemporary data about where they were found. Recently, Soviet archaeologists found similar plates in a grave west of the Volga, in the vicinity of the Don; the eastern limit must have been the Ordos region by the bend of the Hwang Ho. If anything then, these plates may justly be connected with the Hun migration, especially since they date back to the beginning of our era. The plates always occur in pairs, since they were worn virtually as buckles at the opposing ends of the broad belt.

To return to the rest scene, it occurred to me that the same scene is repeated almost word for word in the Hungarian ballad of Anna Molnár. The first part of this ballad, the description of the abduction, is also a good example of the St. Ladislas legend and the eleventh-century laws on the abduction of women. A few words about the laws and customs of the period will be necessary at this juncture for understanding the scene of rest. The abduction of women must have been a general custom among the Finno-Ugrian peoples. János Jankó, for example, a Hungarian ethnographer, found only abducted women at a village near Tobol, and in this village the general belief was that only abducted women were respectable. Many relics tell of this custom which is recently extinct in Hungary but still flourishing among the Votyaks, Cheremis, Finns, and Estonians. Interesting indeed are the linguistic allusions: in the Vogul and Ostyak languages the bride is called "running woman" or "escaping woman." In the Ostyak heroic lays only one word means both wedding and war. Abducting went with pursuit, combat, and general clan warfare, as a rule.

The Hungarian version of the abduction of young girls survives in the saga of the mythical stag. Moreover, paragraph 25 of St. Stephen's Code II says: "Should any knight be so shameless and lewd as to abduct a maid for a wife without her parents' consent, we command that he return the maid to her parents even if he has outraged her; and the abductor shall pay ten steers for the robbery even if later he makes peace with the parents. If a commoner commits this act, he shall compensate for the abduction by paying five steers." Thus this law unequivocally declares that the abductor is punished only if he kidnaps the girl "without her parents' consent." The ancient tradition of abducting women survives to this day as a Hungarian folk custom, though now as a playful rite, indispensable as part of the wedding ceremony.

With this tradition in mind let us discuss the ballad of Anna Molnár. The story is about a soldier abducting Anna Molnár from her husband and her unweaned children. He seats her behind him on his horse (as the Cuman did with the Hungarian girl) and gallops off. Arriving in a forest, they rest. (On the Bántornya painting the Cuman rests his head on the girl's lap.) In this tale, too, the soldier likewise rests his head on Anna's lap and asks her to "have a look at his head." Then he falls asleep. Finally, the woman, by guile, cuts off his head. Several versions of the ballad add that the bodies of seven girls are hanging from the tree under which they rest, and Anna

cuts off her abductor's head out of fear. We also learn from the variants that the expression "have a look at my head" means searching for lice. In other versions the abductor is a Turkish or some other foreign soldier.

Hungarian folktale research for some time considered the scene of the hanged girls to be the most interesting aspect of the ballad of Anna Molnár, and on this basis it was thought that the ballad was none other than one of the variants of the Bluebeard story and came to Hungary from the West. Indeed, the "resting underneath the tree" and the "looking at the head" occurs also in the Western story, in the French, Italian, Portuguese, Spanish, English, Dutch, German, Danish, Swedish, Norwegian, Polish, Slovak, Moravian, Rumanian, and a few south Slavic versions, as though the whole of Europe were a single unit in this respect. The ballad is best known in German-speaking countries. Here is the Swiss version: "The wonderful singing of a knight penetrates into the palace. The young countess wants to join the knight and learn the song from him. She collects her treasures, mounts her best steed, and off they gallop together. At the edge of the forest a turtle dove warns the girl not to trust the word of the knight, who has already ensnared eleven girls, and wants to make her the twelfth. But the knight explains away his conduct. In the forest he spreads his cape on the ground in a clearing and asks her to search for lice in his head. As many locks of his hair as she goes through, so many tears she drops on the knight's face. 'Why do you cry?' the knight asks her. 'Are you crying for your young, proud self, or your father's riches, or your chastity which you will never retrieve? Or perhaps for the pine tree?' The girl admits that she is crying for the pine tree, from which she sees the bodies of eleven girls hanging. 'Don't cry, Anneli, can't you see that you will be the twelfth?' She asks him then to allow her three shouts as a final grace. The knight allows her to shout, for who on earth would hear it in the dense forest? But her brother hears her cry and following in their footsteps soon finishes off the abductor."

A "defective" variety of this ballad survives on both Hungarian and Rumanian territory from which the part about the hanged girls is missing. In my opinion the Hungarian variety—which radiated from Hungary toward the Balkans—is the original one, another version of the St. Ladislas legend, to which the hanged girls were added later.

It should not be forgotten that Hungarian folktale research has analyzed only the Western versions. But in view of new aspects of the subject supplied by the Eastern equivalent of the rest scene in the Siberian gold plates, we should now try to find the Oriental analogy not only in the picture but in the text as well, on the basis of Lajos Vargyas's work. The story has many variants in Turkish-Tartar heroic poems. The following is an example which illustrates my original thesis that the peoples of Eurasia are much nearer to one another than distances and the Tower of Babel of languages would suggest. In a Kachints song the young sister of a hero is abducted by an enemy warrior. The brother sets out in pursuit, wandering all over the world until he finds them at last in an iron house with nine corners. "The brave warrior, Töngus Khan, was asleep in his golden bed, while seven yellow maids held his head, searching for lice." A fierce duel now starts in which the hero defeats his opponent and the demons of the underworld. In this he is aided by his magic horse, which kills the opponent's "double" ("outer life-soul") and thus saves his master.

Two points are of interest in this tale: first, the magic horse that has the same

64. St. Ladislas legend: the "rest scene" from (a) Bántornya; (b) Erdőfüle (the original frescoes have perished and are known only from Károly Gulyás's copy); (c) Zsegra (painted over several times; the first layer can still be seen at the feet of the seated girl).

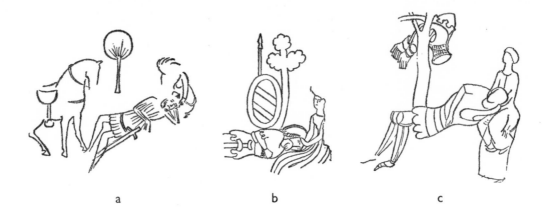

a b c

abilities as St. Ladislas' steed, and second, according to a fresco in the church of Vitfalva, Szepes County, the king lies not under a tree but in a bed with brocade drapery, with his head on a girl's lap for her to "search" his hair.

Eastern analogies also show that this was not a simple combat, because in the fierce fight the demons of the underworld also took part (according to an ancient Russian chronicle St. Ladislas' opponent was Batu Khan himself). In the Oriental parallels, according to Vargyas, the delicing scene always occurs at a turning point in the tale. This fact will be of importance in connection with the discovery that "searching in the head" in the language of symbols means infinitely more than mere tenderness.

Having examined the texts, we can return to analyzing the finds and paintings; first we will discuss the pair of "Siberian gold plates." The reclining knight has clearly hung up his quiver and bow on the tree. Variants of this scene occur in Hungarian frescoes, too. In the earliest fresco (Vitfalva, thirteenth century), behind the girl the head of the Cuman is seen on the end of a spear stuck in the ground. On the Zsegra fresco, which was heavily restored in the seventeenth century but still faithfully preserves the original fourteenth-century detail, St. Ladislas, stretching himself at full length on the rock, reclines his head on the girl's lap after he has hung his crowned helmet and gauntlets on the branch of the tree. In the Maksa picture the king is at rest with his spear leaning against his shield. At Székelyderzs the resting king has thrust his sword into the ground at his side. At Bántornya the Cuman's horse is tethered to his spear, which is stuck into the ground. In these scenes therefore the motif of the arms being laid down or hung up on a tree constantly recurs. This seemingly insignificant detail brings us to the same conclusion as our conclusion regarding the series as a whole—that the legend goes back to the beginnings of our era and to the world of the steppe, the country of the gold plates. It should not be supposed that the quiver hanging from a branch is an idyllic accessory or an insignificant "motif." On the contrary. It is highly important, as I shall show. In his famous Book IV on the Scythians, Herodotus writes about the Massagetae: "Each of them marries only one woman, but she is common property. If a Massagetae male desires

a woman, he hangs his quiver on her wagon and then has her undisturbed." O. M. Kosven, discussing the survival of the matriarchy, says in connection with the Nayars of India: "According to Ibn Batuta, if a man goes to see a woman, he puts a sign on her entrance, and if the others see this warning sign, they pass by and do not enter." Pietro della Valle, a Roman patrician, writes of the custom that "when a man who is having a love affair with a woman goes to see her, he leaves his arms at her door, at the sight of which no one will enter while he is inside."

Thus the arms laid down or hung up beside the dallying couple in the St. Ladislas legend are not emotional elements but the nuptials of the knight and the girl. The same unequivocal interpretation of the real meaning of the story can be taken from the "searching in the head," which is a love caress. The Swiss ballad previously quoted says explicitly that the girl weeps over her lost virginity. This helps us understand the meaning of the Bántornya fresco too, where, in a short respite from pursuit, the girl "looks into the head of the Cuman."

In Western representations the symbolism of the weapons hung up is completely missing—a further proof of the Oriental origin of the story. Nor is it immaterial from our point of view that the rest scene is often repeated in sixteenth-century Persian miniatures, in the scene of Leila and Madjnun, exactly as in Hungarian frescoes, but naturally in the idyllic style of miniatures. In the Persian miniatures, however, the posting of weapons on trees has faded from the painters' memories.

In this attempt to analyze the parallels of a scene commonly found in Hungarian frescoes, we had to travel all over Eurasia and examine art from many time periods. László Németh's comparison with spectral analysis involuntarily comes to mind: sometimes one band of the spectrum of art was stronger, sometimes another, but wherever we went we felt at home.

Now we turn to another scene in the legend—the duel—behind which, as I have already said, I suspect the struggle of cosmic forces. This time the only part of the legend to be treated in detail is the one which serves as the theme for a title-page woodcut in the Augsburg edition of the *Thuróczi Chronicle* (1488). Here, the wood cutter, obviously Western trained, placed the abduction scene in space, but in the duel of the two heroes he observed a strict bandlike composition and symmetry. The upper series of pictures from illustration 65 will be discussed in the following paragraph.

On both sides the horses of the pursuers are shown tied to a tree, as reflections of each other. In the middle stand the two unarmed combatants, grabbing at each other's shoulders. In one part of the frescoes the combatants are pulling at each other's belts (trying to tear off this symbol of freedom, which would be tantamount to defeat), just as in Central Asian pictures representing religious combat. The absence of weapons, which are also laid down at offerings, is itself evidence that this was no everyday scuffle. The upper band of the *Thuróczi Chronicle* would be perfectly symmetrical if the figure of the girl did not tilt the composition to the right. This, and the fact that the girl is missing from the parallel scenes, suggests that the St. Ladislas legend was woven together from two sources: the first stresses the abduction and the subsequent fight and the second stresses the ceremonial struggle in which the girl played no part.

The symmetrically composed scene in the *Thuróczi Chronicle* of the two dismounted heroes fighting occurs on Hungarian capitals on columns of the Romanesque and Gothic periods, but without the figure of the girl. It seems to me that the inference

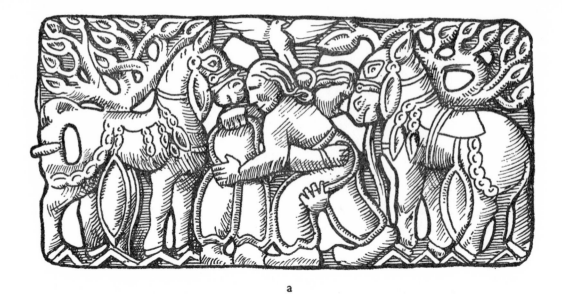

a

65. The unarmed, "sacred combat." The weapons have been put aside and the horses stand beside their masters. (a) The bronze plate from Ordos; (b) silver bowl from the Urals; (c) part of the title page of the 1488 Augsburg edition of the *Thuróczi Chronicle*.

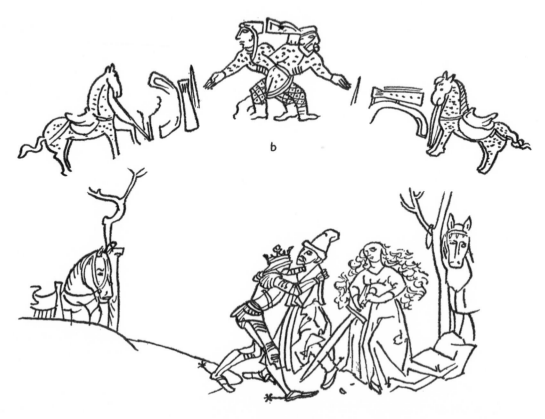

b

c

as to the blending of the two legends is confirmed. Several versions of the legend must have been known to the medieval Hungarians, judging by the frescoes. On one of them, the horses on both sides are mute observers as their masters fight; on the other, the horses, tied to a tree, as on the Siberian gold plates, stand peacefully at each other's side. In the third example, standing behind their masters, they also carry on a life and death struggle, biting into each other's pasterns (the Achilles tendon!) and sawing the air and each other with their forelegs. At times the painters no longer knew what the story was all about, and they just laid the face of one horse on the other *(Vatican Legendary, Illuminated Chronicle)*. These three roles of the two horses occur in the steppe versions too, so the roles cannot have been the invention of the medieval artists, much less that of the Italian painter of Nagyvárad, of whom we know nothing.

In the preceding discussion, we observed that the wood cutter of the *Thuróczi Chronicle* worked on the basis of an old tradition, composing perfectly symmetrical

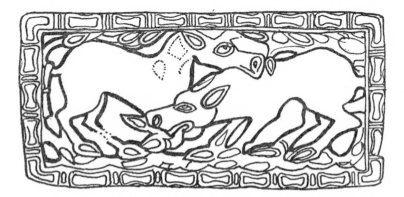

a

66. Horses biting at each other (a) on a bronze plate from Ordos; (b) in the St. Ladislas legend fresco at Sepsikilyén. Both scenes show the horses biting into each other's pasterns.

b

67. Untying implement from Pörös. In the original publication the two standing figures are back to back. However, the position of the drawing proves that the present drawing, made from the original, is the right one. There is no third figure at the point of the implement; only vague, worn lines are visible.

pictures. The figures of the two heroes fighting first appeared on a Scythian gold plate. However, the hair style of the two men seems to differ. An exact replica of the scene is depicted in the *Thuróczi Chronicle* in Ordos art, thousands of miles away, dating from about the beginning of our era. One of the belt mountings shows two heroes, their hair plaited in pigtails and wearing long trousers, throwing their arms about each other's waists. This wrestling technique is identical with that depicted on the Scythian plates and on parallel versions of the steppe and Germanic art which will be presented later. There can be no doubt that the fight was fought according to sacral "rules" and not according to the artist's imagination. Over the wrestling pair from Ordos, two birds hover with spread wings, a clear sign that this is not an everyday fight. On both sides of the fighters, horses, tied to trees, stand with the same sort of trappings as on the "Siberian gold plates," as though they had stepped out of the *Thuróczi Chronicle*. Apparently the scene represents a heroic lay that was sung all over the steppes for thousands of years, as evidenced by a Sassanid silver bowl which is an even more detailed repetition of the same scene. On the silver bowl the weapons of the two grappling heroes are laid down by their sides, and farther to the left and right their horses are placed symmetrically, mirroring each other. On the rim of the bowl is a hunting scene with the two hunters. It seems that the legend is related to the miraculous hunt of the two hunting brothers as well. Unfortunately, this picture has no caption, so nothing definite can be said. The duel has survived not only in the medieval St. Ladislas legend but also in Persian miniature art, where the scene (weapons laid aside, horses tied to trees on both sides) is exactly parallel.

The description of the scene is as essential a part of Eastern heroic epics as the rest scene. Vargyas writes that this scene is such a general element in Siberian epics that it is sometimes repeated word for word. He quotes the following typical text from Radloff: "Jumping off their horses, they throw off their armor and begin to wrestle. They grab each other's hips and grapple wildly, tossing each other to and

120

fro. They tear at each other's body with their bare hands. They fight for seven days, and never fall to the ground. They fight for nine days, and neither of the two can floor the other. Meanwhile they whinny like fiery colts and bellow like young oxen. The iron mountain-side that leans against the sky, slowly crumbles away and becomes a flat plain. Meanwhile no fowl could stay in its nest, and no beast in its lair." The years pass in this way, the heroes get emaciated, until the opponent begins to grow weak. M. P. Griaznov quotes many parallels from heroic poems to show the sacral character of the fight. It must not be supposed that it is a mere poetic simile that the heroes neigh like colts and bellow like oxen, since sometimes the heroes fight each other in animal form—just as the two hunting brothers chase the mythical stag in the shape of animals. To substantiate my view, let me cite a passage from Canto 27 of the Finnish *Kalevala*. Ahti, the master of Pohjola, gives Lemminkeinen a mug of beer teeming with snakes, worms, and lizards. The hero flies into a rage, whereupon Ahti conjures up a pool in the ground. Lemminkeinen conjures up a bull and a golden-haired ox who drink up the pool. Then Ahti emits a wolf from his mouth which devours the bull. The magic duel goes on: they fight each other in the guise of a hare and a dog, a squirrel and a beech-marten, a fox and a hen, until at last a hawk settles the fight. They conjure these animals out of their mouths (verbal magic), then take to their swords, and a terrible combat ensues that ends with Lemminkeinen's victory.

The warriors' horses are also worth studying. As has been mentioned, these are not always impassive observers of the struggle between their masters; the horses jump and kick and bite and tear at each other. The frescoes forcefully evoke the bloody combat, despite their simplicity as drawings. The combat is one of the loftiest motifs of the legends of the ancient steppes and the Hungarian world. Far from being every-day animals, the horses are magic (*táltos* in Hungarian), just as their masters are no common mortals but great heroes and magicians (shamans; also *táltos* in Hungarian) in whom cosmic forces are embodied. The picture of the horses tearing at each other is repeated in the art of the Ordos region, from which we have just quoted the description of the combat. Leaving for the present the rich folk literature and other relics of the magic steeds, I will quote the lines of Bonfini, King Matthias's humanist, on St. Ladislas's horse. "It is told of St. Ladislas's steed that it was not so remarkable for its strength and perseverance as for other natural properties. He fulfilled in a miraculous manner his master's every word, command, or wave of the hand, attacked the enemy with kicks and bites, never abandoning his master; and he proved skilful and clever in the times of greatest danger." A comparison with the magic horses in the sagas about Charlemagne of the *Shahname*, or in Turkish and Tartar heroic epics, shows that the same magic steed crops up everywhere. A signi-ficant motif is that of horses biting at each other's pasterns, just as the Cuman warrior can be wounded only in his Achilles tendon. Hungarian legends about magic steeds and their shaman masters provide some fine examples of this means of attack and defeat.

Hungarian *táltos* sagas are generally built upon the following story: A *táltos* (shaman) comes to work in the house of a farmer; when, changing into a bull, he fights another magic bull from the clouds, he asks for his master's help, namely, that should the master see him flag in the struggle, he should strike the pastern—or Achilles tendon—of the other bull with a hayfork. Thus even the bull is vulnerable in the same place as the Cuman.

In the Elk (Ursa major) saga of the Voguls, the hunter is not successful even

when he sends a whole flight of arrows after the six-legged elk, because he can bring the elk down only if he succeeds in cutting the pastern. In fact, every steppe hunter strives to bring down game in this way. Cowherds often prevented wild cattle from straying by cutting one of their Achilles tendons. Both the Cuman warrior and the magic horse can be wounded only on this spot. Eurasian parallels of these saga motifs are easy to find, the most obvious being Achilles, whom Thetis made invulnerable by dipping him into the water of the Styx. But, on the heel by which she held him, Achilles remained vulnerable, and here the arrow guided by Apollo through the hands of Paris struck him. Siegfried took a bath in dragon's blood, and its horny film, covering his whole body, made him invulnerable; while he was in the bath, however, a leaf became stuck to his back, and this was later his downfall. Isfendiar, the Persian hero, is also invulnerable, except his eyes, where the magic ointment did not reach. Jason of the Golden Fleece was also made invulnerable by a magic ointment. Thus the legends of this kind, including the St. Ladislas legend, are innumerable. Germanic mythology has likewise preserved the memory of the cut Achilles tendon: when Volundr (Wieland), the famous blacksmith, had the main artery of his leg cut while resisting, he was taken into captivity.

Let us repeat again the points that emerged in the analysis of the St. Ladislas legend. Two invulnerable opponents fight each other, and they lay aside their weapons because they are ineffective against the other. During the duel, they throw their arms around each other or pull at each other's belt. Meanwhile, the Cuman belches forth fire, but it does not harm St. Ladislas. The Cuman is vulnerable in his Achilles tendon, so the abducted girl severs it. After he is dead, the girl holds her nuptials with the hero underneath a tree, while the latter's weapons are hung up on a branch and the girl "searches" the hair of the hero. In some versions of the legend, the horses also take part in the struggle. The hero of the tale noticeably always wears a white garb and his opponent a black one. Their horses are of the same color. The saga must have had a long history on the steppes because it first emerged in Scythian times, but it occurs in many versions in Ordos, too. Parallel stories are found among the shamanistic sagas. In view of all this, it is not inappropriate to say that this combat

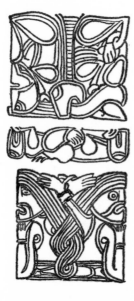

68. Relief ornamentation
on the hilt of the Snartemo sword.

69. The Snartemo "sacred combat" and its Oriental parallel.

is not between two strong men but between two cosmic heroes, Ahura-Mazda and Ahriman, the Princes of Light and Darkness. In a later interpretation this myth appears in a number of variants as a struggle between Iran and Turan, between town dwellers and stockbreeders, between St. Ladislas and the Cuman.

It seems to me that the cosmic conception of the world underlying this legend existed among the Avars and the Germanic tribes. As evidence of this theory, two finds will suffice. An Avar "untying implement" was excavated in a place in the Great Hungarian Plain that now belongs to Yugoslavia. It is not difficult to recognize on the implement the two dismounted warriors, who, devoid of arms, turn toward each other. Their hair styles differ, denoting their different descent. Even the horses are dissimilar. The design and its variants (with the World Tree and the two hunting brothers) can be traced back to Central Asia. A proof of this is the cropped and jutting mane of these horses, which is a characteristic ornament of *taki* (horses). It seems therefore that the ancestral version of the St. Ladislas legend was known in the Avar Period and was recounted all over the Avar Empire.

53–55 Another discovery is perhaps even more interesting. In his article on the Veszkény find, Joachim Werner quotes the plates of the sword of Snartemo as a parallel. Although I cannot agree with Werner's interpretation of the Veszkény find (as I will explain later), I must say that the Snartemo parallel is splendid. The familiar sacral combat is recognizable at first sight in the middle of the cycle of pictures on the hilt, transcribed of course into the northern style. The animals above and beneath the fighting heroes are thus the steeds, or animals suggestive of horses. In view of this scene we can look again at the design of the Veszkény find, where the two heroes can be recognized, again wearing their hair differently (one seems to have a moustache, the other is close shaven), and their horses can be distinguished in the intertwined pair of animals, which, according to Fettich, are two projections of the same animal. Thus we come here, too, to the fight of the cosmic heroes from which the St. Ladislas legend derived.

It may be rather tiresome to say again that what we have so far believed to be medieval Hungarian, Avar, Germanic, Sassanid, and so forth, was in fact the great common mythological asset of the peoples of the Migration Period, even if they spoke different languages and could not understand each other's speech.

The Great Goddess

So far, the emphasis of this discussion has been mainly on the Avars and the Hungarians, with a brief reference to a few points of contact with the Germanic world. The subject of this next section concerns the very basis of the art of the Germanic peoples, although the art pervades the steppe as well. The question is what the Germanic Animal Style represented and not whether it had Scythian or Roman antecedents (apparently it had both). In brief, why did the Germanic peoples adopt the animal representations and mingle them with their ornamental art?

I think it will be helpful to say first what the conclusions of this study will be. In many respects they agree with those of a brief essay by Robert Bleichsteiner, although our conclusions are independent of each other. The theory runs as follows: Germanic animal ornament mostly represents the Great Goddess and partly the divine male ancestor. It was not the study of myths that led to this conclusion but a close observation of the archaeological finds. The results will therefore be presented in a different way from before, in chronological order, with explanatory comments where necessary.

(a) The Luristan bronzes. In the representations of Sraosha and Ashi all the elements are present, and though the form later changed, the elements are still recognizable in the Germanic finds. One of the zoomorphic motifs, that of the cock, deserves particular attention. The cock may have been transformed into the birds of prey of the Migration Period, and it would be worth reexamining the Avar gryphons, too, from this point of view. Specimens of the later animal kingdom are found amassed upon the bodies of the androgynous deities of Luristan bronze finds dating back to the turn of the first millennium B.C.

(b) Greek depiction. As against the amassed animals of the Luristan finds, here optical order rules. The animals do not grow out of the female bodies but are the attendants of Potnia Théron, the Great Goddess. Beside her stand the four-legged beasts of prey, and above her fly the fowls of the sky. Although there are cosmic symbols on both sides, only the fish was painted on her dress. If the picture of Potnia Théron is compared with Avar and kindred representations of the World Tree, the mythological change is remarkable, inasmuch as the place of the Great Goddess is taken by the World Tree! The mythological images mingle to such an extent that it is hard to separate them from one another. For the time being it will suffice to say that in representing the goddess (or god) of fertility the bronze finds from Luristan are on a more barbaric level than the Greek objects; whereas the Luristan masters produced hybrids, the Greeks juxtaposed logically.

(c) Unification of Luristan and Greek approaches. The unification of the two concepts can be found on a Greek find from the Ukraine which was made for the Scythians. From under the skirt of a woman wearing a *kalathos* headdress, miraculous creatures and serpents uncoil. The gold plate was a horse's frontlet, and the Scythians must have instructed the Greek goldsmith from whom they ordered this work to represent their ancestral saga.

Among Scythian sagas two speak of an ancestress with the lower body of a serpent. According to the first, Heracles, in the course of his adventures, came to the

124

70. Ashi, the Goddess of Fertility. Luristan bronze.

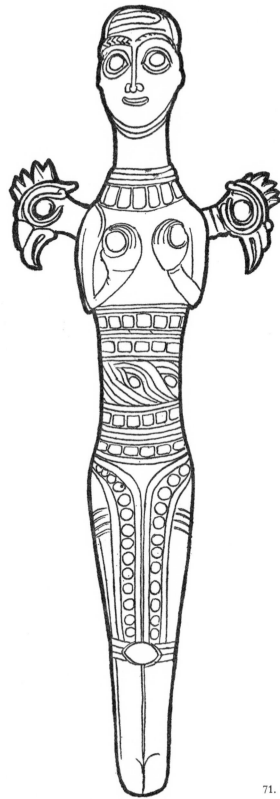

71. Sraosha, the God of Justice. Luristan bronze.

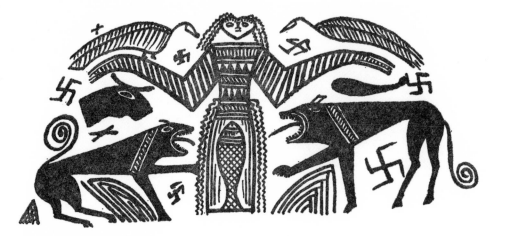

land of Hylaia where he sired Agathyrsus, Gelonus, and Skythes by a virgin with a serpent's body. According to the records of Diodorus Siculus, it was Zeus himself who begot Skythes by a Scythian woman who from the waist down had a snake's body.

This ancestral saga was the one that the Greek goldsmith shaped in his own way. The picture is undoubtedly more than an empty repetition of Luristan and Greek antecedents, combining Greek and more barbaric approaches. We know that of all their deities the Scythians worshipped Hestia most, or in Scythian, Tabiti. Thus the female principle was uppermost in their religion. When the Germanic Sciris of approximately 200 B.C. settled down between the descendants of the Scythians and the Sarmatians, the worship of the ancestress obviously still survived, since very strong matriarchal traits predominated in Sarmatian society.

(d) Germanic and Slavic fibulae from the Ukraine and Rumania. It is worth remembering that in connection with the Germanic jewels of Bakodpuszta and Szilágysomlyó not only the fibulae with animal figures but also those with mere animal heads represented animals. If in the light of these antecedents we now examine some of the fibulae from Pasterskoe-Gorodishche and Rumania, the similarities between them and the antecedents are immediately recognizable. The birds of prey (?) heads growing out of the body of the fibulae are placed laterally. In fact, the luxuriant Style II. (with indentation) of the Slavic or Avar fibula from Coșoveni de Jos speaks more unequivocally than any explanation. The people who wore these fibulae or made these early Germanic animal representations reached Hungary, too. In one Hungarian Avar cemetery at Csákberény, we found, besides the early fibula with concentric rings, the Pasterskoe form. It hardly needs to be said that the content of the Germanic zoomorphic fibulae was practically the personification of the Great Goddess, and in this the content is related with Avar animal fights or the group of animals around the Tree of Life.

126 73. Frontlet made to Scythian order depicting the Scythian tribal saga.

70. Ashi, the Goddess of Fertility. Luristan bronze.

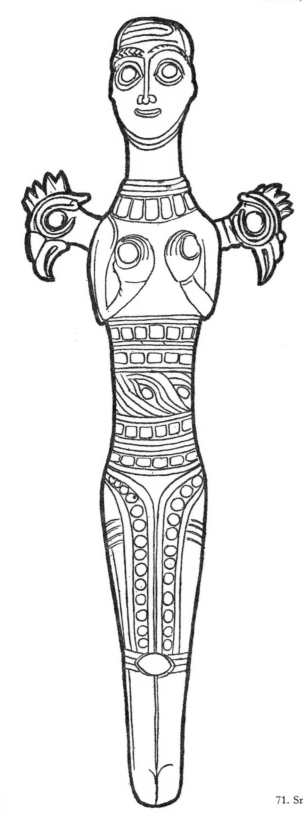

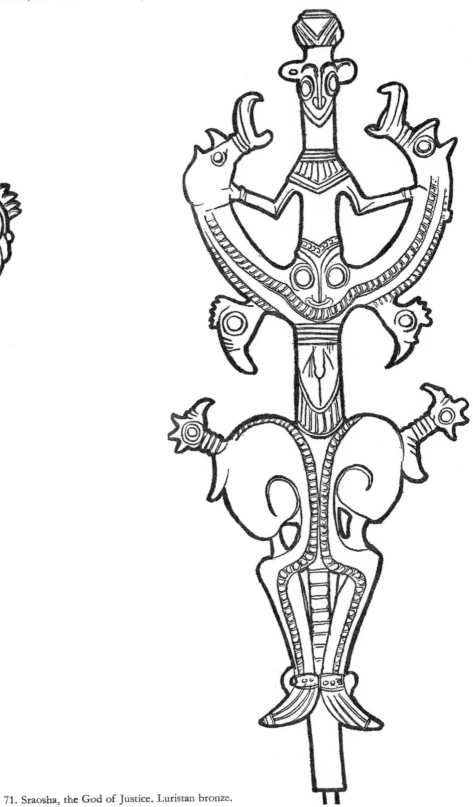

71. Sraosha, the God of Justice. Luristan bronze.

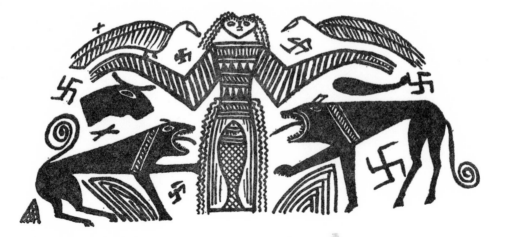

land of Hylaia where he sired Agathyrsus, Gelonus, and Skythes by a virgin with a serpent's body. According to the records of Diodorus Siculus, it was Zeus himself who begot Skythes by a Scythian woman who from the waist down had a snake's body.

This ancestral saga was the one that the Greek goldsmith shaped in his own way. The picture is undoubtedly more than an empty repetition of Luristan and Greek antecedents, combining Greek and more barbaric approaches. We know that of all their deities the Scythians worshipped Hestia most, or in Scythian, Tabiti. Thus the female principle was uppermost in their religion. When the Germanic Sciris of approximately 200 B.C. settled down between the descendants of the Scythians and the Sarmatians, the worship of the ancestress obviously still survived, since very strong matriarchal traits predominated in Sarmatian society.

(d) Germanic and Slavic fibulae from the Ukraine and Rumania. It is worth remembering that in connection with the Germanic jewels of Bakodpuszta and Szilágysomlyó not only the fibulae with animal figures but also those with mere animal heads represented animals. If in the light of these antecedents we now examine some of the fibulae from Pasterskoe-Gorodishche and Rumania, the similarities between them and the antecedents are immediately recognizable. The birds of prey (?) heads growing out of the body of the fibulae are placed laterally. In fact, the luxuriant Style II. (with indentation) of the Slavic or Avar fibula from Coșoveni de Jos speaks more unequivocally than any explanation. The people who wore these fibulae or made these early Germanic animal representations reached Hungary, too. In one Hungarian Avar cemetery at Csákberény, we found, besides the early fibula with concentric rings, the Pasterskoe form. It hardly needs to be said that the content of the Germanic zoomorphic fibulae was practically the personification of the Great Goddess, and in this the content is related with Avar animal fights or the group of animals around the Tree of Life.

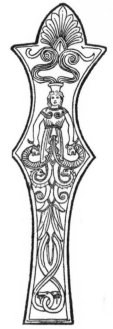

126 73. Frontlet made to Scythian order depicting the Scythian tribal saga.

(e) The redeeming god or goddess. As evidence that the original meaning, that is, the creative and redeeming goddess or god, survived in Germanic animal ornament, an eighth- or ninth-century picture of Christ will illustrate the point. Here God the Son appears surrounded by animals, beasts of prey, birds, gryphons, and fishes. There can hardly be more decisive proof that this is consistent with the original meaning of Germanic zoomorphic fibulae.

Herewith we are trying to unravel the Eastern warp and woof of Germanic animal ornament; but, the reason why the Late Roman laterally placed animal motif was borrowed must have been the same.

Thus, what previously existed intangibly in the myth was now embodied; what had previously never been represented was now seen on shoulders, on belts, swords, and weapons. Further evidence of this could be provided by the divine figures in Germanic mythology, mainly Freya and the other female deities; inasmuch as these are already familiar, it will be enough just to mention them. Life-giving woman became the center of Indo-European mythology. We need only read Tacitus to find how strong the belief in the female principle was among the Germanic tribes even in his time: "They believe that there is some sacred strength and a gift of prophecy in women, so that they listen to what they say..." And, writing about the Lombards,

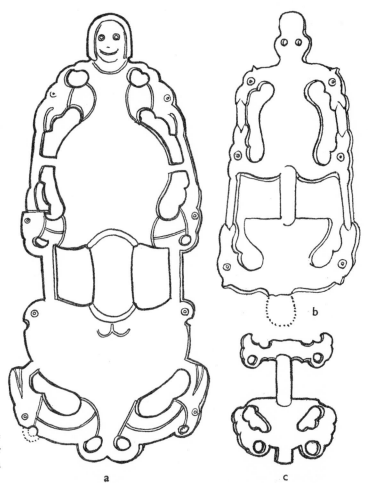

74. Two fibulae (a–b) from Pasterskoe Gorodishche and the fragment (c) of a similar fibula from Csákberény. A similar piece was found in the southern part of the Great Hungarian Plain (now Vojvodina in Yugoslavia).

127

75. Fibula from Coşoveni de Jos in a private collection at Craiova. The fibula teems with symbols, but the surviving retinue of the deities can be recognized.

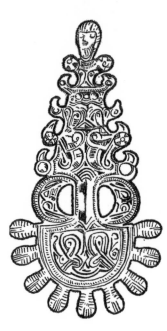

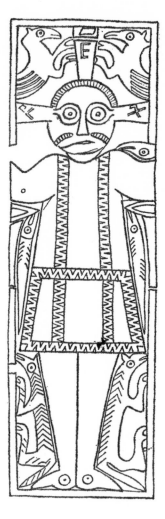

76. Christ on the Cross. An ivory relief from Werden Abbey. All the motifs previously associated with the ancient gods on the fibulae are now lent an "interpretatio ecclesiastica," grouped around Christ and referring to him.

Tacitus says: "They all worship Nerthus, Mother Earth, and think that she intervenes in the affairs of men and sometimes visits her people... However, (and this is typical of the age preceding the animal style) it is unworthy of the sublime nature of the gods to represent them in human form..." Authorities on Germanic mythology emphasize that, in general, Germanic deities are dim and blurred and their corporeality insubstantial. It was in this respect that the vicinity of the Romans and the intermingling with Scythian-Sarmatian culture brought a change. The incorporeal became corporeal, and, since every deity had his or her own animal attendant or personification, not man but the animal form was represented in art. Freya's cat carriage or hawk's wings, Freyr's boars, and Odin's raven were ancient symbols, just as Siegfried kept his name secret, calling himself Fair Stag. The names of the heroes also suggest a similar environment; Beowulf or Wolfdietrich are good examples of this. The fighting bulls are found in the Germanic sagas, too, and, in fact, the steppe saga of the mythical stag is reflected by the story of Finn and Oisin: Finn and his companions were returning from a hunt when a doe ran across the trail and only Finn and his two dogs could keep track of her. After a while, the doe lay down

128

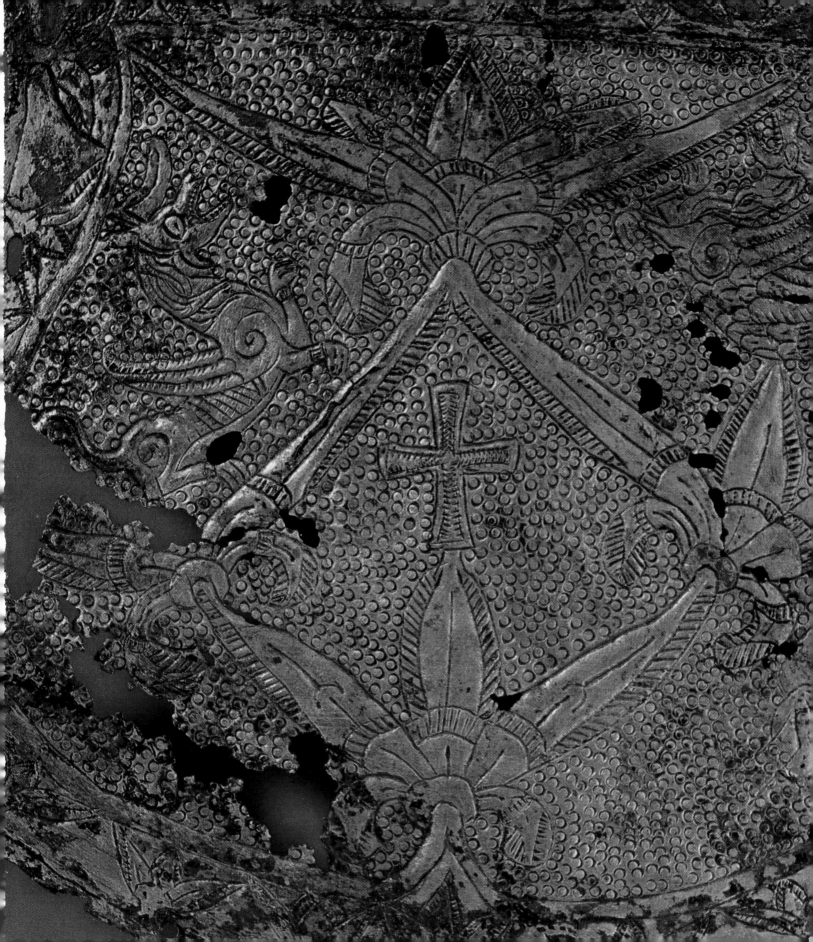

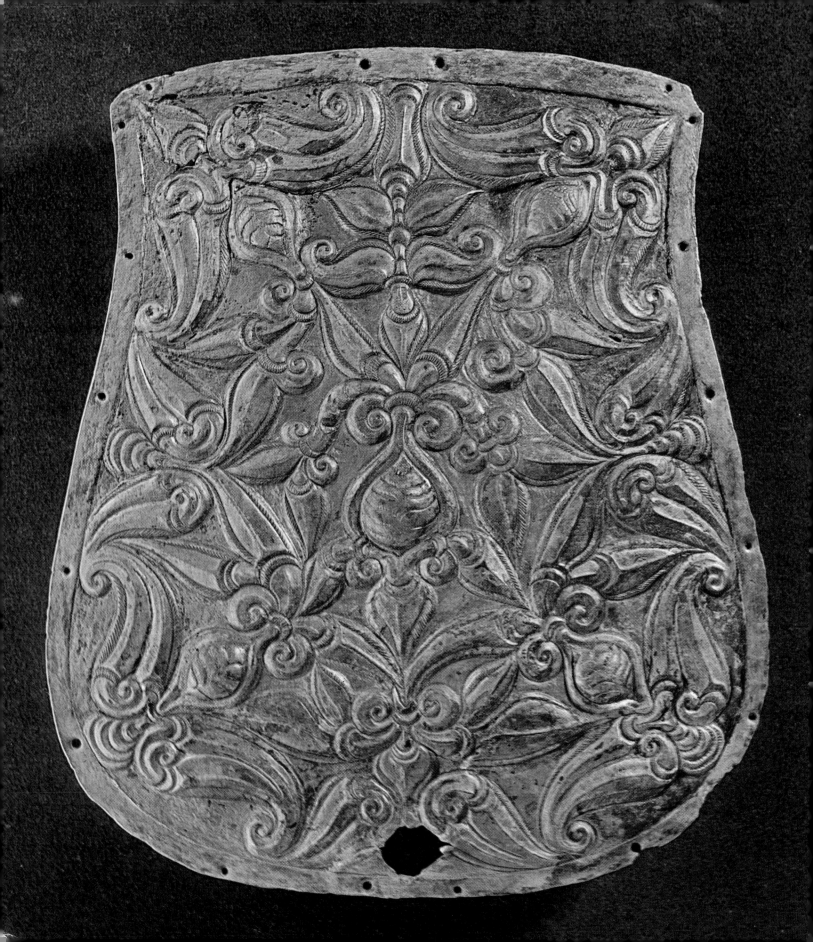

on the grass and began to play with the two hounds. Finn took the doe home, and there she changed back into a beautiful girl, for a wicked sorcerer had cast a spell on her. There are many more adventures in the tale but the upshot of it is that Finn's son by the doe girl, Oisin, the "Small Stag," turns up after being supposed lost. This tale proves how common the knowledge of olden times was among plow men and stockbreeders, when in their tales their ancestors would take on the shape of animals as well. Clearly, the Germanic Animal Style is not a sort of superficial ornament borrowed from the south, but an embodiment of the existing myth, as was the custom among other peoples. In his memorable book, Worringer described how it was transformed in the north.

Before finishing this short discussion of the myth of the Great Goddess, we should glance at the other side. Just as the representation of Christ among the Germanic peoples derived much from the heathen past, so the worship of the Holy Virgin preserved many things from the ancient belief in the Great Goddess. At the end of the nineteenth century, Lajos Kálmány remarked in one of the annotations to his great ethnographic collection that the goddess of our ancient creed lived on in a Christian guise in the popular worship of the Holy Virgin.

After all this, it would be surprising indeed if we were not to find this belief in the goddess of the Scythian-Sarmatian peoples in Slavic popular belief, inasmuch as these peoples lived on Slavic territory. V. A. Gorodtsev demonstrated in the first decades of this century that the entire Scythian mythology survived in Russian peasant embroidery. Bereginya personified Mother Earth, and her figure on the embroideries was often replaced by the Tree of Life. We have already quoted examples of this interchange. Gorodtsev's discoveries were expanded by B. A. Rybakov, who pointed to the totemistic heritage and the cult of the Magna Mater and to a bearded god whom he found on the fibulae of Pasterskoe. (The latter occurs on the Coşoveni de Jos fibula.) Thus the worship of the Great Goddess passed well beyond the narrow confines of the various language areas.

The Son of the Sun

Oriental rulers often used the titles of the "Son of the Sky" or "Son of the Sun," as did the rulers of the steppe peoples and later the Khazars and Hungarians too, after the latter had shaken off Khazar rule. The belief springs from the same source, the myth of the struggle of Light and Darkness, and it is thus no mere chance that in the Hungarian St. Ladislas legend the Hungarian king represents Light, or the Sun. More convincing evidence of the existence of the "Son of the Sun" epithet was discovered by the prominent linguist Dezső Pais, who analyzed the two names of the Hungarian princes which denoted rank, namely, kündü and gyula. In 900 Ibn Rusta wrote of these names: "They call their chieftain kndh, this being the name of the greater king. The other king who administers affairs is called djlh. And the Hungarians

77. (a–b). Doubting Thomas and the pattern of Christ's robe on an ivory relief made about 990 (c); pattern of Jars 3 and 4 in the Nagyszentmiklós treasure; (d–e) the cross in the middle of the Stephanus Rex coins.

do what the *djlh* commands." The old Magyar word *kündü* derives from the Turkish *kün*, which means sun or light. The name *gyula*, also derived from the Turkish, signifies torch or light. We know from Arab sources that the sign of the Khazar "chief king" was the sun and that of the second king was the torch. The correspondence is complete, showing that the insignia of Khazar royalty also occurred with the Hungarians as well. The symbol of the sun must have been made of pure gold, judging from the other finds discussed in this book.

It is now appropriate to discuss the Nagyszentmiklós treasure. It is made of pure gold, and the symbol of the sun is predominant. In his detailed analysis of the Nagyszentmiklós treasure, Nicola Mavrodinov considers it an ancient Bulgarian find, and this classification is how it is exhibited in the Kunsthistorisches Museum in Vienna. Although the question of ethnic origin is of no great importance with such international works of art, it is nonetheless not wholly immaterial.

The treasure was found in the village of Nagyszentmiklós south of the Maros River in 1791; it consists of 23 gold vessels. It was first thought to be Attila's treasure, but today it is considered to be Late Avar or Bulgarian, dating from the ninth or tenth century. I have analyzed the treasure, and I have concluded that the question of origin needs reexamining. The numeration of articles followed here is that given in József Hampel's monograph, which corresponds to the numeration used in the international professional literature.

First, we shall discuss the plain textile patterns on jars Nos. 3 and 4. The ornamented surface is filled with crosses reticulated diagonally. Wedge motifs are placed between the crosses. This plain ornament is a replica of the pattern on the royal robe. A proof of this is that the pattern is found on Carolingian coins as an emblem of kingship, although on these coins the wedges between the feet of the crosses are not quite the same as those on the jars. Moreover, the apostles wear the same robes, for example, St. Thomas, and again, at the Byzantine court robes ornamented with this pattern could be worn only by ecclesiasts and the emperor; this arrangement is what we find on a masterpiece of twelfth-century Hungarian medieval art, St. Ladislas's

146–162

154

130

herma (reliquary bust), although the crosses are replaced by new-blown flowers. The same textile pattern ornament is found on the first coins of the Hungarian kings, that is, in the middle of the Stephanus Rex coins. The same coins bear one of the runic signs of the Nagyszentmiklós treasure as well, a sign that is not known anywhere else—a *P* with an arm prolonged above and below. Since the minting dies of medieval coins were made by the royal goldsmiths and silversmiths, these two corresponding pieces of evidence, translated into the language of history, mean that jars Nos. 3 and 4, like the other objects made in the same workshop, were produced by the goldsmiths and silversmiths of the first Hungarian kings at the end of the tenth century and early in the eleventh century.

However, in addition to this conclusive evidence, there is also written corroboration of the Hungarian origin of the Nagyszentmiklós treasure, as György Györffy has established. To follow his argument we must know that there are not only runic inscriptions on the treasure but texts written in Greek characters, too. Some of the texts are written in Greek, others in Turkish. Reading them presents no special problem. In the Turkish text, two names, Boila and Butaul, are indeclinable proper names. It should be remarked, furthermore, that in the early Hungarian kingdom place names were derived from the name of the clan chief who owned the land. In the vicinity of Nagyszentmiklós, moreover, both names occur as place names. The territory where the treasure turned up was in St. Stephen's time the property of Chieftain Ajtony. His power vied with the king's, who finally succeeded in defeating him in 1028. Possibly this date coincides with the burying of the treasure. The gold table set made in the royal goldsmith's workshop may have come into Ajtony's possession as a gift from the king.

Thus the following facts speak for the Hungarian origin of the treasure: the patterns correspond with those of the first Hungarian coins, a letter of the runic script occurs which is not used anywhere else, and the two names found in the treasure figured among contemporary Hungarian landowners in the neighborhood. On the basis of the Greek inscription, Géza Fejér also concluded that certain parts of the treasure were made for a Hungarian king and that the whole ensemble had been Hungarian property. But even more conclusive evidence is that the sun symbol in the treasure is often repeated in early Hungarian work. The exquisite ornamental disks that were dug up in Rakamaz and Zemplén would have proved the Hungarian origin of the treasure even without the other evidence just given.

With these conclusions in mind, we can now re-examine the treasure from an artistic point of view. This analysis is not the first and no doubt not the last either, because no other treasure of the Migration Period has had so much written about it.

The conclusion I reached after examining the treasure recently was that it does not consist of a chance assembly of pieces; rather, it represents two full table sets. The two sets differ in style. Moreover, runic inscriptions are on nearly every piece in the first set, and although the other set has none, it has Greek inscriptions, enamel work, representational ornament, and animal fights. Disregarding that the forms of the two sets have nothing in common, the conclusion must inevitably be that in some respects the Nagyszentmiklós treasure resembles the Szilágysomlyó find. The Germanic princely treasure likewise consisted of two parts, and we simplified things by saying that the first find belonged to the prince and the second find to the princess, since animal representations occurred only on the latter. The situation is uncannily similar with the Nagyszentmiklós treasure, so I cannot help assuming that the table

set with the runic script belonged to the prince and the other one to the princess. Irrespective of the question as to whether or not this assumption is justified, the fact remains that the Nagyszentmiklós treasure consists of two different table sets.

In the runic set are four jars (Nos. 3, 4, 5, and 6), four drinking vessels (Nos. 11, 12, 20, and 21) and a small dessert bowl (No. 8); the old drinking horn (No. 17) may also have belonged in this set. The set is completed by two omphalic cups (Nos. 9 and 10) that could be hung from the belt and two smaller bowls with handles (Nos. 15 and 16). The other table set included three jars (Nos. 1, 2, and 7), three drinking cups with animal heads (Nos. 13, 14, and 18), two omphalic cups (Nos. 20 and 21), and a dessert bowl (No. 19). The very fact that the omphalic cups worn on belts occur twice is an indication of there being two sets. As we can see, the second set is teeming with animal representations, reminding us of a feature of the finds of the Conquest Period: the bulk of the finds with animal representations came from women's graves.

That such a set really represented a unit is proved by a set found on a silver platter in the Altai Mountains. Such sets may have been made for tables like the earlier ones that were excavated at Pazyryk. Unfortunately, the question as to the variety of beverages the four jars or three jars may have contained is unanswerable, since it is likely that the four jars and three jars, respectively, did not belong to as many persons, only to one. At any rate, that a special jar or cup was reserved for every drink suggests a great gastronomic culture: the users did not blend tastes and flavors. This theory is substantiated by some observations of István Dienes on the subject. He called my attention to a travel diary kept by Rubruquis, who wrote that in the East the aristocrats generally drank four kinds of beverages—kumys or the more fashionable karakumys, mead, wine, and corn gin. Evidence of this custom is the work of the French silversmith Willelmus who, after being kidnapped by the Hungarians, at Mengükhan's behest made a wonderful vessel from 750 kilograms of silver with the aid of the fifty master craftsmen assigned to him. From this huge silver jar, four kinds of beverages could be tapped at banquets, and the drinks were carried around by cup bearers.

Returning to the art of the treasure, we may assume that the set with no runic inscriptions derives stylistically and technically from Iran, Byzantium, or the Caucasus; the other set must come from the gold and silver workshops of the Árpáds, and it probably includes the work of several masters. In the discussion on the Hungarians of the Conquest Period, we mentioned that exogamy may have been popular among the ruling classes, just as it was among the Árpáds, where we can prove its existence. The differences between the parts of the treasures pose the question whether or not the first belonged to the prince and the second to the princess.

A table set like this was the finest dowry at the time. I once suggested that the second set might have been the gift of the Savard Hungarians who went off to the Caucasus. We know from Constantine Porphyrogenitus that Byzantium sent ambassadors to the Hungarians of Pannonia until the middle of the tenth century. The names of Boila and Butaul on the second table set should not be overlooked, since their occurrence on the set may imply that they were closely related to Ajtony. The relations between the great lords living in the southern part of this country and Byzantium are well known, and these relations might explain the Byzantine or Bulgarian links as well as the Christian features. A third explanation for the two table sets having been found together is that the second table set is closely related

XV. Detail of the rim of "Lehel's horn." Jászberény, Jász Museum

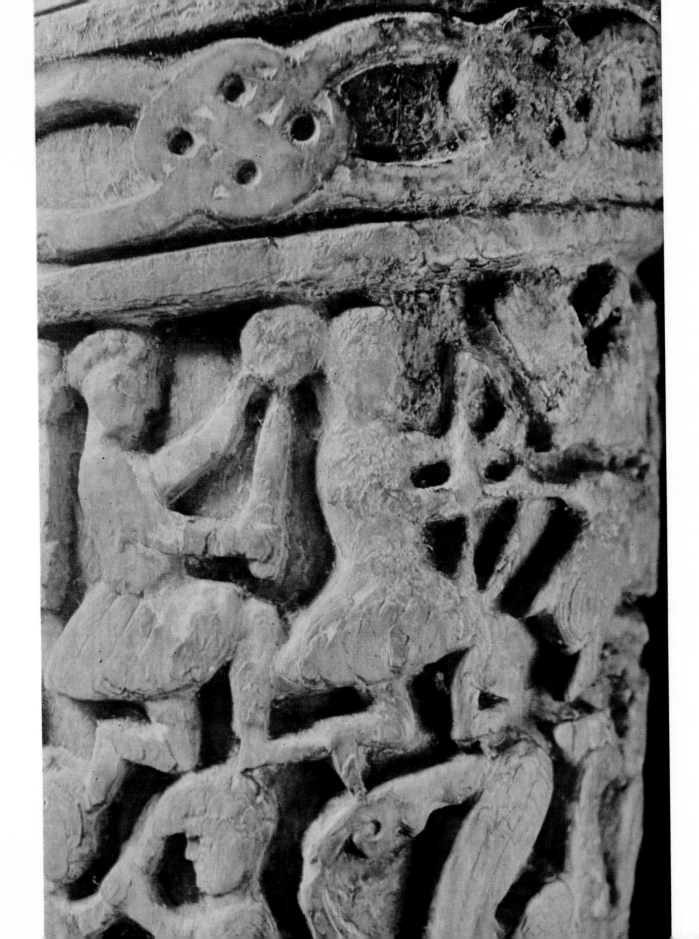

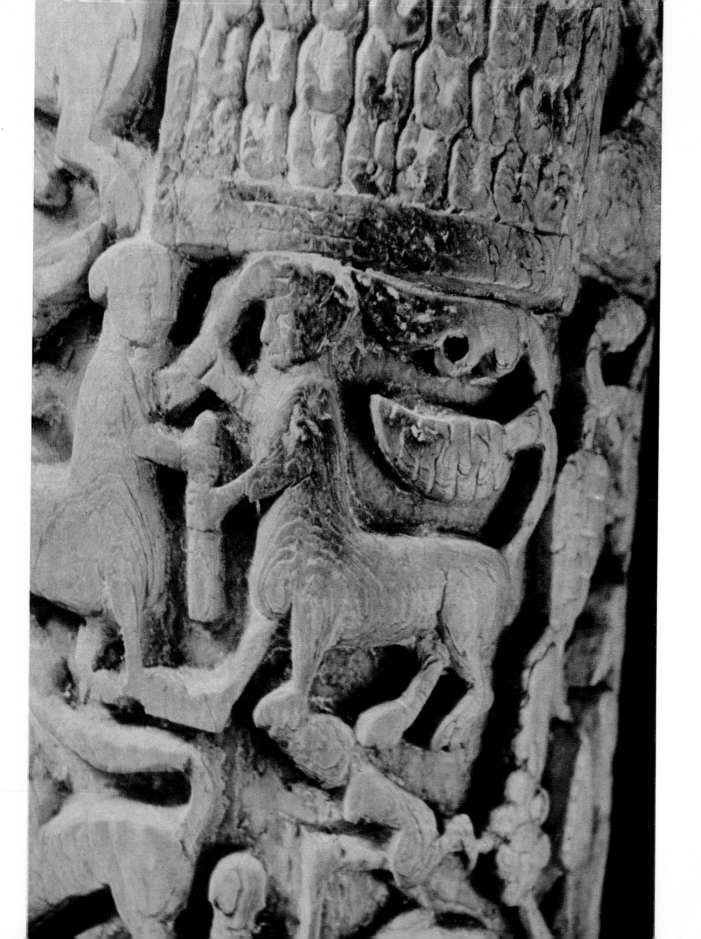

to Late Avar/Hungarian goldwork and silverwork. Possibly the second treasure is the legacy of a tenth-century progeny of a Late Avar/Hungarian princely family. Here, too, the custom of exogamy must have been at work. The Anonymus Chronicler wrote that Árpád chose the daughter of the ruler of Trans-Tisza to be the wife of his son, that is, he concluded a marriage agreement with one of the local princes.

All these haphazard thoughts are not only the thought continuum of an archaeologist at work, but they seem to be of the utmost importance when we try to analyze

146–153 the mythology of jars Nos. 2 and 7 in the treasure, both of which are of outstanding artistic value. The subject is a very complex one, and a full treatment (ornamentation and so forth) would require a whole monograph. Here we will discuss only the latest attempts at resolving the problem. One scholar, Camilla Trever, thought

156 that the woman who was carried off by an eagle may have been the Iranian Anahita and the scene of the fighting beasts was perhaps a symbol of the spring and autumn solstices. The custom in Iran was to give presents on these occasions, and the two jars may have been such gifts. Fettich ascribes the two man-beasts with pointed beards on the jars to the Dionysus cult, that is, he connects them with the Hellenistic motifs that spread all over the steppes. Mavrodinov collates the "divine abduction" scene with the representations of Ganymede and finds a link between the pictures on the other disks and the wood carvings on the Terracina chest, which he thinks is the work of Bulgarian artists. The debate was revived with the publication of József Csalog's highly stimulating work, which demonstrated experimentally that the shape of the Nagyszentmiklós jars and the way the ornament divides the surface (disks, meandering lines) imitates the bottle gourd and its mode of suspension. That is, the jars in the treasure evoke steppe forms and steppe usages. The formal parallels were collected in an exemplary way by Mavrodinov, who included the works of his predecessors, too; his parallels established links in Iran, the world of the steppes, the Far East, and Byzantium. Certainly we know that the goldsmiths composing the reliefs were continuing great traditions; one of their workshops, for instance, handled the compasses in a masterly way and divided the surfaces with precision (Jar No. 2), whereas another master of the same group made Jar No. 7 with a minimum of calculations on the spur of the moment.

The discussion of theories explaining the treasure could be continued *ad infinitum*. I think the most interesting experiment attempting to explain the scenes on the jars was made by the distinguished art historian György Györffy. He considers the whole treasure to be Hungarian in origin, and he attempts to derive the scenes from Hungarian mythology. The very comprehensiveness of this solution makes it suspect, but I shall quote from it, since even if it does not reveal the "program" prescribed to the goldsmith by those who placed the order, most probably the users or possessors of the treasure must have interpreted the reliefs in this way. Let us examine one by one the four disks of Jar No. 2:

146–147 (1) The "victorious prince" sits upon his horse, holding in his left hand a prisoner by the hair, in his right hand a banner. The severed head of another prisoner hangs from his pommel. In this scene Györffy sees the picture of the man who ordered the treasures to be made. This seems very doubtful. An exact parallel to the scene, except that the prince is on foot, is found on the gold solidi of Theodosius II (402 to 450) and on a minor group of Roman small bronzes from the end of the fourth century. The parallel scenes mean that the picture is not a portrait at all. However, what is important is that both Mavrodinov and Györffy conclude that the mounted king

133

78. Perm bronzes in the Moscow Historical Museum. In addition to the "ascension" scene, a whole series of classical motifs are interspersed, among these presumably shamanistic scenes.

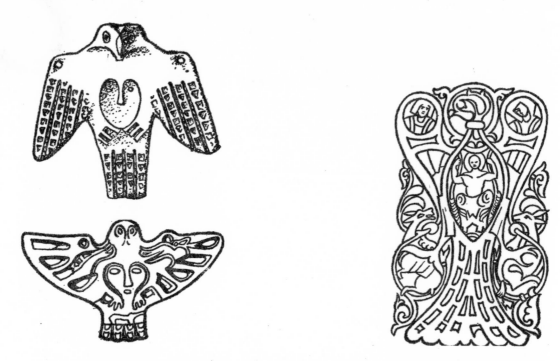

79. The ceiling of the Cappella Palatina of Palermo, with the scene of the Ascension. Hungarian-Sicilian contacts are known to have existed from the end of the eleventh century, with the marriage of King Koloman.

or prince has nothing to do with the Sassanid Period. Indeed, Györffy thinks that he is of Hungarian origin. The difficulty with this theory is that although the gold-smith rendered the helmet, armor, boots, flag, and trappings with great precision the horseman has no stirrups. And, with a Hungarian prince, this omission is nonsense. We know of one or two silver bowls from the Sassanid sphere of influence, presumably made by Hungarian silversmiths, and on them the feet of the horseman definitely rest in stirrups. Unfortunately, therefore, we have not gone any farther in interpreting the first disk than establishing that it did not come from an area under Sassanid influence.

(2) A stag killed by a gryphon. For this disk Györffy accepts Alföldi's explanation, which was based on a Noin-Ula parallel that the scene represents a wolverine (and not an eagle, as it turned out) hunting down a stag. Györffy drew far-reaching conclusions from this assumption that the animal was a wolverine because the wolverine plays a role in the two *pashker* sagas of the Voguls, and Györffy etymologizes the name Bashkir from *pashker*. So here we reach a stalemate, because the starting point itself is wrong.

More interesting is Györffy's suggestion that the symbolic language of animal fights may have been vividly alive in the minds of the Hungarians. According to ancient Hungarian chronicles, the reason the Magyars left their original country to migrate to the heart of Europe was that great eagles had attacked and killed many of their cattle and horses.

152–153

Thus a satisfactory interpretation of the scene is impossible to find. However, one valuable observation worth noting is that the Hungarian or Turkish owners of the treasure—or those who had it made—may have seen their own mythology in the animal fights inherited from Scythian times.

150–151 (3) The eagle with spread wings holding in its talons a naked woman who offers it a drink, or else she is holding a leafy branch in her hands. A very similar scene is found on a large silver bowl in the Hermitage. Remembering that the eagle with spread wings often recurs on Hungarian ornamental disks, we can reinterpret the whole scene, according to Györffy, to mean a representation of the Emese saga or the saga of the Turul Eagle. Anonymus describes the birth of Prince Álmos in this way: "Ugeg was an exalted and noble leader in Scythia who at Dentumoger married Chieftain Eunodbilia's daughter Emese. He had a son by her named Álmos (The Dream Child). He was given this name because his mother had had a divine vision, in which the god appeared to her in the form of a Turul Eagle and made her pregnant..." The scene is undoubtedly of antique origin. It has been linked with the representations of the Persian Anahita, the Indian Garuda, or Ganymede. There are also many parallels among the bronze finds from Perm, which means that the saga was known between the fifth and tenth centuries in the forested regions of Russia and transmitted across the steppes.

As far as interpretation and derivation are concerned, I can offer no definite solution, but we should note that the scene is always related to royalty. Until now scholars have ignored a twelfth-century fresco in the Cappella Palatina in Palermo in which an eagle flying skyward holds a man and two deer in his talons. On his wings are probably the symbols of the sun and the moon. Once again we find the picture of the prince seated in the Oriental manner and holding a cup in his hand. The style of the painting suggests the Turkic frescoes of Penjikenti, the Region of the Seven Rivers. In interpreting the finds in the Nagyszentmiklós treasure, therefore, we cannot disregard the Islamic factor. We have already seen that with Árpád's Hungarians Persian Islamic art streamed into Europe.

148–149 (4) A prince hunting on a winged lion with a human face. The figure of the prince only confirms the view that without a regard for the Islamic influence we cannot solve the questions posed by the Nagyszentmiklós treasure. The wings of the lion seem to mean that the hunt takes place in the other world. The scene—as many have found—is almost the exact replica of Mohammed galloping to heaven on his *burak*, as depicted in miniatures after the turn of the millennium. The hunt also unequivocally evokes the pictures of the royal hunts. The lion with the human face also has its parallel in antiquity—a human-faced panther is on one of the Sarmatian plates from Kuban. Fettich ascribes this figure, too, to the retinue of Dionysus.

Thus we are not even halfway toward finding a satisfactory solution of the problematic scenes on Jar No. 2. Irrespective of the correctness or incorrectness of the various explanations, however, the most interesting aspect of the whole scholarly quest is that all those engaged in unraveling the riddle are forced to consider the arts of peoples throughout Eurasia, inasmuch as parallels and antecedents are found all over the place. We Hungarians are gratified to see that one of the finest symbols of this great ethnic and artistic unity is the Nagyszentmiklós treasure, a beautiful relic of the wealth of the early Hungarian kings and princes.

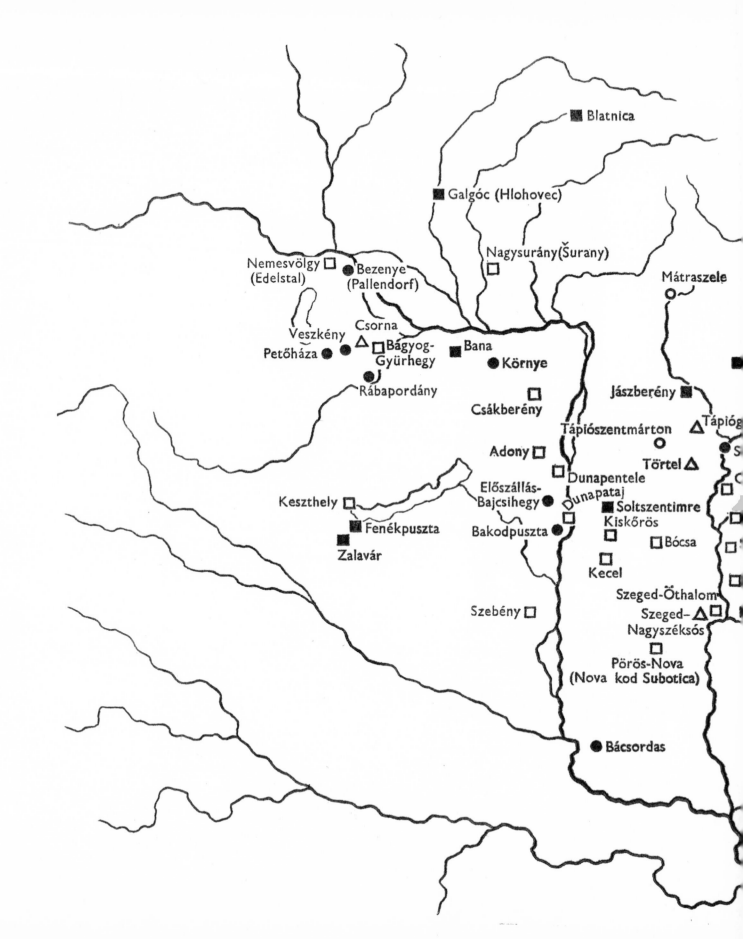

Blatnica

Galgóc (Hlohovec)

Nagysurány(Šurany)

Mátraszele

Nemesvölgy (Edelstal)

Bezenye (Pallendorf)

Veszkény

Csorna

Petőháza

Bágyog-Gyürhegy

Bana

Környe

Rábapordány

Csákberény

Jászberény

Tápióg

Tápiószentmárton

Törtel

Adony

Dunapentele

Keszthely

Dunapataj

Előszállás-Bajcsihegy

Soltszentimre

Fenékpuszta

Bakodpuszta

Kiskőrös

Zalavár

Bócsa

Kecel

Szeged-Öthalom

Szeged-Nagyszéksós

Szebény

Pörös-Nova (Nova kod Subotica)

Bácsordas

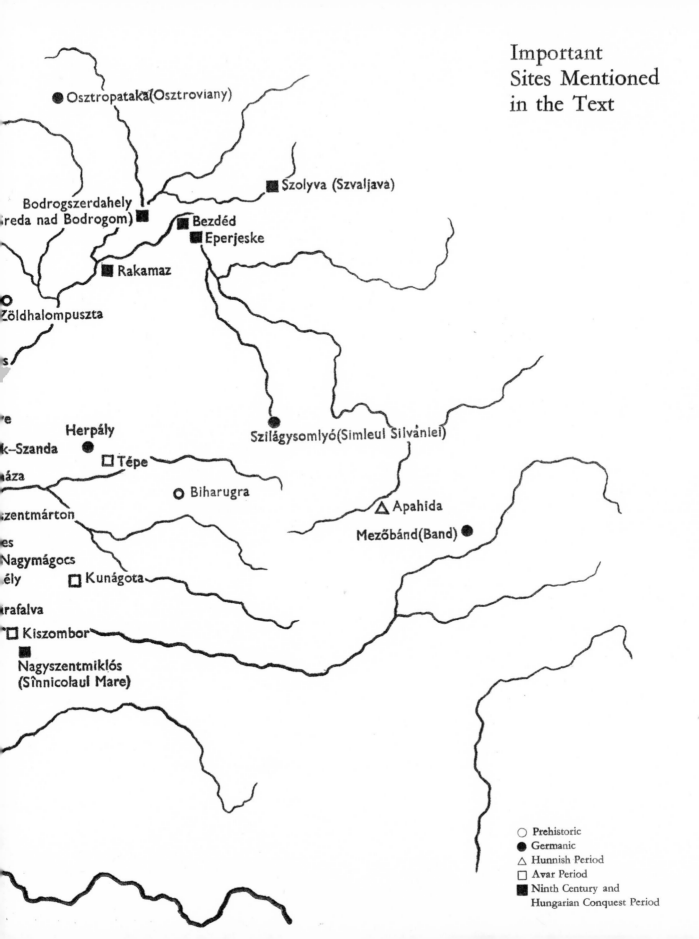

Important
Sites Mentioned
in the Text

● Osztropataka(Osztroviany)

■ Szolyva (Szvaljava)

Bodrogszerdahely
(reda nad Bodrogom) ■

■ Bezdéd
■ Eperjeske

■ Rakamaz

○ Zöldhalompuszta

Herpály
k–Szanda ●
□ Tépe

○ Biharugra

zentmárton

Nagymágocs
ély
□ Kunágota

rafalva

□ Kiszombor

■ Nagyszentmiklós
(Sînnicolaul Mare)

Szilágysomlyó(Simleul Silvaniei) ●

△ Apahida
Mezőbánd(Band) ●

○ Prehistoric
● Germanic
△ Hunnish Period
□ Avar Period
■ Ninth Century and
Hungarian Conquest Period

CONCLUSION

The finest aspect of historical and archaeological research is that it can never be ended because each successful solution raises more unsolved questions. An archaeologist wanting to conjure up the past is like Lemminkeinen's mother in the Finnish *Kalevala*. It is a memorable passage in the lay when the narrator tells how the desperate mother searches for the dismembered body of her son, which was thrown into the deep waters of the nether world, and how she rakes up and fits the limbs together in order to anoint them with her magic ointment and bring to life the son she had loved so dearly.

Archaeologists delve into the darkness of the past and use logic and imagination to fit together the jigsaw puzzles of the past, although we are forced to realize again and again that the parts we find do not yet fit together perfectly. The puzzle should fit together to a *t*, for then and only then can we evoke the truth about the people of the past. We did not initiate the work, nor shall we be able to finish it. More and more excavations, more and more finds, facts, and ideas will contribute to the hope that one day the work will be complete. This book is a link in a long chain of studies, and as such it examines the Eurasian past of the Carpathian Basin. Unfortunately, what has so far been established is only a fraction of what remains to be done.

APPENDIXES

Appendix A. Abbreviations

ActaArchHung — *Acta Archaeologica Academiae Scientiarum Hungaricae*

Alföldi: Untergang — Alföldi, A.: *Untergang der Römerherrschaft in Pannonien.* II. Leipzig, 1926.

Alföldi: Leletek a hun korszakból — Alföldi, A.: *Leletek a hunkorszakból és ethnikai szétválasztásuk—Funde aus der Hunnenzeit und ihre ethnische Sonderung.* ArchHung. IX (1932).

ArchAnz — *Archäologischer Anzeiger*

ArchÉrt — *Archaeologiai Értesítő*

ArchHung — *Archaeologia Hungarica*

ArkhSSSR — *Arkheologiya SSSR*

AUB — *Annales Universitatis Scientiarum Budapestiensis de Rolando Eötvös nominatae, Sectio Historica*

Banner—Jakabffy — Banner—Jakabffy: *A Közép-Duna-medence régészeti bibliográfiája.* I–II–III. Budapest, 1954, 1961, 1968.

BTM — Budapesti Történeti Múzeum, Budapest

DissArch — *Dissertationes Archaeologicae*

DissPann — *Dissertationes Pannonicae*

DolgKolozsvár — *Dolgozatok az Erdélyi Nemzeti Múzeum Érem- és Régiségtárából—Travaux de la Section Numismatique et Archéologique du Musée National de Transylvanie à Kolozsvár*

DolgSzeged — *Dolgozatok a Szegedi Tudományegyetem Régiségtudományi Intézetéből—Travaux de l'Institut d'Archéologie de l'Université François-Joseph à Szeged*

Erdélyi: Jánoshida — Erdélyi, I.: *A jánoshidai avarkori temető. Régészeti Füzetek* Ser. II. 1.

ESA — *Eurasia Septentrionalis Antiqua*

Fettich: A késői hun fémművesség — Fettich, N.: *Régészeti tanulmányok a késői hun fémművesség történetéhez—Archäologische Studien zur Geschichte der späthunnischen Metallkunst.* ArchHung. XXXI (1951).

Fettich: A honfoglaló magyarság fémművessége — Fettich, N.: *A honfoglaló magyarság fémművessége—Die Metallkunst der landnehmenden Ungarn.* I–II. ArchHung. XXI (1937).

FFC — *Folklore Fellows Communications*

FoliaArch — *Folia Archaeologica*

Girshman: Persia — Girshman, R.: *Persia.* 1964.

Hampel: Alterthümer — Hampel, J.: *Alterthümer des frühen Mittelalters in Ungarn.* I–III. Braunschweig, 1905.

Harva: Die religiösen Vorstellungen — Harva, Uno: *Die religiösen Vorstellungen der altaischen Völker.* FFC LII. Helsingfors, 1938.

Horváth: Az üllői és kiskőrösi avar temető — Horváth, T.: *Az üllői és kiskőrösi avar temető—Die awarischen Gräberfelder von Üllő und Kiskőrös.* ArchHung. XIX (1935).

IGAIMK — *Izvestiya Gosudarstvennoy Akademii Institut Materialnoy Kultury*

IPEK	*Jahrbuch für Prähistorische und Ethnographische Kunst*
KCsA	*Kőrösi Csoma Archivum*
László: Études	László, Gy.: *Études archéologiques sur l'histoire de la société des Avars.* ArchHung. XXXIV (1955).
László: A honfoglaló magyar nép élete	László, G.: *A honfoglaló magyar nép élete* [The Life of the Conquering Hungarian People]. Budapest, 1944.
MAGW	*Mitteilungen der Anthropologischen Gesellschaft in Wien*
MIA	*Materialy i Issledovaniya po Arkheologii SSSR.* Moscow
MNM	Magyar Nemzeti Múzeum, Budapest
MNy	*Magyar Nyelv*
Noll: Kat.	Noll, R.: *Von Altertum zum Mittelalter (Führer durch das Kunsthistorische Museum. Nr. 8).* Vienna, 1958.
RAD	*Rad vojvodanskih muzeja.* N. Sad
Strzygowski: Altai-Iran	Strzygowski, J.: *Altai-Iran und Völkerwanderung.* Leipzig, 1917.
StudHistSlov	*Studia Historica Slovaca*
TrudyInstEtnogr	*Trudy Instituta Etnografii im. N. N. Miklubo-Maklaja*
Werner: Die Langobarden	Werner, J.: *Die Langobarden in Pannonien.* Munich, 1962.

Appendix B.
Bibliographical Notes

It would be tempting to say that each chapter of this book in its entirety was based on my own experiences and observations, but this statement would be grossly misleading. Just as individual cultures cannot be understood in isolation because they materialized as a result of the interplay of all Eurasian cultures, so effective individual archaeological work is impossible without recourse to the strenuous effort of previous scholars; this book in its turn will serve only as raw material from which future archaeologists will work. The literature quoted in the individual chapters denotes primarily the previous stations along the road leading to our present state of knowledge—stations without which the theories propounded in this book could never have materialized. Of course, our survey of the literature is not complete; however, Hungarian archaeology is furnished with a splendid bibliography encompassing the whole of the Carpathian Basin, and anyone interested can pursue questions of detail in the works listed there (Banner—Jakabffy: *A Közép-Duna-medence régészeti bibliográfiája* [The Archaeological Bibliography of the Central Danube Basin], I–II–III, 1954, 1961, 1968).

Introduction

Many ideas similar to those treated in this book will be found in a book called *Formprobleme der Gothik*, 1922, by W. Worringer. For further study the following books are recommended: S. V. Kiselev: *Drevnyaya istoriya yuzhnoi Sibiri*, MIA, 1949; M. Gryaznov: *L'Art ancien de l'Altaï*, Leningrad, 1958; Gyula Sebestyén: *Regösénekek* [Lays] and *Regösök* [Minstrels], *Népköltési Gyűjtemény*, Volumes IV and V; for the "iron" superstitions see the treatises by Sándor Solymossy, *Magyarország Néprajza*, IV, 292–303, and Gyula László: "Études archéologiques sur l'histoire de la société des Avars," ArchHung, XXXIV (1955), 134–144. The comparative material of Hungarian folktales used for substantiating the international parallels was borrowed from *Magyar népmesetípusok*, I–II, Pécs, 1957, by János Berze Nagy.

I. Farming and Livestock Breeding

ANTECEDENTS

For a succinct outline of American Indian stockbreeding and farming, see László Depsy: *A talajkimerülés befolyása az államok életére* [The Influence of Soil Depletion on the Life of the States], Pest, 1896, 24. The source for the description of seminomadic conditions was Antal Bartha: *A IX–X. századi magyar társadalom* [Hungarian Society in the 9th and 10th Centuries], Budapest, 1968. In addition to A. Furtwängler's work, *Der Goldfund von Vettersfelde*, Berlin, 1883, for the rudiments of art theory see H. Kühn, in *Primitive Kunst, Ebert Reallexikon der Vorgeschichte*: X, 1927, and my own book: *Az ősember művészete* [The Art of Primitive Man], Budapest, 1968. On the subject of the Scythian animal style I quoted from G. Boroffka: *Scythian Art*, London, 1928.

THE ANTECEDENTS OF THE ANIMAL STYLE IN THE CARPATHIAN BASIN

Sources chiefly used are: S. Gallus and T. Horváth: *A legrégibb lovasnép Magyarországon—Un peuple cavalier préscythique en Hongrie.* DissPann, Ser. II. 9 (1940); N. Fettich: *A zöldhalompusztai szkíta lelet—La Trouvaille scythe de Zöldhalompuszta près de Miskolc, Hongrie*, and Fettich: *A garcsinovói szkíta lelet—Der skythische Fund von Gartschinowo*, ArchHung, XV (1934), as well as Ervin Supka: *Adatok a szkíta emlékanyag eredetkérdéséhez* [Data Relating to the Questions of Origin of the Scythian Finds], Budapest, 1935.

THE GERMANIC PEOPLES

There is no call here for me to list the vast material on the Germanic Animal Style II, and I will quote only the most recent and important works. W. Holmquist: *Germanic Art During the Late Roman Period*, Stockholm, 1955, 9–42; J. Werner: *Die Langobarden in Pannonien*, Munich, 1962; Nándor Fettich: *Régészeti tanulmányok a késői hun fémművesség történetéhez—Archäologische Studien zur Geschichte der späthunnischen Metallkunst*, ArchHung, XXXI (1951), Chapter VII, etc.—Concerning the two Szilágysomlyó finds, reference was made, in addition to an older work by József Hampel (Hampel: Alterthümer), mainly to Fettich's exemplary treatise *A szilágysomlyói második kincs—Der zweite Schatz von Szilágysomlyó*, which appeared as ArchHung, VIII (1932), and for its exact inventory data to the catalog of the Kunsthistorisches Museum (Noll: Kat.) R. Noll: *Vom Altertum zum Mittelalter*, Vienna, 1958.—With regard to the royal finds of Bakodpuszta, in addition to the established literature (Hampel, Fettich, etc.), István Bóna has written a great deal that is new, *A magyar régészet regénye* [The Story of Hungarian Archaeology], Budapest, 1968, 115–125. Besides Károly Kerényi's study (Labyrinth-Studien. Humanistische Seelenforschungen, Munich—Vienna, 1966, 226–288), the pictures in a Mongolian album were used (*L'Art populaire et l'artisanat mongolique*. Ulan-

Bator, no date available) as well as one of the fundamental studies of József Csemegi: "Motringfonal, lánckereszt, hurkoskereszt" [Skein, Chain Cross, Looped Cross], *Művészettörténeti Tanulmányok*, 1960, 7–33. References to the basket-shaped earrings were borrowed from A. Alföldi: *Untergang der Römerherrschaft in Pannonien*, II, Leipzig, 1926, and from Nándor Fettich: *A késői hun fémművesség*, Tables XLI–XLII. The following works I also found most useful. E. Oxenstierna: *Die Nordgermanen*, Stuttgart, 1957; P. Paulsen's essay on the Vikings which appeared in ArchHung, XII: *Magyarországi viking leletek az észak- és nyugat-európai kultúrtörténet megvilágításában—Wikingerfunde aus Ungarn im Lichte der Nord und Westeuropäischen Frühgeschichte*, ArchHung, XII (1933); two excellent works by István Bóna: "Die Langobarden in Ungarn," ActaArchHung, 7 (1956), 183–244, and "Cundpald fecit," ActaArchHung, 18 (1966), 279–325; J. Werner: *Die Langobarden in Pannonien*, Munich, 1962, and several studies by Fettich, for example, "Der Schildbuckel von Herpály," Acta Archaeologica, Copenhagen, 1930, 221–262. I also derived great benefit from H. Mitscha-Märheim's splendid book *Dunkle Jahrhunderte, goldene Spuren*, Vienna, 1963. In regard to the later periods, Fettich: "A prágai Szent István kard régészeti megvilágításban" [The St. Stephen Sword in Prague as Seen by an Archaeologist], *Szent István Emlékkönyv*, III, Budapest, 1939, 475–516 and my own study on minting, Gyula László: "Die Anfänge der ungarischen Münzprägung," AUB, IV (1962), 27–53, served as sources.

THE HUNS

In addition to Hampel: Alterthümer, whom I constantly referred to, the best collection of sources for the history of the Huns will be found in *Attila és hunjai* [Attila and His Huns], Budapest, 1940, edited by Gyula Németh. The Chinese sources were compiled by Lajos Ligeti (op. cit., 273–277). Outstanding works for defining Hunnish finds are: András Alföldi: *Leletek a hun korszakból és ethnikai szétválasztásuk—Funde aus der Hunnenzeit und ihre ethnische Sonderung*, ArchHung, IX (1932), and J. Werner: "Bogenfragmente aus Carnuntum und von der unteren Wolga," ESA (1932), 33–58. We owe the most comprehensive volume also to Werner: *Beiträge zur Archäologie des Attila-Reiches*, Munich, 1956. Several important observations on the golden bow of the Huns were made by Gyula László and János Harmatta. Harmatta: "The Golden Bow of the Huns," ActaArchHung, I (1951), 107–151; and Gyula László: "The Significance of the Hun Golden Bow," ActaArchHung, I (1951), 91–106. Thought-provoking observations will be found in F. Altheim's works (for example, *Attila und die Hunnen*, Baden-Baden, 1951) and in E. A. Thompson: *A History of Attila and the Huns*, Oxford, 1948. The critical edition of the Siberian gold finds is S. I. Rudenko's work in Arkh-SSSR, D. 3–9 (1962); on the cicada fibulae I quote a treatise by H. Kühn: "Die Zikadenfiebeln der Völkerwanderungszeit," IPEK, I (1935), 85–106, and with regard to the crowned kettles I have used my own material (László: *Études*).

THE AVARS

For basic works on the history of the Avars, the best information can be found in Dezső Csallány's survey of finds (*Archäologische Denkmäler der Awarenzeit in Mitteleuropa*, Budapest, 1956), and A. Kollatz's bibliography (*Bibliographie der historischen und archäologischen Veröffentlichungen zur Awarenzeit Mitteleuropas und des fernen Ostens*, Frankfurt, 1956). For Byzantine historical sources, see G. Moravcsik's monumental work: *Byzantino-turcica*, I–II, Berlin, 1958. For the first occurrence of the ethnic term Avar: G. Moravcsik: "Abaris, Priester von Apollon," KCsA, I (1935–1939), 104–118. For the gryphon-Avar relationship, see Samu Szádeczky-Kardoss: "Avarok és griffek

Priscosnál, Herodotnál és a régészeti leletanyagban" [Avars and Gryphons in Priscus and Herodotus, and in Archaeological Finds], *Antik Tanulmányok*, XIV (1967), 257–262. The problem of Heftalite origin is treated in "Heftaliták, hunok, avarok, onogurok" [Heftalites, Huns, Avars, Onogurs] by Károly Czeglédy, MNY L (1954), 142 ff. The archaeological material proper figures in Hampel: Alterthümer, as Third Group (Avars) and as Second Group (Sarmatian-Hunnish group). András Alföldi's series (Untergang) places Hampel's Second Group in the Avar Period, while Fettich [for example, Nándor Fettich and Arnold Marosi: *Dunapentelei avar sírleletek—Trouvailles avares de Dunapentele*, ArchHung, XVIII (1936)] and Dezső Csallány in his studies usually place the group in the Late Avar Period, suggesting that a "change in fashion" was responsible for it. My own study takes a different view (László: *Études*), on the grounds that these fundamental changes can be explained only by the incursion of a new people, whom I suppose to be the early Magyars or Hungarians [ActaArchHung, XVII (1965), 73–75]. I dealt with the appearance of Christianity among the Avars in "Die Reiternomaden der Völkerwanderungszeit und das Christentum in Ungarn," *Zeitschrift für Kirchengeschichte* (1940) 126–146; in Hungarian: "Újabb keresztény nyomok az avarkorból" [More Christian Vestiges from the Avar Period], DolgSzeged (1940), 145–158, and by András Alföldi: "A kereszténység nyomai a népvándorlás korában" [The Vestiges of Christianity in the Migration Period], *Szent István Emlékkönyv*, I, Budapest, 1938, 151–170. The quotation from G. Kossina may be found on page 218 of *Die Deutsche Vorgeschichte*, Leipzig, 1941 (where see also Plates 424 and 429). Important questions are discussed in the works of the following authors: Fettich: A honfoglaló magyarság fémművessége and Tibor Horváth: Az üllői és kiskőrösi avar temető. We also owe the elaboration of the Blatnica finds to Fettich: A honfoglaló magyarság fémművessége (Chapter IX). Basic works on the rinceau question are J. Strzygowski: *Altai-Iran und Völkerwanderung*, Leipzig, 1917 and Vol. II of András Alföldi's Untergang. For anthropomorphous motifs in the bronze casting of the Avar Period see Fettich: A honfoglaló magyarság fémművessége (Chapter II), and J. Dekan: "Les motifs figuraux humains sur les bronzes moulés de la zone danubienne centrale à l'époque précédant l'empire de la Grande Moravie," StudHistSlov, II (1964), 52–102. For the Mártély strap ends see Gyula László: "A mártélyi avar szíjvégről—Le bout de ceinturon avar de Mártély," FoliaArch, VIII (1956), 105–113, and "Contribution à l'archéologie de l'époque des migrations. I. Le ferret du bout de ceinturon avar de Mártély," ActaArchHung, 8 (1957), 165–172; for the Bánhalma strap end see the studies by Gyula Kaposvári and Viktor Szabó, Jászkunság, 1956, 166–174, 235–242. The comprehensive literature on the Daniel buckles can be found in Cabrol–Leclercq: Dict. d'arch. chrétienne, VI/2 (1925), 1814–1827. András Alföldi wrote on the Jug of St. Maurice: "Die Goldkanne von St. Maurice d'Agaune," *Zeitschrift für A. Schweiz. Arch. und Kunstgeschichte*, 10 (1948), 1–27.

THE SLAVS

J. Strzygowski wrote studies on Slav architecture (*Die altslawische Kunst*, Augsburg, 1929). Ibn Rusta's data on Swet-Malik was assessed by J. Marquart (*Streifzüge*, 1903, 468). The most recent works on the hair rings are Béla Szőke: *A honfoglaló és kora Árpád-kori magyarság régészeti emlékei* [The Archaeological Relics of the Hungarians of the Conquest and Early Árpád Periods], Budapest, 1962; Alán Kralovánszki: "Adatok az ún. S-végű hajkarika etnikumjelző szerepéhez" [Data on the Ethnical Role of the So-called S-ended Hair Rings], ArchÉrt, 83 (1956), 206–212; Károly Mesterházi: "Az S-végű hajkarika elterjedése a Kárpátmedencében"—Die Verbreitung des Haaringes mit S-Ende im Karpatenbecken—*A Debreceni Déri Múzeum Évkönyve*, 1962–1964, 95–113. Fettich's erroneous dating of the Darufalva find A késői hun fémműves-

ség and the cultural history of the find are further discussed by István Bóna: "A darufalvi ezüstkincs," *Soproni Szemle* (1962), 312–318; "Der Silberschatz von Darufalva," ActaArchHung (1964), 151–169.

THE ART OF ÁRPÁD'S MAGYARS

This section is mostly based on the results of recent Hungarian research. The basis of the prehistoric sketch is *Őstörténetünk legkorábbi szakaszai* [The Earliest Phases of Our Prehistory], Budapest, 1961, by Gyula László. (A summary in German appeared in "Congressus secundus internationalis Fenno-Ugristarum, Helsinki," 1965, Pars II, 35–40.) The statements on everyday life are based mostly on my books *A honfoglaló magyar nép élete*, and *Hunor és Magyar nyomában* [In the Wake of Hunor and Magyar], Budapest, 1967. I made considerable use of Fettich's works on the Conquest Period, *A honfoglaló magyarság fémművessége*, and István Dienes's recent researches "Honfoglaláskori tarsolyainkról—Les aumônières hongroises de l'époque de la conquête," FoliaArch, XVI (1964), 79–112. Ibn Abba's aphorism appears in M. Brion: *Art abstrait*, Paris, 1956. Zoltán Tóth's book *Attila's Schwert*, Budapest, 1930, was also very instructive.

IN PRAISE OF CRAFTS

A description of the goldsmiths' and silversmiths' graves in Hungary can be found in the following books: Fettich: *Az avarkori műipar Magyarországon. I. Fogazási ornamentika és ötvöseszköz leletek—Das Kunstgewerbe der Awarenzeit in Ungarn. I. Zahnschnittornamentik und Pressmodellfunde*, ArchHung, I (1926); and in Dezső Csallány: *A kunszentmártoni avarkori ötvössír—Goldschmiedegrab aus der Awarenzeit in Kunszentmárton*, Szentes, 1933. István Kovács reported on his excavations at Mezőbánd "A mezőbándi ásatások—Les fouillages de Mezőbánd," in *Kolozsvári Dolgozatok*, 1913, 265–429. A critical publication of the Tépe find was written by me: Gyula László: "A tépei lelet. Kiegészítő adatok Supka Ervin leletközléséhez,—La trouvaille de Tépe. Quelques additions à l'étude de Ervin Supka, ArchÉrt (1913), 395–408," ArchÉrt (1940), 77–90. The work of the Presbyter Theophylus is quoted from W. Theobald's edition (*Des Theophil. presb. Div. art. Sched.*, Berlin, 1933). Marc Rosenberg's observations were taken from *Geschichte der Goldschmiedekunst. Granulation*, Frankfurt, 1918. Attempts at ascertaining the technique of bronze casting may be found in Fettich: *Bronzeguss und Nomadenkunst*, Prague, 1929; József Huszka: *A magyar turáni ornamentika története* [History of the Hungarian Turanian Ornamentation], Budapest, 1930, and in István Erdélyi: *A jánoshidai avarkori temető* [The Avar Period Cemetery at Jánoshida], Budapest, 1958 (*Régészeti Füzetek* Ser. II. 1). S. I. Rudenko's standard work is "Sibirskaya kollektsiya Petra I," ArchSSSR, D. 3–9 (1962), 24–27. The totally abortive idea of deriving the rinceau and gryphon group from the Gepids was raised by Fettich in Vol. XVIII of ArchHung (Nándor Fettich and Arnold Marosi: *Dunapentelei avar sírleletek—Trouvailles avares de Dunapentele*.) For the section on the blacksmiths, the following books proved very useful: G. Heckenast, G. Nováki, G. Vastagh, and E. Zoltay: *A vaskohászat története Magyarországon 1400-ig* [The History of Metallurgy in Hungary Up to 1400], Budapest, 1968; Antal Bartha's observations in *Történelmi Szemle* (1961), 133–154; Emil Szegedy's oral communications, and Béla Pósta's excellent analysis of the Gyulafehérvár saber: DolgKolozsvár VII (1917), 5–15. On the bone carvings I. Erdélyi made some valuable comments in *A jánoshidai avarkori temető* [The Avar Period Cemetery of Jánoshida], *Régészeti Füzetek*, Ser. II. 1. 60–68 and my own observations should also be mentioned here [Gyula László: *A koroncói lelet és a magyar honfoglaló nyerge—Der Grabfund von Koroncó und der altungarische Sattel*, ArchHung, XXVII (1942)]. In the scant literature on

the pottery of the Migration Period little has been done since Tibor Horváth's pioneer work: *Az üllői és kiskőrösi avar temető*. Mention should be made of Nándor Parádi: *Technikai vizsgálatok népvándorláskori és Árpád-kori edényeken* [A Technical Examination of the Pottery of the Migration and Árpád Periods], *Régészeti Füzetek*, 12 (1959); Éva Garam: "A szebényi temető" — Die awarischen Gräberfelder von Szebény und die spätawarische, hellgelbe dünnwändige Scheibenkeramik," DissArch, 9 (1969), 63–65. Notable research on Late Avar pottery was done by D. Bialeková, Symposium, Nitra, 1966, 1–23. Remains of the burnished ornament technique and black pottery known from Roman times were first discussed in Alföldi's book on the Huns: *Leletek a hun korszakból*. Much of my knowledge of the glass industry, particularly bead-making, derives from the Moroccan material in the Ethnographical Museum of Neuchâtel and from Professor Jean Gabus's obliging verbal communications.

III. Mythology

THE TWO HUNTING BROTHERS

For this section mainly the following sources were used: A. Alföldi: "Die theriomorphe Weltbetrachtung in den hochasiatischen Kulturen," ArchAnz (1931), 393–418; an IGAIMK volume of 1937: "La reconstruction des couleurs primitives d'un tapis de Noin-Ula," S. V. Ivanov's large-scale work on the figurative art of the peoples of Siberia in TrudyInstEtnogr, N. S. XXII, Moscow, 1954 and another by the same author on the ornaments used by the peoples of Siberia in TrudyInstEtnogr, N. S. 81, Moscow, 1963. For the dating of the Scythian animal fights see K. Schofeld: "Der skythische Tierstil in Südrussland," ESA (1937), 1–78. I quote the Hungarian chronicles here, and elsewhere too, from E. Szentpétery's: *Scriptores rerum hungaricarum* (SRH), I–II, Budapest, 1937–1938. György Györffy's book is *Krónikáink és a magyar őstörténet* [Our Chronicles and Hungarian Prehistory], Budapest, 1948. The scene on the drinking horn of Chernigov is described on page 412 of László: *A honfoglaló magyar nép élete*. The sketch printed in this book was made after the original preserved in the Historical Museum of Moscow. I would like at this juncture to thank the directors of the Museum for their kindness. Concerning the shamanistic belief and the *táltos* rites, I can recommend the works of Vilmos Diószegi, whose research is based on the complete Soviet material, for example, *A sámánhit emlékei a magyar népi műveltségben* [The Remains of the Shamanistic Creed in Hungarian Folk Culture], Budapest, 1958. The Secret History of the Mongolians was published in Lajos Ligeti's translation and with his comments in Budapest, 1962. The full series of the Avar bone drawings was first published in my book (Études), 153–158.

THE TREE THAT REACHES TO THE SKY
(THE TREE OF LIFE)

The drawing on the Jar of Mokrin was first discussed in my *A népvándorláskori lovas népek ősvallásáról* [On the Ancient Religion of the Equestrian Peoples of the Migration Period], Kolozsvár, 1946. My interpretation was accepted, although Csallány has recently tried to challenge it in the Yearbook of the Móra Ferenc Museum, 1966, 72 ff., asserting that it is a meaningless children's drawing. His arguments will not stand up to scholarly criticism. Of the vast literature about the Tree of Life, mention should be made, in the field that interests us more closely, of a book by Uno Harva, *Die religiösen Vorstellungen*

der altaischen Völker, FFC, LII, Helsingfors, 1938. Parallels from Hungarian folklore to the World Tree of Mokrin were discussed by Sándor Szűcs in *Ethnographia,* LVI (1945), 23–25. An elaboration of the story motif of The Tree That Reaches to the Sky appears in Vol. III of *A Magyarság Néprajza,* 226 ff., by János Berze Nagy. For the representations of the bull-headed horses see O. Jansé: "Le cheval cornu et la boule magique," IPEK (1925), 60–72, and E. Oxenstierna: *Die Nordgermanen,* Stuttgart, 1957, Tables 48, 49, 65.

THE COSMIC DUEL

My views on the subject were first put forward in *A honfoglaló magyar nép élete,* Budapest, 1944. The literature of the Siberian gold plates can be found in Rudenko op. cit., ArkhSSSR, 3–9, 1962, the literature of the "Siberian gold plate" excavated west of the Volga, in V. Silov: *Soobschch. Gos. Ermitazha,* IX (1956). Further sources: Lajos Vargyas's op. cit., "Kutatások a népballada középkori történetéhez" [Researches into the Medieval History of Folk Ballads], II; *Ethnographia,* 1960, 479–523; a study by M. P. Gryaznov in *Sbornik Ermitazha,* 1961. For the literature on the untying implement (NB. *bogozó*) from the excavations by László Szekeres (Sekereš) at: *Seoba Naroda,* Zemun, 1962, 54. Comments on the Sword of Snartemo: *Norske Oldfunn,* VII, and B. Hougen: *Snartemo funnane,* Oslo, 1935. J. Werner, op. cit., deals in detail with the relations between Veszkény and Snartemo, although he does not mention the possibilities I raise in the text.

THE GREAT GODDESS

R. Bleichsteiner, "Zum eurasiatischen Tierstil," *Bericht des Asien-Arbeitskreises,* 2, Vienna, 1939, 9–47. R. Girshman: *Persia,* 1964, 42–47. (V. A. Rybakov: *Die Kunst der alten Slawen,* in: *Geschichte der russischen Kunst,* I., Dresden, 1957).

THE SON OF THE SUN

For the vast literature on the Nagyszentmiklós treasure see Banner–Jakabffy, I (1954), 445–447. I will quote here only the most important works directly used: J. Hampel: "Der Goldfund von Nagyszentmiklós," *Ungarische Revue,* 1885, 161–199; J. Hampel: "A nagyszentmiklósi kincs" [The Nagyszentmiklós Treasure], ArchÉrt (1884), 1–168; Riegl–Zimmermann: *Spätrömische Kunstindustrie,* Vienna, 1927; N. Mavrodinov: *Le Trésor protobulgare de Nagyszentmiklós,* ArchHung, XXIX (1943); Nándor Fettich: A honfoglaló magyarság fémművessége, Chapter IX, and Tibor Horváth: Az üllői és kiskőrösi avar temető, Chapter VI. All these authors put forward many new ideas on the subject. The division of the treasure into two table sets is discussed in Gyula László: "Jegyzetek a nagyszentmiklósi kincsről" [Annotations to the Nagyszentmiklós Treasure], FoliaArch, IX, (1957), 141–152, and "Contribution à l'archéologie des migrations des peuples," ActaArchHung, 8 (1958), 186–198. For the explanation of Jar No. 2 in the treasure, see György Györffy: *Tanulmányok a magyar állam eredetéről* [Essays on the Origin of the Hungarian State], Budapest, 1959, 107–119. On the find in the kurgan at Chaa Tash, L. A. Evtyukhov and S. V. Kisselev reported in Vol. III of *Kratkiye Soobshcheniya* (1940), 39–42. Parallels may be found in Camilla Trever: *Nouveaux plats sassanides de l'Ermitage,* Moscow-Leningrad, 1937. The Rakamaz find was first commented on by Dezső Csallány in ActaArchHung, 10 (1959), 281–325. For the Hungarian coronation scepter see Gyula László: "Adatok a koronázási jogar megvilágításához" [Data on the Coronation Scepter], *Szent István Emlékkönyv,* III, Budapest, 1939, 419–448.

Before finishing this bibliography, I must express my thanks to those who made the illustrations in this book more complete with the photographs of their unpublished finds. My thanks are due above all to Katalin Nagy, Margit Nagy, István Bóna, Sarolta B. Szatmári, Viktor János Szabó, and Péter Németh and especially to Éva Garam.

Appendix C.
List of Text Illustrations

(For abbreviations see the List of Abbreviations)

detailed analysis of the reconstruction based on grave finds and ethnographical parallels, see László, Gyula: ArchHung, XXVII, Plate 23.

46. Stamped patterns on Gepid vessels. Nagy, M., unpublished treatise, 1968.

47. Attempted reconstruction of the painted patterns on the jug found in Grave 130 of the Avar cemetery at Szeged-Kundomb. The drawing was made in the mid-1930s, and the paint has since come off. Fettich also saw something similar in the painting of the jug. See Fettich: ArchHung, XXI, 108.

48. Scene of fighting beasts on the Kul-Oba vase made by Greek craftsmen for the Scythians. Leningrad, Hermitage. Plate 198 in Minns, E. H.: *Scythians and Greeks*, Oxford, 1913.

49. Analytical drawing of the scene of the fighting beasts generally found on Avar strap ends. I drew the hoofed animal in the middle with a dotted line to distinguish it from the two rapacious gryphons. For the photo see *Plate 119* of this book.

50. Detail of the Chernigov drinking horn. Moscow, Historical Museum. Tolstoy–Kondakov: *Russkiye drevnosti* V (1897), 14 ff. I made the sketch from the original with the permission of the Moscow Historical Museum.

51. Detail of "Lehel's horn" in the Jász Museum at Jászberény. Tenth century. *Plates 182* to *189* of this book.

52. Bronze bridle from Luristan showing a fawn sucking an antlered hind. Ninth or eighth century B.C. Girshman, C. R.: *Persia* (1964), Plate 75.

53. Gilded silver breastplate ornament from the Seven Brothers kurgan. Leningrad, Hermitage. Compare, Minns, E. H.: *Scythians and Greeks*, Oxford, 1913, Plate 105.

54. Avar bone engravings: (a) Jutas, Grave 125. Veszprém, Bakony Museum; (b) drawing of an untying implement from Alpár. Kecskemét, Katona József Museum. Perished in the Second World War; (c) drawing of an untying implement in the Janus Pannonius Museum of Pécs; (d) drawing of a bone plate from Tiszaújfalu. Kecskemét, Katona József Museum. Perished in the Second World War. For a detailed analysis of the drawings see László, Gyula: ArchHung, XXXIV, 155–157.

55. Decoration on a bone jar from the Avar cemetery at Mokrin. For discussion see László, Gyula: *A népvándorlás lovas népeinek ősvallása* [Ancient Religion of the Equestrian Peoples of the Migration Period], Kolozsvár, 1946.

56a–b. Shaman drums. Nineteenth century. Altai region. Harva, Uno: FFC. LII, 15, and Plate 96.

57. The World Tree according to the Siberian Kets. Nineteenth century. Ivanov, S. V.: TrudyInstEtnogr, XXII, Plate 175. The interior of the World Tree and the lower row of animals are black; the other drawings are red.

58a–b. Tenth-century Norse stone crosses from the Isle of Man. Hencken, O'Neill: "A Gaming Board of the Viking Age," Acta Archaeologica, IV (1933), 85–104.

59. Drawing of a salt(?)-holder with bull-headed horses found in Grave 48 of the Sopronkőhida cemetery. See Török, G.: "Pogány kultusz emléke a sopronkőhidai temetőben—Evidence of a Pagan Cult in the Cemetery at Sopronkőhida," FoliaArch, XIV (1962), 83–98, Plates XIII to XV.

60a–c. Bull-headed horses in Norse art. Plates 29, 48, and 65 of Oxenstierna, E.: *Die Nordgermanen*, Plate 29: on a *bracteate* from Vadstena; Plate 48: on a *bracteate* from Asum (Skane); and Plate 65: incised, from the ornament of a stone memorial.

61. Drawing of the salt(?)-holder in Tata Museum. See Török, G.: FoliaArch, XIV (1962), Plates 1–2. My thanks are due to Sarolta B. Szatmári for the picture.

62. The St. Ladislas legend frescoes in the Unitarian Church at Sepsikilyén. According to the copies in the possession of the National Inspectorate of Historical Monuments.

63. Drawing of the right-hand part of a pair of the "Siberian gold clasps." For this drawing I used the analytical drawings in Gryaznov, M. P.: *Arkh. Sbornik Ermitazha*, 3 (1961), Plates 10–14.

64. St. Ladislas legend; the "rest scene." (a) Bántornya. Compare Stelé, F.: *Monumenta artis slovanicae*, I, 59–68, Plate XVII; (b) Erdőfüle. The frescoes were destroyed, the only surviving record being the copy of Gulyás, K. Karácson, B.: *A fülei ág. ev. templom története* [The History of the Calvinist Church of Füle], Kisújszállás, 1899, Plate I; (c) Zsegra. Painted over several times. The first layer can still be seen at the feet of the sitting girl. By courtesy of the National Inspectorate of Historical Monuments.

65. Parallels of the St. Ladislas legend: (a) the bronze plate from Ordos. László, Gyula: *A honfoglaló magyar nép élete*, XL, Plate 2, and Gryaznov, M. P.: *Arkh. Sbornik Ermitazha*, 3 (1961), Plate 3; (b) detail of a silver bowl from Kotsky Gorodok. László, Gyula: op. cit., Plates XLI to XLII, and Gryaznov: op. cit., Plate 2; (c) from the title page of the Augsburg edition of the *Thuróczi Chronicle*, 1488. László, Gyula: op. cit., Plate XL. 1.

66. (a) Bronze plate from Ordos, with horses biting at each other. László, Gyula: op. cit., Plate XLIV 1; (b) detail of the St. Ladislas legend fresco from Sepsikilyén. László, Gyula: op. cit., Plate XLIV 2.

67. Drawing of an untying implement from Pörös. First printed: Szekeres (Sekereš), L.: RAD, 1957, and Seoba Naroda, Zemun, 1962, 45, Fig. 3. The drawing was made from the original, and it presents the two figures and the horse in a different order from that in earlier prints. The view of the drawing on the untying implement is natural as it is represented in my drawing, and its story, too, makes sense only then. My thanks are due to László Szekeres (Sekereš), director of the Museum of Szabadka (Subotica), for giving me a chance to study the object.

68. Drawings of the hilt of the Snartemo sword according to the photograph shown in Plates I–II of Norske Olfunn, VII (1935).

69. The "sacred combat" at Snartemo, *Fig. 68*, and its counterpart from Kotskij Gorodok, *Fig. 65b*.

70. Ashi, the Goddess of Fertility. Luristan. Beginning of first millennium B.C. Girshman: *Persia*, Plate 47.

Appendix D.
List of Black and White Plates

The finds shown in the plates have been selected to give the reader a fair survey of the Migration Period and the Early Medieval Period in Hungary and the Carpathian Basin. However, this selection cannot be complete and cannot aim to be a substitute for some basic publications with illustrative material much richer than that in this book. Thus, to gain a fuller picture of the subject, the reader should refer to József Hampel's three-volume compendium *Alterthümer des frühen Mittelalters in Ungarn*, Braunschweig, 1905; the *Archaeologiai Értesítő*; the volumes of *Archaeologia Hungarica*; *Dissertationes Pannonicae*; *Folia Archaeologica*; and those of the provincial museums; and particularly *Acta Archaeologica Academiae Scientiarum Hungarica*, which appears also in foreign languages. In general, we include only finds that have been published before. A few scholars have offered their unpublished material, too, of which some selections are given here, although without the usual data, since this publication of such finds is only of an informative character.

1–2. Two phalerae from Biharugra. On the swastikalike pattern of the triple-partitioned openwork disk, the heads of birds of prey can be seen; the other is a quadruple-partitioned punched disk.
MNM, Inv. Nos.: 65/1929.13, 15. Diam.: 5.7 cm and 4.8 cm, respectively

3–4. Small bronze horse from the early Hallstatt period. Unknown provenance.
MNM, Inv. No.: 60/1951.17. Length: 8.2 cm; height: 6.5 cm

5–6. Scythian golden stag. Shield ornament from a cremation burial in the kurgan at Zöldhalompuszta. A thick, stamped, gold plate. The eyes of the collapsing stag are embossed with glass paste.
MNM, Inv. No.: 2/1929.1. Length: 37 cm

7–8. Electrum stag ornamenting a shield from Tápiószentmárton, from a kurgan cremation burial. A worthy counterpart of the classical golden stags found in southern Russia.
MNM, Inv. No.: 47/1923.1. Length: 22.7 cm

9–10. Scythian beads from Graves 34 and 35 of the cemetery at Vekerzug. These big, knobby, inlaid beads appeared in Hungary first with the Scythians, later with the Sarmatians of the Avar Period and the Hungarians of the Conquest Period (although these later beads were smaller in size).
MNM, Inv. No.: 53.51.87. Size of the large beads: 2.5 cm

11. Scythian strap end from Mátraszele, with an accumulation of animal figures. Found in a separate grave. Earlier it was considered to be a quiver ornament, but it was found in one of the cemeteries of Ananjino (Zuevo, Grave 168) at the end of a belt.
MNM, Inv. No.: 35/1931.1. Length: 11.5 cm

12. Scythian rattles with animal figures, with iron rattles in the openwork part. Their use has not yet been clarified (on top of carriage poles, flag poles, or at the end of the spikes found in shamans' graves?), although their artistic value does not lie in their use but in their exquisite proportions and mature forms, and, last but not least, in the pleasant sound of their rattles.
MNM, Inv. Nos.: 3/1929, 62.1.135. Height: 21 and 18 cm, respectively
The third piece is unpublished.

13. Two Scythian rattles showing deer.
MNM, Inv. Nos.: 64/1907.1, 65/1907.1. Height: 14 and 17 cm, respectively

14. Beads from the grave of a Sarmatian woman from Kiskőrös. Beads are characteristic grave furniture in female graves of the Sarmatian Period and are found in large numbers, worn mostly on the neck, on belts, on the wrists, or the hem of dresses. The acids in the earth have bleached the once iridescent glass-paste beads.
MNM, Inv. No.: 37/1950.14

15. Enameled Sarmatian fibula showing a roe from Jászmonostor. During Roman rule, in the areas inhabited by the Celts but mainly in Gaul, Celtic champlevé enamel survived. From there as export goods they reached Pannonia and the Sarmatian tribes, particularly in the first centuries of Roman rule.
MNM, Inv. No.: 80/1895.3. Diam.: 3.6 cm

16. Chalcedony beads in the shape of barrels from the Sarmatian Period, unearthed in the vicinity of Szarvas. These opaline stones, which are found in the Carpathian Basin, are easy to polish. The Sarmatians used ringed or barrel-shaped forms. Nothing is known of their makers or where they were made.
MNM, Inv. No.: 75/1893, 1567–1574

17. The vessels of the Sarmatian Period were fine pottery. Their evenly

fired clay still gives a tinkling sound when knocked. The shapes of these wheel-turned pots reflect the classic world of forms, with local and Ukrainian antecedents. (Grave 44, Csongrád.)
MNM, Inv. Nos.: 45/1893.121, 54.2.100. Height: 12 and 17 cm, respectively

18. Gratianus' large gold coin from the first Szilágysomlyó find. The series of masks welded on the rim were made with the same technique as that used for the small animal figures on the disked fibula of the second Szilágysomlyó find. This proves, among other things, that the two finds belonged together. Between the heads is filigree and granulated ornament, as on the fibulae of the second Szilágysomlyó find.
Vienna, Kunsthistorisches Museum, Inv. No.: M. 232478. Diam: 6.4 cm; weight: 57.96 g

19–21. The great princely necklace of the first Szilágysomlyó find. In the middle is a smoky-topaz sphere, and on each side of a *crater* rampant panthers can be seen. The pendants are vine leaves, with a whole collection of the tools of the period among them, tiny replicas of hunting weapons, fishing tools, and farming implements. The find is of unparalleled historical importance because it discloses the daily life at the turn of the fourth and fifth centuries.
Vienna, Kunsthistorisches Museum, Inv. No.: VII B 1.
Length (without the sphere): 17.75 cm

22. Lion-ornamented pair of fibulae from the second Szilágysomlyó find. The bow of the fibula is shaped by the embossed lion figure; at its feet a small animal can be seen. The edges are fringed with the ancient cymatium motif. The red of the stone inlay (pyro-garnet) also indicates royalty.
MNM, Inv. No.: 122/1895.5, 5a. Length: 15.3 cm

23. Detail of the lion-ornamented fibula from the Szilágysomlyó find.

24. Part of the pair of fibulae with animal heads from Szilágysomlyó. At the foot of the fibula, two composite, virtually heraldic animals can be seen; in the middle of the fringe is a boar's head flanked by the heads of birds of prey. The inlay is colored garnet; the surface is ornamented with granulation and beaded wire.
MNM, Inv. No.: 122/1895.7. Length: 13 cm

25. Part of the disk-shaped pair of fibulae from the second Szilágysomlyó find. The cover plate of the pure gold fibula is set with rock crystal encircled by a cloisonné ring of garnet. On the lateral plate lions can be seen jumping and, at the lower edge, cowering.
MNM, Inv. No.: 122/1895.8. Diam: 10.3–10.7 cm

26. Detail of the disk-shaped fibula.

27. Detail of part of the pair of enameled fibulae from the second Szilágysomlyó find. The fibula has a Celtic enamel covering encased in green and red brownish *pelta* patterns; the surface is enriched, in addition to the cloisonné garnet plates, by a spiked pattern laced of double wire thread. In the middle is a large oval cornelian. The fibula is cast in silver and plated with gold.
MNM, Inv. No.: 122/1895, 6–6a. Length: 12.3 cm

28–29. Omphalic cup of pure gold from the second Szilágysomlyó find. The cup, shaped like a spherical section, was made of 1-mm-thick plate.

On the rim are six inverted rhomboid figures, that is, six triangles each, following the usual ornamental method, and in the middle a six-petaled rosette. The dangling ring indicates that originally the cup was worn suspended from a belt, as were the drinking cups of the Nagyszentmiklós treasure and nomad drinking vessels in general.
MNM, Inv. No.: 122/1895.17. Diam: 10.3 cm

30. Large onyx fibula from the second Szilágysomlyó find. This finely polished oval onyx plate was applied to a cross-bow type fibula of Late Roman character. The onyx plate is surrounded by a row of cells with red, white, and green inlay. There is garnet inlay in the disk-shaped cells set in the onyx plate and glass and rock crystal inlay in the cells holding the structure.
MNM, Inv. No.: 122/1895.1. Length: 17.1 cm

31. Large onyx fibula from the Osztropataka find. It is closely related to the onyx fibula from Szilágysomlyó. It would seem that onyx, and perhaps the rock crystal too, had some spell-breaking—apotropaic—significance in the rites of the Germanic princely families.
Vienna, Kunsthistorisches Museum, Inv. No.: VII, B 30. Length: 15 cm; weight: 83.7 g

32. Silver sandal (?) mountings from the Osztropataka find. Gold objects were twice (1790, 1865) found at Osztropataka. The pieces of the treasure found in 1790 were taken to Vienna (Kunsthistorisches Museum); the second part to the Hungarian National Museum. Among the second part, very fragmentary sandal (?) mountings can be seen. The border of the silverplate is of "barbaric" character, whereas the flat field shows molds of Roman stamped patterns (bust and Sphinx).
MNM, Inv. No.: 69.2.7. Length: 17.5 cm

33–36. Shield boss from the Gepid princely grave at Herpály. In its ornamentation the "barbaric" and classical elements are alloyed as on the Osztropataka plates. Here, too, the ornamentation developed at the hands of local goldsmiths; the fighting beasts are perhaps a Celtic tradition, whereas the grylli preserve an old tradition.
MNM, Inv. Nos.: 9/1885, 38/1854. Height: 15.4 cm

37–38. Two bracelets of the princess of Bakodpuszta. At Dunapataj (the Avar princely find excavated here will be dealt with later) three female graves were found during fieldwork in 1859, presumably the graves of the female members of a Sciri princely family. The bracelets found in the grave of the princess exemplify the best traditions of Germanic cloisonné in the style of the south Russian masters.
MNM, Inv. No.: 19/1860.1. Diam: 8–8.8 cm

39. In the Rábapordány find, south Russian traditions are again alloyed with local and distant northern elements (for example, the amber beads). We have published here only the picture of the pair of fibulae.
MNM, Inv. No.: 16/1926.1–2. Length: 12.2 cm

40–41. Buckle from the Bácsordas find showing chip-carved rinceau and labyrinth ornament and animal figures as rim decoration. The antecedents of animal motif on the rim are found among the Scythians (see Mátraszele, *Plate 11* of this book) and Late Roman work. The buckle is cast of solid silver and gilt.
MNM, Inv. No.: 119/1907.1. Length: 14.9 cm

42. A pair of silverplate fibulae from Tiszalök. These large fibulae with a semicircular ending are generally believed to relate to the movements of the Ostrogoths. They are plain as a rule, but here at the axis an animal's head can be observed and underneath it are the heads of two birds of prey bending in a crescent.
MNM, Inv. No.: 12/1948.7. Length: 20.2 cm

43. Golden *bracteata* from Grave 21 of the Lombard cemetery at Várpalota. The cemetery was established by one of the most distinguished Lombard clans. There are also Avar graves in the cemetery. These *bracteatae* are northern imitations of Late Roman imperial images like those in the second Szilágysomlyó find *(see Plate 18 of this book)*. One can see clearly how the Roman pattern changed at the hands of the Germanic goldsmiths.
Veszprém, Bakony Museum, Inv. No.: 61.17. Diam: 2.1 cm

44. Detail of an ornamental hairpin from the Avar-Germanic cemetery at Környe. Gilded bronze cast. The body of the animal with the head of a bird of prey is composed of interlace.
MNM.
Unpublished. My thanks are due to Ágnes Salamon for permission to publish

45–46. Pair of gilt silver fibulae from the Lombard cemetery at Várpalota. Plate 45 is from Grave 19; Plate 46 is from Grave 13.
Veszprém, Bakony Museum, Inv. Nos.: 61.17.57 and 56.7.113. Length: 7.5 cm and 5 cm, respectively

47. Pair of fibulae from the Lombard cemetery at Bezenye. This is the oft-quoted pair of fibulae, from a grave with rich finds, on the reverse of which is a runic inscription. Interpretation of the inscriptions according to Hampel, J.: Alterthümer, II, 76: "Godahid" and "(w)unja," and "segun" and "Arispoba."
Mosonmagyaróvár, Hanság Museum, Inv. No.: 58.291.1–2. Length: 10.5 cm; width: 6.5 cm

48. Gepid and Hun pottery from the cemetery of Szolnok-Szanda. Incredibly diversified characteristics of form and ornamentation may be observed on the products of sixth- and seventh-century potters—burnished stamped ornament and a great variety of size and profile.
Szolnok, Damjanich János Museum.
Unpublished cemetery. My thanks are due to Ilona Kovrig for permission to publish.
The vessel in the background derives from the Lombard cemetery of Kápolnásnyék.
MNM, Inv. No.: 37/1931.1

49–50. Details of the fibula with runic inscription from Bezenye.

51–52. Strap end with silver inlay from the Avar cemetery (Grave 200) at Előszállás-Bajcsihegy. Silver inlay in the Avar Period points, in general, to Bayuvar or Aleman (?) population or silversmiths, as compared with the indented Germanic Animal Style II, which indicates the Germani, who lived here longer.
Székesfehérvár, István Király Museum.
Unpublished cemetery. By courtesy of István Bóna

53–55. Details from the Veszkény find. This find was long considered a Carolingian relic. Lately, according to J. Werner, it is thought to be of Lombard origin. In the find, anthropomorphic figures blend with ribbon-bodied pairs of animals. The technique is discussed in the text and analytical drawings.
Sopron, Liszt Ferenc Museum, Inv. No.: 59.1.1–37

56–57. Bone comb from the grave of a Germanic prince at Lébény. (End of fourth century or early fifth century.)
Mosonmagyaróvár, Hanság Museum, Inv. No.: 64.1–2. Dimensions: 6.5 × 8.6 cm

58. Gold strap end from the former Jankovich collection. The indentation shows the ornamentation of the Germanic Animal Style II.
MNM, Inv. No.: ORN.JANK. 49. Height: 4.8 cm

59–61. The Cundpald chalice. In shape it accords with late eighth-century Carolingian chalices. The gilded copper vessel is ornamented on its rim and foot. In István Bóna's opinion it belonged to a missionary bishop who fell into Avar captivity during Charlemagne's campaigns against the Avars.
Sopron, Liszt Ferenc Museum, Inv. No.: 57.17.1. Height: 11.8 cm

62–63. St. Stephen's sword, ornamented with ivory. It figures in the Inventory of Prague Cathedral, dated 1355, as "gladius beati Stephani regis Ungariae, cum manubrio eburneo," and the type of the sword also corresponds to the end of the tenth century. On the ivory mounting of this sword from Ulfberth's workshop, Norse ornamentation of the transition period from the Jellinge to the Ringerike style can be seen.
Prague, St. Vitus Cathedral. The present length of the sword is 75 cm.

64. Silver inlaid sword found in the Danube bed at Budapest.
Budapest, Historical Museum, Medieval Department 475. Hilt: 13 cm; blade: 82 cm long, 5 cm wide

65. Bronze cauldron from Törtel. The rim of the huge bronze vessel is ornamented with a row of semicircular pseudofibulae and pendants. Large bronze cauldrons like this spread from Central Asia to the Rhine, undoubtedly as a result of the Hun migration.
MNM, Inv. No.: 22/1896.1. Height: 88 cm

66. Pendant of a crown from the Omharus find found at Apahida. The burial finds are kept in the Transylvanian National Museum at Kolozsvár (Cluj); but, two pendants were sent to the MNM in 1897. This piece, ornamented with garnet inlay and animal heads, bears the imprint of Germanic goldwork and silverwork or, rather, the goldsmith's tradition of southern Russia.
MNM, Inv. No.: 27/1897.1. Length: 15 cm

67–68. A Coptic bronze lamp from Tápiógyörgye. Originally, it stood on a high bronze stand. Parallels are known from coptic times from the fifth century on. Presumably it came to Hungary as trade with Byzantium picked up in the Hunnish Period and through other contacts.
MNM, Inv. No.: 13/1938. Length: 21.4 cm

69. "Popular" cicada fibula cast in bronze and chiseled.
Provenance: Szatmár.
MNM, Inv. No.: 12/1897/1. Height: 8.1 cm

70. Cicada fibulae from Györköny. Cast in silver and gilt. As on Germanic jewelry of the period, the eyes and mouth are highlighted by almandine

inlay. Cicada fibulae are found on the whole over the same area as the Hunnish cauldrons. (Compare Kühn: IPEK, I (1935), 88, Plate 21.)
MNM, Inv. No.: ORN.JANK. 47–48. Height: 7 cm

71–72. Diadem from the Hunnish Period found at Csorna. We can observe perhaps the most interesting feature of the Hun goldsmith's craft in the following: in contrast to the strict geometry of the Germanic goldsmith's stone inlay, the Hun goldsmith and silversmith adapted himself to the shape of the precious stones and did not fill up the surface at his disposal but arranged the stones at random.
MNM, Inv. No.: 55.36.1. Length: 26.5 cm

73. Gold cup from the finds of the Hunnish princely cremation grave at Szeged-Nagyszéksós. The openwork gold cup should be imagined in the pattern of the Chosroe bowl (Paris, Bibliographie Nationale). The bowl was originally decorated with glass and polished stone inlay. There is an inscription in Greek characters on the inside surface of the base of the vessel.
MNM, Inv. No.: 4/1926. Height: 10.9 cm

74. Details of the finds from the princely cremation grave at Szeged-Nagyszéksós. The grave was found by chance, and a great part of the finds had perished by the time a proper excavation could be started. However, the detailed photographs and color plates shown here include all the aspects of the goldsmiths' and silversmiths' techniques of the Hunnish Period, such as stone inlay, stamping, casting, the use of beaded wires, and so forth. The greater part of these techniques are identical with those used by contemporary Germanic goldsmiths and silversmiths, inasmuch as both carried on the traditions of the south Russian workshops.
Szeged, Móra Ferenc Museum, Inv. No.: 4/1926.

75. Basket-shaped earrings from the great cemeteries at Keszthely. In part of these cemeteries on the outskirts of Keszthely, which were unfortunately excavated by amateurs, remains of the ancient population of the Roman Period or perhaps later immigrant Romanicized peoples were found. Among the fine pieces they left behind are these giant basket-shaped earrings, which are barbaric imitations of the small jewels of Late Roman times.
MNM, Inv. No: 27/1884. Diam: 5 to 6 cm

76–77. Bossed beads of many colors from the Early Avar Period. This kind of bead, the antecedents of which can be traced back to Scythian-Sarmatian times, is a typical find in female graves of the Early Avar Period. The glass paste became porose and faded underground.
Szentes, Koszta József Museum, Inv. No. (inner row): 55.29.6–19; (outer row): 55.36.35–78.

78–79. Disk-shaped fibula showing the apotheosis of an emperor. From the vicinity of Keszthely. Although the iconography is undoubtedly ancient and its interpretation—in that period—is presumably Christian, the fibula was a local product and not an imported piece. Proof of this is the indentation we know so well from the Hungarian remains of the Germanic Animal Style II.
MNM, Inv. No.: 119/1882.130. Diam: 5.7 cm

80–81. Disk-shaped fibula from the Keszthely cemeteries. It represents Bellerophon, the killer of the Chimera, with an obvious allusion to St. George. Disk-shaped fibulae and basket-shaped earrings are the legacy of a whole people, and it cannot be mere chance that their finding places in Transdanubia, in the vicinity of Keszthely and Pécs, indicate the survival of Late Roman culture.
MNM, Inv. No.: 61.72.1. Diam: 4.8 cm

82. Stamping molds from the goldsmith's grave of Adony. The most characteristic finds in the goldsmiths' and silversmiths' graves in Hungary are stamping molds cast of solid bronze, which also show the form and ornamentation of the mountings on Early Avar belts.
MNM, Inv. No.: 99/1880.1, 3–6, 9–12. Length of the bigger strap end: 6.1 cm

83–84. The goldsmith's grave found at Kunszentmárton includes the richest tool and stamping mold find in Hungary; several "barbaric" ornamental molds of a Byzantine character, complicated but done with a sure hand, testify to the maturity of the goldsmith's skill. Two of these are shown here greatly enlarged to bring out the detail.
Szentes, Koszta József Museum, Inv. No.: 55.40.1. Height: 7.5 cm

85. The grave of an Avar prince's daughter at Kiskőrös-Vágóhíd (Grave VIII). The neck of the girl, who was a few years old, was adorned with a collar interwoven with gold thread from which hang five almandine pendants and tiny bells.
MNM, Inv. No.: 12/1935.2–6, 9. Length of the large almandine-ornamented pendant: 4.3 cm

86. Pseudobuckle from the *khagan* find at Tépe. Unfortunately only a very small fragment of the find is extant—a pseudobuckle, one-quarter of a silver bowl, the hilt mounting of a dagger, and a silver chalice—although judging by the pseudobuckle (the most exquisite among all known specimens found in Eurasia), the find may have been as rich as the Poltava find (Pereshchepina).
MNM, Inv. No.: 65/1912. Length: 5.2 cm

87. Gold cup from the Avar princely find at Bócsa. A vassal of the *khagan* of Tépe may have been the chieftain whose solitary grave was found by chance in 1935. Nevertheless, the find can be said to be complete. The prince had a double belt with gold ornaments, a quiver with golden mountings, a sword, a drinking horn, and a cup, and his rank was indicated by twenty-five arrowheads. Similar cups of silver have been excavated from many princely graves of the Avar period.
MNM, Inv. No.: 7/1935.14. Height: 8.5 cm

88. Avar imitations of Byzantine solidi. It was an outstanding numismatist, the late Elemér Jónás, who noticed that attempts had been made in Hungary to mint Byzantine solidi, which meant an effort in the period to switch over to independent minting. These solidi from the period of Heraclius, Constantinus II, and Constantinus Pogonatus VII were the imitations of those solidi—identical in weight, but barbaric in design.
MNM, Numismatic Department

89–91. Detail of bone carvings from the Avar Period. Bone carvings of many diversified forms have been found in the graves of the Early and Late Avar Periods. Most frequent in the female graves are the bone tubes for holding needles and in the men's graves the untying implements. The carvings shown represent contemporary turning techniques and the patterns with animal heads.

The needle case: Homokmégy, Grave 82
MNM, Inv. No.: 25/1932.17.
Szeged, Móra Ferenc Museum.
Carving in the shape of a duck's head: Fehértó, Cemetery B, Grave 23.
The untying implement *(bogozó)*: Kiskőrös-Cebe
Unpublished

92. Bone carving of an Avar quiver from Dunapentele. The background of the richly undulating scrolls was obviously painted so that the pattern would stand out clearly.
MNM, Inv. No.: 73/1908. Length: 13.7 cm

93. Strap end ornamented with ribbon interlace from the Avar cemetery at Homokmégy-halom. Many variants have been found of the ribbon interlace on straps and, in general, on the belt mountings of Avar men. Until now, only the Germanic influence on these belts has been the subject of research, but interlace ornament spans very great distances in time and place, so we can decide where they come from only if we are acquainted with the concrete circumstances connected with them.
MNM.
Unpublished. Gyula László's excavation

94. Avar pottery from the cemetery at Csákberény. In this, one of our richest Early Avar cemeteries, there are traces of many ancient traditions, both in the shape of the vessels and the technology of pottery, as these specimens show.
Székesfehérvár, István Király Museum.
Unpublished. Gyula László's excavation

95. A silver plate from the Avar Period showing an eagle tearing at a fish. The iconographical antecedents of this scene go back to Scythian times; originally, perhaps, they figured in the ancient emblem of Olbia. In the Avar Period they appeared again, particularly in the south Russian stratum of the Avars. Originally, this piece may have been a pendant. The idea that it was an ear flap on a helmet—in which case the picture was upside down—is erroneous.
Szeged, Móra Ferenc Museum, Inv. No.: 1/1884. Width: 6.5 cm

96. Late Avar strap end with plant ornament. Found at Tápé.
Szeged, Móra Ferenc Museum.
Unpublished. Excavated by Alajos Bálint

97. Late Avar strap end with plant ornament. From Csongrád-Mámai-dűlő.
Szentes, Koszta József Museum, Inv. No.: 55.21.1. Length: 18.3 cm

98. Reverse of a Late Avar strap end with rinceau ornament. Found at Klárafalva. (Obverse side shown in *Plates 125 and 126* of this book.)
Szeged, Móra Ferenc Museum, Inv. No.: 53.44.1. Length: 9.3 cm

99. Late Avar strap end, with rinceau composition.
Szeged, Móra Ferenc Museum.
Unpublished

100. Late Avar strap end with rinceau composition. Szeged-Öthalom.
Szeged, Móra Ferenc Museum, Inv. No.: 1/1884. Length: 7.1 cm; width: 1.9 cm; thickness: 0.35 cm

101. Late Avar strap end with rinceau composition.
Szeged, Móra Ferenc Museum.
Unpublished

102. Late Avar finds from the cemetery at Székkutas.
Hódmezővásárhely, Tornyai János Museum.
Unpublished. Excavated by B. Katalin Nagy. By courtesy of B. Katalin Nagy

103. Finds from the Avar cemetery at Szeged-Kundomb, Grave 285.
Szeged, Móra Ferenc Museum, Inv. No.: 53.1.831

104–107. Enlarged picture of the obverse and reverse of the Mártély strap end. Iconography unsolved.
MNM, Inv. No.: 95/1891. Original length of strap end: 11 cm

108–109. Late Avar strap end from the cemetery at Nagymágócs-Ótompa, with a row of gryphons facing right.
Szentes, Koszta József Museum, Inv. No.: 55.37.2. Length: 13 cm

110. Belt mountings ornamented with gryphons of Szentes-Lapistó. The three mountings are notable for their "insignificant differences," which could not have come about if an identical casting mold was used (note the wings, tail, beak). The differences must be due to a "retouched" wax cast.
Szentes, Koszta József Museum, Inv. No.: 55.22/A90. Height of the mountings: 5.4 cm

111. Gilded bronze belt mounting from the great Avar cemeteries at Keszthely.
MNM, Inv. No.: 62.133.1. Length: 3.5 cm

112. Strap end ornamented with boar's head, from Nemesvölgy (Edelstal, Austria).
MNM, Inv. No.: 161/1885.1. Length: 9.6 cm

113. Cast and chiseled horse's head, from Böcs. A pure survival of the Scythian tradition, however, the modeling resembles the bull-headed bowl in the Nagyszentmiklós treasure. (See *Plates 157 and 158* of this book.)
MNM.
Unpublished

114–118. Large strap end from the Nagysurány cemetery. Plate 117 shows the canvas imprint of the reverse. (Greatly enlarged.)
MNM, Inv. No.: 106/1884. Length: 9.3 cm
Plate 118 is a canvas imprint of the reverse of the Siberian gold finds. Similar processes can be found later among the Normans. (Reproduced from Rudenko, S. J.: *Sibirskaya kollektsiya Petra I,* Leningrad, 1962, Plate 25.)

119. Late Avar strap end showing fighting beasts from Dévaványa.
MNM, Inv. No.: 3/1937.1. Length: 11.7 cm

120. Late Avar strap end showing fighting beasts. (Klárafalva, Cemetery B, Grave 11.)
Szeged, Móra Ferenc Museum.
Unpublished

121. Late Avar strap end showing fighting beasts.
MNM, Inv. No.: 61.78.3. Length: 11.8 cm

122–124. Details of the strap end shown in *Plate 121*, greatly enlarged.

125–126. Strap end from Klárafalva, showing a hunting scene. The galloping movement of the horse is a characteristic Iranian motif.
Szeged, Móra Ferenc Museum, Inv. No.: 53.44.1. Length: 9.3 cm. (For reverse, see *Plate 98* of this book.)

127. Detail of a strap end from Bánhalma showing *senmurv* hunters.
Szolnok, Damjanich János Museum, Inv. No.: 54.6.1. Length: 11.9 cm

128–131. Strap end from Grave 32 in the Avar cemetery at Kecel, with fighting beasts and a human-headed lion.
MNM, Inv. No.: 7/1933.30. Length: 11.2 cm

132–133. Belt mountings, greatly enlarged, from the Balatonszőlős cemetery. The horseman shown in the disk-shaped mounting may be associated with both the horseman in the Nagyszentmiklós treasure (see *Plates 146 and 147* of this book) and Sassanid representations of horsemen.
Veszprém, Bakony Museum.
Unpublished. Excavated by Péter Németh. By courtesy of Péter Németh

134–135. Pair of golden clasps from the Avar Period found at Dunapataj. The cover was once ornamented with stone inlay and strung beads. Similar pairs of clasps have been found in female graves of the Late Avar Period, and for this reason Tibor Horváth (ArchHung, XIX [1935], 61 ff. and Plate XLVIII) dates this solitary pair of gold clasps to the Late Avar Period.
MNM, Inv. No.: 138/1870. Length: 11 cm

136. Detail of a silver-inlaid Avar pair of stirrups. From Csabrendek.
Keszthely, Balaton Museum, Inv. No.: 58.15.1. Dimensions: 16.9×11.7 cm

137. Ninth-century salt (?) holder made of antler, from Tatabánya.
Tata, Kuny Domonkos Museum.
No detailed publication has been made as yet.

138. Ninth-century salt (?) holder made of antler, from Sopronkőhida.
Sopron, Liszt Ferenc Museum, Inv. No.: 62.24.85. Length: 17.6 cm

139. Late Avar pottery. Similar wheel-turned forms and firing methods to those found in Late Avar-Carolingian pottery occur in the East. These vessels are from the pieces of the Late Avar cemetery at Keszthely-Fenékpuszta.
MNM.
Unpublished. Excavated by Gyula László

140. Earring from Zalavár.
MNM, Inv. No.: 53.18.7/A. Length: 7 cm

141–144. Sword, belt mountings, and trappings from the Blatnica find.
MNM, Inv. No.: 241/1876. Length of sword (hilt and blade): 69.5 cm

145. "Attila's sword" or "Sword of Charlemagne" in the Vienna Schatzkammer, among the coronation jewels of the Holy Roman Empire.

German tradition—which seems of modern origin—considers it to be Harun al-Rashid's gift to Charlemagne. (Actually, the saber is more recent.) Early German tradition links the sword with the Árpáds and Jordanes' legend of "Attila's sword." At present, it is thought the sword was made by Hungarian armorers at the end of the ninth century or in the early tenth century.
Vienna, Schatzkammer, Inv. No.: 162. H. Fillitz. Katalog der weltlichen und der geistlichen Schatzkammer, Vienna, 1956. Length: 90.5 cm

Details of the Nagyszentmiklós treasure.
Plates 146–162.
Vienna, Kunsthistorisches Museum

146–147. Armor-clad "victorious prince" on Jar 2 as he rides with his prisoner and the head of a vanquished enemy.

148–149. Hunter riding a winged lion with a human head on Jar 2.

150–151. The "ascension" scene on Jar 2. Eagle carrying off in his claws a girl holding palmette flowers in each hand.

152–153. Gryphon attacking a collapsing roe on Jar 2.
Inv. No.: VII B 33. Height: 22 cm

154–156. Jar 3.
Inv. No: VII B 2. Height 21 cm
Jar 6.
Inv. No.: VII B 28. Height: 23.5 cm
Jar 7.
Inv. No.: VII B 40. Height: 22.5 cm

157–158. Drinking vessel (No. 13) with an animal's head. The stylization of the head is an exquisite example of steppe art. (Compare the horse's head from Böcs, *Plate 113* of this book.)
Inv. No.: VII B 10. Length: 12.7 cm

159–160. Ornament on the middle disk of a shallow cup (No. 21). Usually suspended from belt. Inside and bottom view. Enamel should be imagined in the cells of the cross of the internal view.
Inv. No.: VII B 34. Diam: 12 cm

161–162. "Dessert bowl" (No. 19). Between the miraculous beings on the disks is a layer of glass paste. Presumably, enamel was once in the cells of the ornament.

163–164. Ornamental disks from a rich female grave at Rakamaz. The disks decorated the leather straps hanging from the headdress. The connection, in content and form, between them and jars 2 and 7 of the Nagyszentmiklós treasure is unmistakable.
Nyíregyháza, Jósa András Museum, Inv. No.: 64.875.6–7. Diam: 8.2–8.3 cm

165. Detail of purse plate, showing unmistakable influence of textile antecedents.
Túrkeve, Museum.
Unpublished. By courtesy of János Szabó

166–168. Purse plate from a clan chief's grave (Grave 8) in the Conquest Period cemetery at Bezdéd. In the middle of the palmette composition

is a cross, with legendary animals on each side. The clan chief was buried, according to the pagan rite, along with a horse hide, which makes the Christian interpretation dubious.
MNM, Inv. No.: 86/1896.235. Height: 13.7 cm

169. Purse plate from a horseman's grave at Szolyva. The upper rim is decorated with a textilelike pattern; the background of the surface ornament, a clear, cool composition of palmettes growing out of one another, is gilt. Single-plane design.
MNM, Inv. No.: 148/1897. Height: 12.5 cm

170. Purse plate from a horseman's grave at Bana. On the gilded silver plate is an infinitely unfolding palmette pattern.
MNM, Inv. No.: 59.3.1.A. Dimensions: 11.6×11.5 cm
Only a picture of it has been published.

171. Detail of a purse plate from a Conquest Period horseman's grave at Galgóc. Infinite interlace pattern of looping and meandering bands. A silver *dirhem* minted in Samarkand in 918–19 dates the plate.
MNM, Inv. No.: 42/1871.3. Height: 12.5 cm

172. Purse plate from horseman's Grave 3 at Eperjeske. The design, drawn with bravura and built on a central axis, remains on a single plane. The background is gilt.
Nyíregyháza, Jósa András Museum, Inv. No.: 64.879.2. Dimensions: 13.1× 11.8 cm

173. A product of the blacksmith's craft in the Conquest Period: bridles from Muszka.
MNM, Inv. No.: 45/1898.9

174. Pair of Byzantine earrings from Grave 1 (female) in the Conquest Period cemetery at Kecel.
MNM, Inv. No.: 3/1935.1. Height: 4.4 cm

175. Bracelets from female graves of the Conquest Period.
1. Sarkad. *MNM, Inv. No.: 1/1927.3. Diam: 6.8 cm*
2. Mezőzombor. *Miskolc, Herman Ottó Museum, Inv. No.: 62.27.11. Diam: 7.3 cm*
3. Egyek. *MNM, Inv. No.: 31/1860.7. Diam: 6 cm*
4. Heves. *MNM, Inv. No.: 3/1938.4. Dimensions: 7×6.5 cm*
5. Egyek. *MNM, Inv. No.: 31.1960.7. Diam: 6.2 cm*
6. Nagykáta. *MNM, Inv. No.: 32/1892.1. Diam: 6.3 cm*

176. Gold bracelets from the Conquest Period, found at Zsennye.
MNM, Inv. No.: 2/1928.1–2. Diam.: 7.9 cm

177. Gilded silver belt mountings from the Conquest Period, found at Karancslapujtő.
MNM, Inv. No.: 16/1939.1–2. Buckle: length, 9.1 cm; width, 3.8 cm

178. Trappings from a female grave at Balotaszállás-Felsőbalota, Szeged-Bojárhalom.
Kiskunhalas, Thorma János Museum.
Unpublished. Excavated by István Dienes

179. Mountings from a rich female grave at Szeged-Bojárhalom.
Szeged, Móra Ferenc Museum, Inv. No.: 14/1890

180–181. Two sides of the strap end from Benepuszta. Ladánybene-Benepuszta.
MNM, Inv. No.: 9/1846. Dimensions: 2.6×4.4 cm

182–189. "Lehel's horn." Tenth-century Byzantine work. The horn was used to open the circus games. The raised hand of the emperor was the opening signal of the ceremonies, and the entire program of the games is shown in the symbols inscribed on disks and the interchanging scenes on the bands, enclosed by a row of jugglers. The loose patterning of the banded straps indicates that the maker of the horn came from the Northern Balkans or the Carpathian Basin, where he may have learned the interlacing motif. Hungarian legend links the horn to the name of Chieftain Lehel.
Jászberény, Jász Museum. Length: 43 cm

190, 192–193. The Hungarian coronation scepter. The rock crystal ball, which is tenth-century work from Fatimid Egypt, shows three cowering lions. Even the form of the scepter is typical of Oriental regalia. It is the oldest of the Hungarian coronation symbols and may have been kept in the Árpáds' treasury. Its present whereabouts—after being removed to the West in 1945—is unknown.

191. The symbols, in the Western sense, of the formation of the Hungarian State are these first coins, the fine obuli minted in the Regensburg fashion. It is not known whether the inscription on these coins— Stephanus Rex—refers to Prince Stephanus-Géza (970–97) or King Stephanus-István (St. Stephen, 997–1038).
MNM, Numismatic Department

Appendix E.
List of Color Plates

I Golden stag from Tápiószentmárton. Scythian find, fourth century. It was a shield ornament, and presumably a clan sign or princely symbol. *MNM, Inv. No.: 471/1923.1. Length: 22.7 cm*

II Disk-shaped fibula from the Sarmatian Period, third century. In the costumes of Sarmatian women, besides the faded glass-paste beads and smoky white chalcedony beads, enameled fibulae provided a splash of color. Archaeologists consider this a Celtic tradition and indeed the fibulae are found in Romanized territories with a Celtic population. The fibulae reached the Sarmatians on the Great Hungarian Plain presumably as trade wares. *MNM, Inv. No.:75/1893.1257–61. Length: 4.1 cm*

III Details of finds in a Hunnish prince's cremation grave at Szeged-Nagyszéksós. The grave was found by agricultural laborers and was "exploited" for years before archaeologists heard of it. But even so, large quantities of golden dress and weapon ornaments and jewels were given to the museum. The blend of gold and red garnet is aesthetically impressive, too, although originally the colors were merely a sign of power. *Szeged, Móra Ferenc Museum, Inv. No.: 4/1926*

IV Detail of the second Szilágysomlyó find. The pieces of the collection are excellent examples of the various techniques (stone inlay, granulation, Pressblech, and so forth) used by the goldsmiths who made the treasure. The forms of delicate proportions reflect also the refined artistic taste of the craftsmen. *MNM*

V Golden buckle from the former Jankovich collection. The objects represent the indented variety of the Second Germanic Animal Style. A variant of the same theme is at Bezenye, with its two beasts standing back to back. *MNM, Inv. No.: ORN.JANK. 51. Length: 5.5 cm*

VI Pommel mounting from the former Jankovich collection. In the northern parallels of this piece, we always find two beasts facing each other (again the projection into two parts), so this boar-headed bird also had a mate. The Germanic Animal Style II—brows breaking at right angles—is blended here with an Oriental stone inlay. *MNM, Inv. No.: ORN.JANK. 49. Length: 5 cm*

VII Oval belt mounting from a prince's grave at Bócsa. Besides being an exquisite piece of art, its bluish green inlay indicates that its wearer did not wield supreme power. Moreover, although the mounting had no symbolic value on the belt (unlike the pseudobuckle), it was nonetheless placed on the belt, implying that it had the same significance as the pseudobuckles. It seems that on the Bócsa belt the number of mountings had a significance; six pseudobuckles to denote dignity and rank and the number of mountings indicated perhaps the place occupied by the wearer in the clan. The question remains to be solved. *MNM, Inv. No.: 7/1935.4. Length: 2.8 cm*

VIII Inlaid, bossed beads of the Early Avar Period. These fine multicolored beads follow an ancient tradition and also are found among the Scythians. The same kind of bead is still made by Moroccan women with very primitive tools and methods, so it may safely be said that such beads were not imported goods, even in the Avar Period, but were made by the Avar women themselves. Apparently, the more skillful women produced them in series. *MNM, Inv. No.: 12/1934.82*

IX Pseudobuckle from a prince's grave at Bócsa. More or less the same thing happened to the pseudobuckles as to the other regalia: the helmet changed into a crown, the spear into the Holy Spear, the mace into a scepter, etc. The number of buckles once indicated the size of the "fortune" hanging from them: by the Avar Period, and in fact even in the Hunnish Period, only the form of the buckle was preserved, the identity of structure masking a fundamental change of function. *MNM, Inv. No.: 7/1935.2. Length: 4.6 cm*

X A specimen of Late Avar painted pottery excavated in the southern part of the Great Plain. For the cemetery at Székkutas see *Plate 102*. *Unpublished. Katalin Nagy's excavation material now in the Tornyai János Museum at Hódmezővásárhely*

XI Avar openwork strap end; finding place unknown. In this Tree of Life-type composition based on a central axis, an accurate observation of nature (grapes) blends with the pure ornament of the leaves to produce an effect of great beauty. Such openwork strap ends testify to the high artistic level and technical skill of the Avar goldsmiths, silversmiths, and bronze casters. *MNM, Inv. No.: 55.88. Length: 14.2 cm*

XII Gilded bronze mounting with pendant, from Keszthely. In Hungarian archaeological literature the view is often voiced that this exquisite mounting is a "degeneration" of the gryphon motif, that is, it dates from a rather late period. I am inclined to think that, far from being degenerate, this piece testifies to an exceptional sense of form and style, the like of which occurs nowhere else, and so cannot be an abortion of some previously more satisfactory form. What we have here is a unique work of art, something that represents the individual in the impersonal art of the Migration Period.
MNM, Inv. No.: 62.133.1–2. Length: 7 cm

XIII Detail of the purse plate from Bezdéd. The copper purse plate was fired with a thick coating of gold which made the whole purse plate shine. The decorative effect was produced by chasing and punching rings in the surface of the background; the purpose of the chasing was to emphasize the light and shade effect. Another way of bringing out the design was to paint the background in a different color.
MNM, Inv. No.: 86/1896.235. Diam.: 13.7 cm

XIV Purse plate from Szolnok-Strázsahalom. Vigorous linear design, partly chased, in silverplate. The gilt background serves to emphasize the patterning. The light and dark effect and gilt background possibly indicate the patterns were taken from two different sources, the chasing deriving from leatherwork, the background from textile antecedents.
MNM, Inv. No.: 58/1912. Diam.: 14.4 cm

XV Detail of "Lehel's horn." (See also *Plates 182* to *189* of this book.) This horn unites in a condensed form the predominant artistic trends in the tenth century. The interlacing disks on the rim are of Persian origin, the motif of the boy drawing a thorn out of his foot is classical, and the cock beside him is a characteristic symbol of Asia Minor. At the top, the superficies of the horn is framed by a loose interlace ornament of a northern, "barbaric" character. Beneath unfolds the program of festival games represented. In the present detail we see a company of warriors carrying shields; the warriors are engaged in running on their knees. They are wearing a skirt reminiscent of modern Greek male folk dress.
Jászberény, Jász Museum

XVI Detail of "Lehel's horn." One element in the festival games in the hippodromes and circuses must have been the serious or mock revival of the circus games of antiquity. Here centaurs are seen grappling with each other. The reticular intertwining of the figures can easily be observed here: parts of the high relief touch at some points and serve as points of support, but at the same time they weave the design into an ornamental pattern.

PLATES

1–2. Phalerae from Biharugra. Pre-Scythian Period. MNM

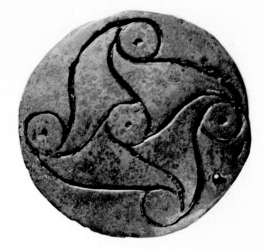

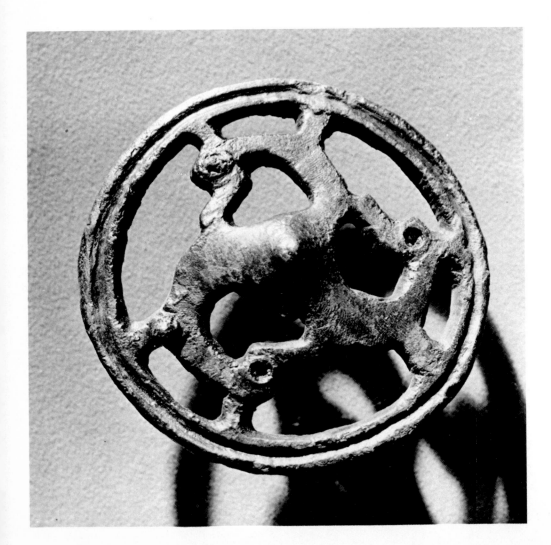

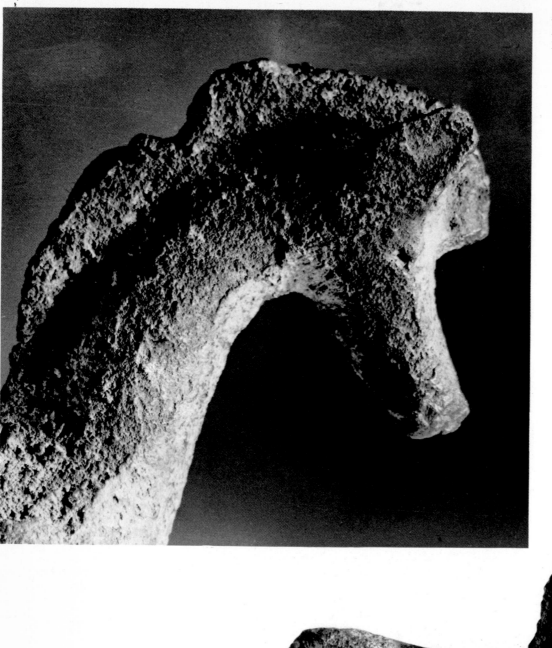

3. Small bronze horse.
Early Hallstatt Period.
MNM

4. Small bronze horse. Early Hallstatt Period. MNM

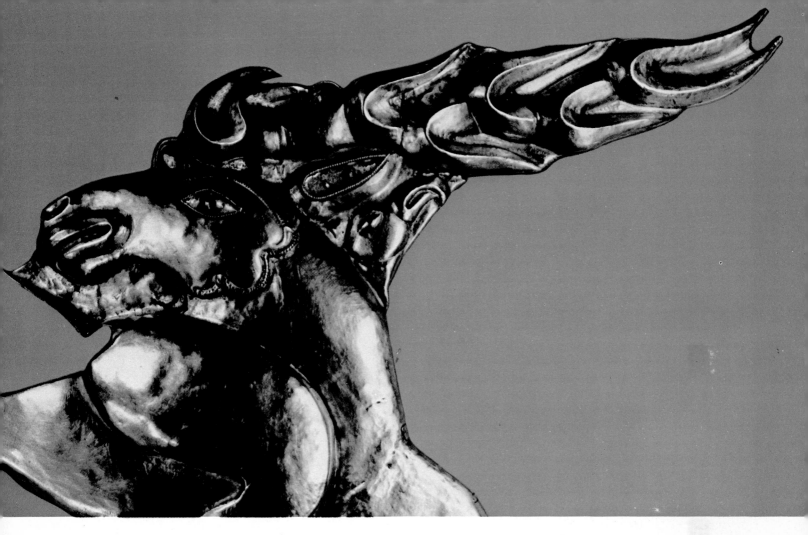

5. Scythian golden stag from Zöldhalompuszta. MNM

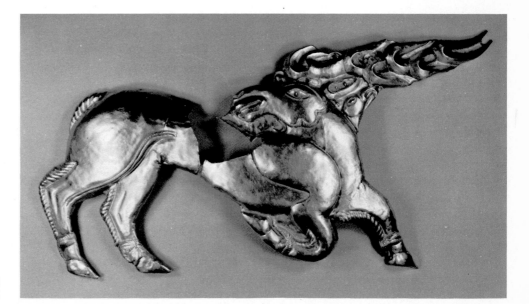

6. Scythian golden stag
from Zöldhalompuszta. MNM

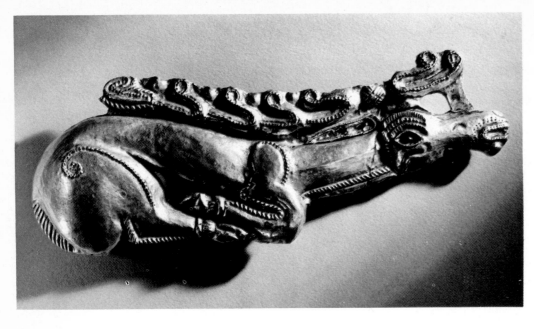

7. Scythian electrum stag from Tápiószentmárton. MNM

8. Scythian electrum stag from Tápiószentmárton. MNM

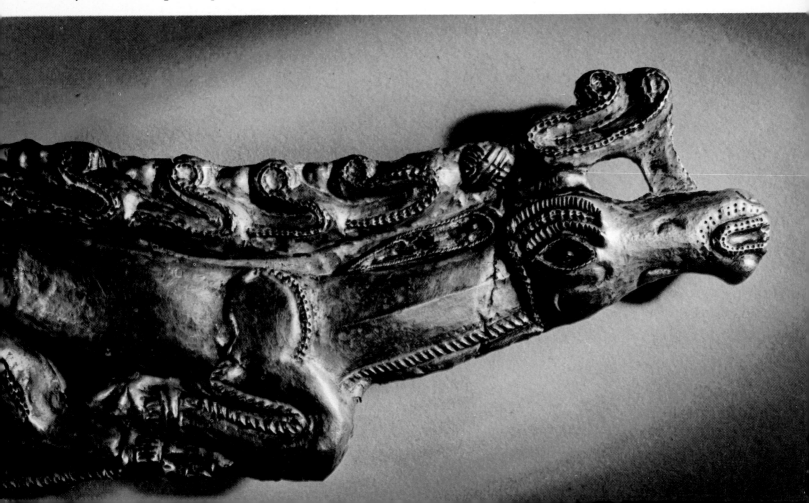

9–10. Scythian beads. MNM

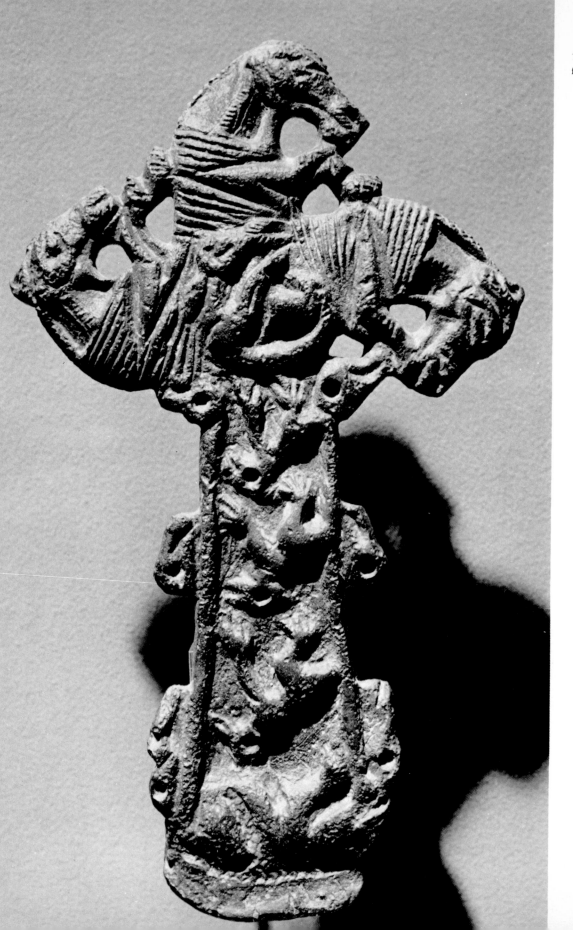

11. Scythian strap end
from Mátraszele. MNM

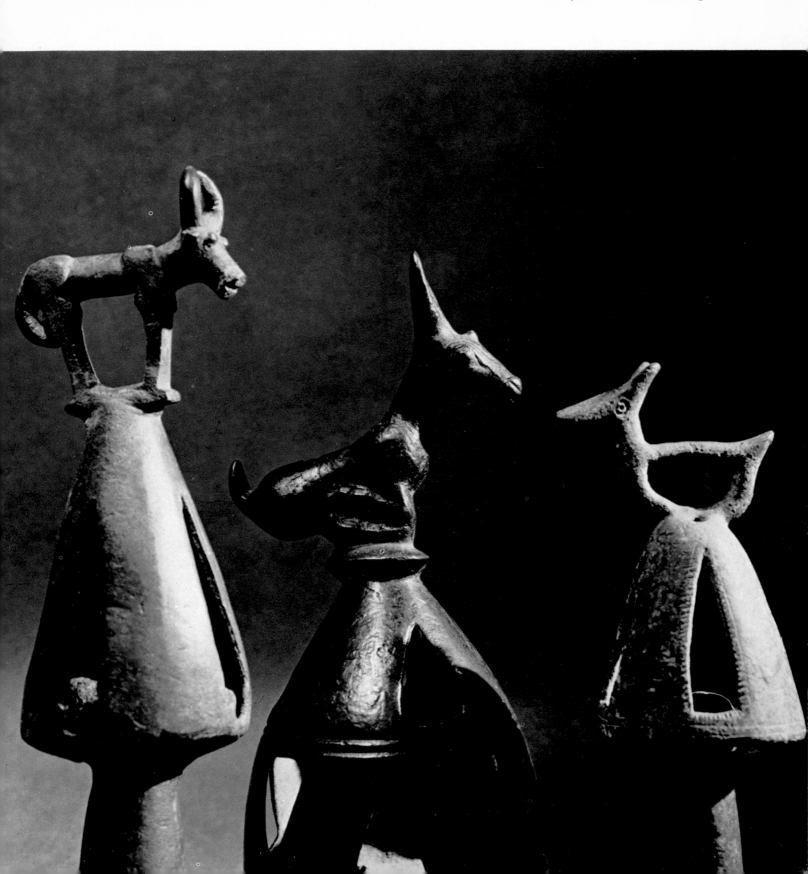

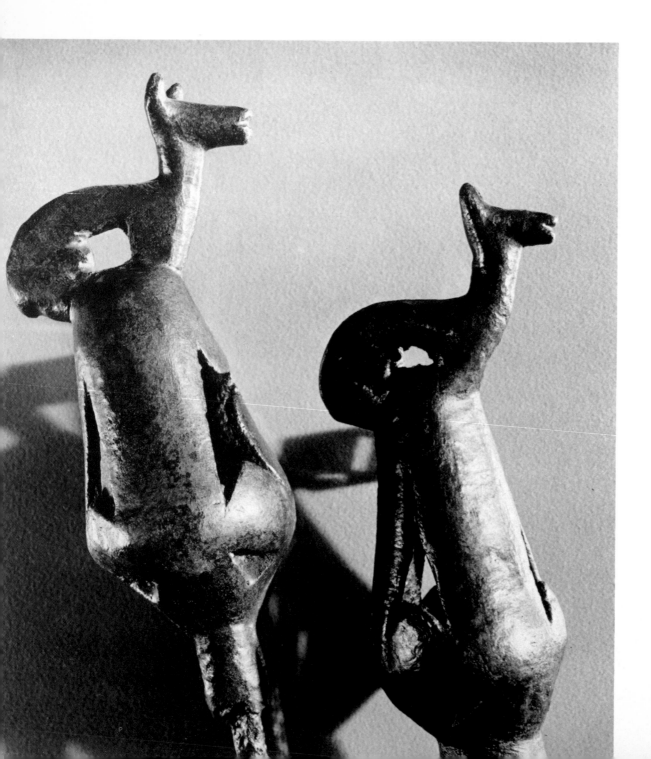

14. Glass-paste beads from Kiskőrös. Sarmatian Period. MNM

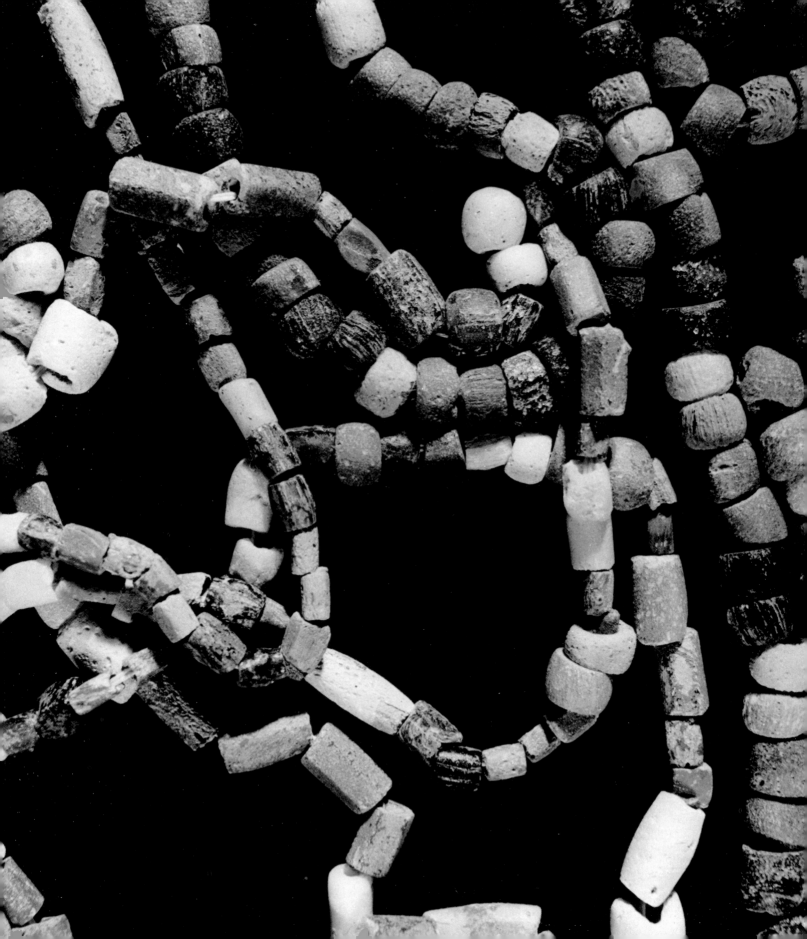

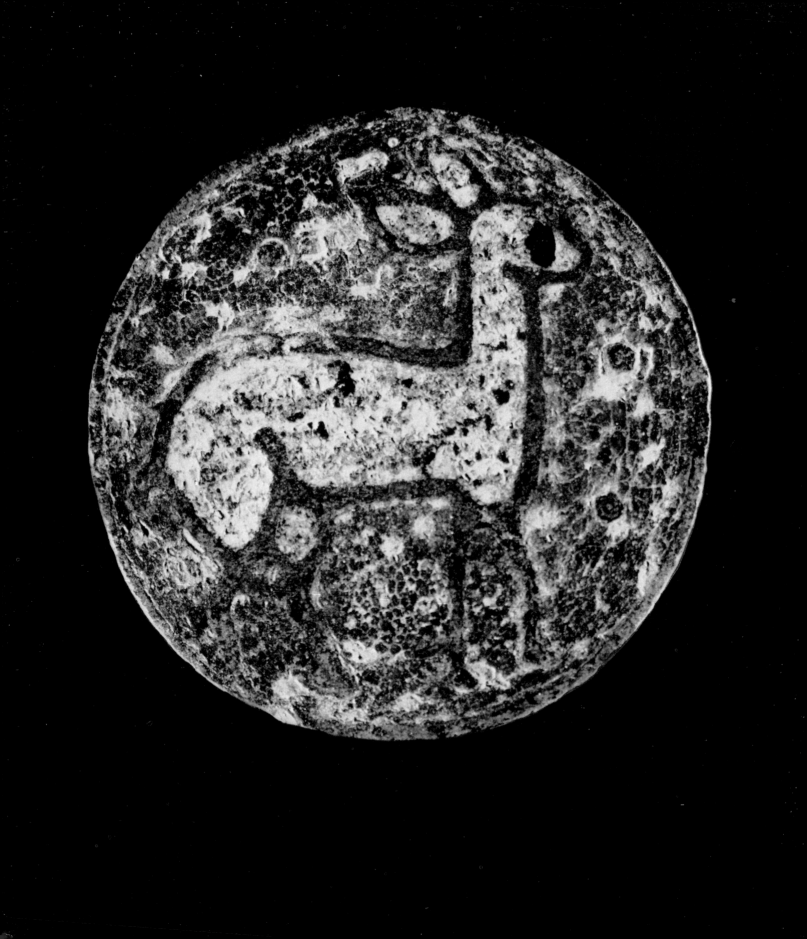

15. Enameled fibula from Jászmonostor. Sarmatian Period. MNM

16. Chalcedony beads in the shape of barrels from the vicinity of Szarvas. Sarmatian Period. MNM

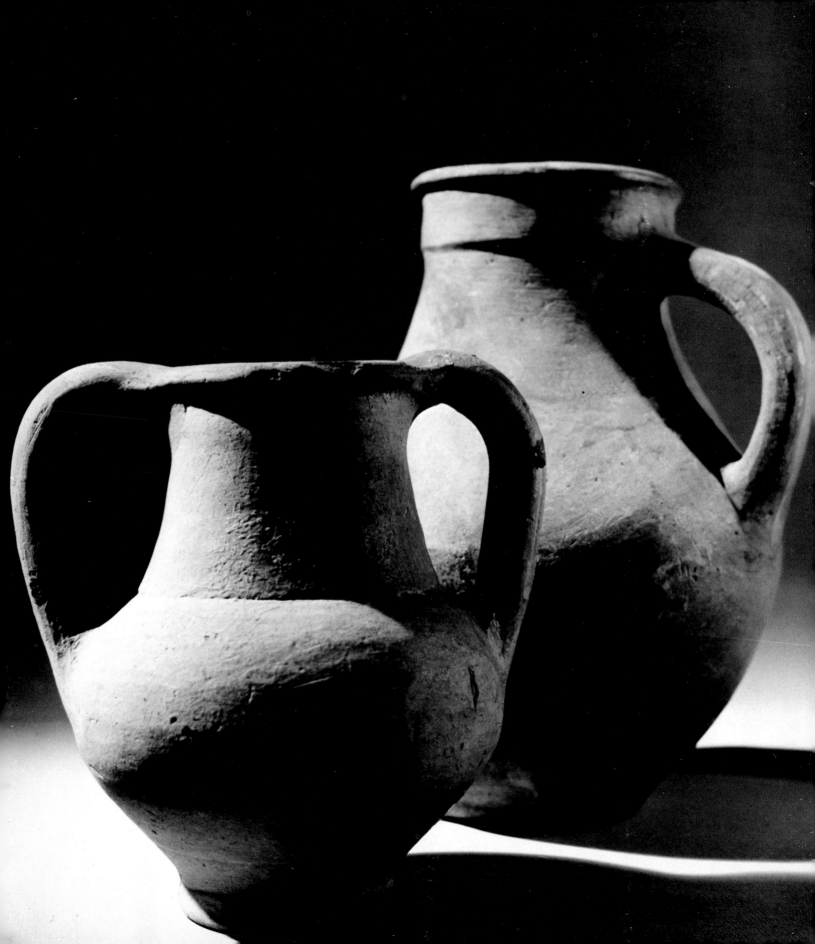

17. Vessels from Csongrád.
Sarmatian Period. MNM

18. Gratianus' large gold coin from
the first Szilágysomlyó find.
Vienna, Kunsthistorisches Museum

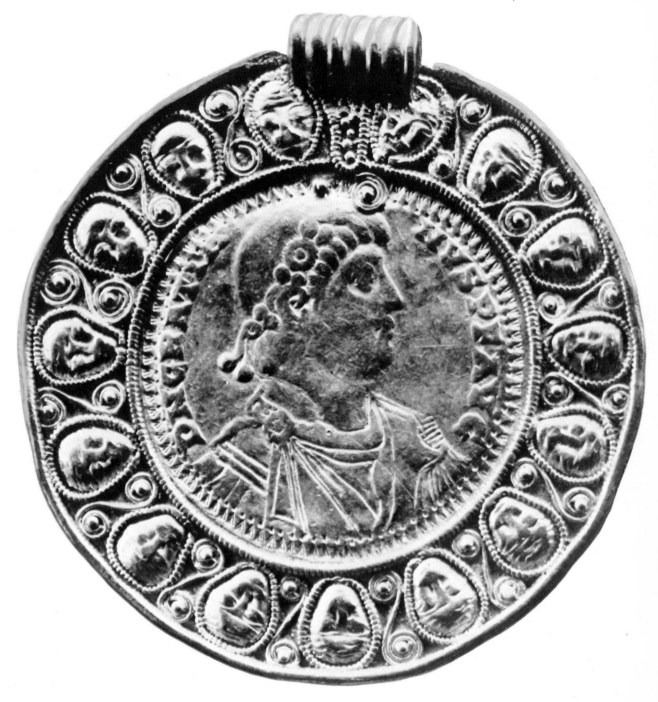

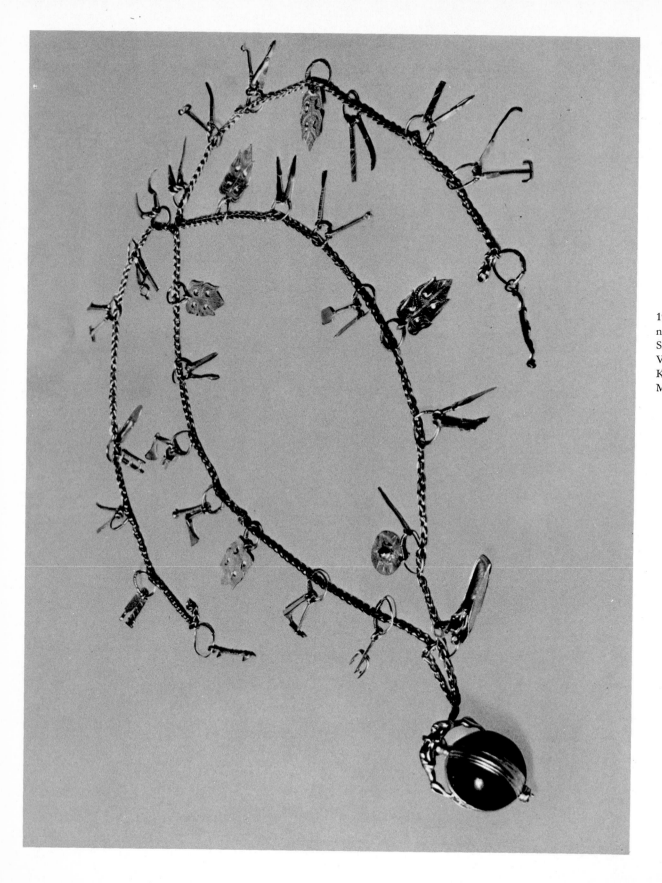

19–21. The princely necklace of the first Szilágysomlyó find. Vienna, Kunsthistorisches Museum

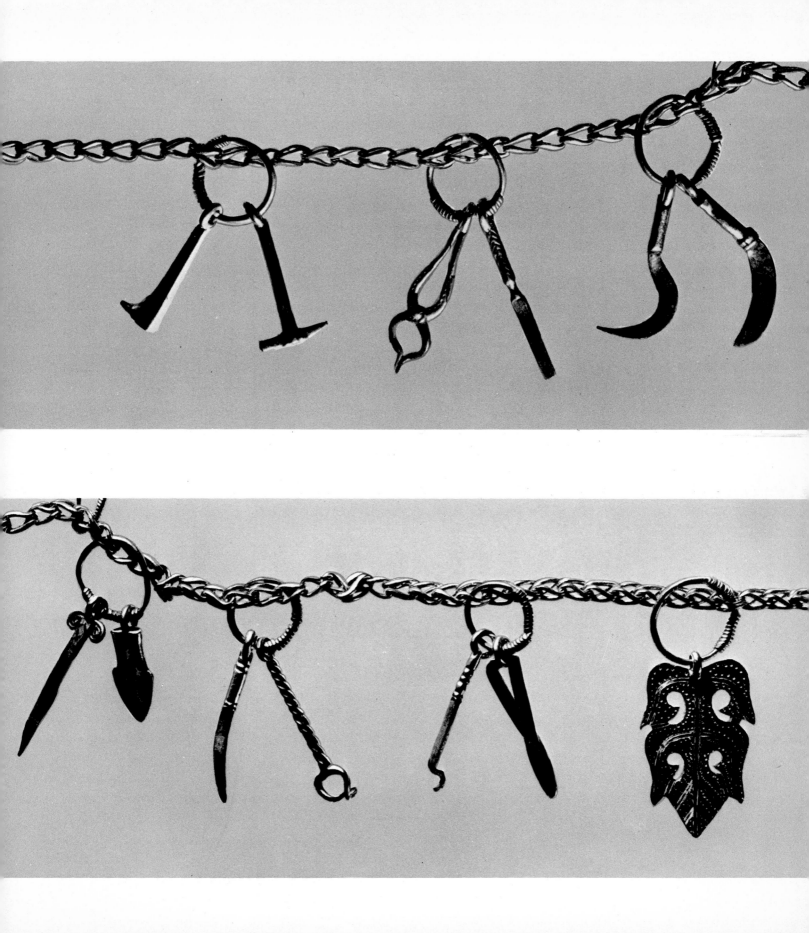

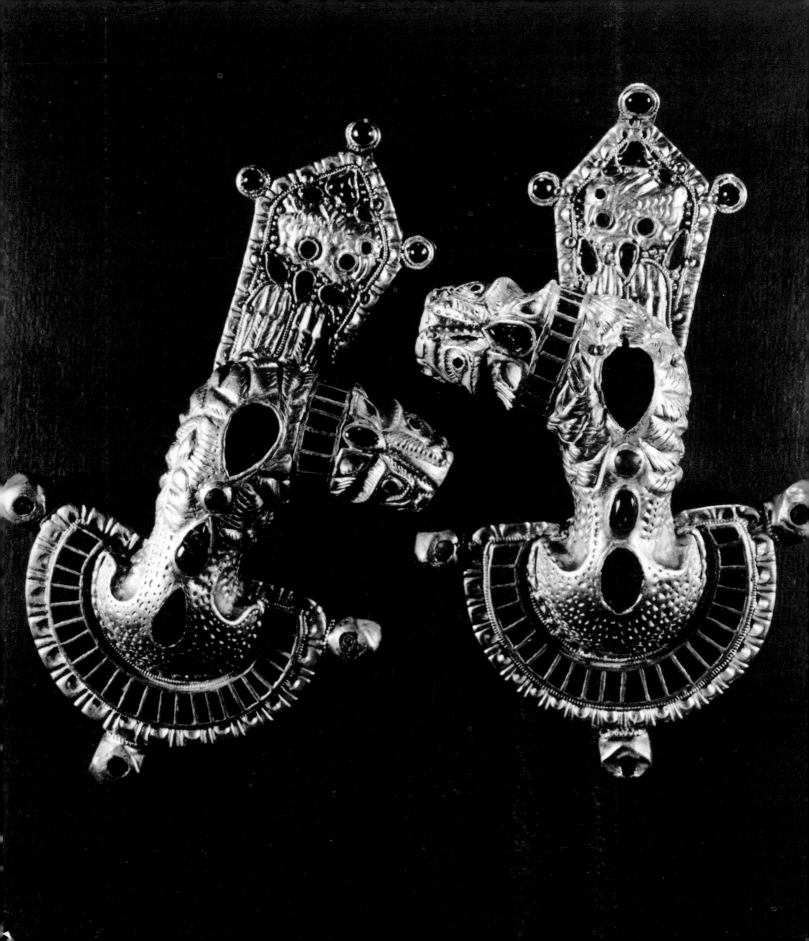

22. Lion-ornamented pair
of fibulae from the second
Szilágysomlyó find. MNM

23. Detail of the lion-ornamented pair of fibulae. MNM

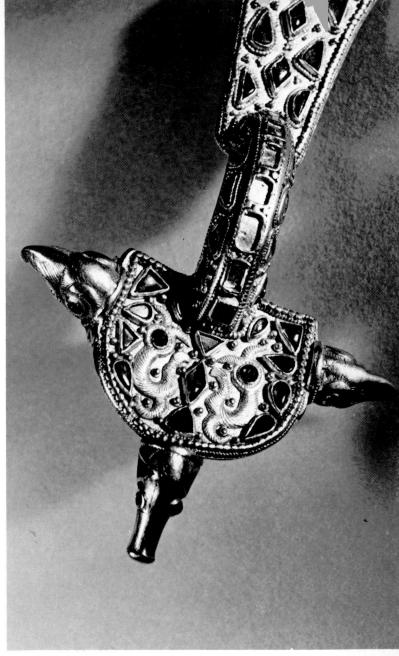

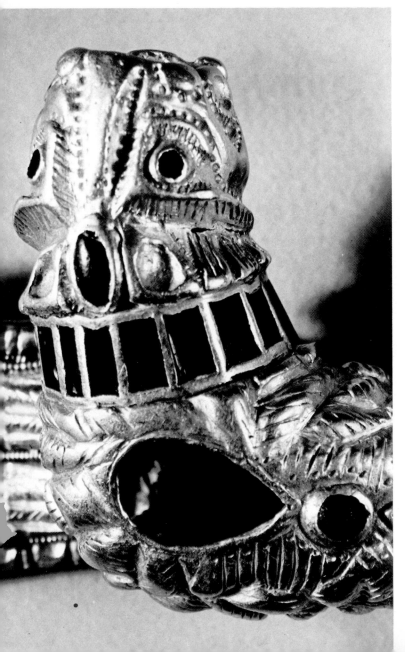

24. Part of the pair of fibulae with animal heads from
the second Szilágysomlyó find. MNM

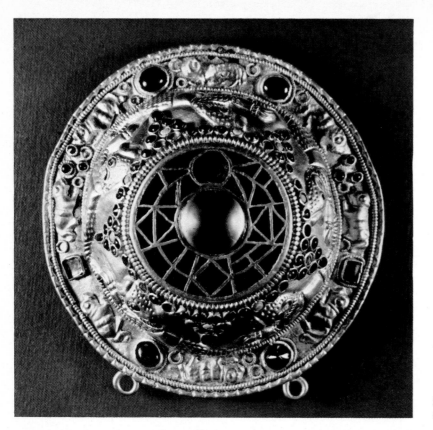

25. Part of the disk-shaped
pair of fibulae from the second
Szilágysomlyó find. MNM

27. Detail of part
of the pair of enameled
fibulae from the second
Szilágysomlyó find. MNM

26. Detail of the disk-shaped
fibula of Plate 25

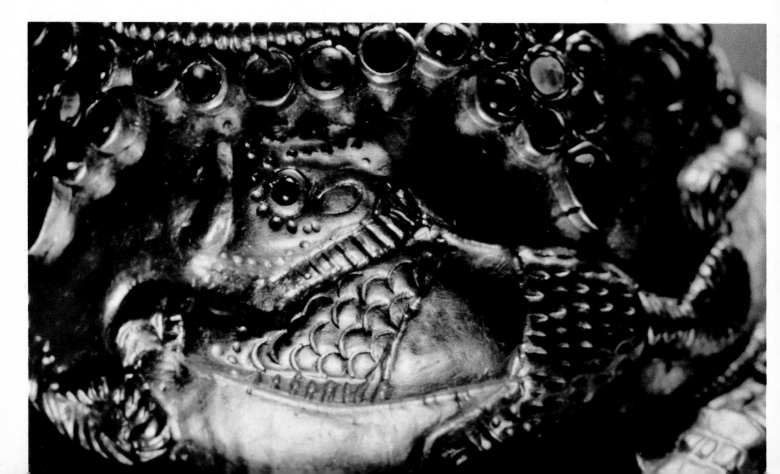

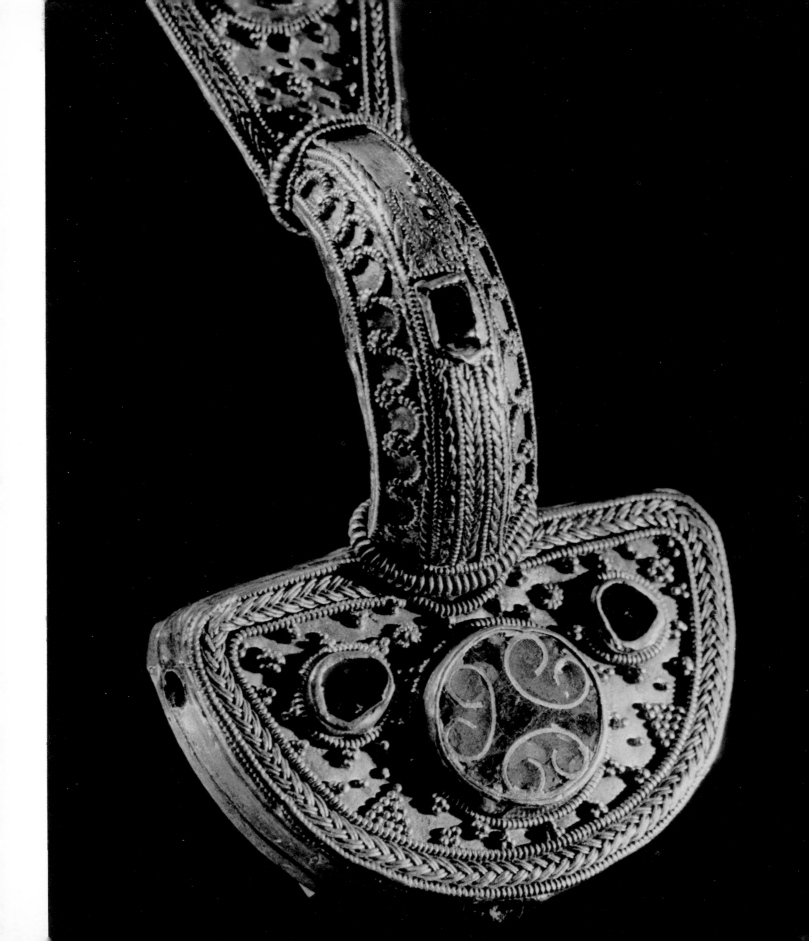

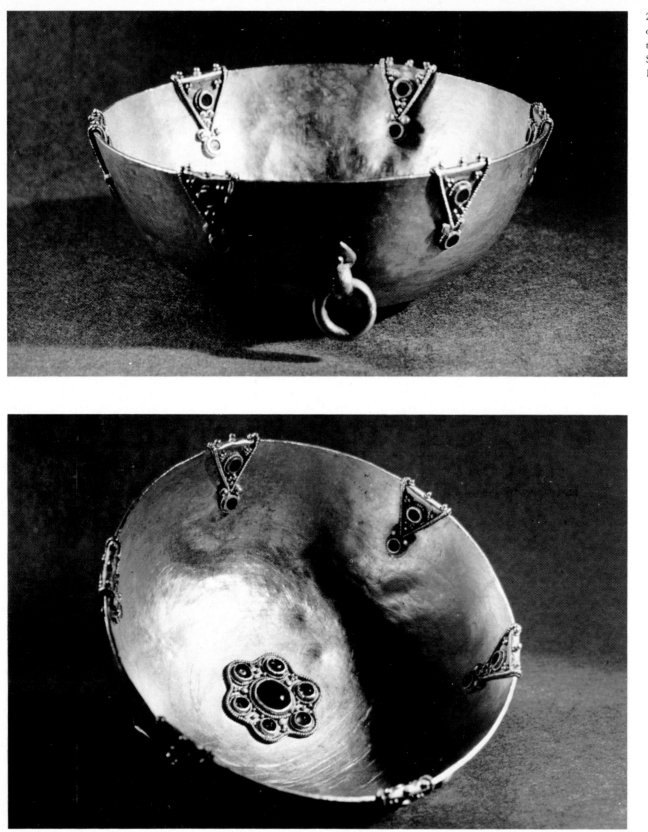

28–29. Omphalic cup
of pure gold from
the second
Szilágysomlyó find.
MNM

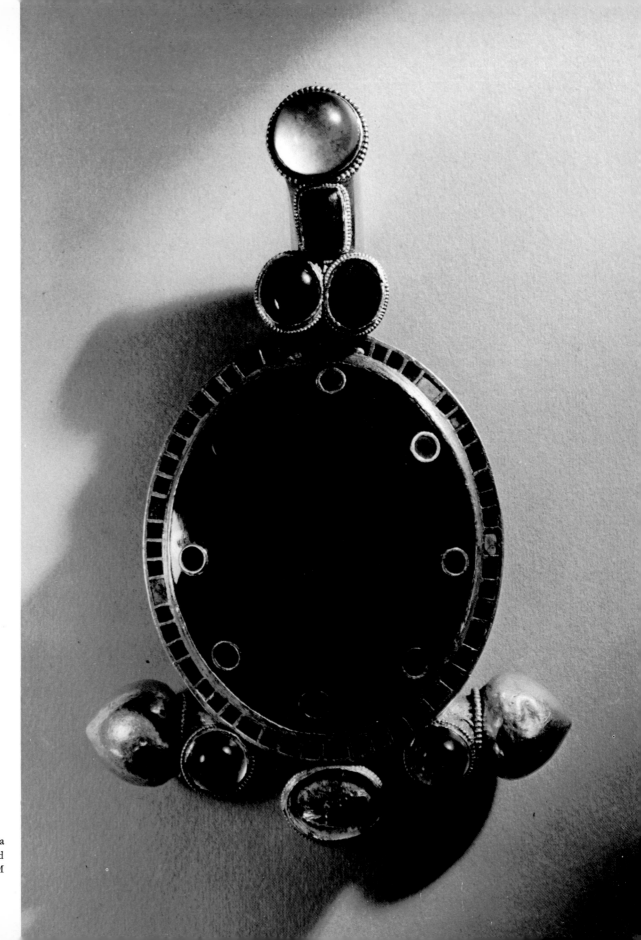

30. Large onyx fibula
from the second
Szilágysomlyó find. MNM

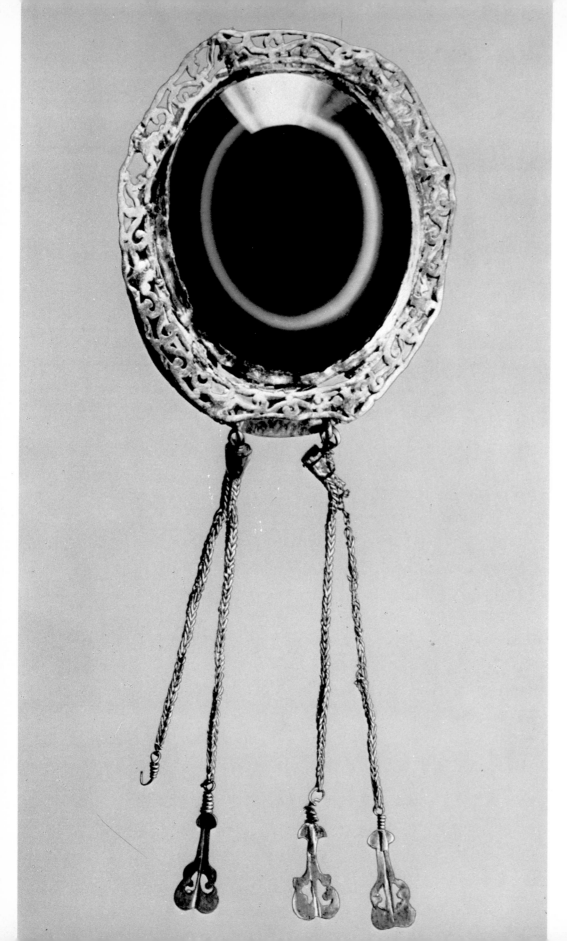

31. Large onyx fibula from
the Osztropataka find. Vienna,
Kunsthistorisches Museum

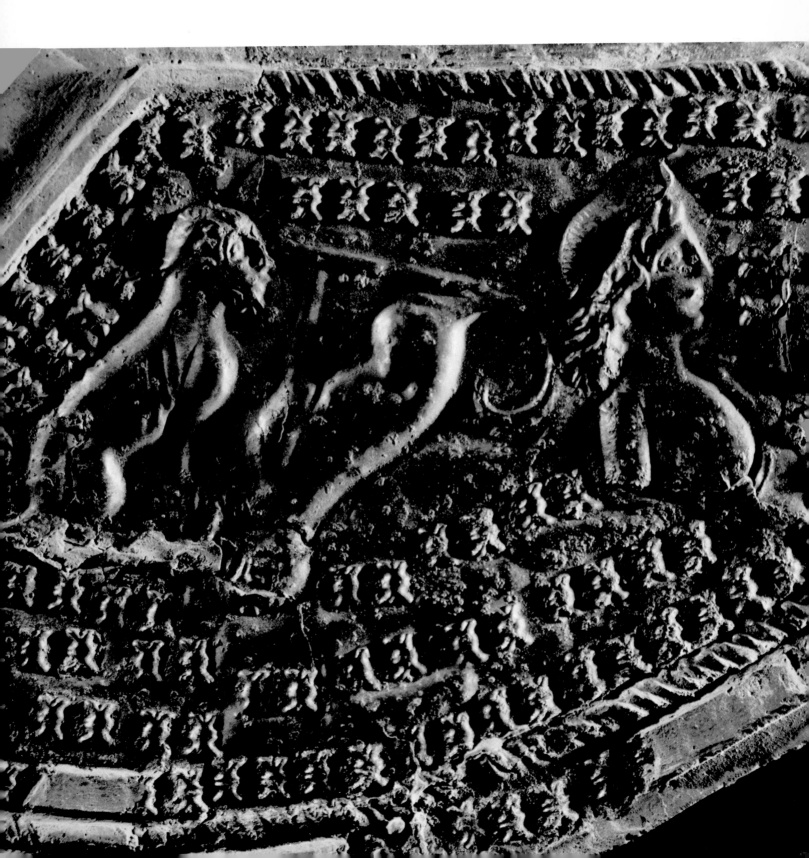

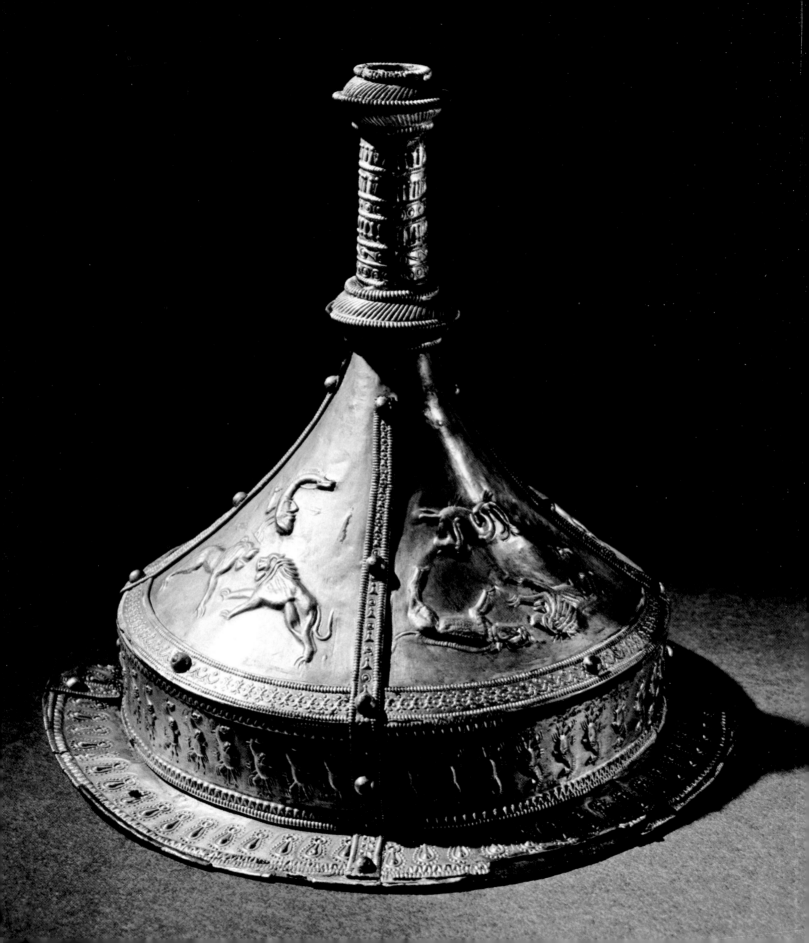

33. Shield boss from Herpály. MNM

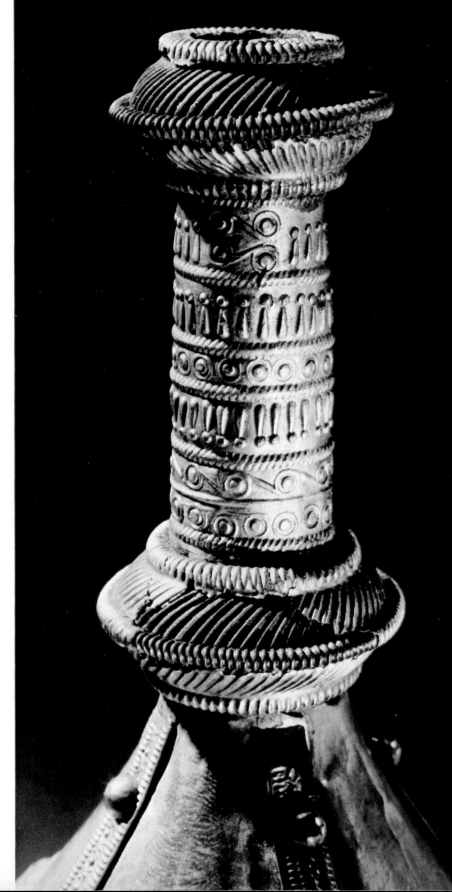

34. Protrusion on the shield boss
from Herpály. MNM

35. Fighting animals on the shield boss from Herpály. MNM

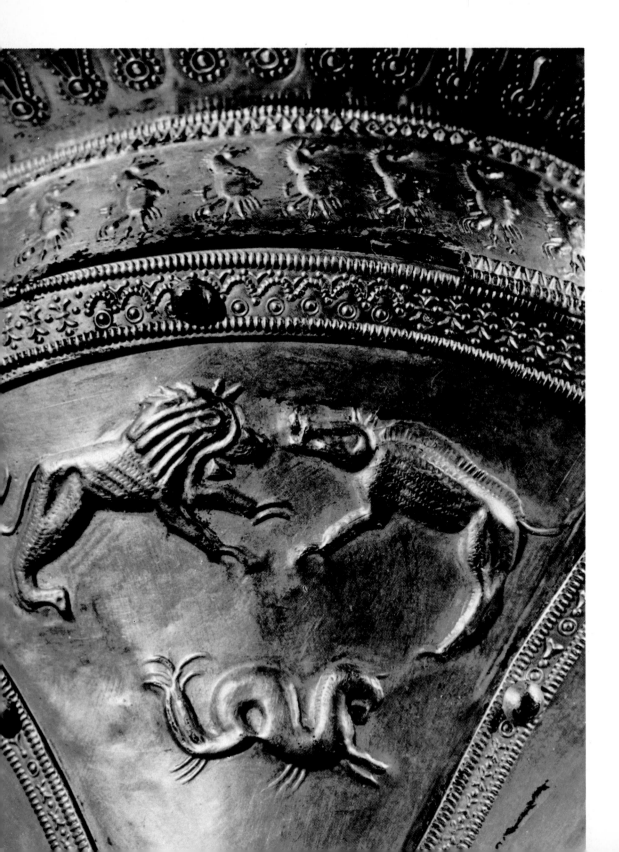

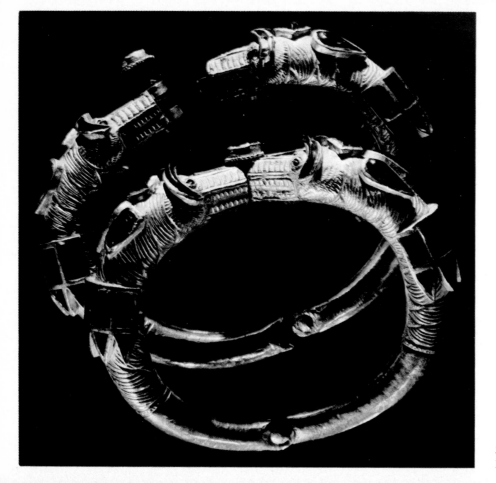

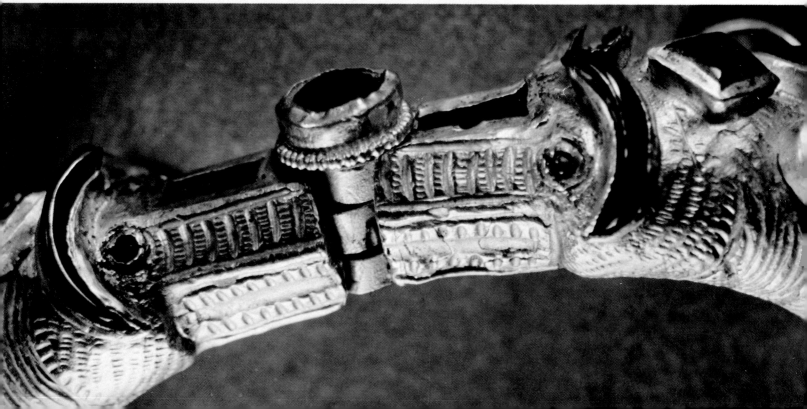

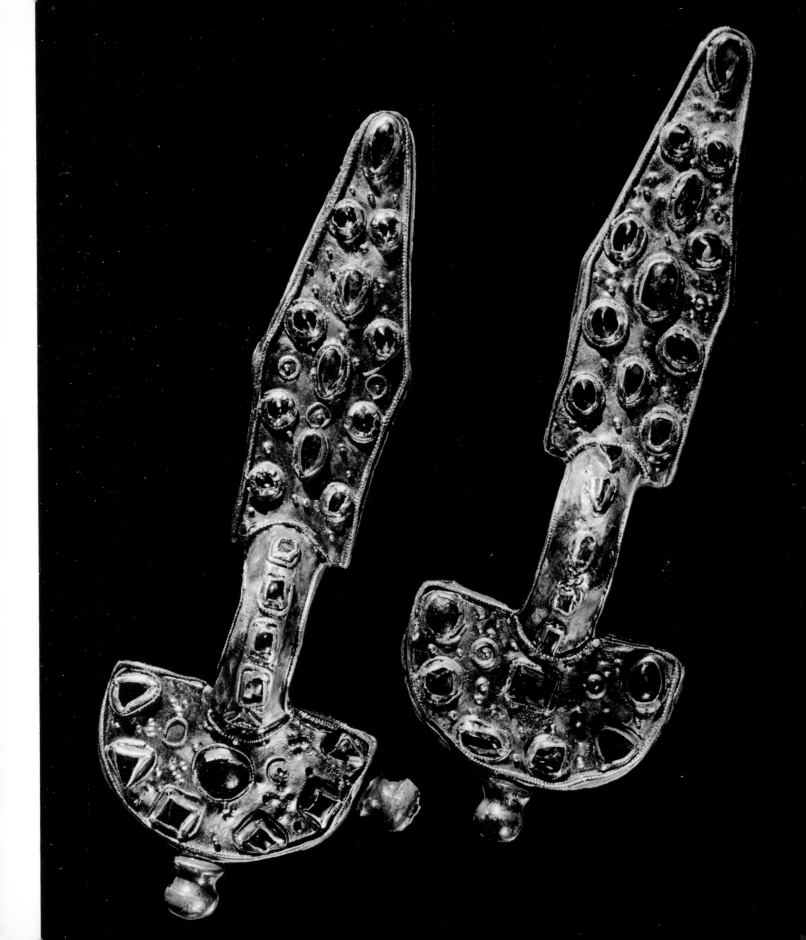

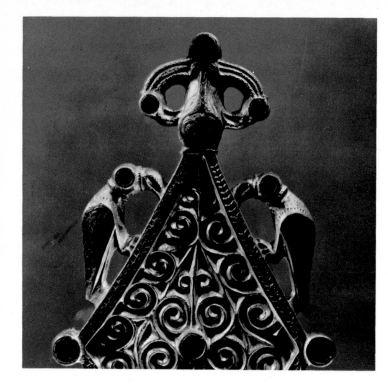

42. A pair of silverplate
fibulae from Tiszalök.
MNM

40–41. Gilded silver
buckle from the Bácsordas find.
MNM

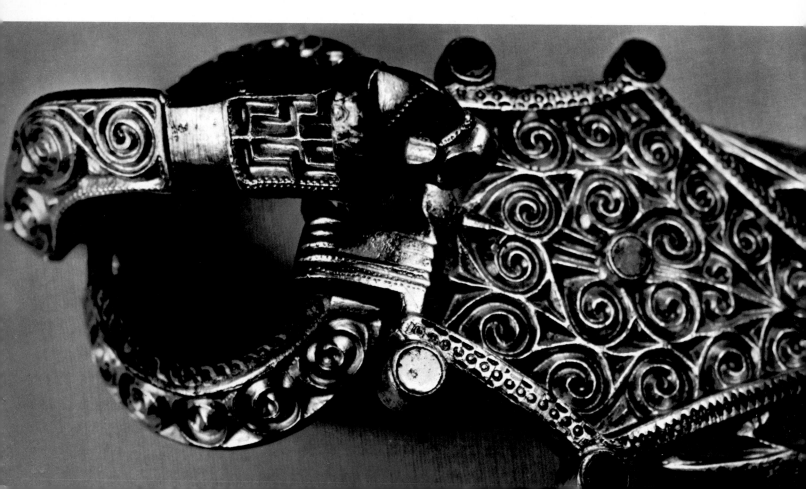

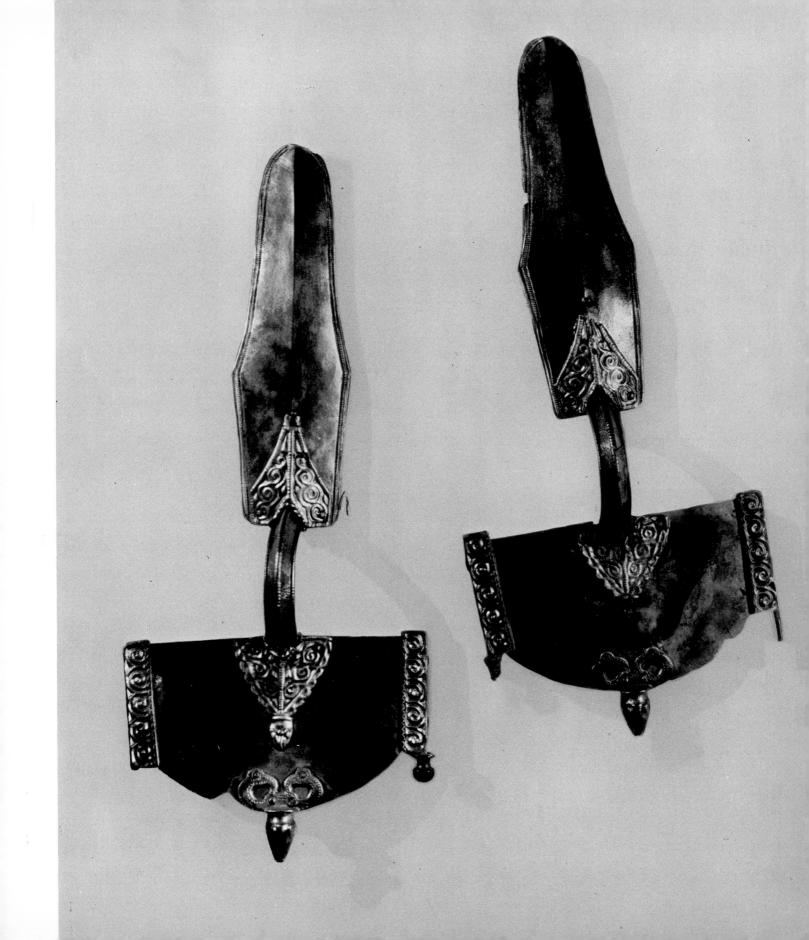

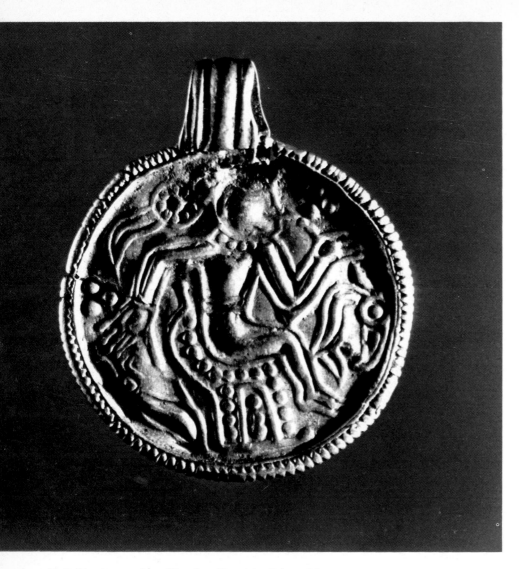

43. Golden *bracteate* from Várpalota. Veszprém, Bakony Museum

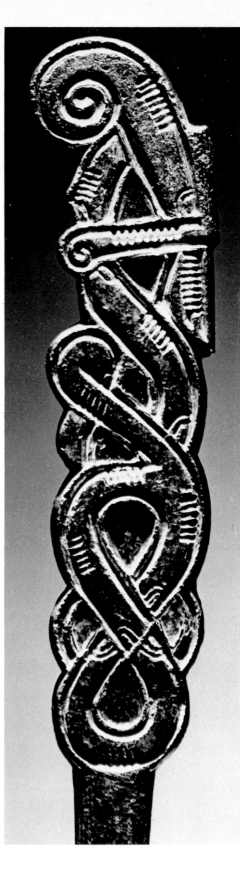

44. Detail of a gilded bronze hairpin found at Környe. MNM

45–46. Pair of gilt silver fibulae from the Lombard cemetery at Várpalota. Veszprém, Bakony Museum

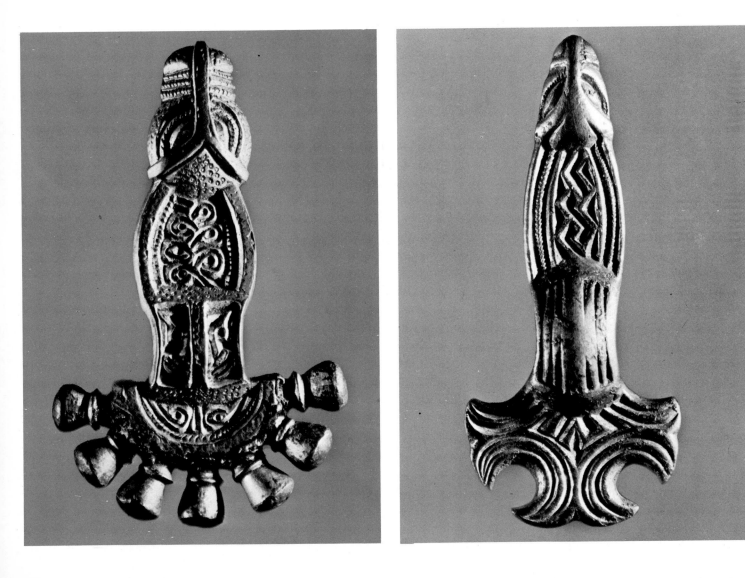

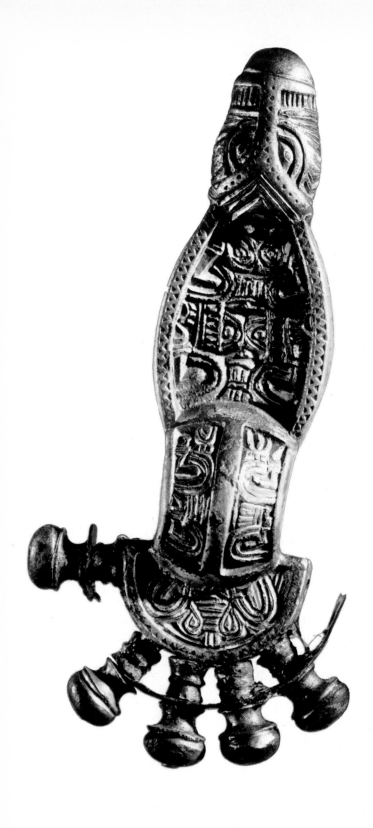
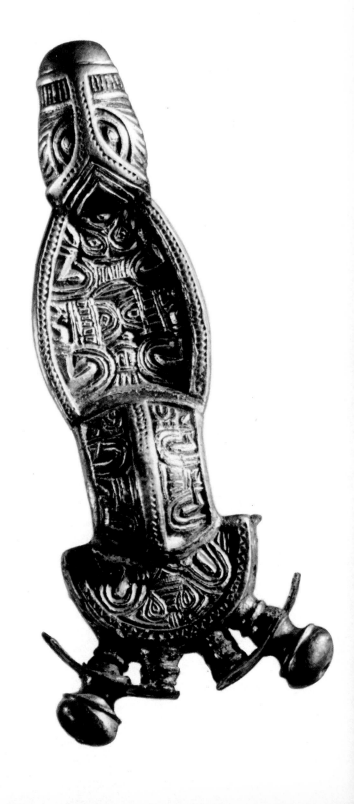

47. Pair of fibulae from
the Lombard cemetery at Bezenye.
Mosonmagyaróvár,
Hanság Museum

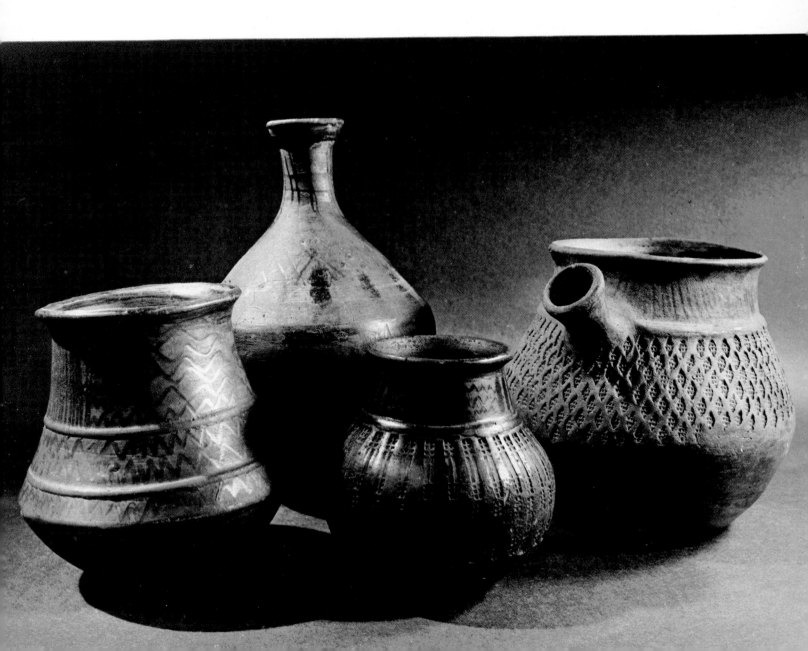

49–50. Details of the fibula
with runic inscriptions from Bezenye

53. Ornamentation of trappings from the Veszkény find. Sopron, Liszt Ferenc Museum

51–52. Strap end with silver inlay from the Avar cemetery at Előszállás-Bajcsihegy. Székesfehérvár, István Király Museum

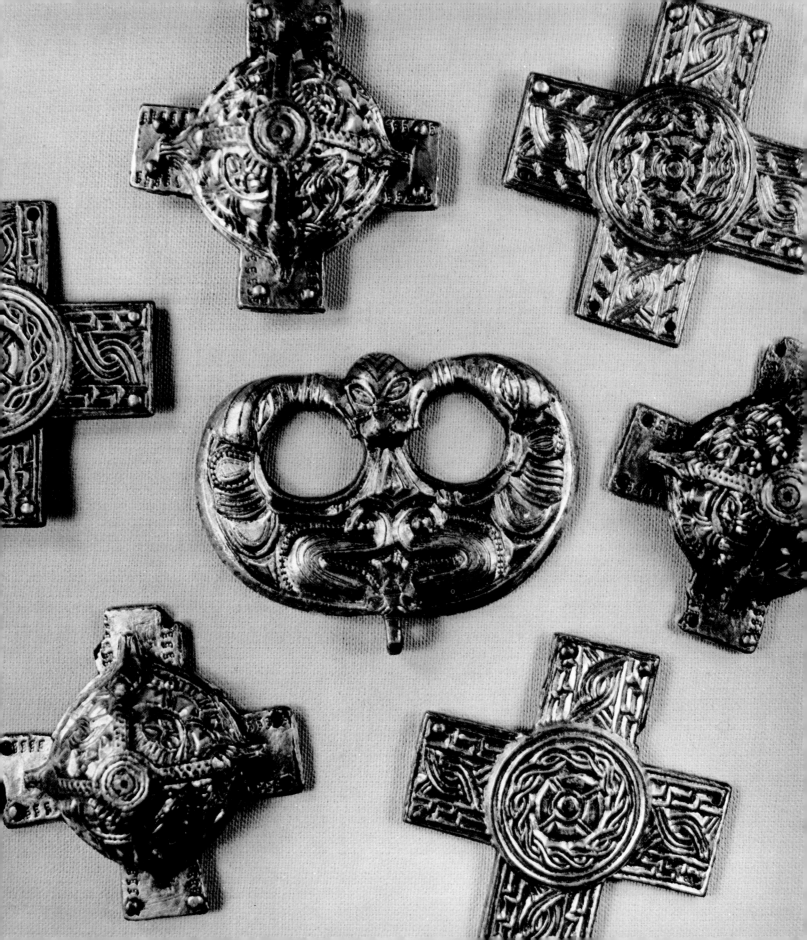

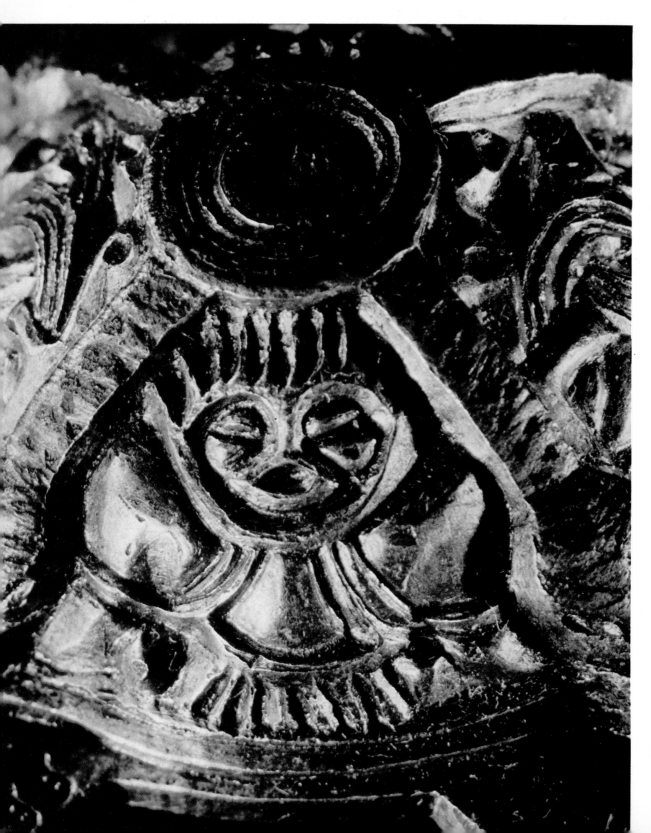

55. Mounting from
the Veszkény find. Sopron,
Liszt Ferenc Museum

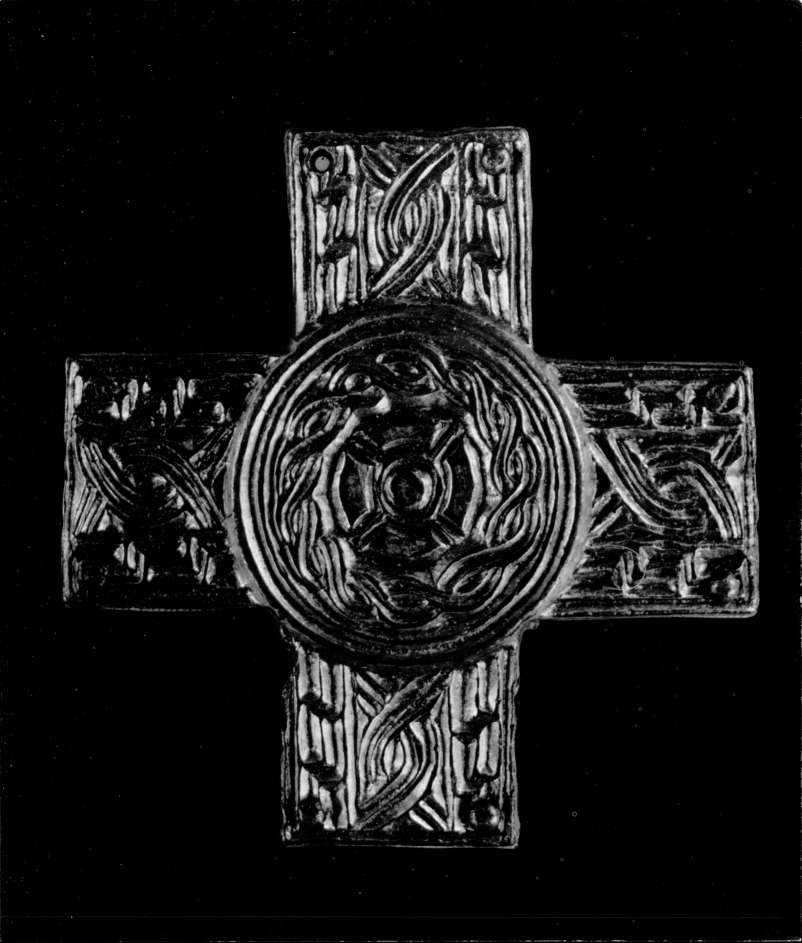

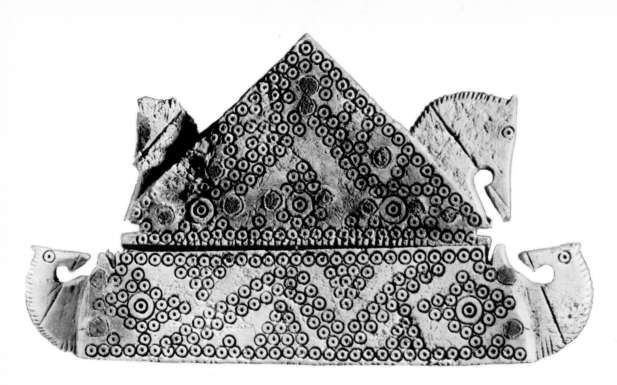

56–57. Bone comb from the grave of a Germanic prince at Lébény. About the turn of the fifth century. Mosonmagyaróvár, Hanság Museum

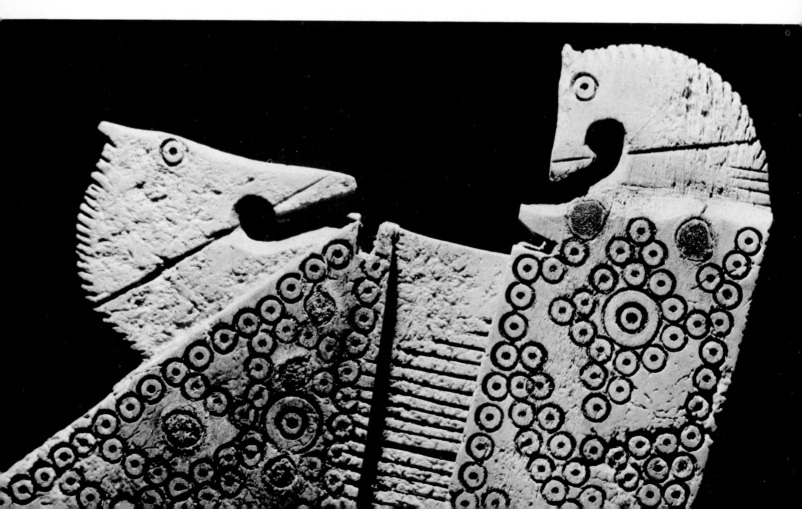

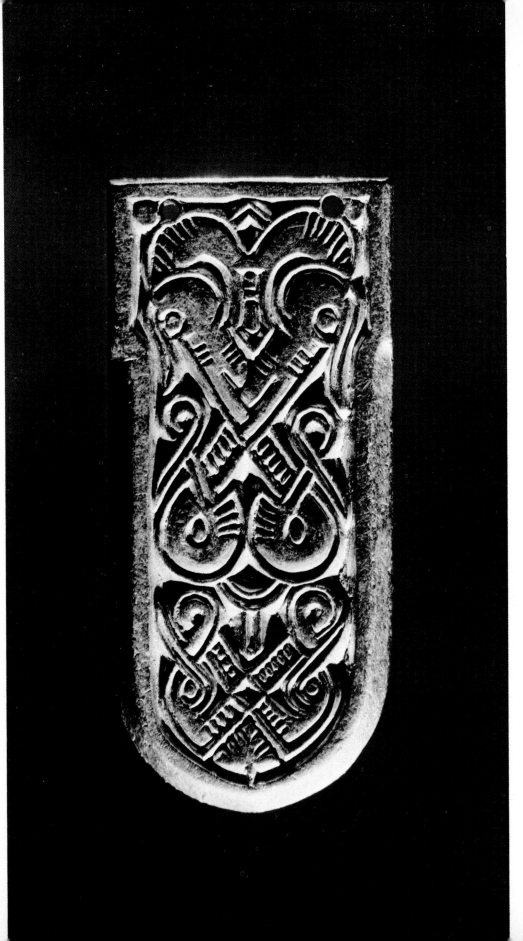

58. Gold strap end from
the former Jankovich collection. MNM

59–61. The Cundpald chalice. Sopron, Liszt Ferenc Museum

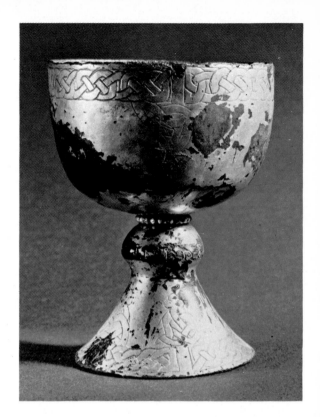

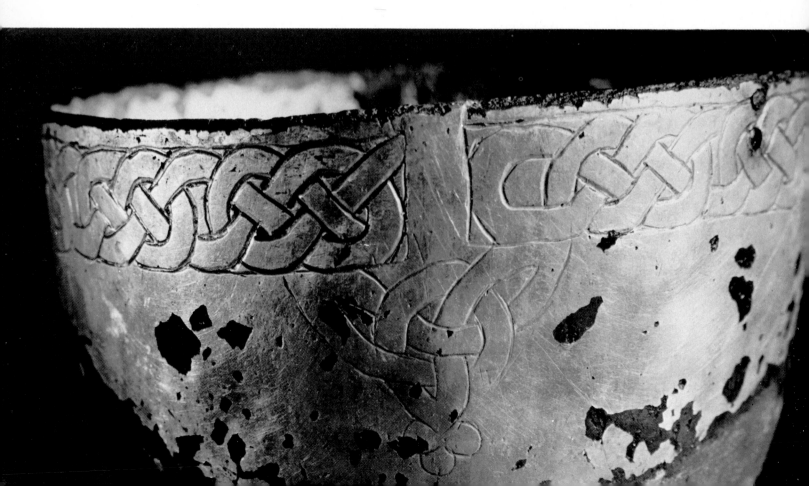

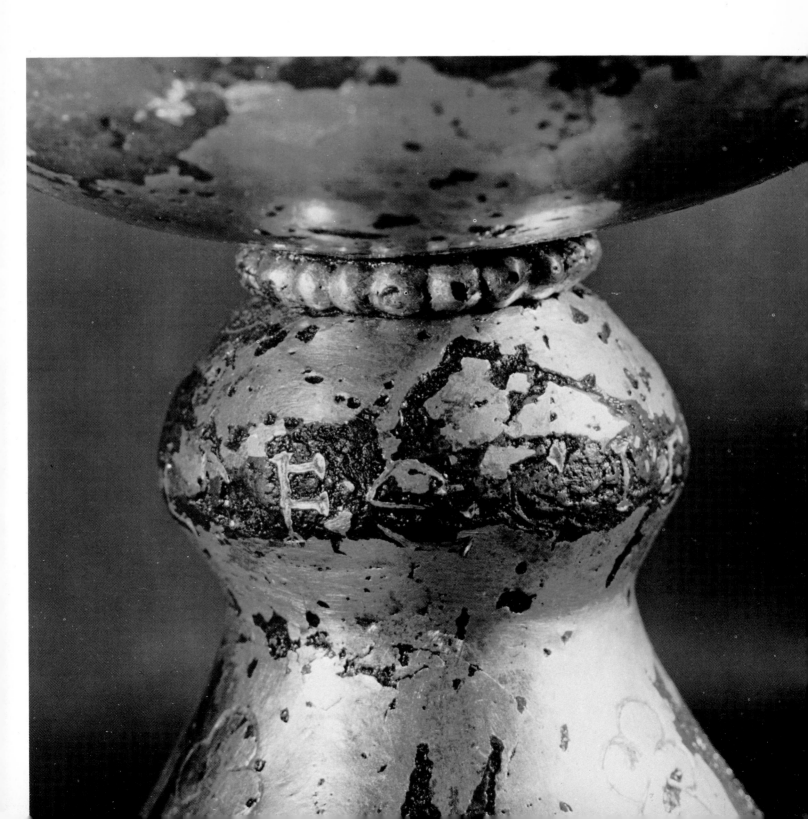

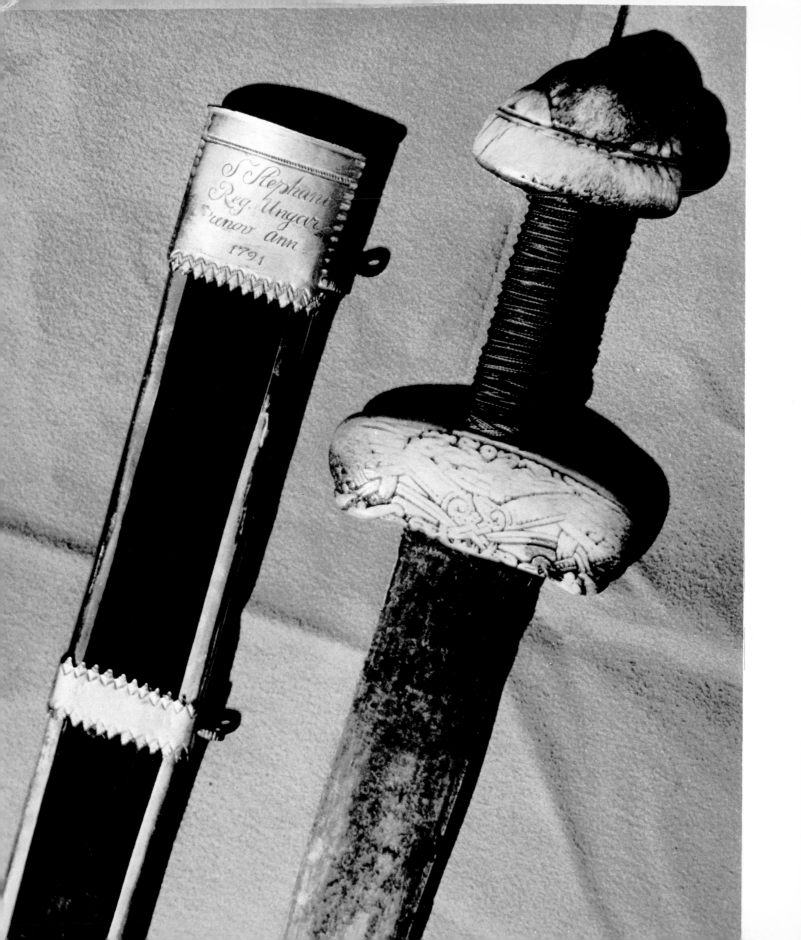

62–63. St. Stephen's sword, ornamented with ivory.
Prague, St. Vitus Cathedral

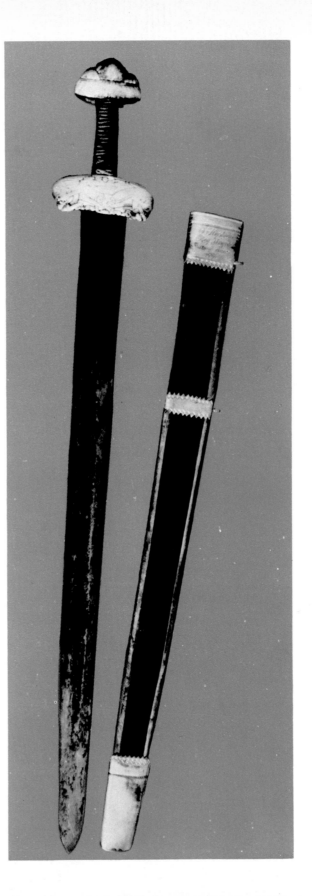

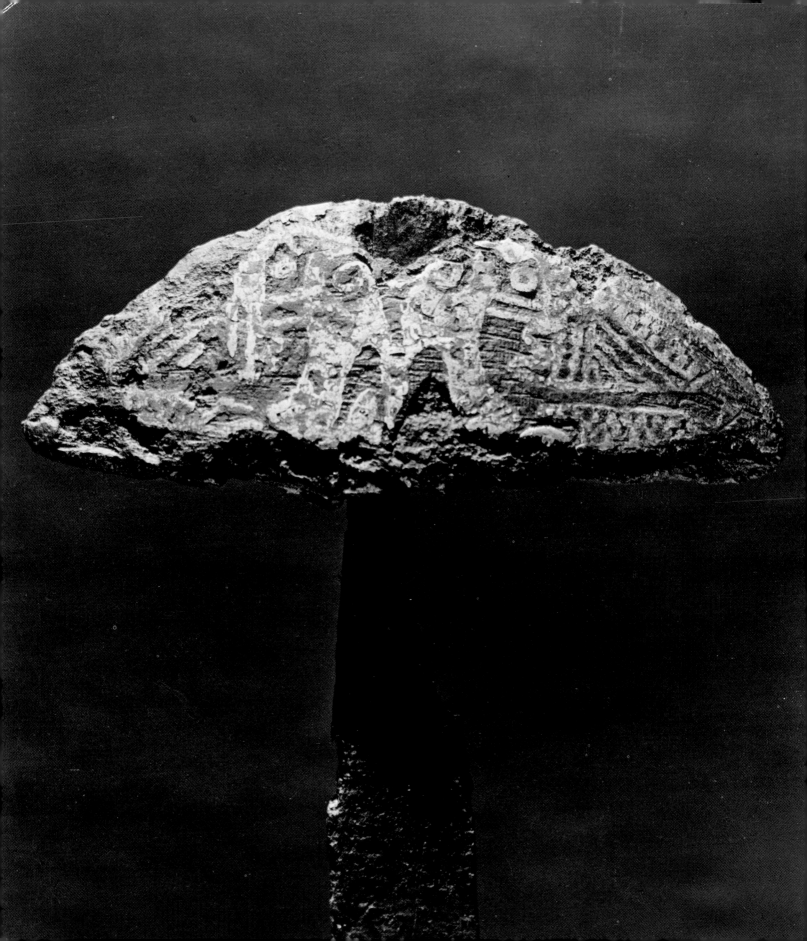

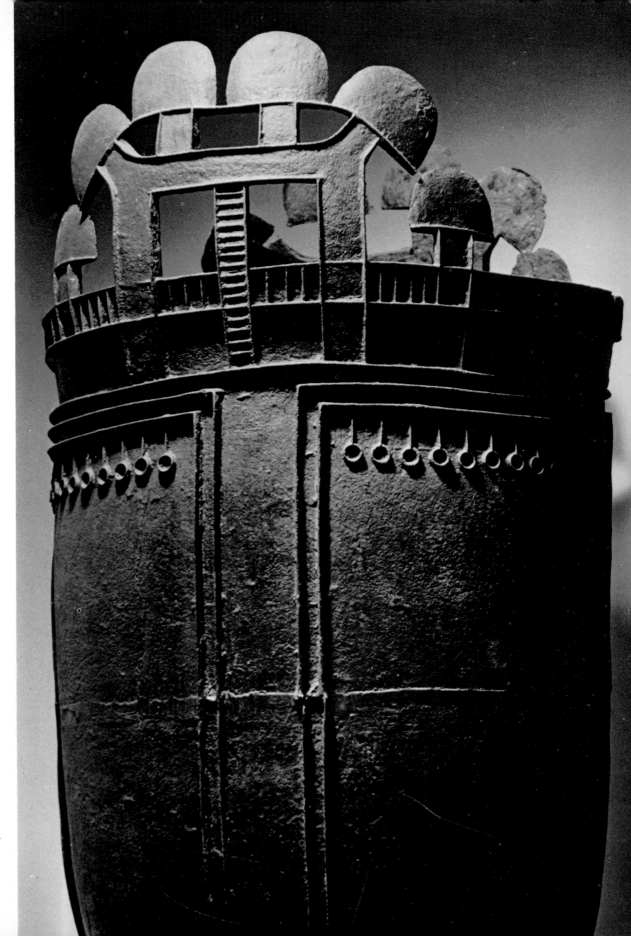

64. The sword
of Budapest. BTM

65. Detail of
the large bronze cauldron
from Törtel. MNM

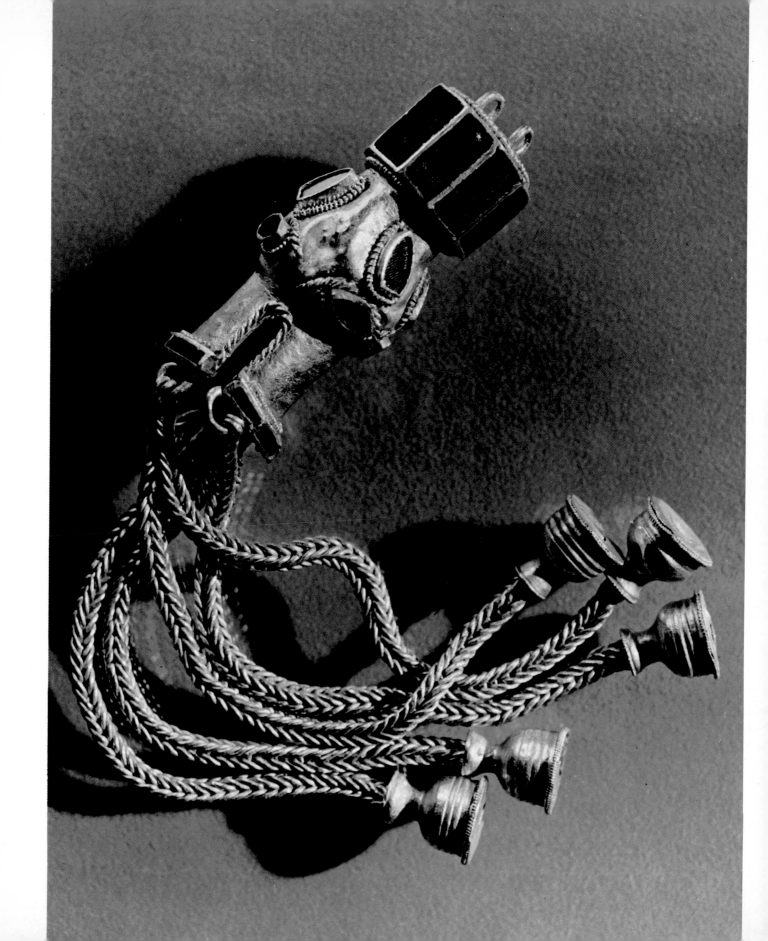

66. Pendant of a crown from
the Omharus find. Apahida. MNM

67–68. Coptic bronze lamp from
Tápiógyörgye. MNM

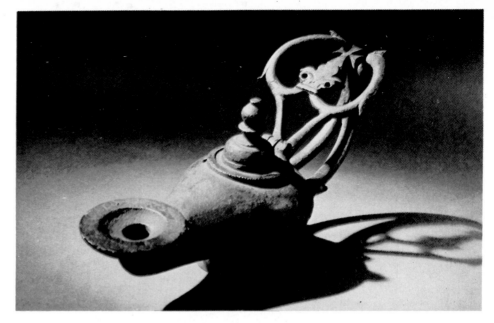

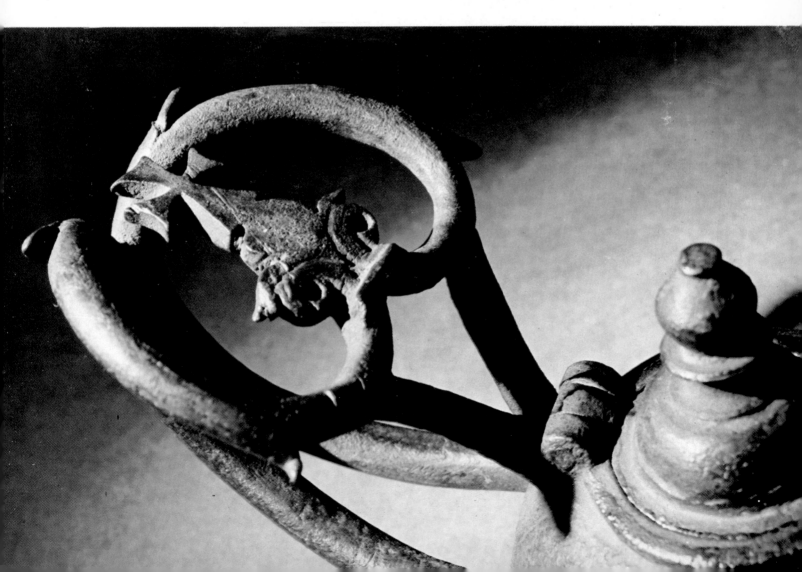

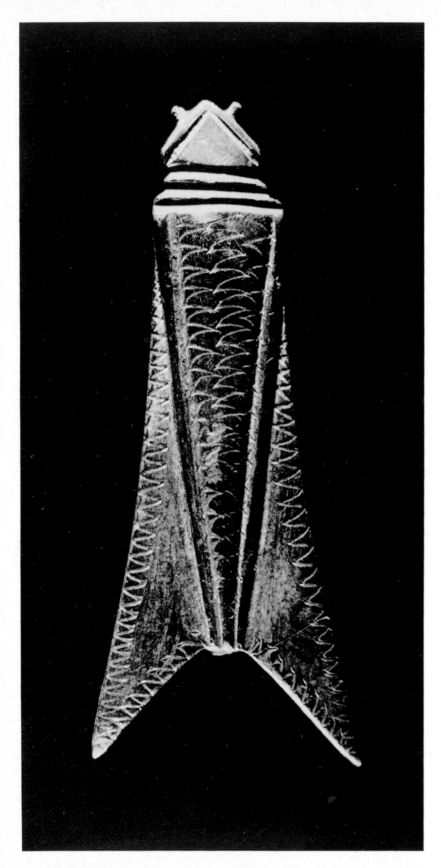

70. Cicada fibulae from Györköny. MNM

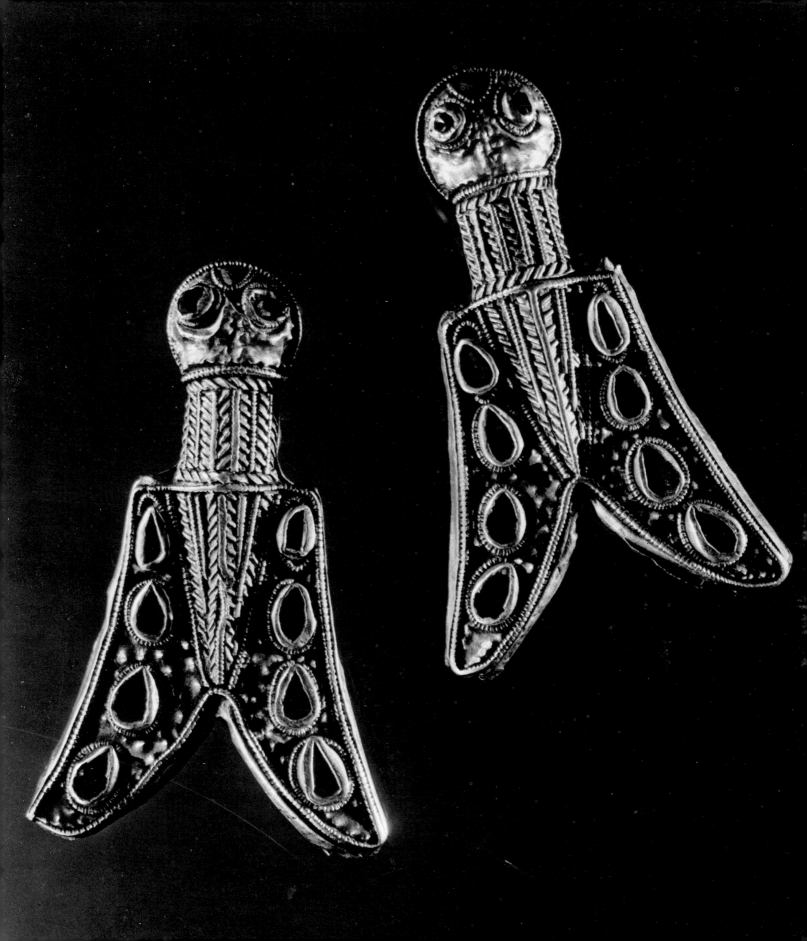

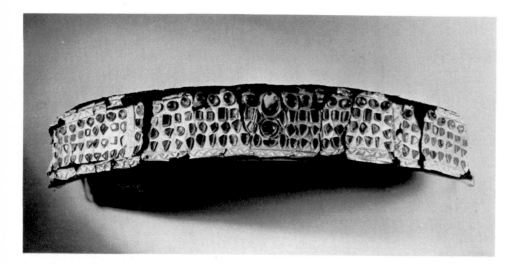

71–72. Diadem from the Hunnish Period, found at Csorna. MNM

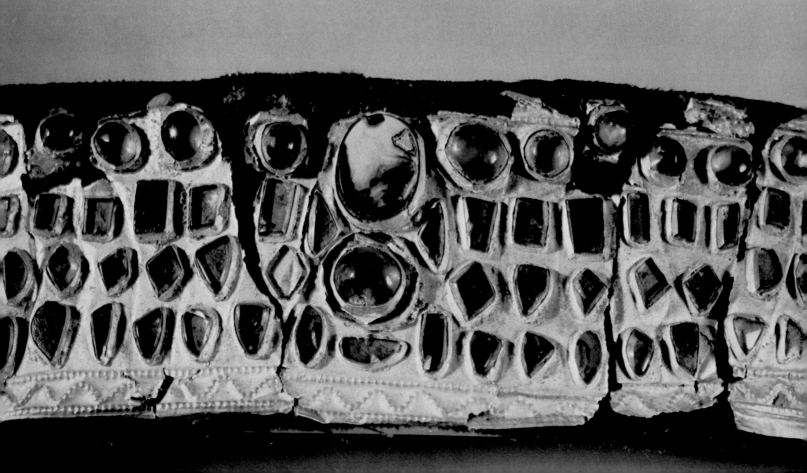

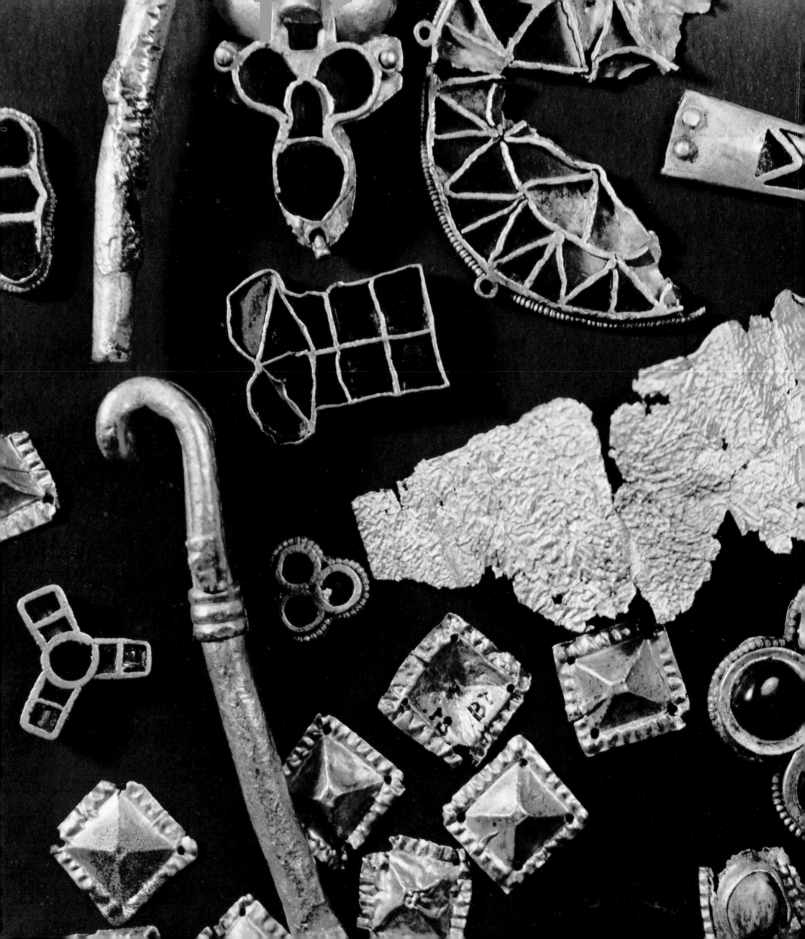

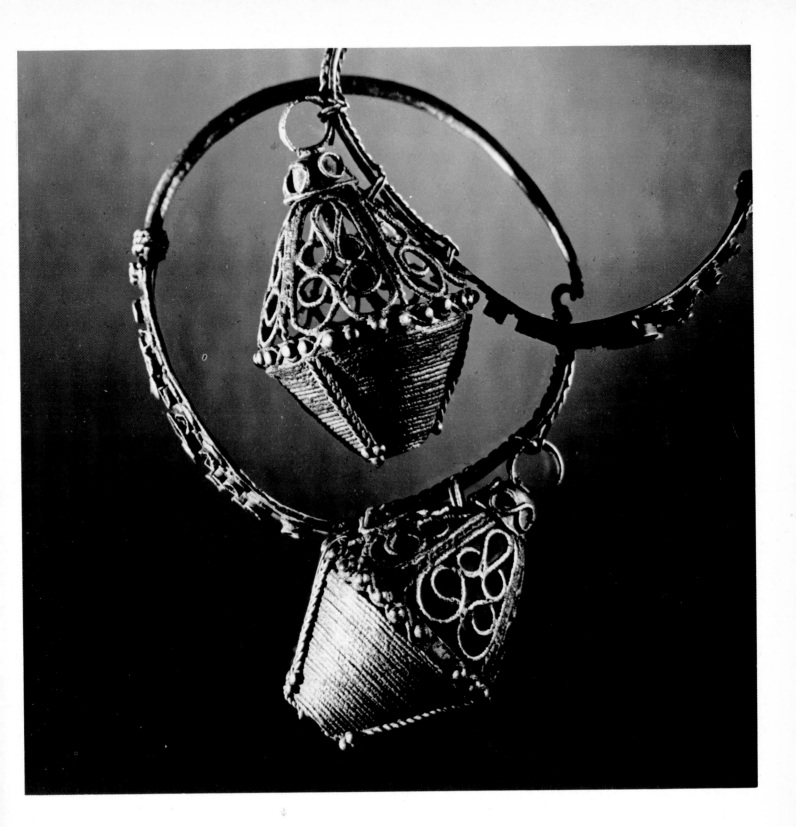

74. Details of the Szeged-Nagyszéksós find.
Szeged, Móra Ferenc Museum

75. Basket-shaped earrings from the great cemeteries at
Keszthely. MNM

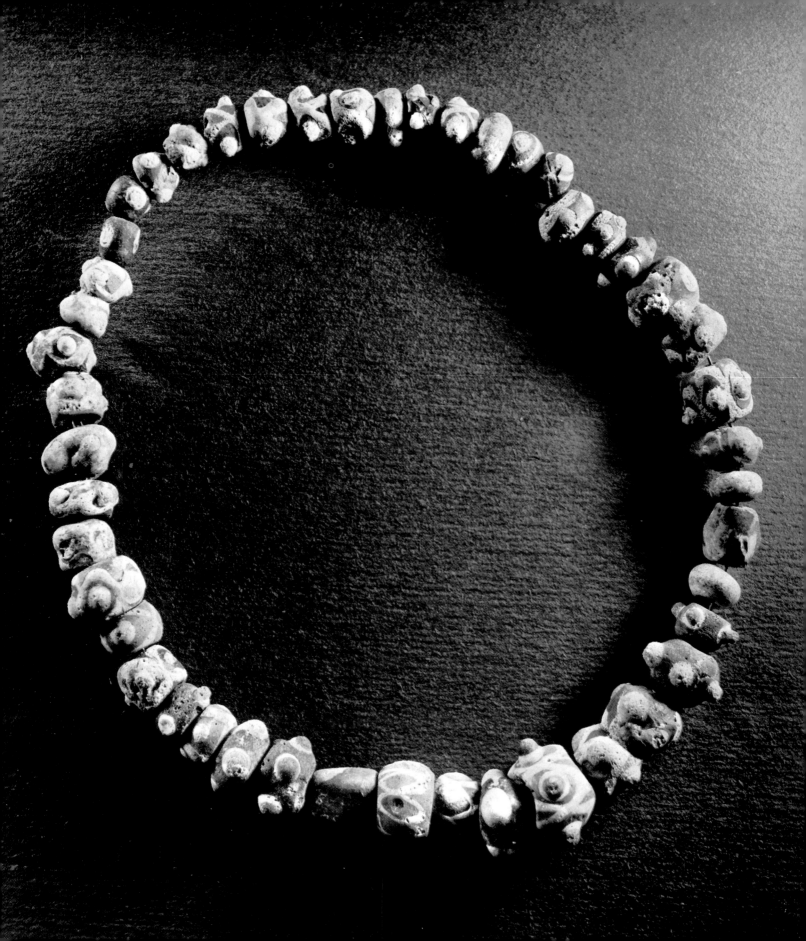

76–77. Bossed beads from
the Early Avar Period.
Szentes, Koszta József Museum

78–79. Disk-shaped fibula showing the apotheosis of an emperor. Vicinity of Keszthely. MNM

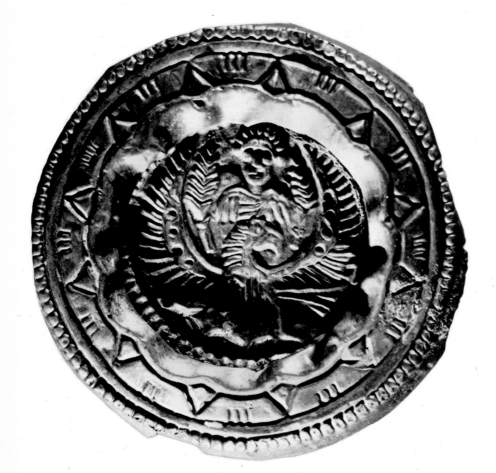

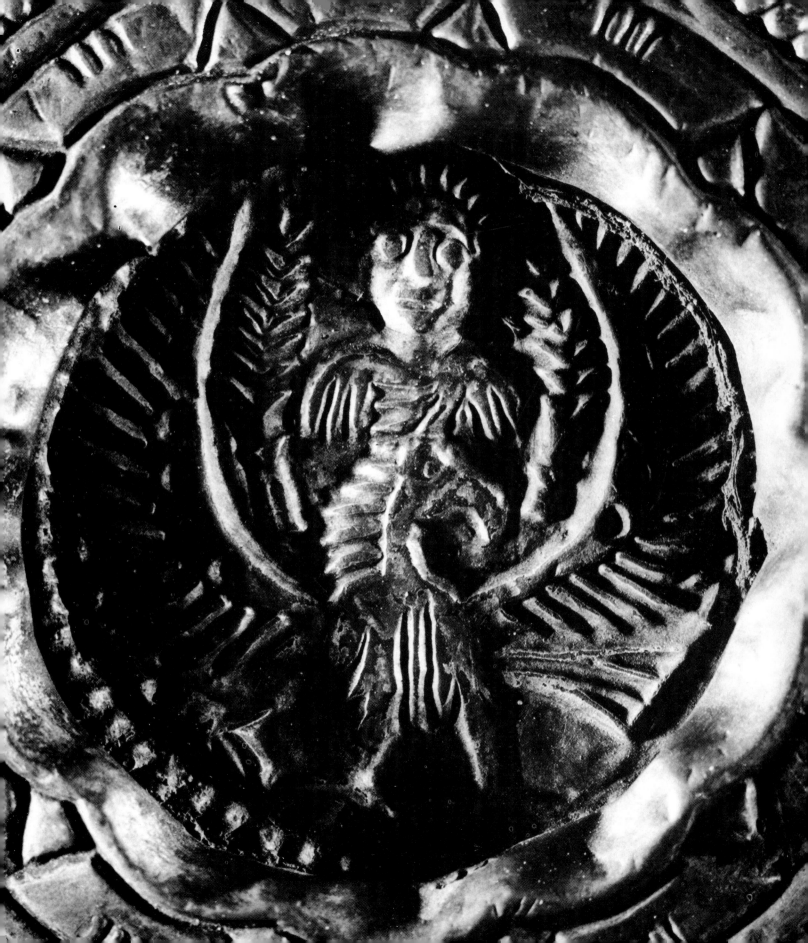

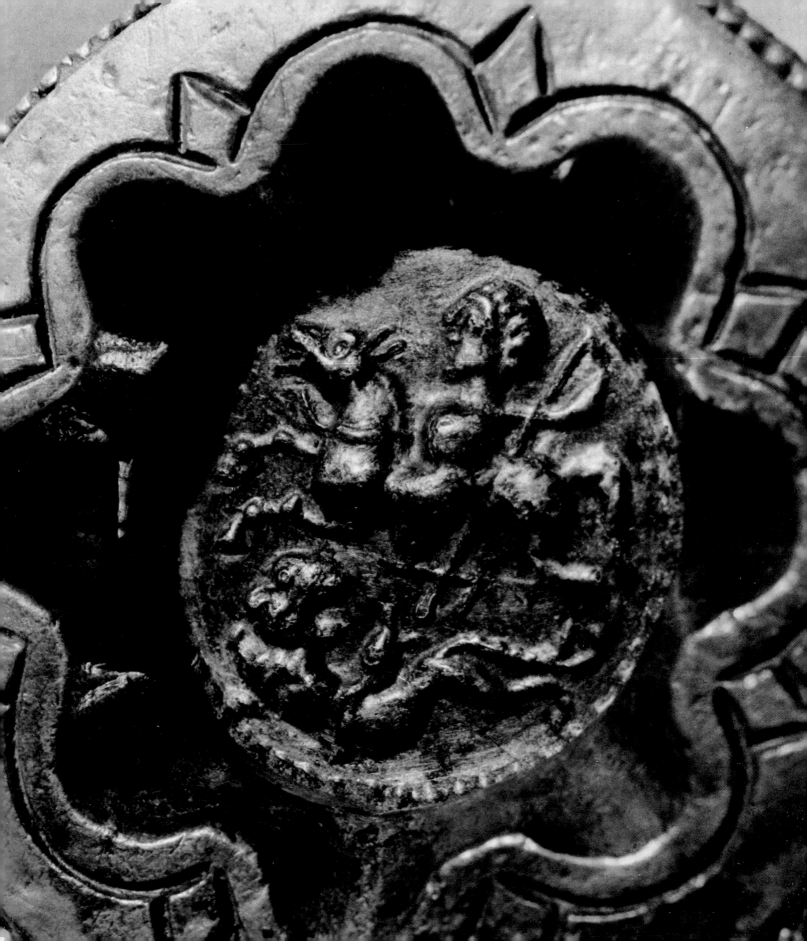

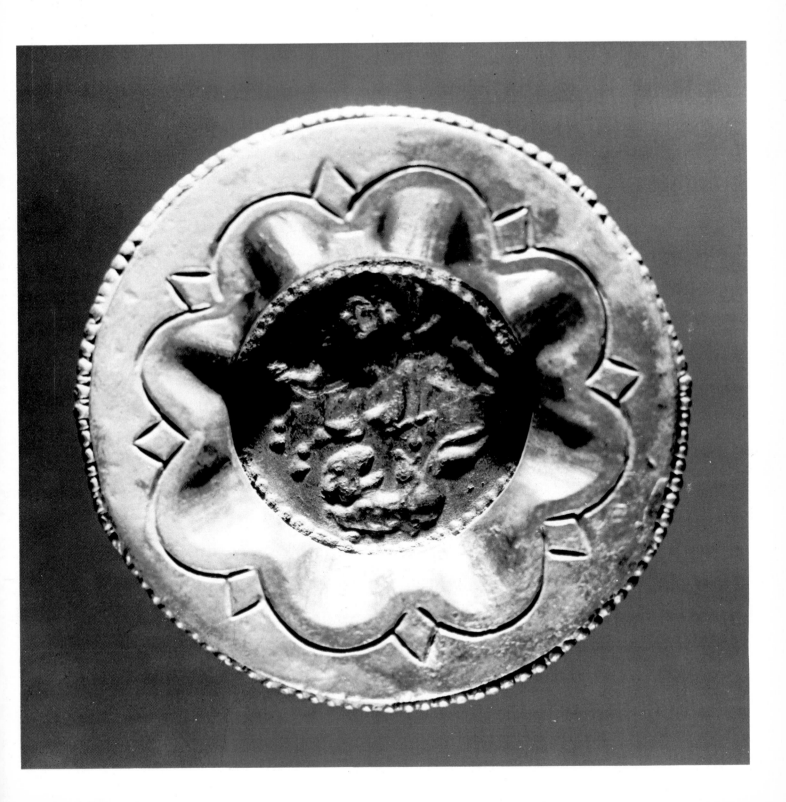

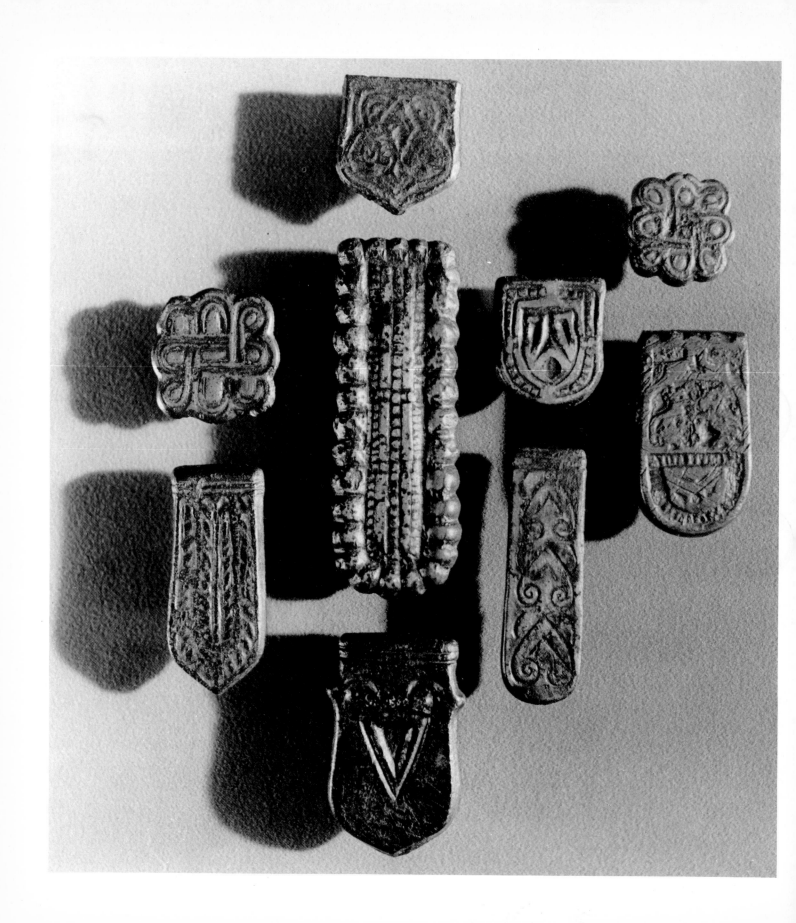

82. Stamping molds from the grave of a goldsmith at Adony. MNM

83–84. Stamping molds from the goldsmith's grave at Kunszentmárton. Szentes, Koszta József Museum

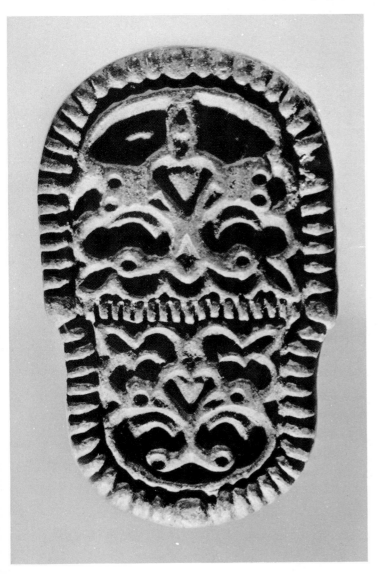

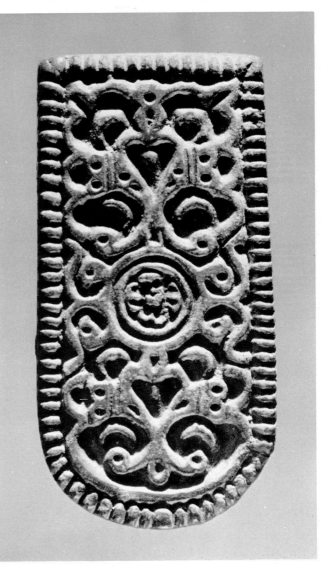

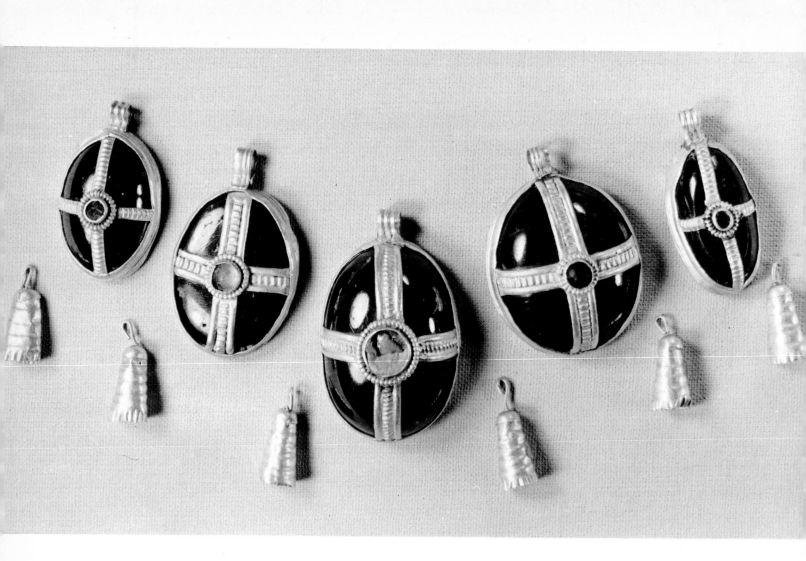

85. The grave of an Avar prince's daughter at Kiskőrös-Vágóhíd. MNM

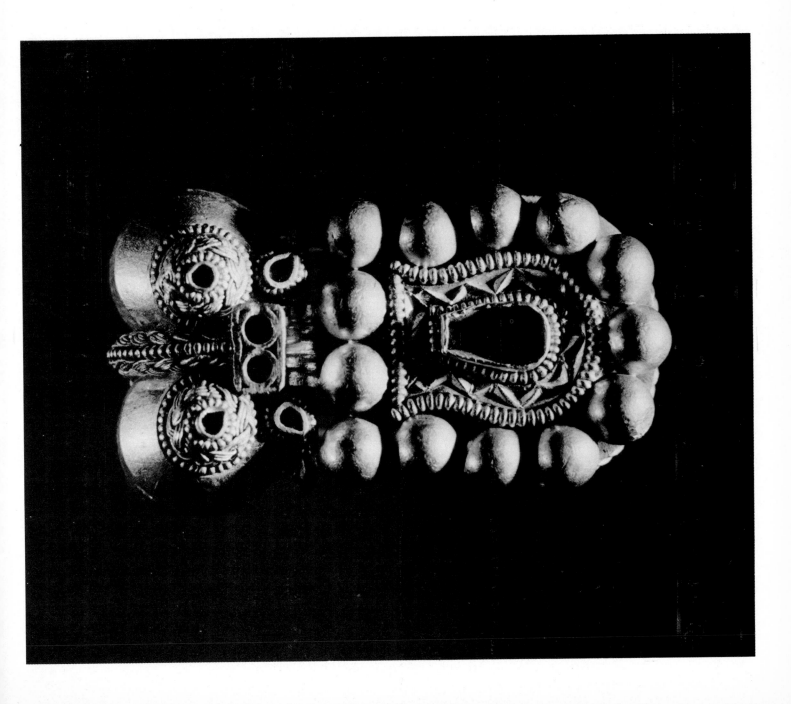

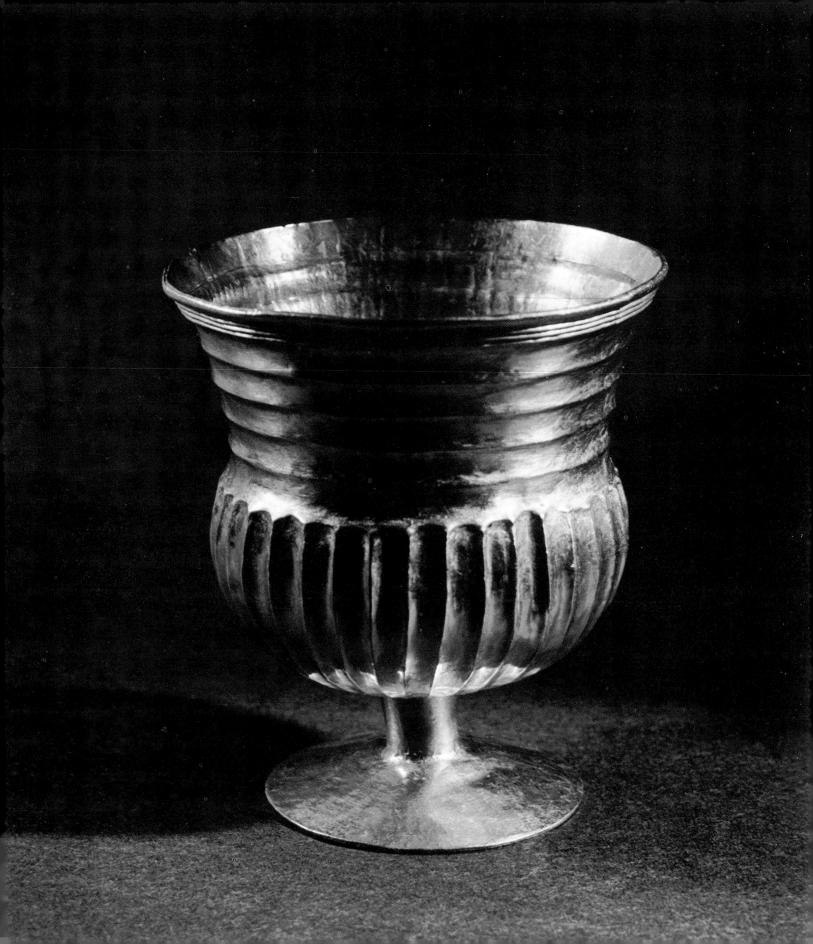

87. Gold cup
from the Avar
princely find
at Bócsa.
MNM

88. Avar
imitations
of Byzantine
solidi.
MNM

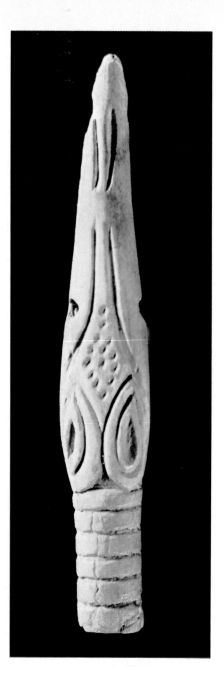

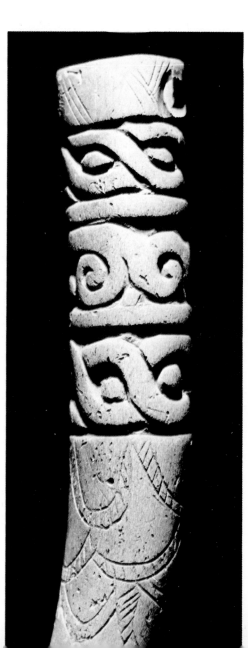

89–91. Avar bone carvings. MNM and Szeged, Móra Ferenc Museum

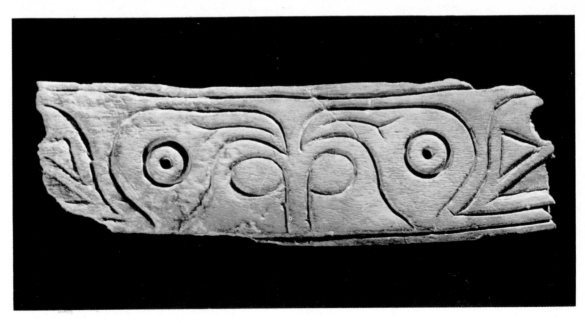

92. Bone carving of an Avar quiver from Dunapentele. MNM

93. Strap end ornamented with interlace from the Avar cemetery at Homokmégy-halom. MNM

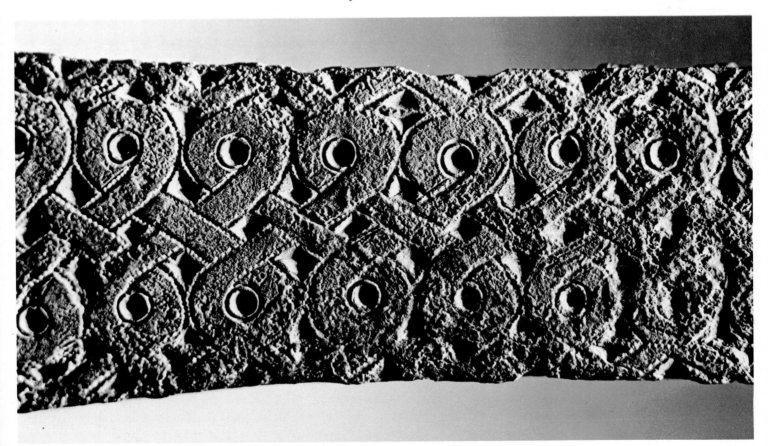

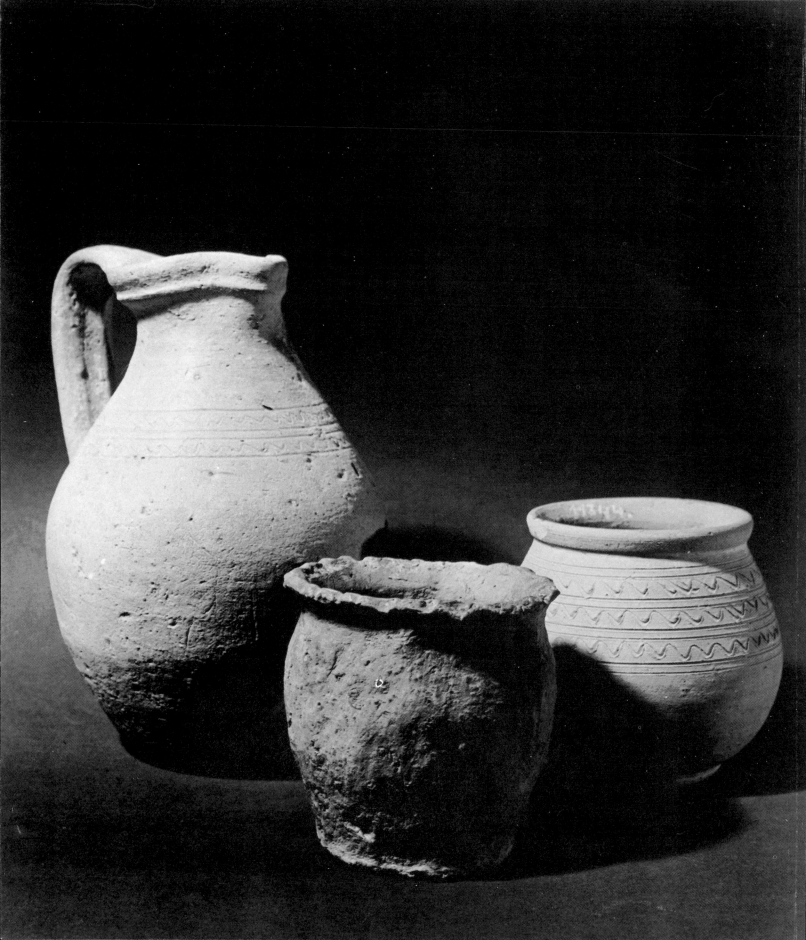

94. Avar pottery from
the cemetery at Csákberény.
Székesfehérvár, István Király Museum

95. Eagle tearing at a fish
on a silver plate from the Avar Period.
Szeged, Móra Ferenc Museum

96. Late Avar strap end with plant ornament from Tápé. Szeged, Móra Ferenc Museum
97. Late Avar strap end with plant ornament from Csongrád-Mámai-dűlő. Szentes, Koszta József Museum
98. The decorated reverse of a Late Avar strap end from Klárafalva. (The obverse side is shown in *Plates 125* and *126*.) Szeged, Móra Ferenc Museum

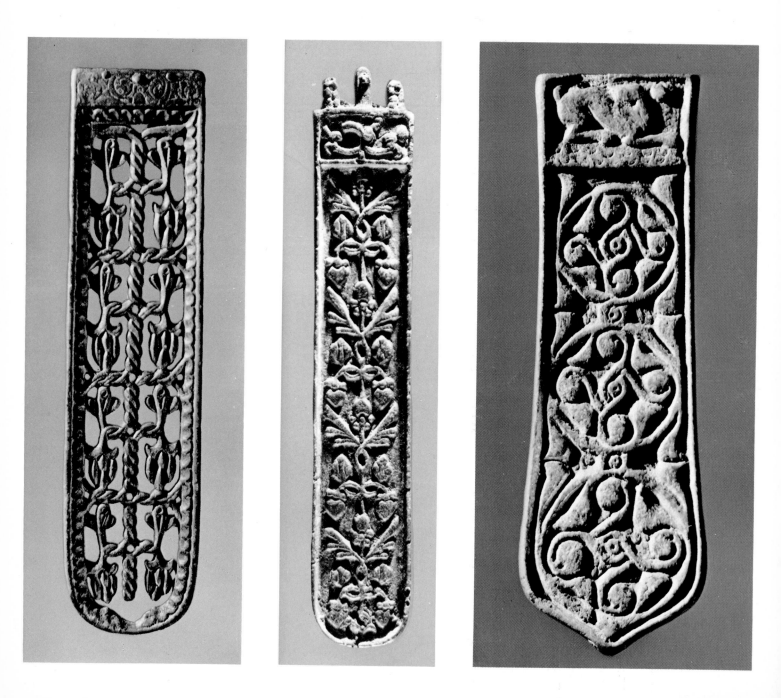

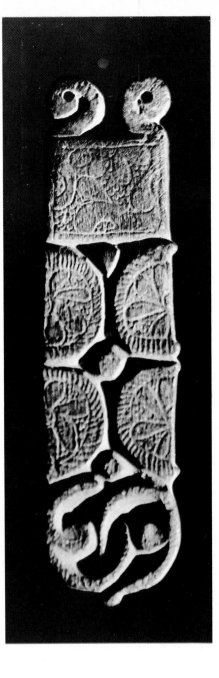

99. Late Avar strap end with rinceau composition. Szeged, Móra Ferenc Museum
100. Late Avar strap end with rinceau composition from Szeged-Öthalom. Szeged, Móra Ferenc Museum
101. Late Avar strap end with rinceau composition. Szeged-Bilisics. Szeged, Móra Ferenc Museum

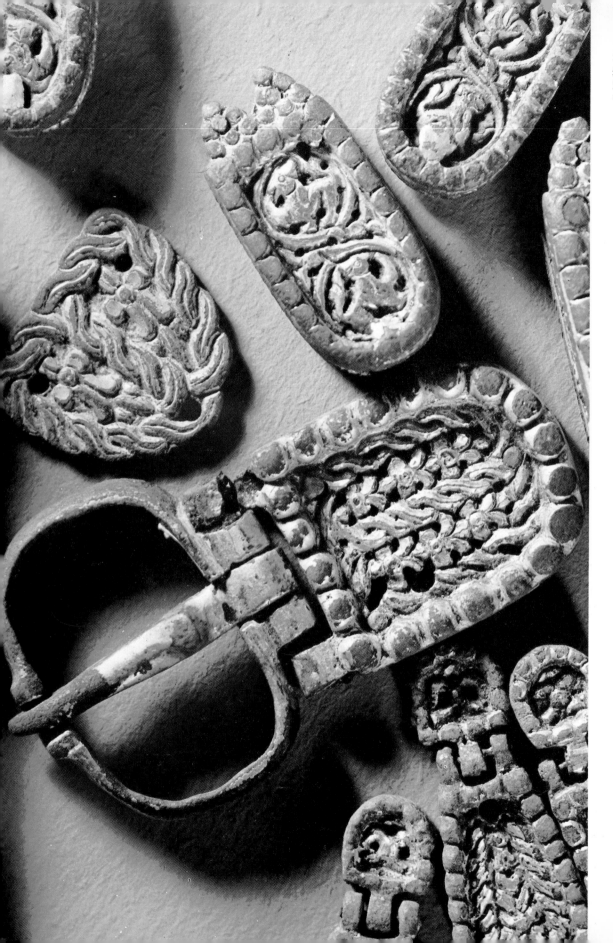

102. Late Avar finds
from the cemetery at Székkutas.
Hódmezővásárhely,
Tornyai János Museum

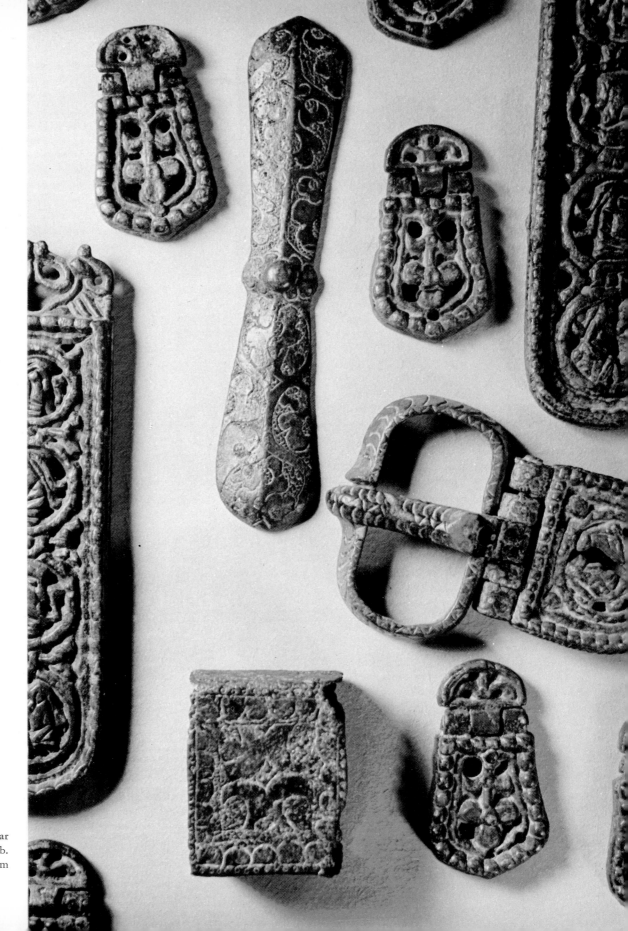

103. Finds from the Avar
cemetery at Szeged-Kundomb.
Szeged, Móra Ferenc Museum

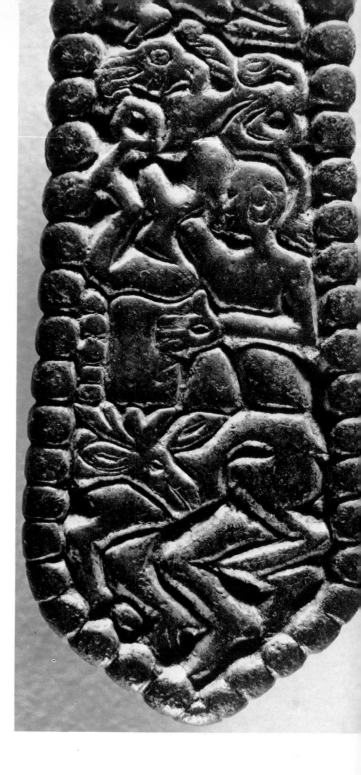

104–105. Enlarged picture of the obverse of
the Mártély strap end. MNM

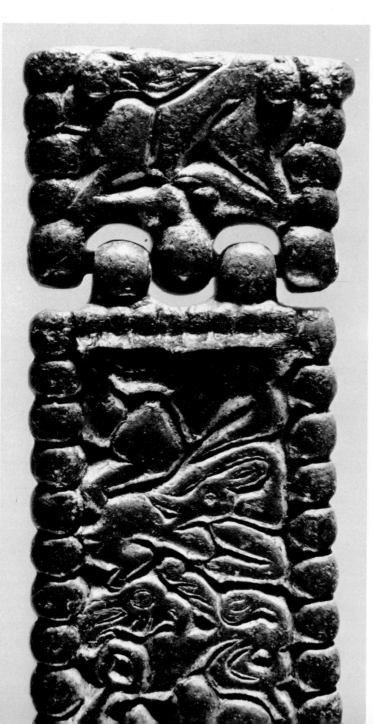

106–107. Enlarged picture of the reverse of the Mártély strap end. MNM

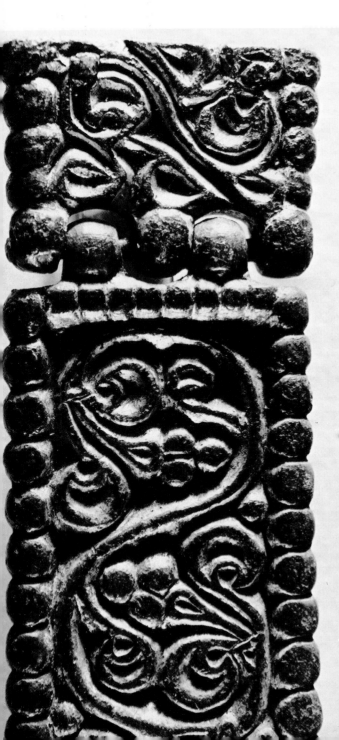
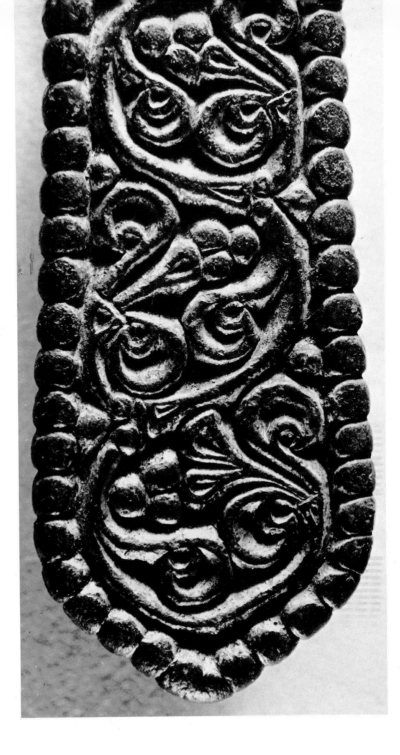

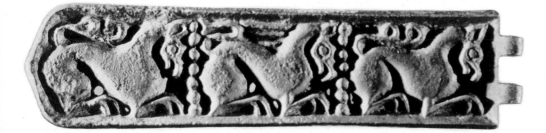

110. Belt mountings ornamented
with gryphons from Szentes-Lapistó.
Szentes, Koszta József Museum

108–109. Late Avar strap end with
gryphon ornament from Nagymágocs-Ótompa.
Szentes, Koszta József Museum

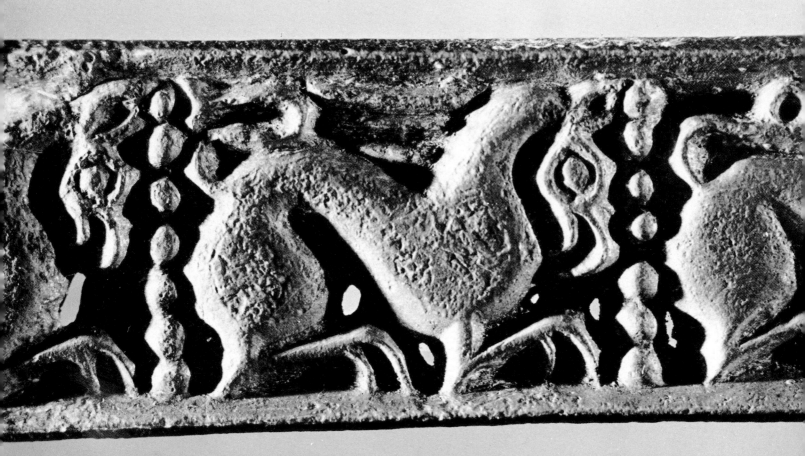

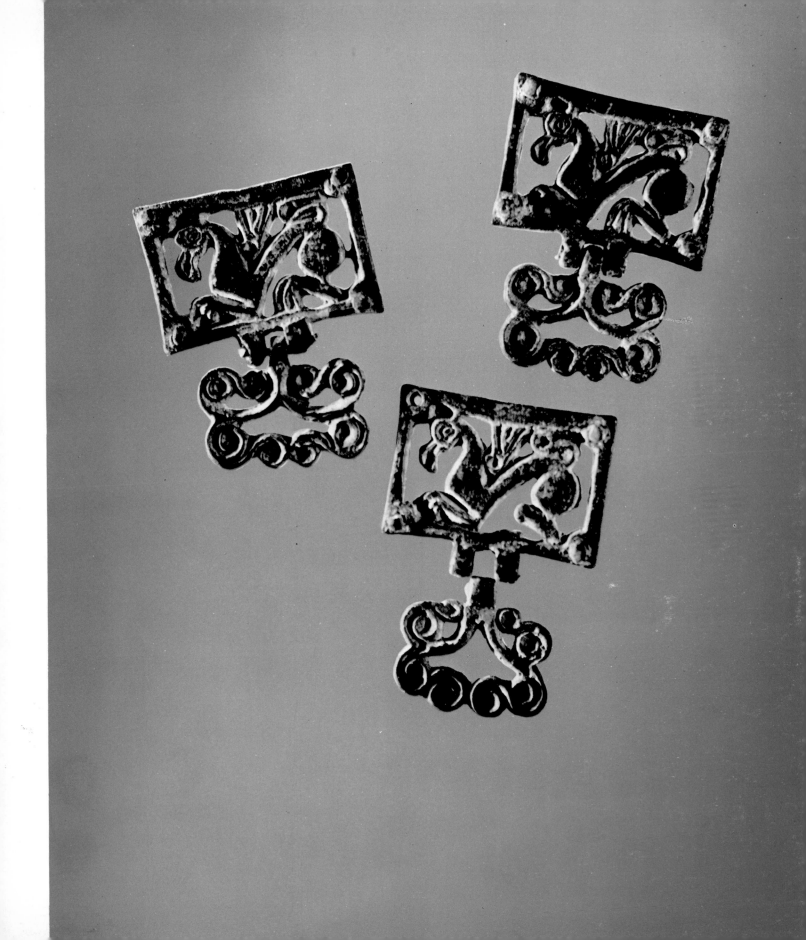

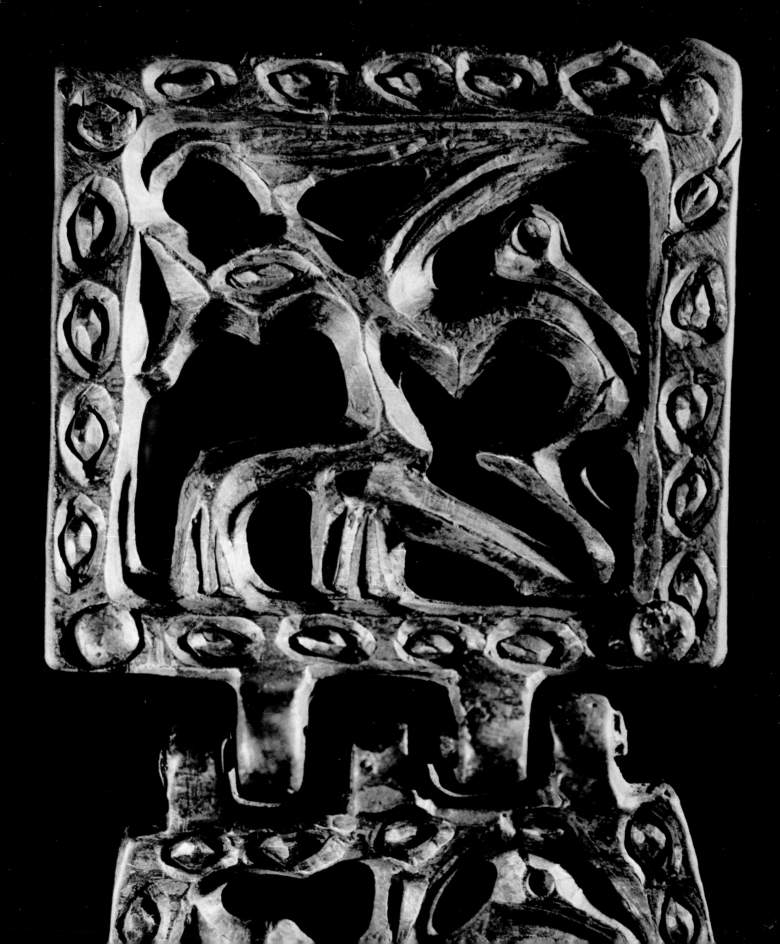

111. Gilded bronze belt
mounting from Keszthely. MNM

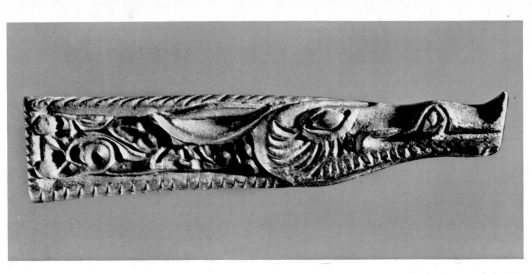

112. Strap end ornamented with boar's head from Nemesvölgy (Edelstal, Austria). MNM

113. Cast and chiseled horse's head from Böcs. MNM

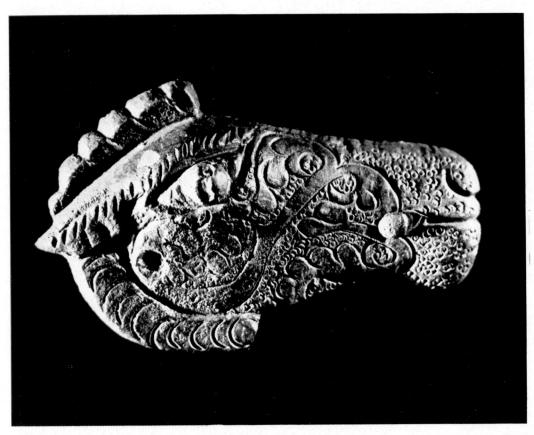

114–115. Details of the large strap end from the Nagysurány cemetery. MNM

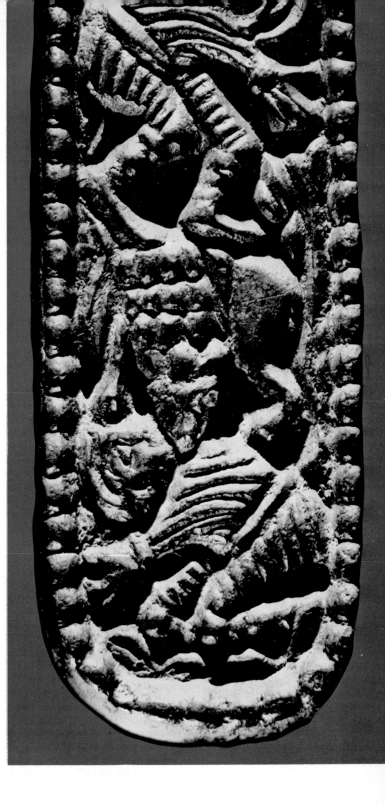

117. Canvas imprint on the reverse of the Nagysurány strap end.

118. The Siberian gold find. Canvas imprint on the reverse. Leningrad, Hermitage

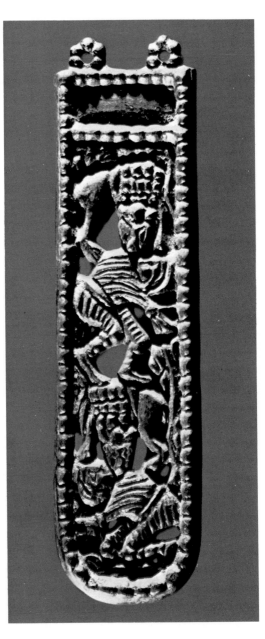

116. The Nagysurány large strap end. MNM

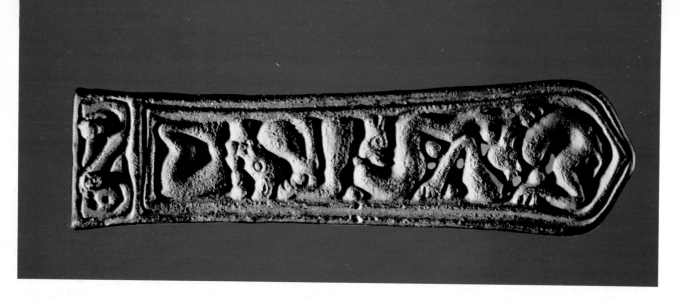

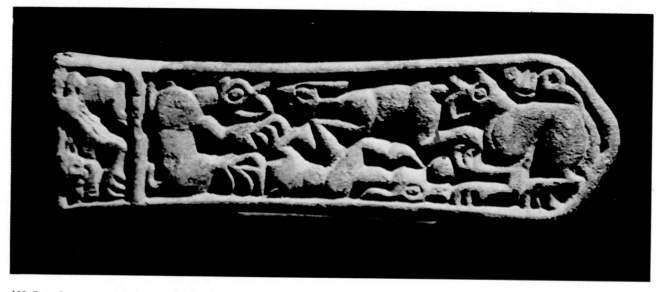

119. Late Avar strap end showing fighting beasts from Dévaványa. MNM
120. Late Avar strap end showing fighting beasts. Szeged, Móra Ferenc Museum

121. Late Avar strap end showing fighting beasts. MNM

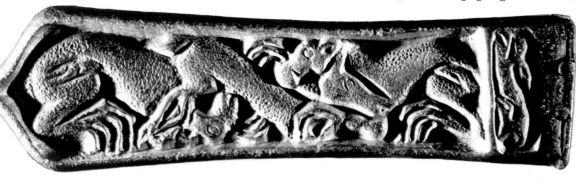

122–124. Details of the fighting
beasts scene in *Plate 121*.

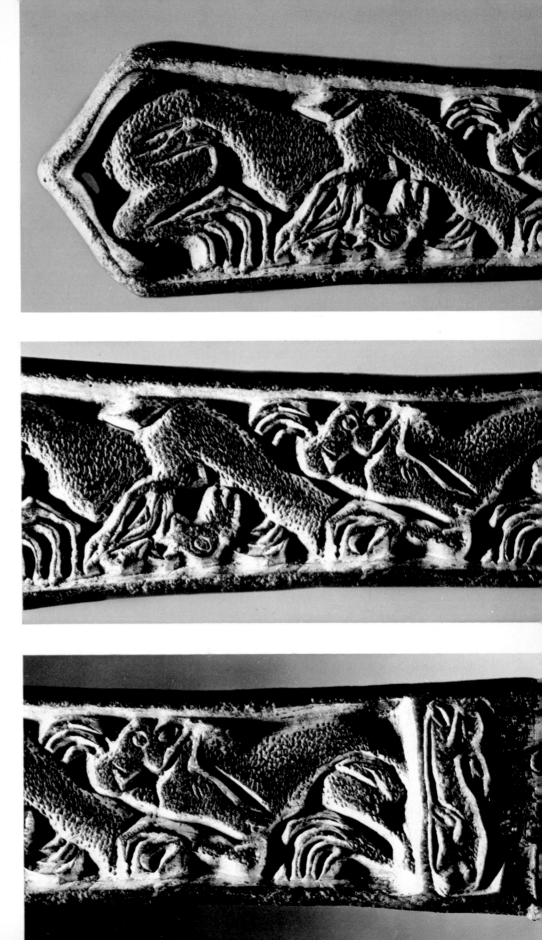

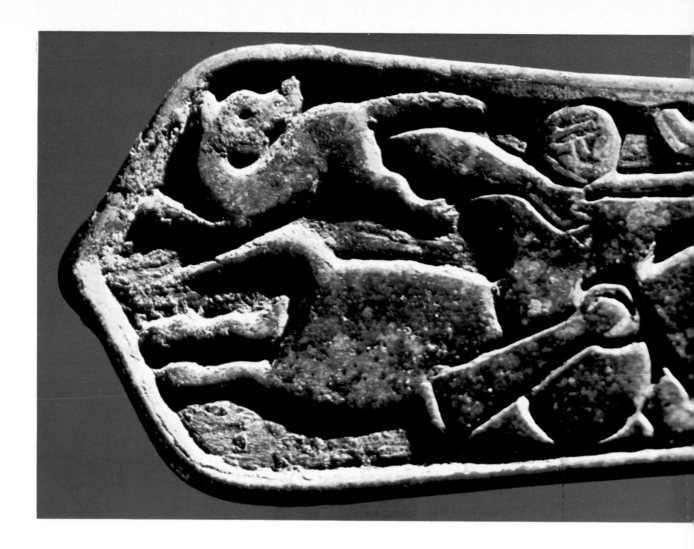

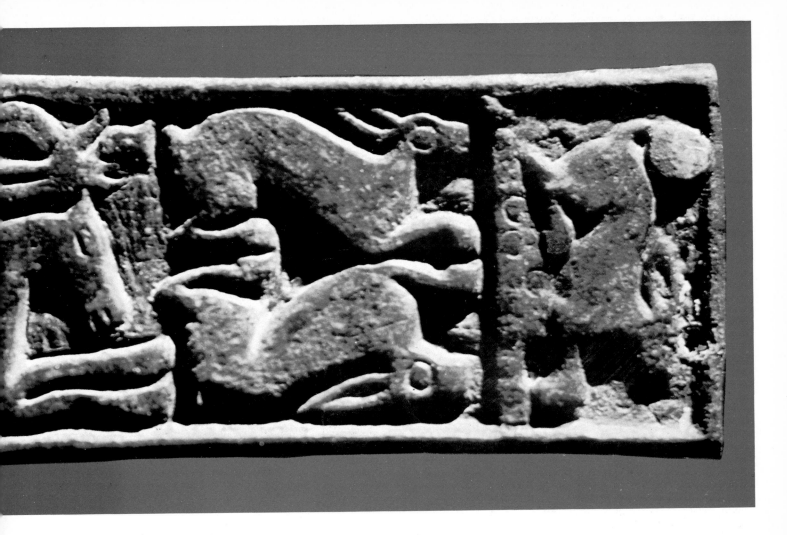

125–126. Strap end from Klárafalva showing a hunting scene. Szeged, Móra Ferenc Museum

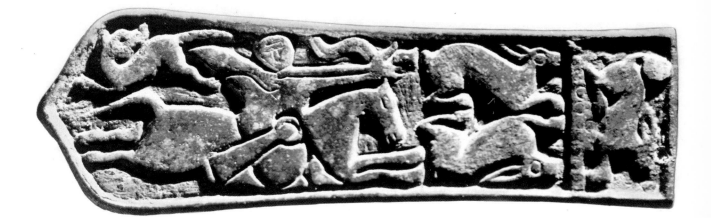

127. Detail of a strap end from Bánhalma showing hunters. Szolnok, Damjanich János Museum

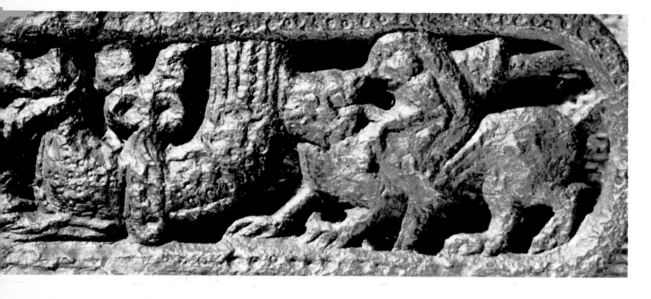

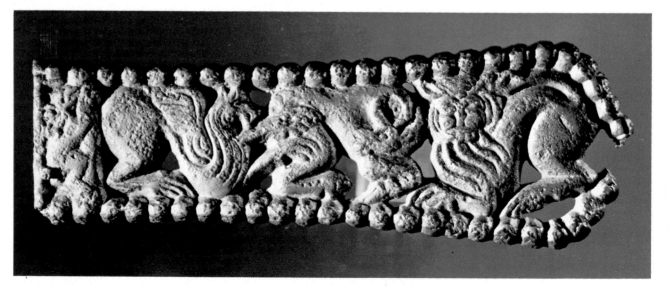

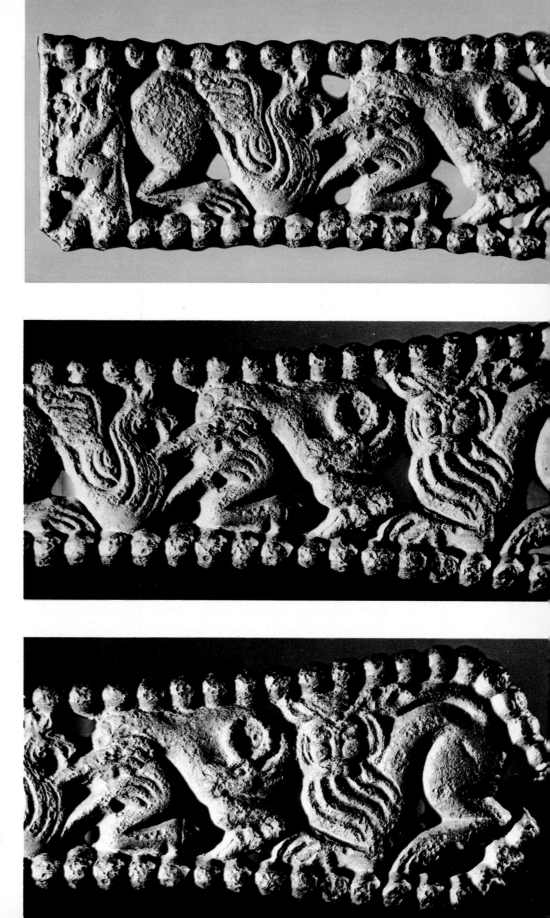

128–131. Late Avar strap end with
fighting beasts and a human-headed lion
from the cemetery at Kecel. MNM

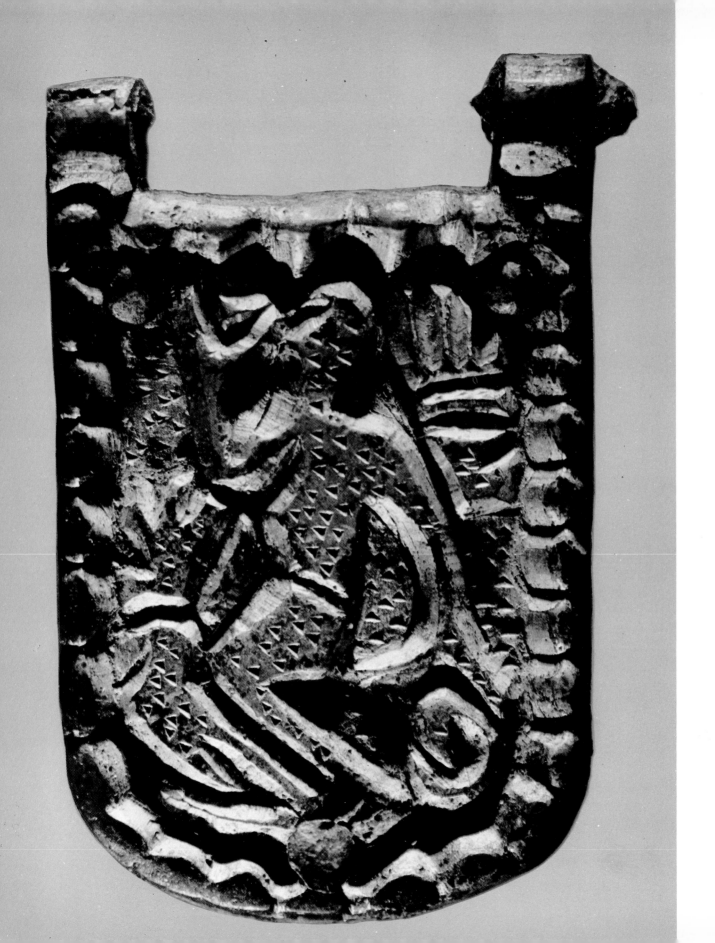

132. Buckle from the Balatonszőlős cemetery. Veszprém, Bakony Museum

133. Disk-shaped mounting from the Balatonszőlős cemetery. Veszprém, Bakony Museum

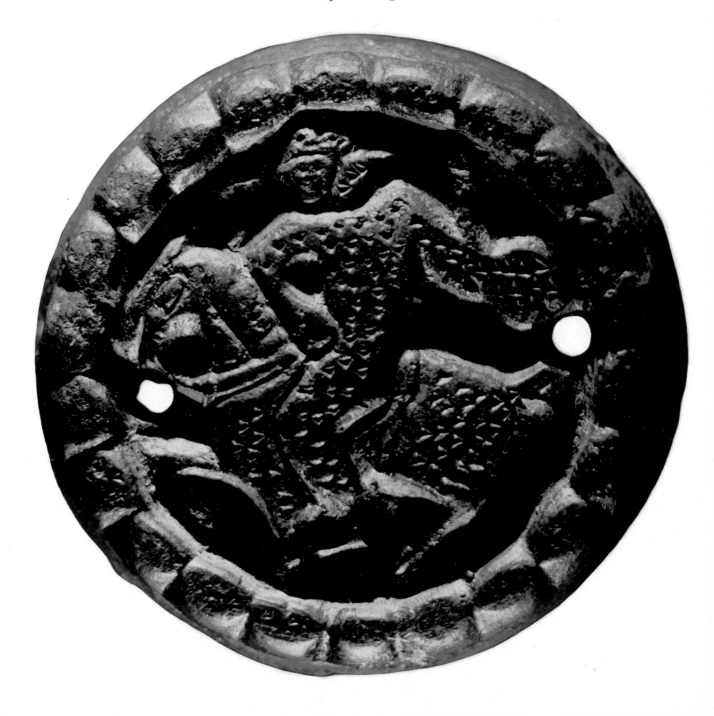

134. Pair of golden clasps from the Avar Period, found at Dunapataj. MNM

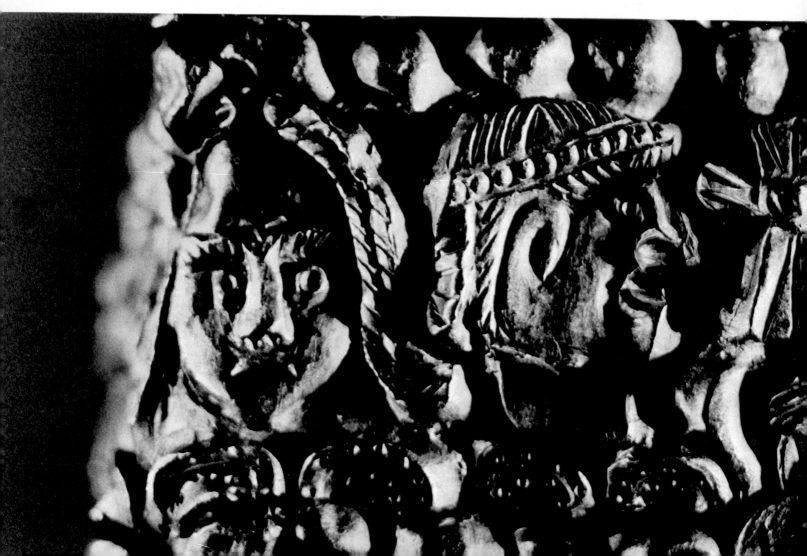

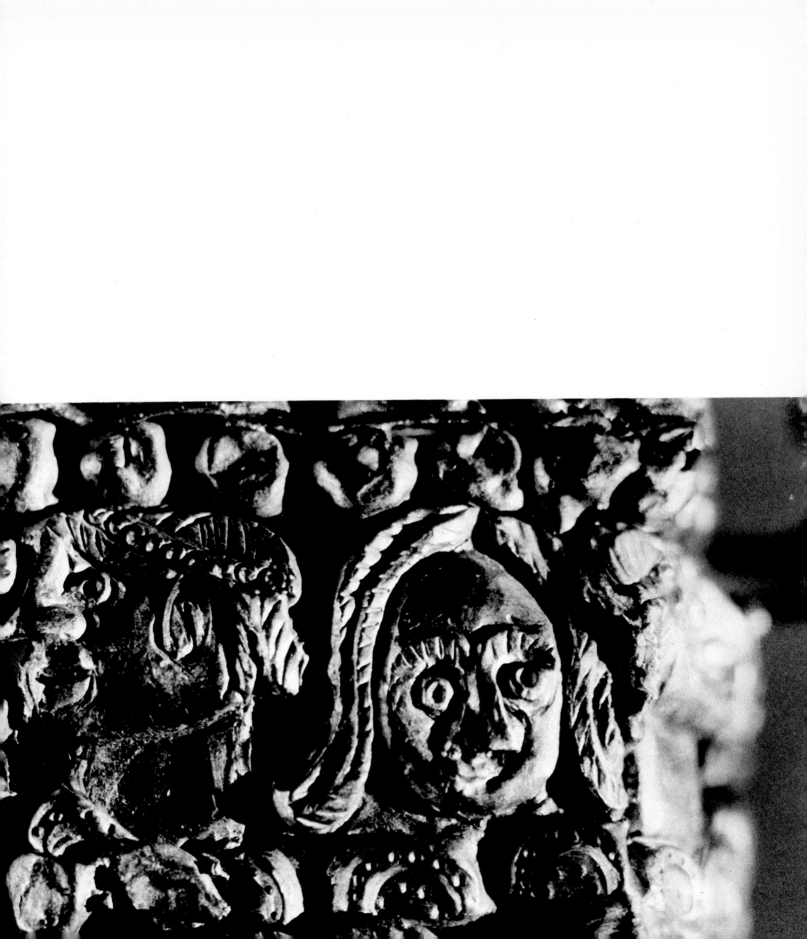

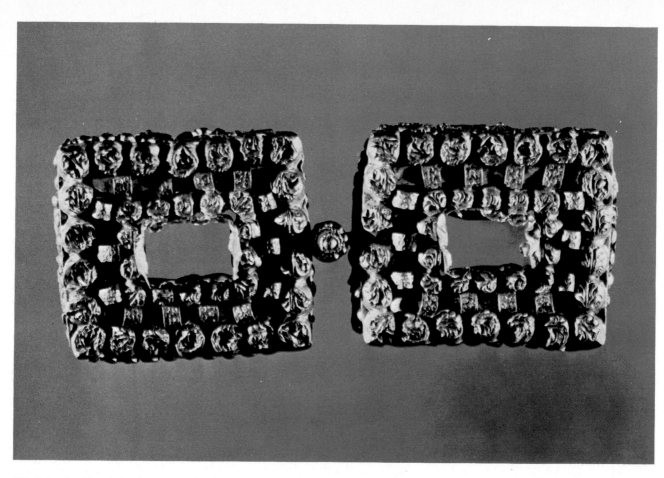

135. Pair of golden clasps from the Avar Period, found at Dunapataj. MNM

137. Ninth-century salt (?)-holder from Tatabánya. Tata, Kuny Domonkos Museum

138. Ninth-century salt (?)-holder made of antler, from Sopronkőhida. Sopron, Liszt Ferenc Museum

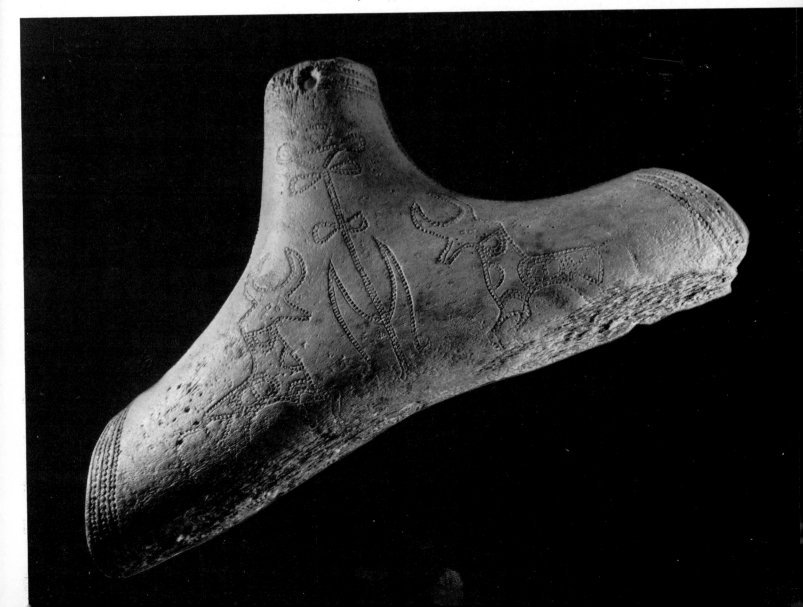

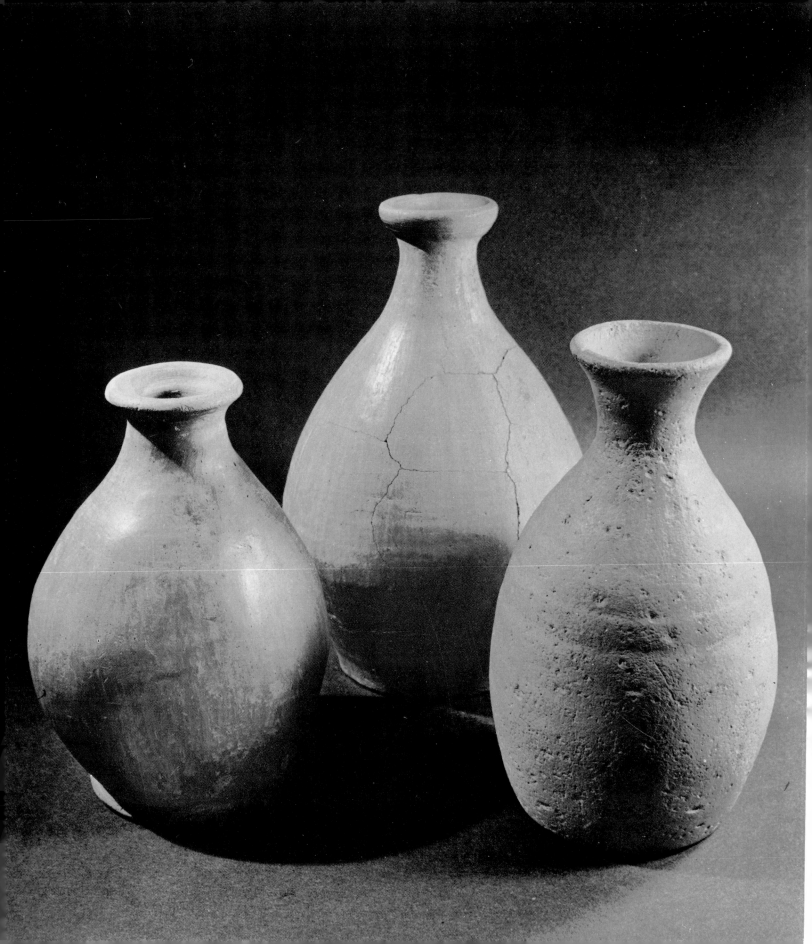

139. Late Avar-Carolingian pottery from the cemetery of Fenékpuszta. MNM

140. Ninth-century earrings from Zalavár. MNM

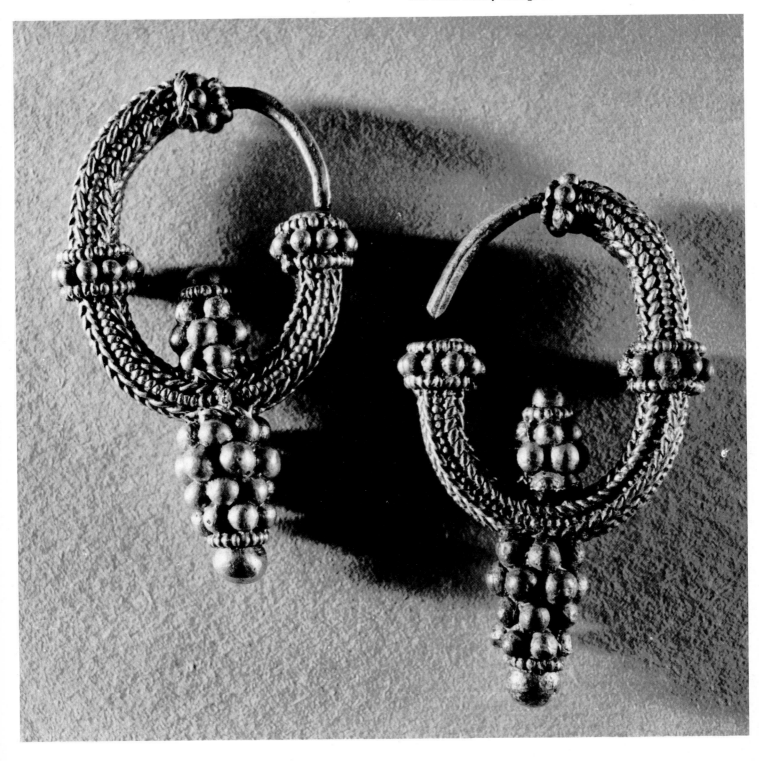

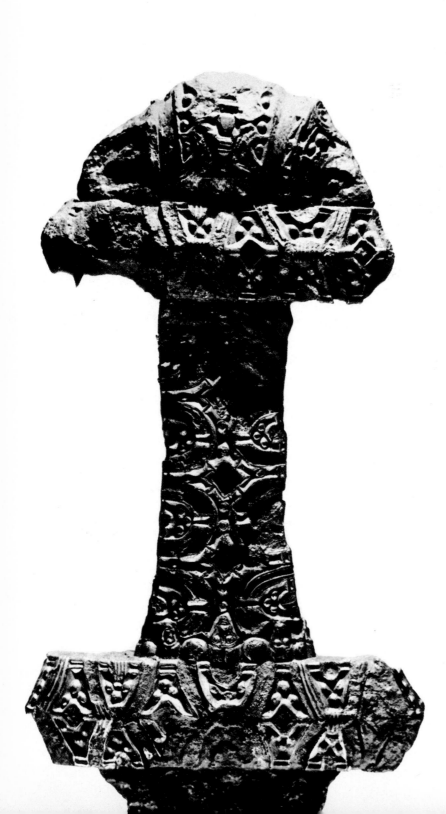

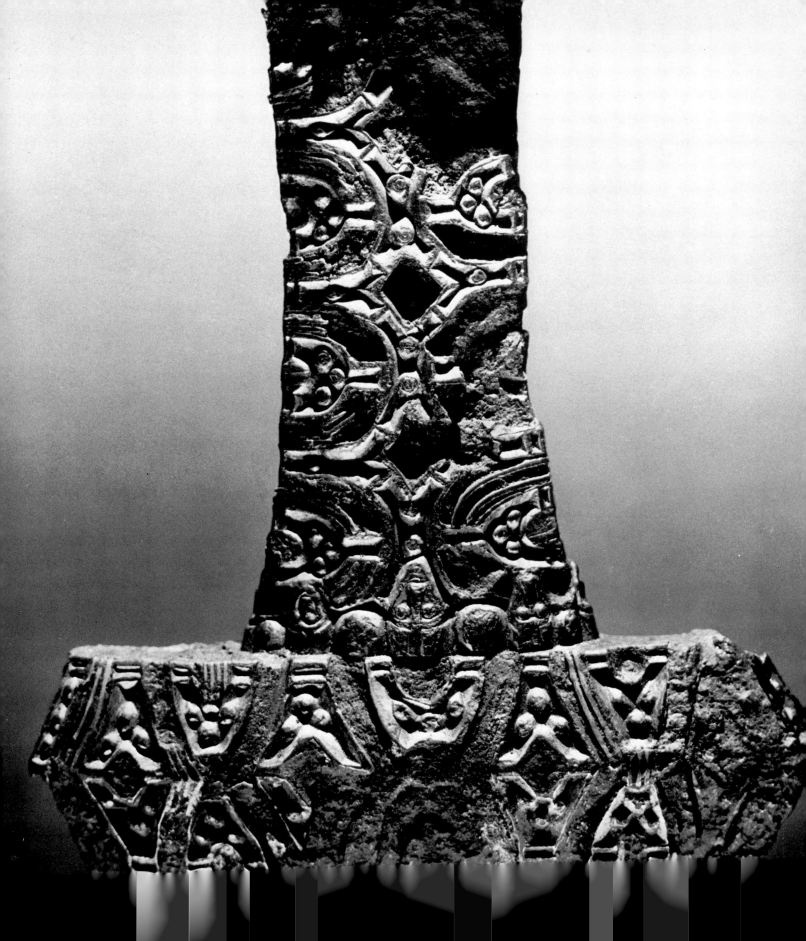

143–144. Mountings of a belt and of the trappings of the Blatnica find. MNM

145. "Attila's sword."
Vienna, Schatzkammer

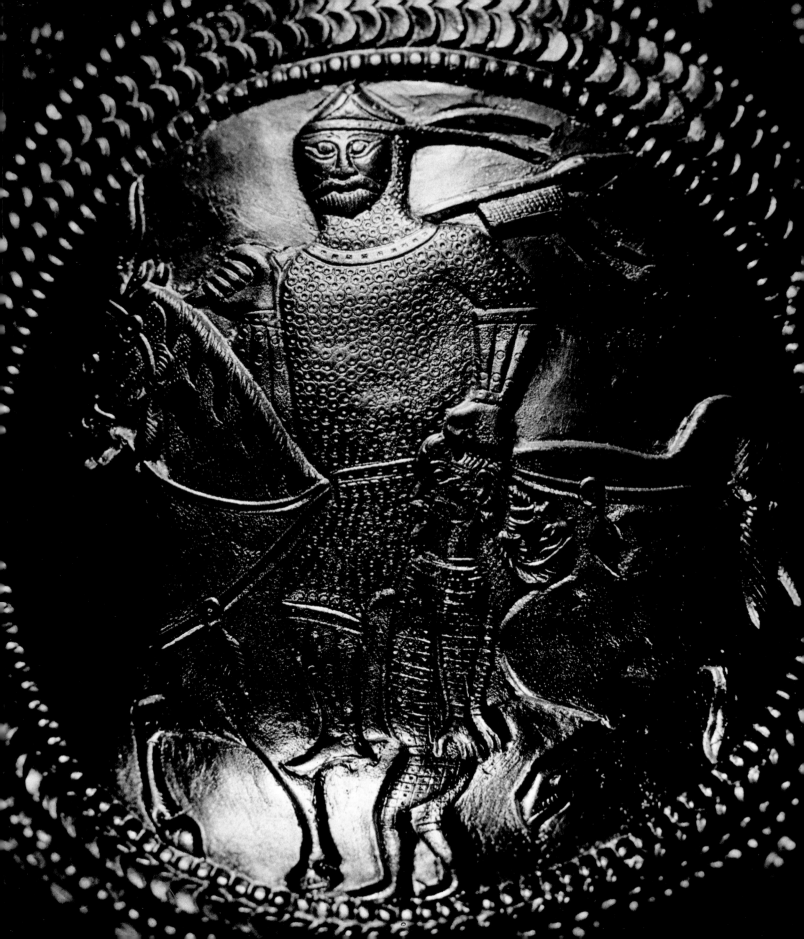

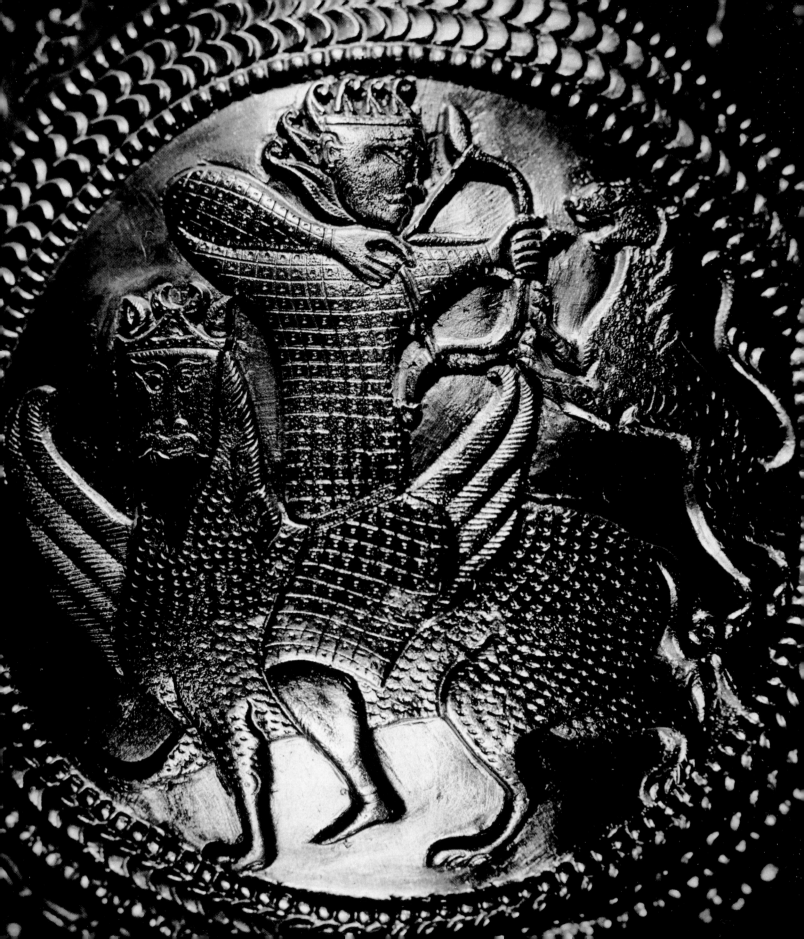

148–149. Hunter riding a winged lion with a human head. Ornament on Jar 2 of the Nagyszentmiklós treasure. Vienna, Kunsthistorisches Museum

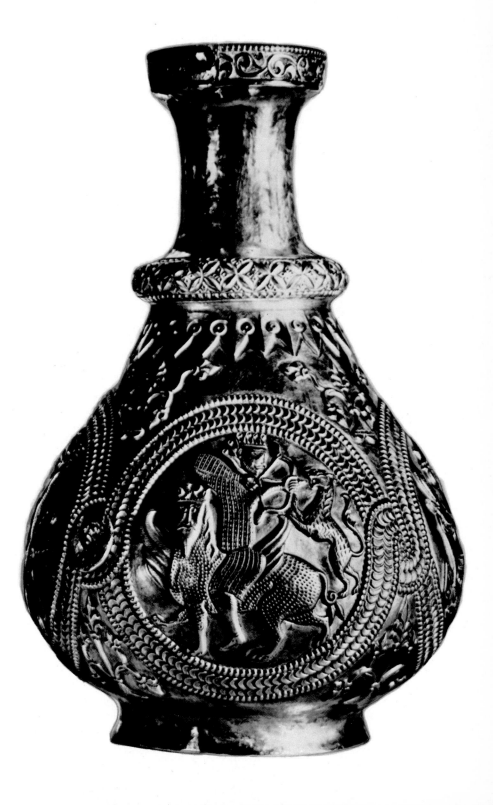

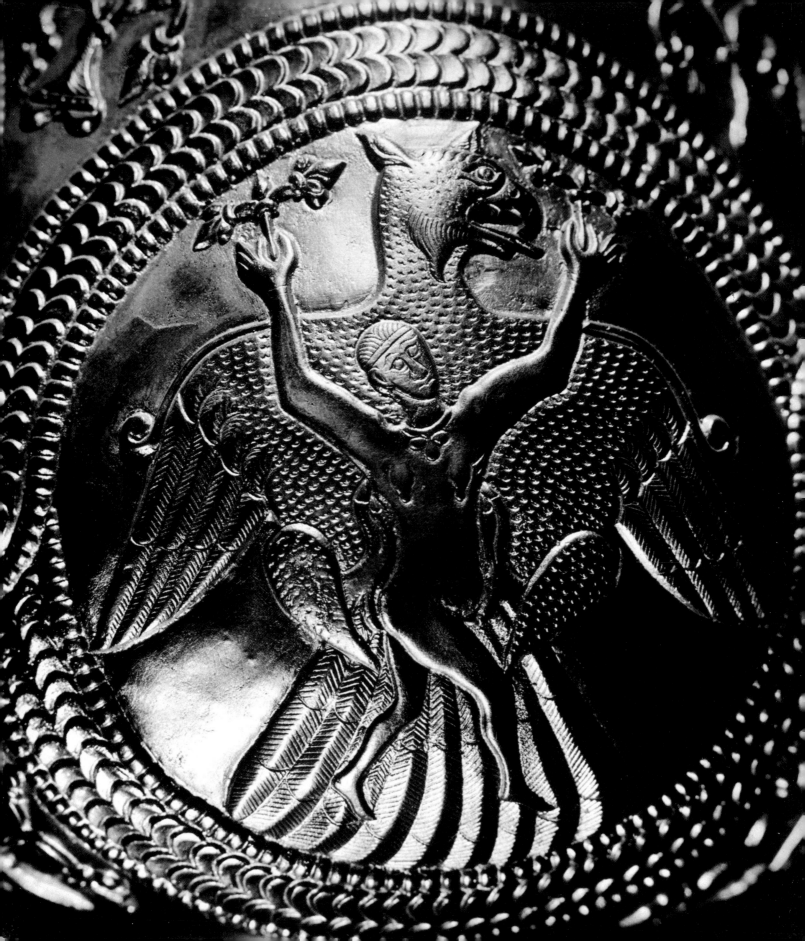

150–151. The "ascension" scene on Jar 2 of the Nagyszentmiklós treasure. Vienna, Kunsthistorisches Museum

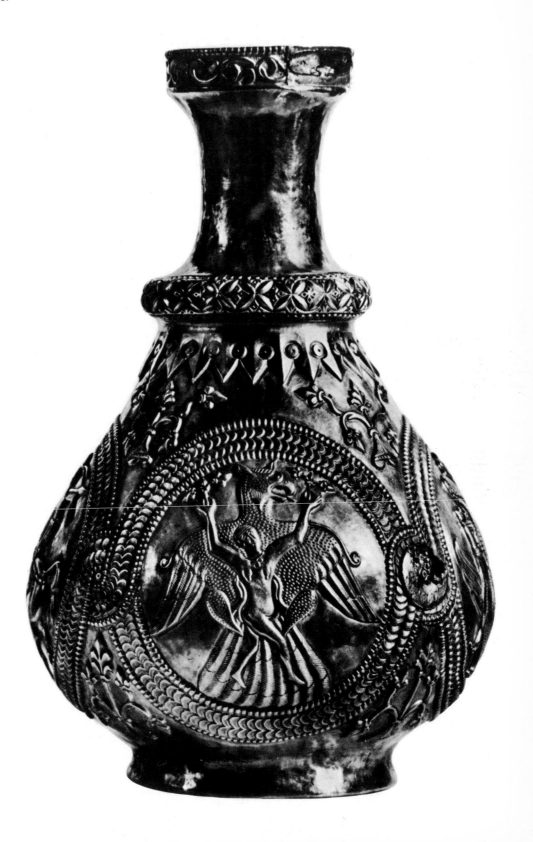

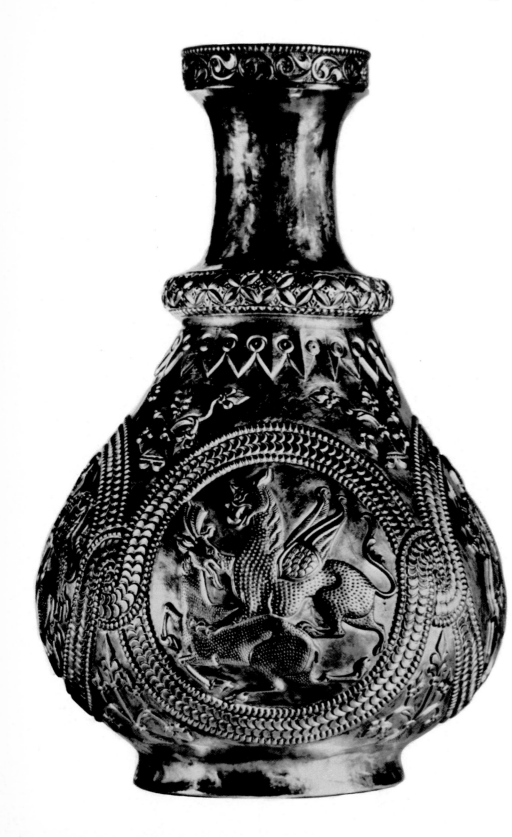

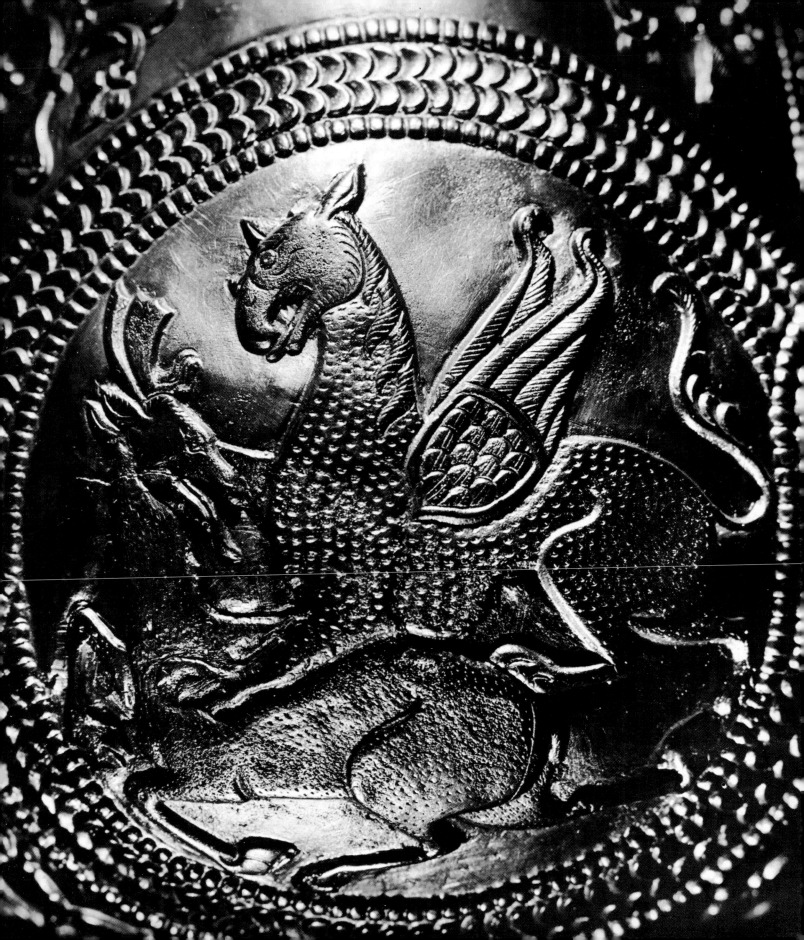

154. Jar 3 of the Nagyszentmiklós treasure.
Vienna, Kunsthistorisches Museum

155. Jar 6 of the Nagyszentmiklós treasure.
Vienna, Kunsthistorisches Museum

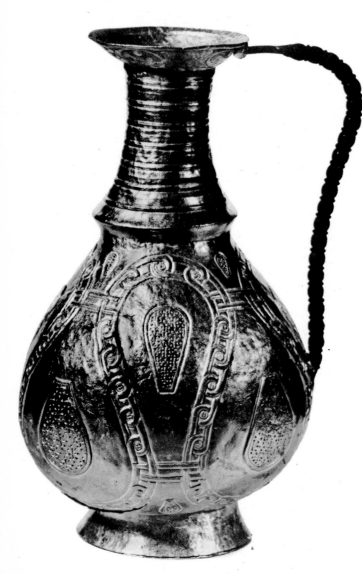

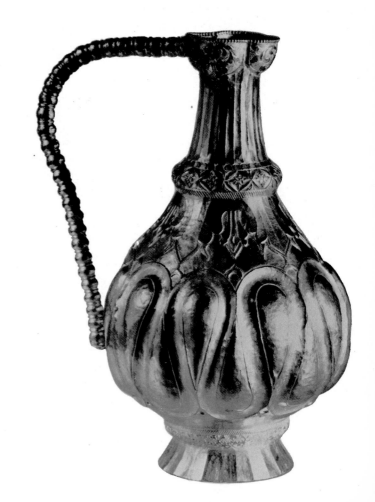

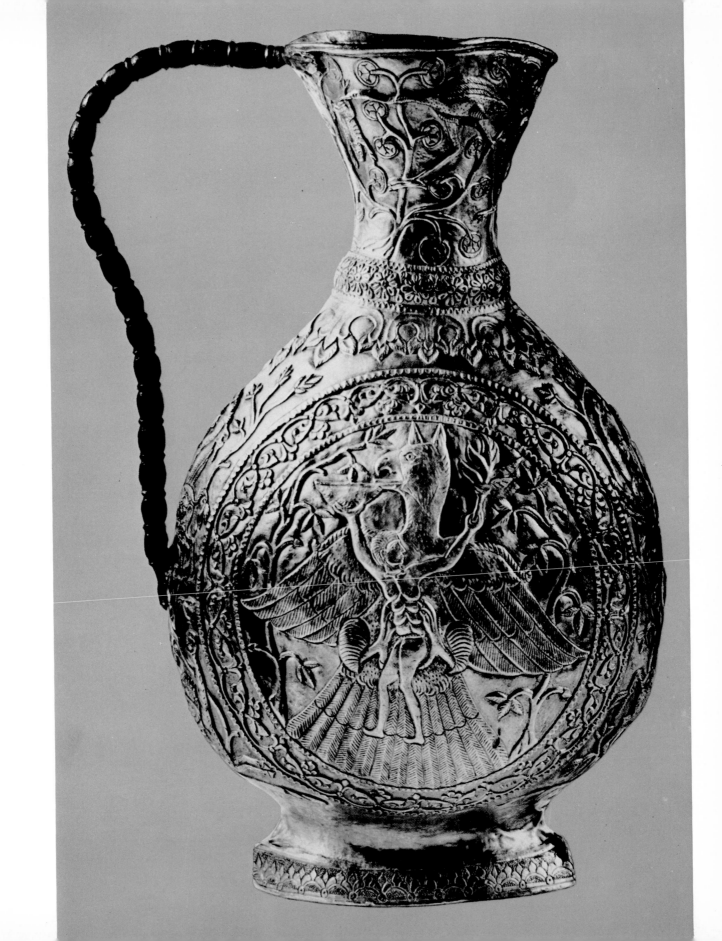

157–158. The drinking vessel (No. 13) of the Nagyszentmiklós treasure. Vienna, Kunsthistorisches Museum

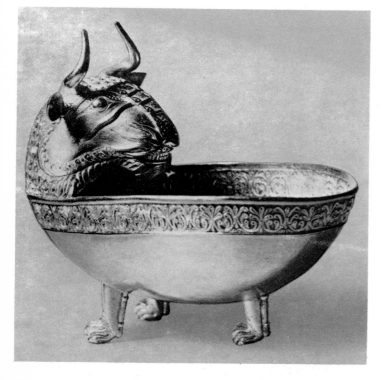

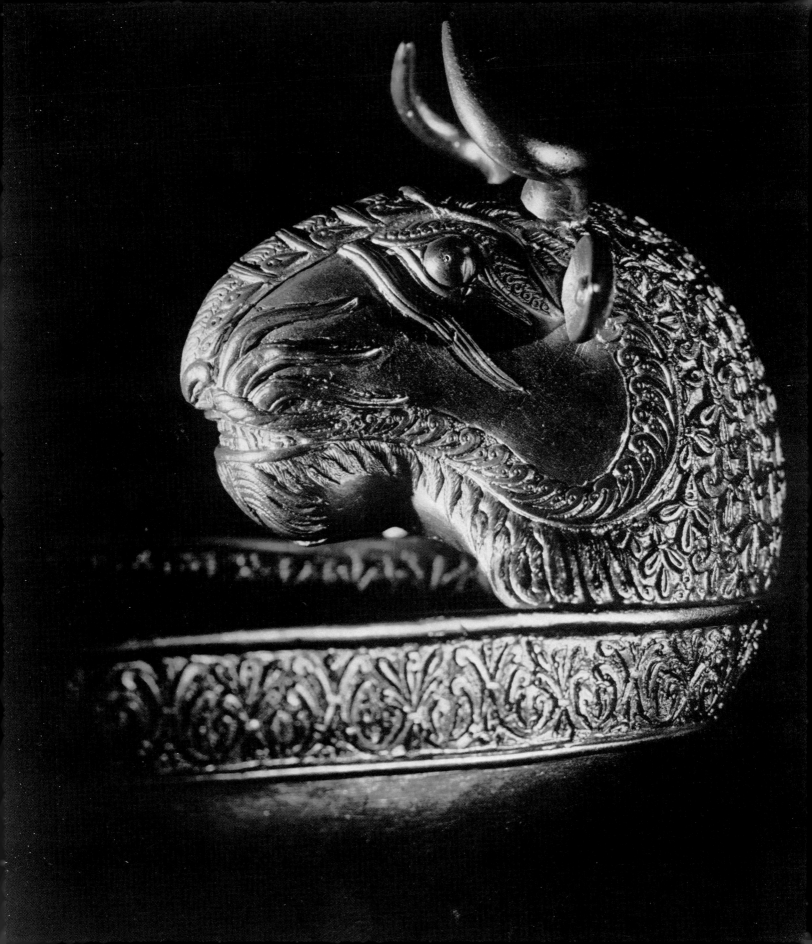

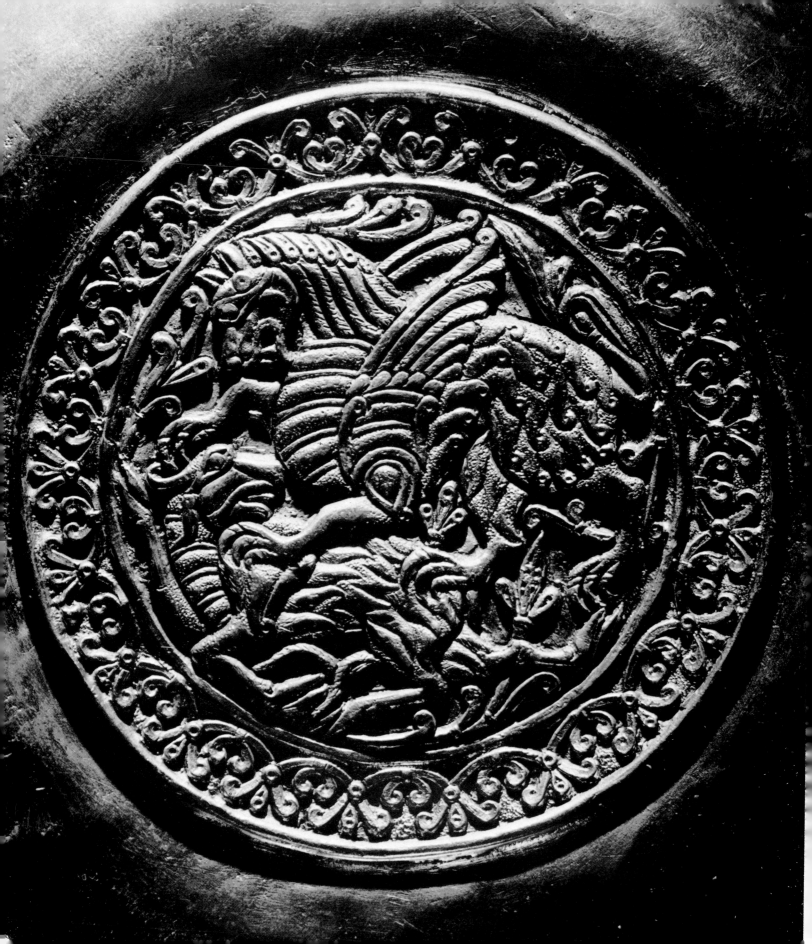

159–160. Ornament on the middle disk of Cup 21 of the Nagyszentmiklós treasure. Vienna, Kunsthistorisches Museum

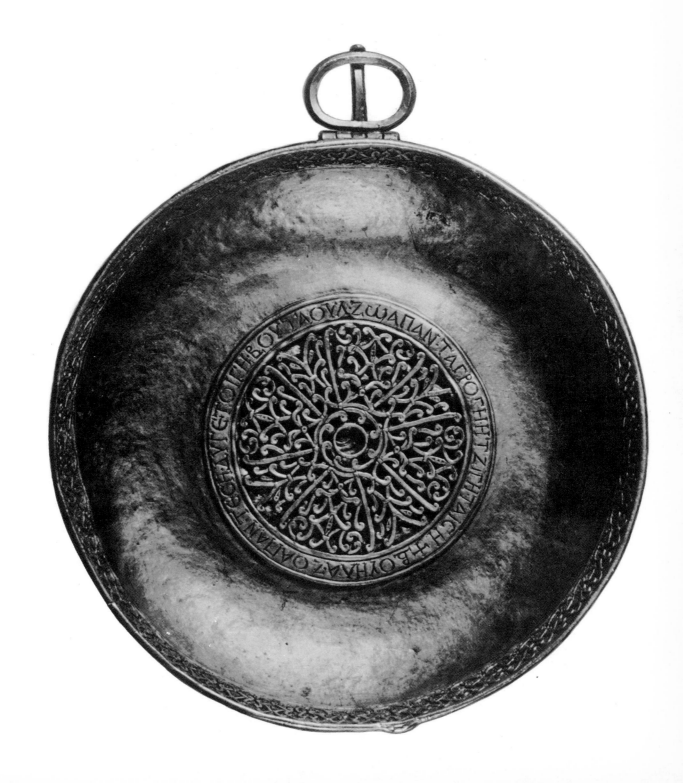

161–162. "Dessert bowl" (No. 19) of the Nagyszentmiklós treasure, Vienna, Kunsthistorisches Museum

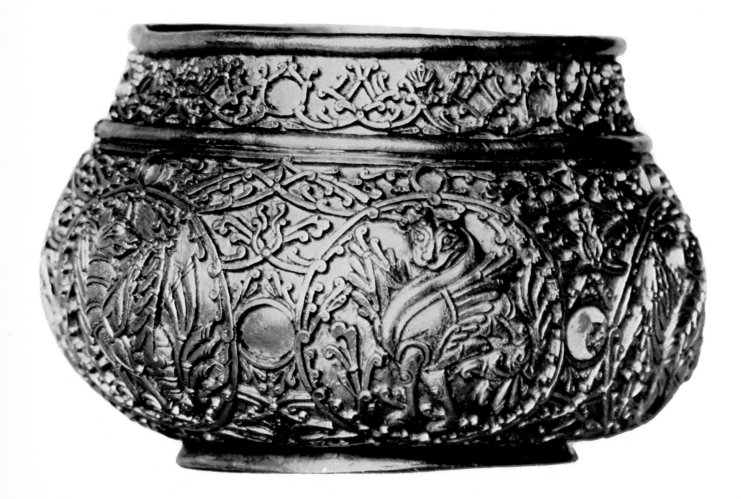

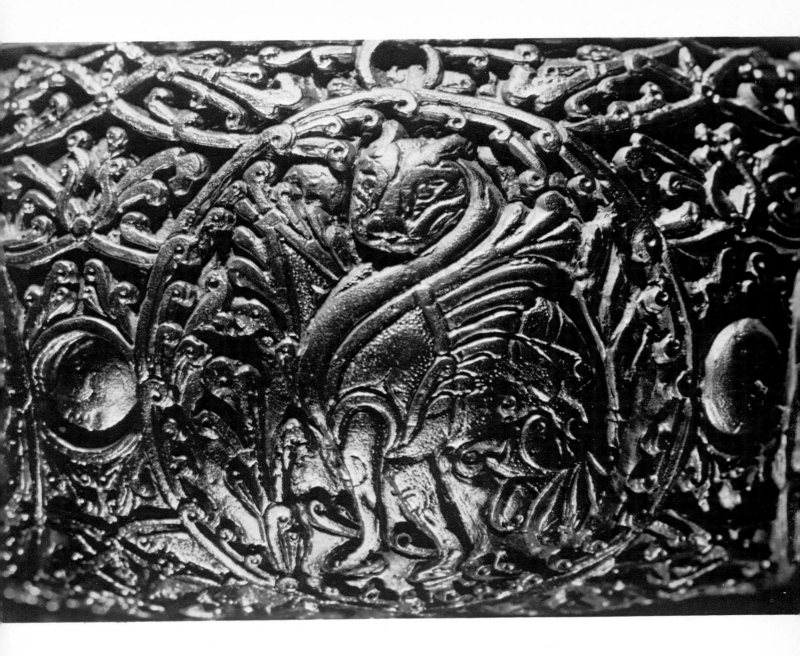

163–164. Ornamental disks from a female grave at Rakamaz. Nyíregyháza, Jósa András Museum

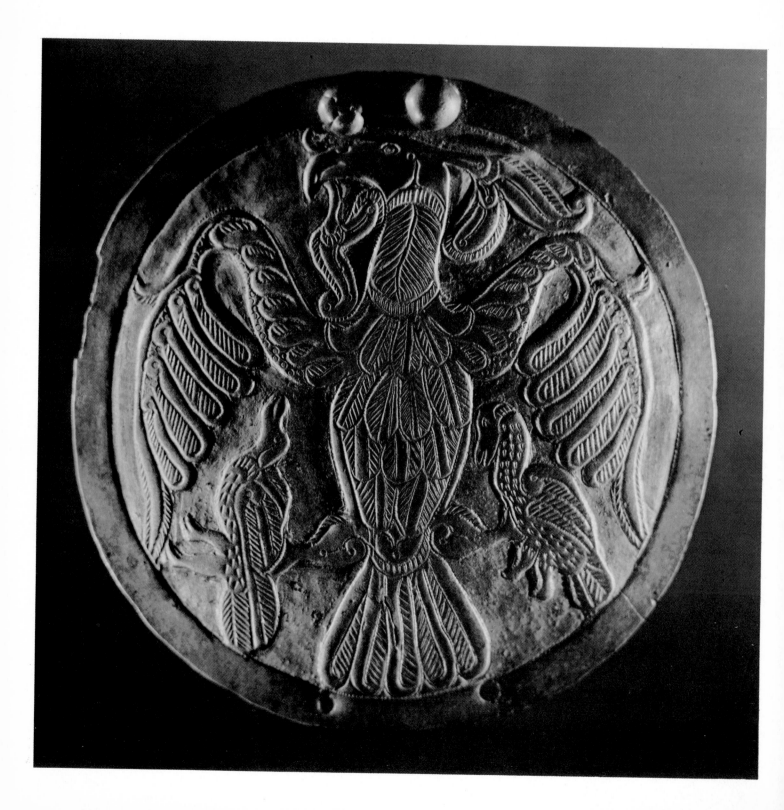

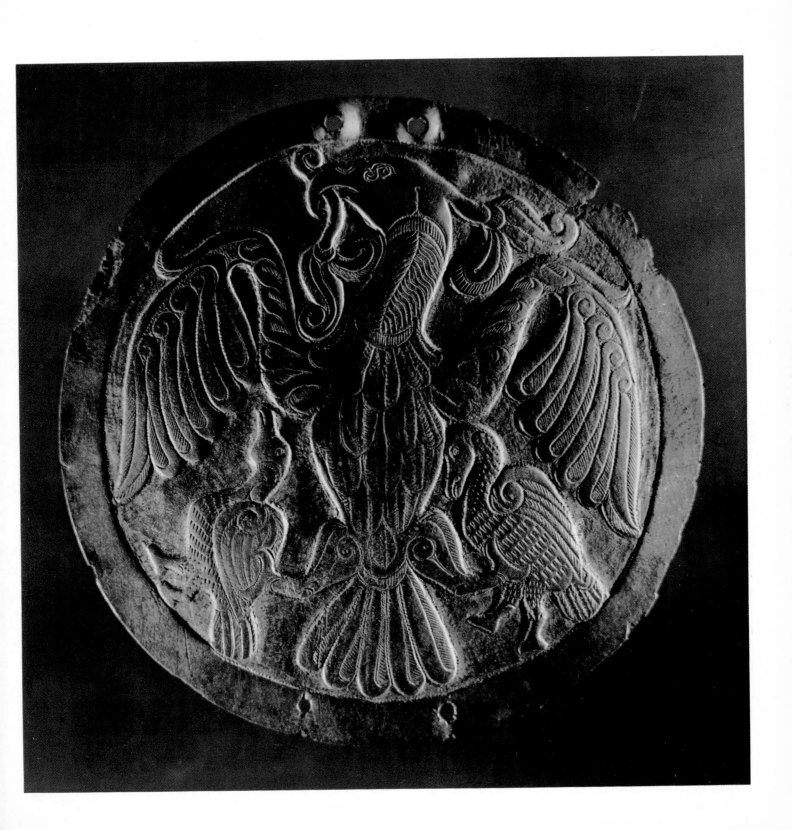

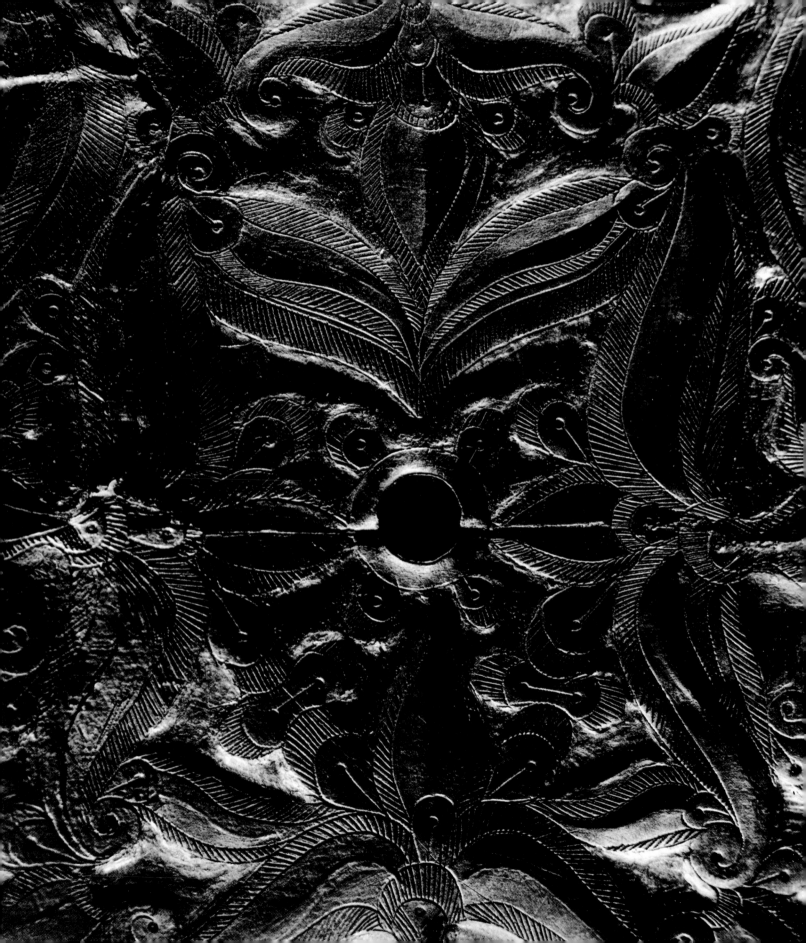

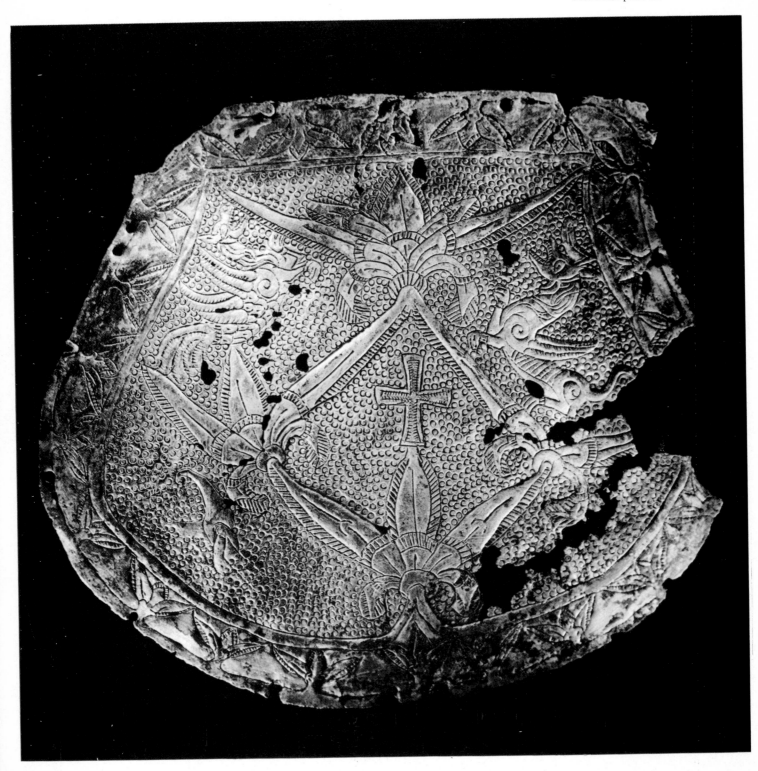

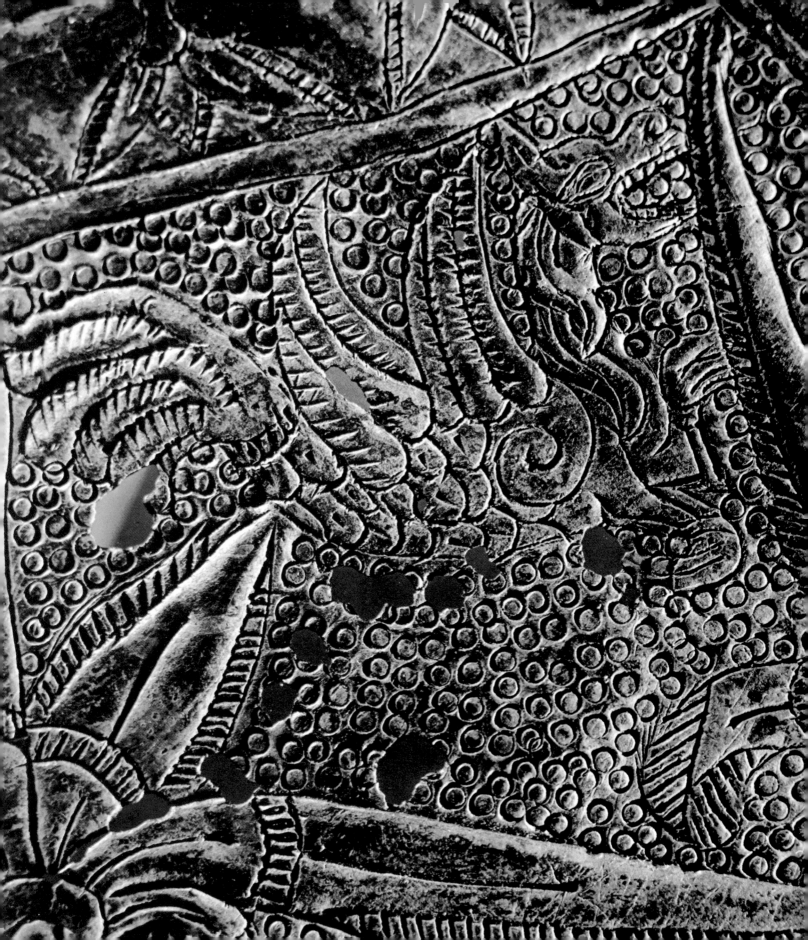

172. Purse plate from Grave 3 at Eperjeske. Nyíregyháza, Jósa András Museum

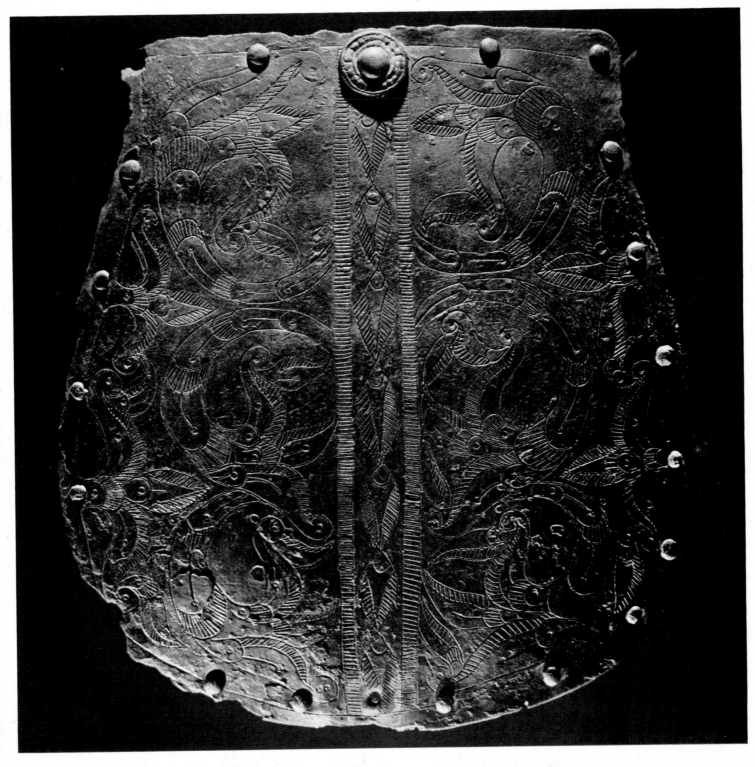

173. Bridles from Muszka. MNM

175. Bracelets
from female graves of
the Conquest Period.
MNM

175. Bracelets
from female graves of
the Conquest Period.
MNM

176. Gold bracelets
from the Conquest Period
found at Zsennye.
MNM

174. Pair of Byzantine earrings from Kecel. MNM

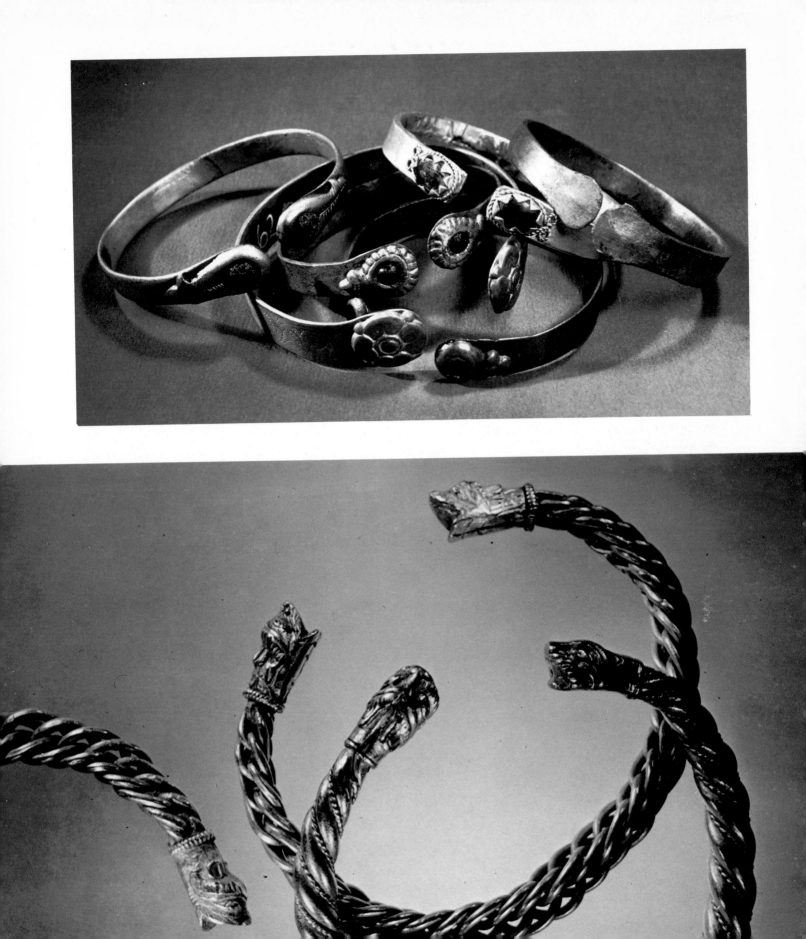

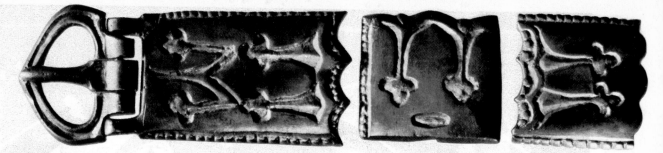

177. Gilded silver belt mountings from the Conquest Period, found at Karancslapujtő. MNM

178. Trappings from a female grave from the Conquest Period. Balotaszállás. Kiskunhalas, Thorma János Museum

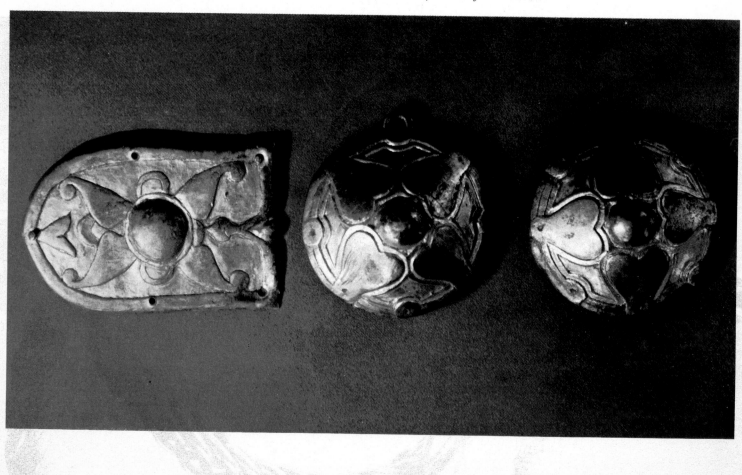

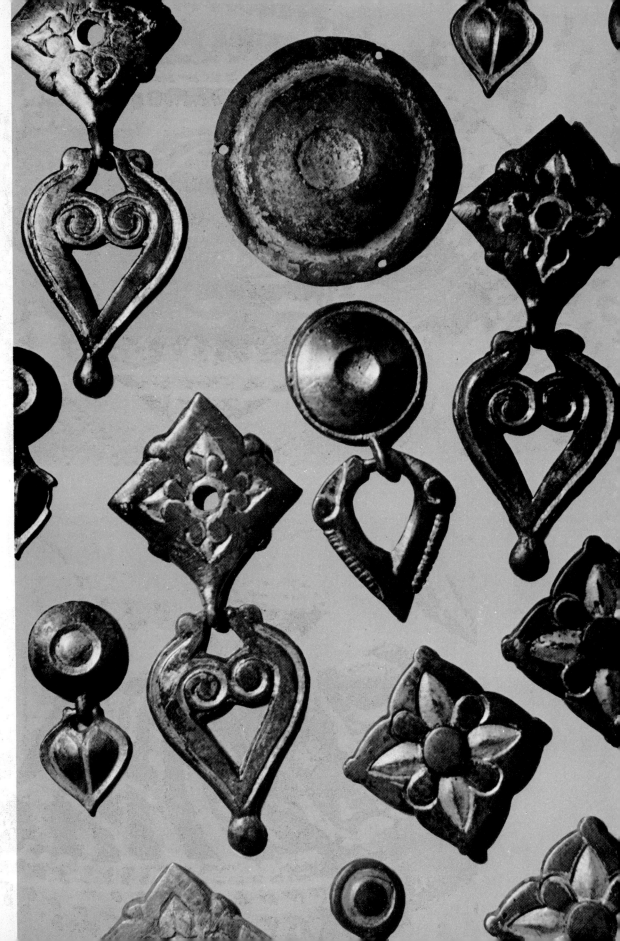

179. Mountings
from a rich female grave
at Szeged-Bojárhalom.
Szeged, Móra Ferenc
Museum

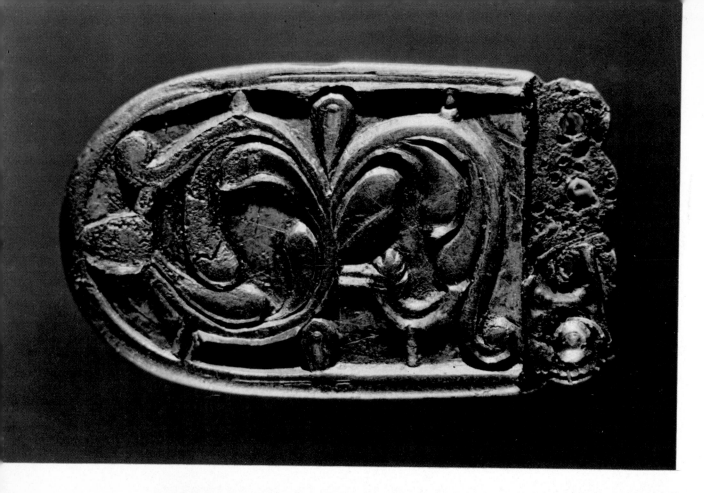

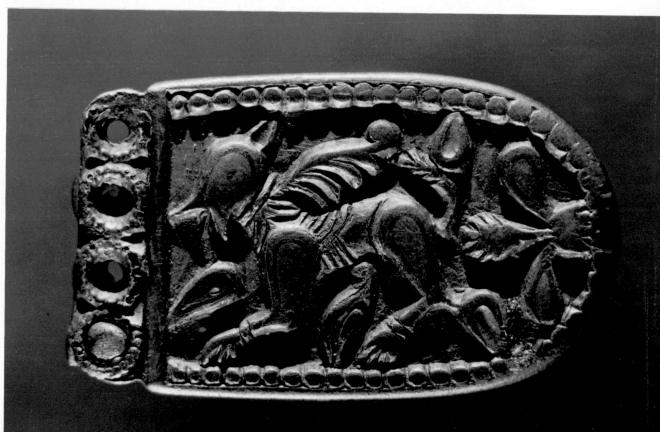

180–181. Two sides of
the strap end from Benepuszta. MNM

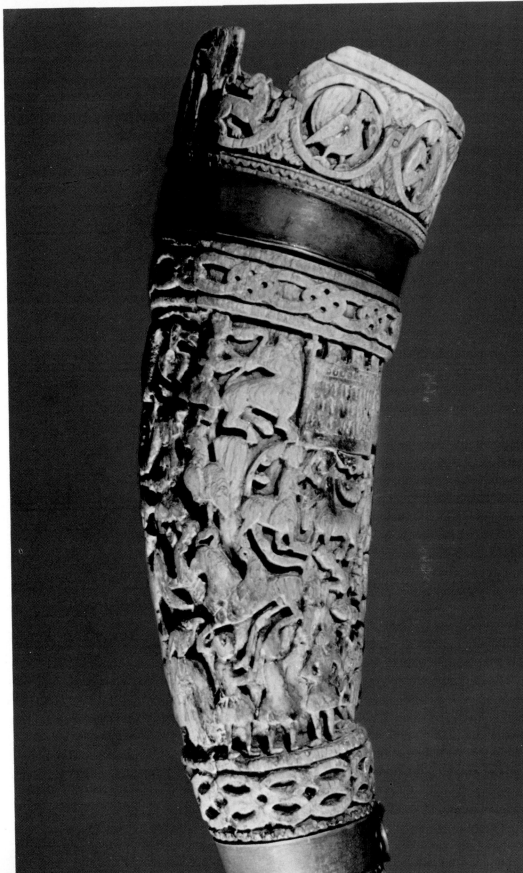

182. "Lehel's horn." Jászberény,
Jász Museum

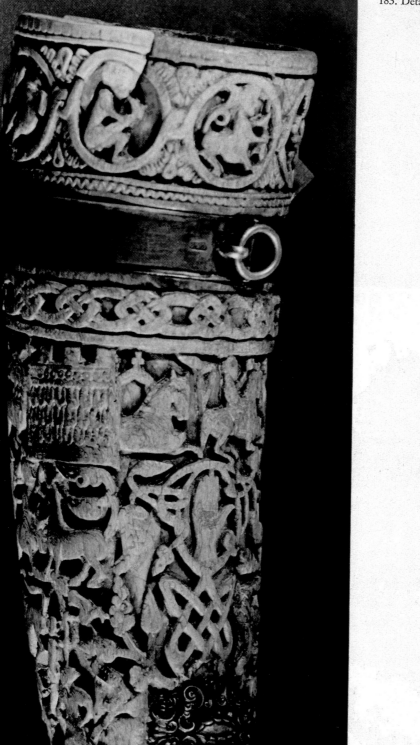

183. Detail of "Lehel's horn." Jászberény, Jász Museum

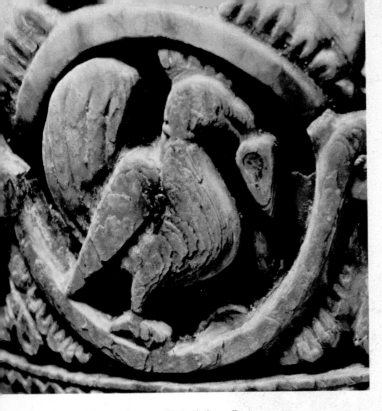

184. Detail of the carvings on "Lehel's horn."

185. Detail of the carvings on "Lehel's horn."

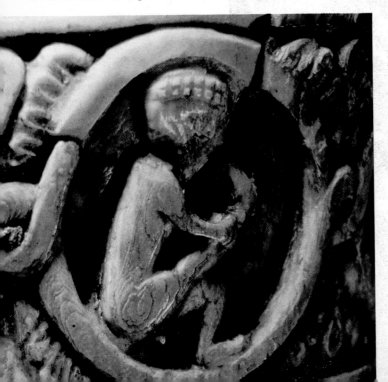

186. Detail of the carvings on "Lehel's horn."

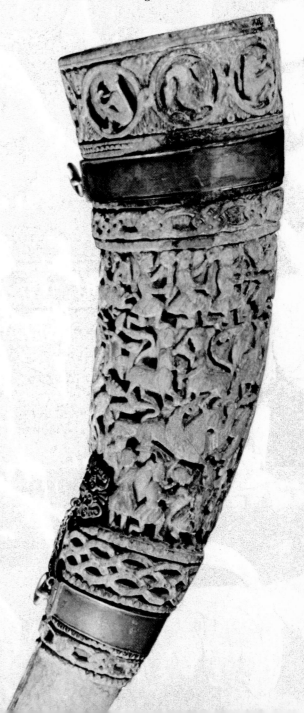

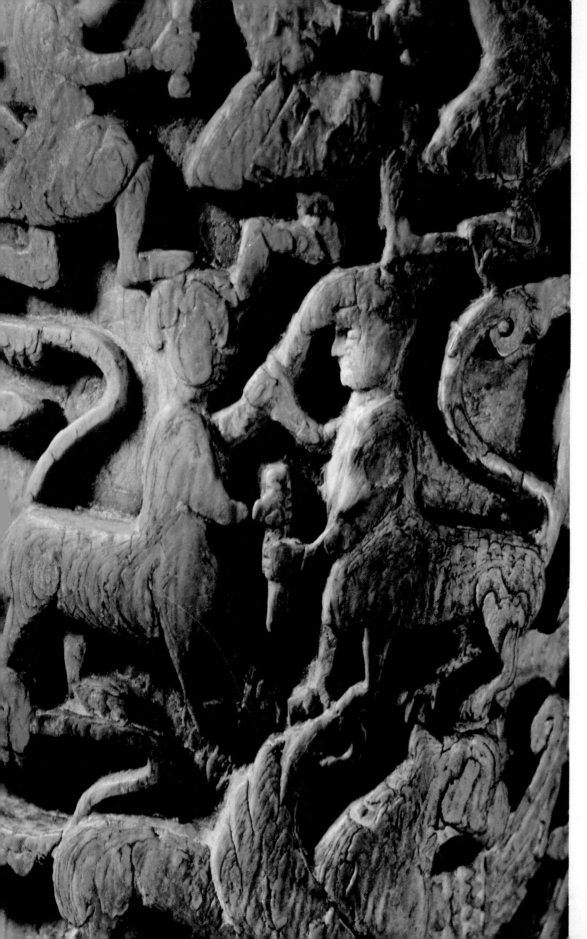

187. Detail of the carvings on "Lehel's horn."

188. Detail of the carvings on "Lehel's horn."

189. Detail of the carvings on "Lehel's horn."

190. The Hungarian coronation scepter.

191. Coins with the inscription Stephanus Rex. MNM

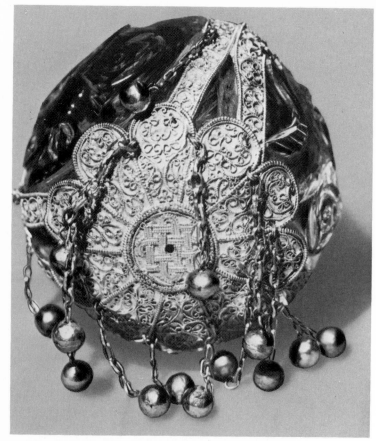

192–193. The Hungarian coronation scepter.

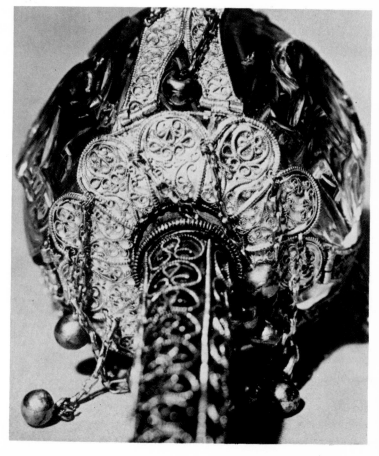

GEORGE *Bush*

GEORGE *Bush*

OUR FORTY-FIRST PRESIDENT

By Sandra Francis

SPIRIT
of America™

The Child's World®, Inc.
Chanhassen, Minnesota

8

GEORGE *Bush*

Published in the United States of America by The Child's World®, Inc.
PO Box 326 • Chanhassen, MN 55317-0326 • 800-599-READ • www.childsworld.com

Acknowledgments
The Creative Spark: Mary Francis-DeMarois, Project Director; Elizabeth Sirimarco Budd, Series Editor; Robert Court, Design and Art Direction; Janine Graham, Page Layout; Jennifer Moyers, Production

The Child's World®, Inc.: Mary Berendes, Publishing Director; Red Line Editorial, Fact Research; Cindy Klingel, Curriculum Advisor; Robert Noyed, Historical Advisor

Photos
Cover: The Library of Congress. All interior photographs are courtesy of the George Bush Library, College Station, Texas

Registration
The Child's World®, Inc., Spirit of America™, and their associated logos are the sole property and registered trademarks of The Child's World®, Inc.

Library of Congress Cataloging-in-Publication Data
Francis, Sandra.
 George Bush : our forty-first president / by Sandra Francis.
 p. cm.
 Includes bibliographical references (p.) and index.
 ISBN 1-56766-875-5 (lib. bdg. : alk. paper)
 1. Bush, George, 1924– .—Juvenile literature. 2. Presidents—United States—Biography—
Juvenile literature. 3. Bush, George, 1924– . 4. Presidents. I. Title.
 E882 .F73 2001
 973.928'092—dc21

 00-013167

18 27 35

Contents

A Privileged Childhood

George Herbert Walker Bush was born on June 12, 1924. He grew up to become the nation's 41st president.

GEORGE HERBERT WALKER BUSH WAS THE first vice president since Martin Van Buren to be elected to the presidency at the end of his vice presidential **term.** Bush became president after Ronald Reagan left office in 1989. At the time, the U.S. government had the largest debt in American history, meaning it owed more money than ever before. The American people hoped their new leader would spend money more wisely.

Throughout his presidency, Bush disagreed with Congress about government spending and about other problems facing the country. But Bush's honesty and efforts won the respect of many Americans. He also displayed great skill in relations with other countries. Congress usually supported him fully in such matters.

President Bush's handling of the Persian Gulf War made him a hero in the eyes of many Americans, but it would not be enough to help him win another election. He spent just four years in the White House.

George Bush was born in Milton, Massachusetts, on June 12, 1924. His family moved soon after, and George grew up in Greenwich, Connecticut. His father, Prescott Bush, was a wealthy businessman. He also

George Bush grew up in a wealthy family that enjoyed many advantages. Even so, he believes his biggest privilege was having parents who loved him. The Bushes were determined that their children would grow up to be good people.

served as a U.S. senator. George, his three brothers, and their sister were raised in a strict but loving home. Religion was an important part of their lives. Prescott Bush taught his children "duty, service, and discipline." George's mother, Dorothy Walker Bush, taught them manners, respect for others, and good sportsmanship. A fine athlete in her own right, Dorothy passed her talents on to George. Throughout his school years, he was especially good at soccer and baseball.

The Bush children enjoyed many privileges. For one thing, they were lucky to attend the best schools. George attended the respected Phillips Academy in Andover, Massachusetts. The Bush children also enjoyed spending their summers at Walker's Point, on the southern coast of Maine. Their grandfather, George Herbert Walker, owned Walker's Point. He also owned a lobster boat, the *Tomboy.* George and his older brother, Prescott, spent

George is shown here in Kennebunkport, Maine, where the Bush family spent its summers. George's grandfather owned a large estate there called Walker's Point. It was in Maine that George developed a lifelong love for the sea. Today his family still spends as much time as possible at Walker's Point.

many wonderful days on the *Tomboy*. They developed a love for the open sea.

In December of 1941, just six months before his graduation from Phillips Academy, George met the girl of his dreams. At a Christmas dance, a friend introduced him to Barbara Pierce from Rye, New York. She was the daughter of a magazine publisher. She and George danced and talked all evening. By the following summer, their affection for each other had turned into a lasting relationship. George and Barbara became secretly engaged when she visited the Bush family at Walker's Point. The two were still teenagers, so they would not marry for several years.

After graduating from Phillips Academy, George ignored his school counselor's advice to go to college. The United States had entered World War II in December of 1941, and George believed it was his duty to join the military and serve his country first. On June 12, 1942, his 18th birthday, George became a seaman second class in the U.S. Navy. He dreamed of becoming a pilot and soon found himself headed for North Carolina to begin flight training. George became a pilot within

Interesting Facts

▶ While in the navy, George Bush flew 58 combat missions before he returned home in December of 1944. For his courageous service, the navy awarded him the Distinguished Flying Cross and three Air Medals.

▶ Barbara's father, Marvin Pierce, was a distant relative of Franklin Pierce, the nation's 14th president.

George Bush joined the navy shortly after finishing high school. Although the educators at his school suggested he go straight to college, George wanted to serve his country first. When he became a pilot, he named his airplane Barbara, *in honor of the girl he left back home.*

one year. When he earned his wings in June of 1943, he was the youngest pilot in the U.S. Navy.

Following intense training, George was assigned to active duty with a torpedo **squadron.** He and his squadron headed for the Pacific. His new home was an aircraft carrier, the *San Jacinto.* George and his crew searched for, photographed, and sometimes attacked the enemy. "Operation Snapshot," as it was called, provided information about the location of destructive Japanese weapons.

10

This was very dangerous work. George had to fly low while another crew-member took pictures. They had to get out quickly before the enemy could fire at them. George and his crew had many narrow escapes.

To the relief of his family, George arrived home safely on Christmas Eve of 1944. Two weeks later, on January 6, 1945, he and Barbara married in her hometown of Rye, New York. The couple then moved to Virginia Beach, where George accepted his assignment at the Oceana Naval Air Station in Virginia. There he trained other men to become pilots. Later that year, on August 14, the Japanese surrendered, and World War II was finally over. George was discharged from service on September 18.

Immediately after George returned home from the navy, he married Barbara Pierce on January 6, 1945.

GEORGE BUSH PILOTED MANY DANGEROUS MISSIONS DURING HIS service with the U.S. Navy. The most frightening of all took place on September 2, 1944. Bush and two other crewmen took off from the deck of the *San Jacinto.* The plane carried bombs and torpedoes, and the crew prepared to attack the enemy on the island of Chichi Jima. But the Japanese were ready to fight back, and Bush's airplane was surrounded by heavy gunfire.

Bush prepared to strike, but suddenly he felt a terrible thud against the side of the plane. Smoke blew into the cockpit. The plane had been hit! Bush and his crew quickly dropped four bombs on the enemy before pulling away. As they reached the sea, Bush ordered the other men to bail out. Then, with smoke blurring his vision, Bush jumped from the plane. Trouble struck when his parachute tore. He quickly unbuckled his gear so that he would not get tangled in the cords of the parachute when he hit the water.

In the terror of the escape, George lost track of the other two crewmen. With an aching head and his arm burning from a wound, he floated for hours before a submarine, the USS *Finback,* arrived to rescue him. The crew hustled George aboard and then quickly took the submarine beneath the water's surface before the Japanese could spot it. A crewmember of the USS *Finback* took the photograph at left as George was being rescued. Unfortunately, George later learned that the other two crewmen from his plane had not survived.

13

The Best of Times

Bush's life at Yale University was fast-paced and busy. He played for the baseball team, studied, and joined clubs. He also devoted time to his wife and newborn son, George.

THE END OF THE WAR BROUGHT HAPPY TIMES to George and Barbara. "We were still young, life lay ahead of us, and the world was at peace. It was the best of times," he once recalled. The couple settled in New Haven, Connecticut, near Yale University. With the war over, George could now go on to college. While living in New Haven, Barbara gave birth to their first child, George Walker, on July 6, 1946.

Meanwhile, Bush balanced his home life and his studies at Yale. Still a good athlete, he was captain of the school's baseball team. He played in the first NCAA College World Series. As an outfielder, he didn't have the best batting average. But his teammates knew that if a ball came his way, he would catch it.

As captain of the Yale baseball team, Bush (right) was chosen to meet baseball legend Babe Ruth (left). "The Babe" was at Yale to present the school's library with the original manuscript of his autobiography, the story of his life.

Bush majored in economics, the science of how people use money, goods, and services. In 1948, he graduated with honors, less than three years after he had started college. Bush had a family to support and was anxious to begin his career. It would have been easy to

15

stay in Connecticut and take advantage of his father's business connections, but George and Barbara decided to make it on their own.

The Bushes moved to Texas, where George hoped to start a career in the oil business. He accepted a sales position at a company called IDECO. He spent more than two years learning the business. Next he teamed up with his good friend, John Overbey. Together, with some help from Bush's family, they formed the Bush-Overbey Oil Development Co. Bush-Overbey purchased the right to look for oil or minerals on people's land. It was a risky business project. If there turned out to be no oil on the land, the company made no money. Fortunately, they managed to earn a small **profit.** In 1953, with two other oil men, they formed a new company called Zapata Petroleum. The following year, they started yet another new company, Zapata Off-Shore.

Bush was very successful. He and Barbara had the security they desired for their family. They moved to Houston to be closer to the company's headquarters. In the late 1950s, Bush began to talk with friends about his growing interest in politics, the work of the

16

government. Many Texans belonged to the Democratic **political party.** The Bush family, however, had always been members of the Republican Party—the opponents of the Democrats. Bush's friends suggested that he change parties if he wanted to win an election. Instead, he and his supporters began to build up the Republican Party in the county where he lived. George served as chairman of the Harris County Republican Party for two years.

In 1964, Bush ran for a seat in the U.S. Senate but lost. He wasn't discouraged, however. He sold his part of the oil business so he could devote all of his attention to politics. Other Republicans noticed Bush's leadership qualities and gave him their support. With their backing, he won election to the House of Representatives in 1966 and again in 1968. With a background in economics and business, he was a natural to

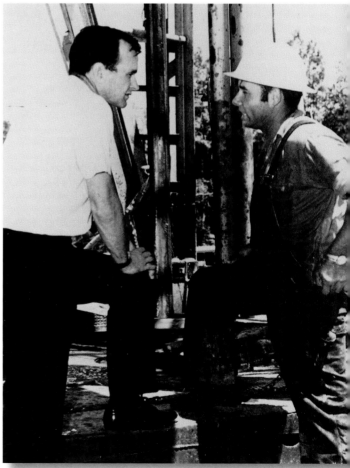

Bush (left) dreamed of achieving success in the oil business. After graduating from Yale in 1948, he moved to Texas. By 1954, he had helped start three successful oil companies.

While Bush's business life was going strong, tragedy struck his family. He and Barbara's young daughter, Robin, was diagnosed with leukemia. Even the best doctors could not save her. Robin died before she turned four years old.

serve on the Ways and Means Committee. This committee helps decide how the government spends its money.

From 1971 to 1977, Bush held many government positions under Republican Presidents Nixon and Ford. He served as the U.S. **ambassador** to the United Nations in 1971 and 1972. Bush understood the important role of the United Nations. This international organization, made up of more than 180 countries, was founded to end war and achieve world peace.

Although Bush wanted to keep his position with the United Nations, President Nixon asked him to take charge of the Republican National Committee. Bush accepted the position. About that time, President Nixon was accused of wrongdoing in what became known as the Watergate **scandal.** Members of the Republican Party, with Nixon's knowledge, had stolen documents from the Democratic Party. This threatened to destroy Nixon's career—and those of many other Republican politicians.

Bush, as chairman of the party, was forced to write the following words to President Nixon: "Dear Mr. President, It is

my considered judgment that you should now **resign** … I now feel that resignation is best for the country.… This letter is much more difficult because of the gratitude I will always feel toward you." Bush believed that it was vital for the country to know that the Republican National Committee had nothing to do with the scandal.

After Nixon resigned, Vice President Gerald Ford became president. He chose Bush to head the U.S. **Liaison** Office in the People's Republic of China. In September of 1974, George, Barbara, and their dog, C. Fred Bush, boarded a plane for Peking. The job turned out to be limited, but the Bushes made the most of their time in China.

After a year and a half, President Ford asked Bush to return to Washington, D.C. Ford wanted him to head the Central Intelligence Agency (CIA). George and Barbara did not

After Bush left the House of Representatives, he held many other important positions in the U.S. government.

19

The Bushes enjoyed their time in China. Before they left, Mao Tse-tung, the leader of the People's Republic of China, told Bush that they would always be welcome to return.

look forward to this assignment. The CIA had earned a bad reputation in recent years. Many of its employees were unhappy as well. But while Bush was head of the CIA, he was able to restore **morale** within the agency and regain worldwide respect for the organization.

20

BARBARA BUSH IS A DEVOTED wife and the mother of six children. She is also one of the most admired of all the first ladies. Barbara has said that people like her because "I look like everybody's grandmother."

In June of 1990, Mrs. Bush was asked to speak at the graduation ceremony of Wellesley College, a school for women. Some students there objected to the selection of Mrs. Bush as the speaker. "Barbara Bush has gained recognition through the achievements of her husband," they said. "Wellesley teaches us that we will be rewarded on the basis of our own merit, not on that of a spouse."

Even though not everyone was happy to greet her, Mrs. Bush received a warm welcome at the ceremony. In her speech, she shared her thoughts and ideas with the young women. "At the end of your life, you will never regret not having passed one more test, not winning one more verdict, or not closing one more deal. You will regret time not spent with a husband, a friend, a child, or a parent.... One does not need to be married, one does not need to have children. But if you do have children, they must come first." She added that she considers herself the "luckiest woman in the world."

Although Mrs. Bush puts her family first, she has devoted herself to helping people all over the country. She believes one of the most urgent problems in America is illiteracy, the inability to read. She organized the Barbara Bush Foundation for Family Literacy to help people learn to read. She has done much to help other people as well, including the homeless, people with AIDS, and the elderly.

Today the Bushes live in Houston, Texas. They spend their vacations at Walker's Point (shown in the photograph above) in Kennebunkport, Maine, with their five living children and 14 grandchildren.

America's Vice President

George Bush headed the CIA for just one year. In 1977, President Jimmy Carter selected another man to head the CIA, so the Bushes returned to Houston.

WHEN BUSH LEFT THE CIA IN 1977, HE found himself unemployed for the first time since 1948. Soon, however, he was asked to advise several large corporations. He became active in various community activities. He also became a professor at Rice University. During this time, Bush was able to renew his Texas friendships and political connections. He even began to consider the possibility of running for president. "I went home to Texas and started thinking, 'Well why not? I'd like to think I can help make things better, here and abroad.'"

In May of 1979, Bush announced that he wanted to be the Republican **candidate** for president. He ended his announcement by quoting the words of President Dwight Eisenhower, promising "a leadership confident

Bush (right) did not accomplish his dream of winning the presidential nomination in 1980. Instead, he became Ronald Reagan's vice president. Reagan (left) and Bush made an excellent team during Reagan's eight years as president.

of our strength, compassionate of heart, and clear in mind, as we turn to the great tasks before us."

To become the candidate, Bush had to win the Republican **nomination.** The contest for the nomination was between Bush and Ronald Reagan, the governor of California.

After a lively campaign, it was clear that Reagan was going to win the nomination. Reagan asked Bush to be the vice-presidential candidate. Bush answered, "I'd be honored, Governor." They were good partners and easily won the election of 1980. They would win the next election in 1984 as well.

On March 30, 1981, a little more than two months after Reagan became president, the nation was shocked to learn that he had been shot. He was seriously wounded and rushed to the hospital. Bush learned of the shooting while on a plane to Austin, Texas. He ordered that the plane return to Washington immediately. There he spoke with confidence to the American people, "I can reassure this nation and the watching world that the American government is functioning fully and effectively." Bush handled the crisis with dignity and calm until Reagan returned to duty less than two weeks later.

Bush had made his fortune in the oil industry. But as vice president, he encouraged people to

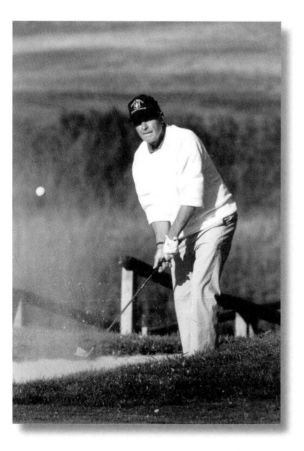

While he was vice president, Bush bought Walker's Point from the rest of his family. He enjoyed life in Maine, playing golf with friends along the shores of the Kennebunkport River.

As vice president, Bush met with leaders from minority groups. He hoped to learn what they believed could improve life in the United States for all Americans.

begin using other kinds of fuel instead of gasoline, which is made from oil. Using other fuels would reduce the pollution caused by gasoline. It would also provide additional sources of fuel if oil became scarce.

Vice President Bush was also concerned about the rising use of illegal drugs in the United States. In 1981, President Reagan put him in charge of the South Florida Task Force. Smugglers from other nations often brought drugs into the United States through Florida. The purpose of the task force was to stop the flow of drugs through that part of the country. Bush quickly brought together many different law-enforcement agencies. He wanted them to work together to stop the drug trade. It was a good first step, but more needed to be done in the countries where the drugs were produced.

In 1988, as Reagan's second term was coming to an end, Bush decided to run for president. He won the nomination, but the race for the White House was not easy. He announced that Dan Quayle from Indiana would be the vice-presidential candidate. Many people thought this was a mistake. Quayle was young and inexperienced. He often made embarrassing speaking blunders. **Debates** were held between the Republican and Democratic candidates. Bush and his Democratic opponent, Michael Dukakis, sometimes seemed boring. Quayle's ignorance and poor choice of words were no match for the sharp wit of Lloyd Bentsen, the Democratic

Bush has long been committed to helping people with disabilities. As vice president, he tried to preserve laws that would help them. As president, he would later pave the way for a new law to help people with disabilities: The Americans with Disabilities Act of 1990.

candidate for vice president. Neither Bush nor Dukakis gave Americans a clear idea of what they planned to do for the country. The American public was left to wonder what choices they had.

The election of 1988 was close, but Bush and Quayle (shown at center) won with 54 percent of the vote.

In the weeks before the election, the issues became more clear. Bush promised he would not raise **taxes,** saying, "Read my lips. No new taxes." This may have helped him win the election, but he would be forced to break his promise.

With the campaign behind him, Bush could put his vast experience to work for the country. He declared to his advisors, "This is going to be an open presidency. I want you all to feel free to call me at any time; I'm going to call you." At his **inauguration** on January 20, 1989, before 300,000 people, Bush spoke of a "new breeze that would sweep the nation."

ONE OF THE GREATEST CHALLENGES OF BUSH'S PRESIDENCY WAS THE PERSIAN GULF War. Saddam Hussein, the **dictator** of Iraq, wanted to control the world's oil supply. He took steps to invade two oil-rich countries, Saudi Arabia and Kuwait. Hussein planned to take over these two countries—and all of their oil. When his forces invaded Kuwait on August 2, 1990, Bush acted quickly to stop him. He brought together **allied forces** from 30 countries. He ordered the U.S. military to prepare a huge number of soldiers for combat. Congress gave President Bush its full approval.

for these actions. The United States and its allies gave Iraq a deadline to leave Kuwait: January 15, 1991.

The plan to stop Iraq became known as "Operation Desert Storm." After months trying to force Hussein to retreat, war finally broke out on January 16, 1991. For more than a month, aircraft bombed Iraqi military targets. Still Hussein would not give up. On February 23, allied troops marched into Kuwait City to force the Iraqis out. By February 27, Iraq was defeated, and the war soon ended.

Some people criticized Bush for stopping the war before Hussein was removed from power, but the U.S. goal was to return control of Kuwait to the Kuwaiti government. With the expertise of General Norman Schwarzkopf (shown above with President Bush), head of the allied forces, the plan was completed successfully.

The Presidency

When Bush ran for president in 1988, he promised to turn the United States into a "kinder, gentler" nation.

THE DEMOCRATS WERE IN CONTROL OF Congress when President Bush entered office. This forced him to make many **compromises.** In June of 1990, for example, he broke his promise of "no new taxes." Democrats wanted a tax increase because the national debt had continued to rise. They believed higher taxes might prevent the government from borrowing so much money. In the end, Bush was forced to agree. His fellow Republicans were angry that he gave in to the Democrats. After this decision, he lost support that he never fully regained. He continued to struggle with the nation's **economy** and with Congress throughout his term.

Bush may have had difficulty achieving his goals for the United States, but his experience

in foreign affairs advanced U.S. leadership around the world. He met with South African leaders to organize a way to end apartheid, the system of laws that separated black people from white people in that country. In 1989, he had ordered troops into Panama to capture General Manuel Noriega. General Noriega was a dictator involved in his country's drug trade. He was brought to the United States and convicted of sending illegal drugs to other countries.

As Bush entered office, **communist** governments throughout Europe began to collapse. The people of these nations wanted to change

When George Bush took office, he said to the nation, "I see history as a book with many pages—and each day we fill a page with acts of hopefulness and meaning. The new breeze blows, a page turns, the story unfolds."

31

▸ As the wife of the vice president and as the first lady, Barbara Bush had the honor of placing the star atop the national Christmas tree 12 times.

▸ President Bush told people that he hated broccoli. Farmers sent the vegetable to the president, hoping to convince him to try it again.

their system of government. They began to build **democracies,** governments similar to that of the United States. Germany was one of these nations. Since the end of World War II, it had been divided into two countries. When a wall was built separating the German city of Berlin into two parts, it came to symbolize the dividing line between communism and democracy. In 1989, the Berlin Wall came down, and the two nations became one.

At the same time, the Soviet Union, a communist superpower, began to change its government. Like President Reagan before him, Bush had many meetings with the leader of the Soviet Union, Mikhail Gorbachev. Since

Bush was forced to compromise with Congress throughout his four years as president.

German Prime Minister Hans-Dietrich Genscher (right) presents Bush with a piece of the Berlin Wall in November of 1989. That year, the world watched as the Berlin Wall crumbled. Since 1961, the wall had symbolized the division between communism and democracy.

the end of World War II, the two countries had had a difficult relationship that became known as the Cold War. During this time, the Soviet Union wanted to spread communism around the world. The United States was committed to stopping it. Both nations began to develop and gather dangerous **nuclear weapons.** For decades, it seemed the tense relations between the two countries could develop into a terrible war.

While Bush was in office, the Cold War came to an end. In August of 1991, he and Gorbachev signed the Strategic Arms Reduction **Treaty** (START I). For the first time, the Soviets and Americans agreed to destroy some of their

Bush was encouraged by the fall of communism around the world. "Out of these troubled times a new world order can emerge," he said. He looked to the future as an "era in which the nations of the world, east and west, north and south, can prosper and live in harmony." He is shown here signing a treaty with Soviet leader Mikhail Gorbachev.

nuclear weapons. In 1992, President Bush and Boris Yeltsin, Russia's new president, signed another treaty, further reducing the number of weapons in both nations. (The Soviet Union dissolved in 1991, and a large portion of it became known officially as Russia.)

In August of 1990, Bush responded to Iraq's invasion of Kuwait. He organized more than 30 countries to stop Iraq and its leader, Saddam Hussein. Congress agreed to cooperate with Bush. It gave him full power to go to war if necessary. War began on January 16, 1991. The United States led its allies in the successful defeat of Iraq. Many Americans praised Bush for his quick and successful operation.

Bush helped begin new peace talks between Israel and Arab countries in the Middle East. For years, Israel had been battling its Arab neighbors. Bush withheld a loan of $10 billion to Israel until it agreed to stop its citizens from settling on Arab lands. This helped him to gain the cooperation of Israel's new leader, Prime Minister Yitzak Rabin.

Bush also signed a trade agreement with Canada and Mexico. The result was the North American Free Trade Agreement (NAFTA) of 1992. The agreement gradually removed taxes to encourage trade between the North American countries.

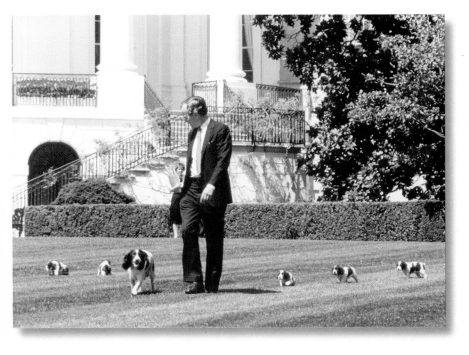

In 1989, Bush took time to stroll on the White House lawn with his dog Millie and her new puppies.

Interesting Facts

▶ In January of 1992, while attending a dinner in Japan, President Bush suddenly became ill. As he passed out, he vomited on the prime minister of Japan! The prime minister kindly held President Bush in his arms until he could be gently laid on the floor. The president regained consciousness a minute later and joked, "Maybe you better roll me under the table, let me sleep, and you just go on with your dinner."

Although Americans admired Bush's success in foreign relations, they were still worried about domestic problems and the economy. Crime was increasing around the country. Unemployment had increased. The national debt was at an all-time high. Even so, Bush easily won the Republican nomination to run in the election of 1992. Democrat Bill Clinton won the election, however. "It hurt a lot," recalled Bush. "But the minute we got back to Houston, Texas, and were welcomed by our neighbors, and went into that little house with two dogs and Barbara and me and no one else, we began to say, 'Hey, life's pretty good.'"

The former president and his wife remain active in public service. In the years since his presidency, the Bushes have visited foreign countries and hosted foreign visitors to the United States. The Bushes have also had the pleasure of watching two of their sons succeed in politics. In 1994, George was elected governor of Texas. He was reelected in 1998, and his brother Jeb was elected governor of Florida that same year.

As the year 2000 rolled around, the Bush family found themselves on the campaign trail again. This time, their son, Governor George W.

Bush, won the Republican nomination for president. His opponent was Bill Clinton's vice president, Al Gore. The extremely close election ended in a near-tie vote. The election was especially close in the state of Florida. At first, it seemed that George W. Bush had won by a small number of votes in that state, but many people questioned the outcome of the election there. They wanted the votes to be recounted.

George and Barbara Bush took a final stroll around the White House grounds on January 20, 1993. When asked what he hoped historians would say about his presidency, Bush replied, "He did his best. Did it with honor."

George and Barbara stood beside their son as agonizing recounts and court battles to decide the election took place. Finally, the U.S. **Supreme Court** said that the recount should end. George W. Bush was declared the winner. The Bushes, proud of their son's success, looked forward to the next four years, remembering their own days in the White House.

1924 George Herbert Walker Bush is born in Milton, Massachusetts, on June 12. The family moves to Connecticut shortly after his birth.

1942 Bush graduates from Phillips Academy, in Andover, Massachusetts. On his 18th birthday, he enlists in the U.S. Navy.

1943 Bush becomes the youngest pilot in the U.S. Navy.

1945 Bush marries Barbara Pierce on January 6. The Japanese surrender in August, ending World War II. Bush leaves the navy in September.

1948 Bush graduates from Yale University. He, Barbara, and their son move to Odessa, Texas, where Bush accepts a job with IDECO.

1951 The Bush-Overbey Oil Development Company is formed in Midland, Texas.

1953 Bush and his business partners found Zapata Petroleum.

1954 Bush and his business partners found Zapata Off-Shore.

1959 The Bushes move to Houston where George runs Zapata Off-Shore.

1963 Bush is elected chairman of the Harris County Republican Party.

1964 Bush loses election to the Senate.

1966 Bush is elected to the U.S. House of Representatives.

1968 Bush is reelected to the House of Representatives.

1970 Bush again runs for the Senate, but loses.

1971 Bush is sworn in as the U.S. ambassador to the United Nations.

1973 Bush becomes chairman of the Republican National Committee.

1974 President Ford appoints Bush chief of the U.S. Liaison Office in the People's Republic of China. George and Barbara Bush move to Peking.

1976 Bush is appointed director of the Central Intelligence Agency (CIA).

1980 Bush is elected Ronald Reagan's vice president.

1981 John Hinckley attempts to assassinate President Reagan. Bush takes over the duties of the president during Reagan's two-week recovery.

1984 Bush and Reagan are reelected.

1988 Bush is elected the 41st president of the United States. Dan Quayle is his vice president.

1989 Bush is inaugurated on January 20. President Bush has his first meeting with Soviet leader Mikhail Gorbachev. Bush sends troops to Panama to capture dictator Manuel Noriega, who is involved in his country's drug trade. The Berlin Wall comes down, reuniting East and West Germany.

1990 Bush signs the Americans with Disabilities Act. Iraq invades Kuwait in August. Bush prepares to stop the invasion.

1991 On January 16, the Persian Gulf War begins when Bush gives orders to begin Operation Desert Storm to drive Iraqi invaders out of Kuwait. Kuwait is liberated in late February. Bush orders an end to combat in the Persian Gulf. Together with Soviet leader Mikhail Gorbachev, Bush signs the Strategic Arms Reduction Treaty (START I), a treaty to reduce nuclear weapons in the two countries. Gorbachev later resigns from his position, and the Soviet Union dissolves.

1992 Bush and Quayle lose the election. Canada, Mexico, and the United States sign the North American Free Trade Agreement to encourage trade between the three countries.

1993 Before leaving office, Bush and the Russian president, Boris Yeltsin, sign START II, banning the most dangerous nuclear weapons. George and Barbara Bush return to private life in Houston after President Bill Clinton enters office.

1994 George and Barbara's oldest son, George W. Bush, is elected governor of Texas.

1997 The George Bush Presidential Library, located at Texas A&M University, is dedicated.

1998 George W. Bush is reelected governor of Texas. John Ellis "Jeb" Bush is elected governor of Florida.

2000 George W. Bush is elected president of the United States after a close election.

allied forces (AL-eyed FOR-sez)
Allied forces are military troops from different countries that come together to fight a common enemy. Bush brought together allied forces from 30 countries during the Persian Gulf War.

ambassador (am-BASS-eh-der)
An ambassador is an important representative sent by one country to another. The United States sends ambassadors to other countries, as well as to the United Nations.

candidate (KAN-dih-det)
A candidate is a person running in an election. Bush hoped to be the Republican presidential candidate in 1980.

communist (KOM-yeh-nist)
In a communist country, the government, not the people, holds all the power, and there is no private ownership of property. The Soviet Union was a communist country.

compromises (KOM-pruh-myz-iz)
Compromises are ways to settle a disagreement in which both sides give up part of what they want. Bush made compromises with Democrats in Congress.

debates (deh-BAYTZ)
Debates are formal discussions on a topic between two or more people. Before an election, candidates participate in debates to express their views.

democracies (deh-MOK-ruh-seez)
Democracies are nations in which the people control the government by electing their own leaders. The United States is a democracy.

dictator (DIK-tay-tor)
A dictator is a ruler with complete power over a country. Saddam Hussein was the dictator of Iraq during the Persian Gulf War.

economy (ee-KON-uh-mee)
An economy is the way money is earned and spent. Bush struggled with the nation's economy while he was president.

inauguration (ih-nawg-yuh-RAY-shun)
An inauguration is the ceremony that takes place when a new president begins a term. Bush's inauguration took place on January 20, 1989.

liaison (lee-AY-zun)
A liaison is a person or group that works to establish friendly relations between two parties. Bush worked at the U.S. Liaison Office in China.

morale (mor-AL)
Morale is the attitude or spirit of a group. Bush was able to restore morale within the CIA.

nomination (nom-ih-NAY-shun)
If someone receives a nomination, he or she is chosen by a political party to run for office. To become the Republican Party's presidential candidate, Bush needed to win the nomination.

**nuclear weapons
(NOO-klee-ur WEH-punz)**
Nuclear weapons use energy to cause powerful explosions, which result in terrible destruction and death. Bush and Soviet leader Mikhail Gorbachev signed a treaty to reduce the number of nuclear weapons in their countries.

**political party
(puh-LIT-ih-kul PAR-tee)**
A political party is a group of people who share similar ideas about how to run a government. Bush is a member of the Republican political party.

profit (PRAH-fit)
A profit is money that is left over after all of the expenses of running a business are subtracted from the total amount of money earned. When it first started out, the Bush-Overbey Oil Development Company earned a small profit.

resign (ree-ZYN)
When people resign, they give up a job or position. The Watergate scandal forced President Nixon to resign.

scandal (SKAN-dul)
A scandal is a shameful action that shocks the public. The Watergate scandal involved President Nixon.

squadron (SKWAD-run)
A squadron is a group of military units. While in the navy, Bush was assigned to a torpedo squadron.

**Supreme Court
(suh-PREEM KORT)**
The U.S. Supreme Court is the most powerful court in the United States. The Supreme Court declared that recounts had to end after the 2000 presidential election.

taxes (TAK-sez)
Taxes are payments of money made by citizens to support a government. During the 1988 election, Bush promised there would be no new taxes while he was president.

term (TERM)
A term is the length of time a politician can keep his or her position by law. A U.S. president's term of office is four years.

treaty (TREE-tee)
A treaty is a formal agreement between nations. In 1991, Bush and Soviet leader Mikhail Gorbachev signed the Strategic Arms Reduction Treaty to reduce the number of weapons each country had.

Our PRESIDENTS

President	Birthplace	Life Span	Presidency	Political Party	First Lady
George Washington	Virginia	1732–1799	1789–1797	None	Martha Dandridge Custis Washington
John Adams	Massachusetts	1735–1826	1797–1801	Federalist	Abigail Smith Adams
Thomas Jefferson	Virginia	1743–1826	1801–1809	Democratic-Republican	widower
James Madison	Virginia	1751–1836	1809–1817	Democratic Republican	Dolley Payne Todd Madison
James Monroe	Virginia	1758–1831	1817–1825	Democratic Republican	Elizabeth Kortright Monroe
John Quincy Adams	Massachusetts	1767–1848	1825–1829	Democratic-Republican	Louisa Johnson Adams
Andrew Jackson	South Carolina	1767–1845	1829–1837	Democrat	widower
Martin Van Buren	New York	1782–1862	1837–1841	Democrat	widower
William H. Harrison'	Virginia	1773–1841	1841	Whig	Anna Symmes Harrison
John Tyler	Virginia	1790–1862	1841–1845	Whig	Letitia Christian Tyler / Julia Gardiner Tyler
James K. Polk	North Carolina	1795–1849	1845–1849	Democrat	Sarah Childress Polk

Our PRESIDENTS

President	Birthplace	Life Span	Presidency	Political Party	First Lady
Zachary Taylor	Virginia	1784–1850	1849–1850	Whig	Margaret Mackall Smith Taylor
Millard Fillmore	New York	1800–1874	1850–1853	Whig	Abigail Powers Fillmore
Franklin Pierce	New Hampshire	1804–1869	1853–1857	Democrat	Jane Means Appleton Pierce
James Buchanan	Pennsylvania	1791–1868	1857–1861	Democrat	never married
Abraham Lincoln	Kentucky	1809–1865	1861–1865	Republican	Mary Todd Lincoln
Andrew Johnson	North Carolina	1808–1875	1865–1869	Democrat	Eliza McCardle Johnson
Ulysses S. Grant	Ohio	1822–1885	1869–1877	Republican	Julia Dent Grant
Rutherford B. Hayes	Ohio	1822–1893	1877–1881	Republican	Lucy Webb Hayes
James A. Garfield	Ohio	1831–1881	1881	Republican	Lucretia Rudolph Garfield
Chester A. Arthur	Vermont	1829–1886	1881–1885	Republican	widower
Grover Cleveland	New Jersey	1837–1908	1885–1889	Democrat	Frances Folsom Cleveland

Our PRESIDENTS

President	Birthplace	Life Span	Presidency	Political Party	First Lady
Benjamin Harrison	Ohio	1833–1901	1889–1893	Republican	Caroline Scott Harrison
Grover Cleveland	New Jersey	1837–1908	1893–1897	Democrat	Frances Folsom Cleveland
William McKinley	Ohio	1843–1901	1897–1901	Republican	Ida Saxton McKinley
Theodore Roosevelt	New York	1858–1919	1901–1909	Republican	Edith Kermit Carow Roosevelt
William H. Taft	Ohio	1857–1930	1909–1913	Republican	Helen Herron Taft
Woodrow Wilson	Virginia	1856–1924	1913–1921	Democrat	Ellen L. Axson Wilson Edith Bolling Galt Wilson
Warren G. Harding	Ohio	1865–1923	1921–1923	Republican	Florence Kling De Wolfe Harding
Calvin Coolidge	Vermont	1872–1933	1923–1929	Republican	Grace Goodhue Coolidge
Herbert C. Hoover	Iowa	1874–1964	1929–1933	Republican	Lou Henry Hoover
Franklin D. Roosevelt	New York	1882–1945	1933–1945	Democrat	Anna Eleanor Roosevelt Roosevelt
Harry S. Truman	Missouri	1884–1972	1945–1953	Democrat	Elizabeth Wallace Truman

Our PRESIDENTS

President	Birthplace	Life Span	Presidency	Political Party	First Lady
Dwight D. Eisenhower	Texas	1890–1969	1953–1961	Republican	Mary "Mamie" Doud Eisenhower
John F. Kennedy	Massachusetts	1917–1963	1961–1963	Democrat	Jacqueline Bouvier Kennedy
Lyndon B. Johnson	Texas	1908–1973	1963–1969	Democrat	Claudia Alta Taylor Johnson
Richard M. Nixon	California	1913–1994	1969–1974	Republican	Thelma Catherine Ryan Nixon
Gerald Ford	Nebraska	1913–	1974–1977	Republican	Elizabeth "Betty" Bloomer Warren Ford
James Carter	Georgia	1924–	1977–1981	Democrat	Rosalynn Smith Carter
Ronald Reagan	Illinois	1911–	1981–1989	Republican	Nancy Davis Reagan
George Bush	Massachusetts	1924–	1989–1993	Republican	Barbara Pierce Bush
William Clinton	Arkansas	1946–	1993–2001	Democrat	Hillary Rodham Clinton
George W. Bush	Connecticut	1946–	2001–	Republican	Laura Welch Bush

Presidential FACTS

Qualifications

To run for president, a candidate must
- be at least 35 years old
- be a citizen who was born in the United States
- have lived in the United States for 14 years

Term of Office

A president's term of office is four years. No president can stay in office for more than two terms.

Election Date

The presidential election takes place every four years on the first Tuesday of November.

Inauguration Date

Presidents are inaugurated on January 20.

Oath of Office

I do solemnly swear I will faithfully execute the office of the President of the United States and will to the best of my ability preserve, protect, and defend the Constitution of the United States.

Write a Letter to the President

One of the best things about being a U.S. citizen is that Americans get to participate in their government. They can speak out if they feel government leaders aren't doing their jobs. They can also praise leaders who are going the extra mile. Do you have something you'd like the president to do? Should the president worry more about the environment and encourage people to recycle? Should the government spend more money on our schools? You can write a letter to the president to say how you feel!

1600 Pennsylvania Avenue
Washington, D.C. 20500

You can even send an e-mail to: president@whitehouse.gov

For Further INFORMATION

Internet Sites

Visit the George Bush Presidential Library:
http://bushlibrary.tamu.edu

Read more about George Bush:
http://www.georgehwbush.com/

Learn more about Barbara Bush:
http://www.firstladies.org/BARBARA_BUSH/FL.HTML

Visit the Barbara Bush Foundation Web site to learn more about the former first lady's literacy project:
http://www.barbarabushfoundation.com/

Learn more about all the presidents and visit the White House:
http://www.whitehouse.gov/WH/glimpse/presidents/html/presidents.html
http://www.thepresidency.org/presinfo.htm
http://www.americanpresidents.org/

Books

Foster, Leila Merrell. *The Story of the Persian Gulf War* (Cornerstones of Freedom). Chicago: Childrens Press, 1991.

Gaines, Ann Graham. *George W. Bush: Our Forty-Third President.* Chanhassen, MN: The Child's World, 2002.

Klingel, Cynthia, and Robert B. Noyed. *Ronald Reagan: Our Fortieth President.* Chanhassen, MN: The Child's World, 2002.

Warren, James A. *Cold War: The American Crusade against the Soviet Union and World Communism, 1945–1990.* New York: Lothrop, Lee & Shepard, 1996.

Index